W9-DFL-018

Interactions

CRITICAL MEDIA STUDIES:
INSTITUTIONS, POLITICS, AND CULTURE

Series Editor
Andrew Calabrese, University of Colorado at Boulder

This new series will cover a broad range of critical research and theory about media in the modern world. It will include work about the changing structures of the media, focusing particularly on work about the political and economic forces and social relations which shape and are shaped by media institutions, structural changes in policy formation and enforcement, technological transformations in the means of communication, and the relationships of all of these to public and private cultures worldwide. Historical research about the media and intellectual histories pertaining to media research and theory are particularly welcomed. Emphasizing the role of social and political theory for informing and shaping research about communications media, *Critical Media Studies* will address the politics of media institutions at national, subnational, and transnational levels. The series will also include short, synthetic texts on "Masters and Concepts" in critical media studies.

Advisory Board

Patricia Aufderheide, American University
Jean-Claude Burgelman, Free University of Brussels
Simone Chambers, University of Colorado at Boulder
Nicholas Garnham, University of Westminster
Hanno Hardt, University of Iowa
Maria Heller, Eötvös Loránd University
Robert Horwitz, University of California at San Diego
Douglas Kellner, University of Texas
Gary Marx, University of Colorado at Boulder
Toby Miller, New York University
Vincent Mosco, Carleton University
Janice Peck, University of Colorado at Boulder
Manjunath Pendakur, University of Western Ontario
Arvind Rajagopal, Purdue University
Kevin Robins, University of Newcastle
Saskia Sassen, Columbia University
Colin Sparks, University of Westminster
Slavko Splichal, University of Ljubljana
Thomas Streeter, University of Vermont
Liesbet van Zoonen, University of Amsterdam
Janet Wasko, University of Oregon

Forthcoming in the Series

Communication, Citizenship, and Social Policy: Rethinking the Limits of the Welfare State, edited by Andrew Calabrese and Jean-Claude Burgelman

Interactions

Critical Studies in Communication, Media, & Journalism

Hanno Hardt

ROWMAN & LITTLEFIELD PUBLISHERS, INC.
Lanham • Boulder • New York • Oxford

ROWMAN & LITTLEFIELD PUBLISHERS, INC.

Published in the United States of America
by Rowman & Littlefield Publishers, Inc.
4720 Boston Way, Lanham, Maryland 20706

12 Hid's Copse Road
Cumnor Hill, Oxford OX2 9JJ, England

British Library Cataloguing in Publication Information Available

Library of Congress Cataloging-in-Publication Data
Hardt, Hanno.
 Interactions : critical studies in communication, media, and
journalism / Hanno Hardt.
 p. cm.—(Critical media studies)
 Most chapters are essays, edited for this publication, which were
previously published in various sources, 1972–1996.
 Includes bibliographical references and index.
 ISBN 0-8476-8887-9 (cloth : alk. paper).—ISBN 0-8476-8888-7
(pbk. : alk. paper)
 1. Communication. 2. Mass media. 3. Journalism. I. Title.
II. Series.
P90.H324 1998
302.2—dc21 98-23718
 CIP

ISBN 0-8476-8887-9 (cloth : alk. paper)
ISBN 0-8476-8888-7 (pbk. : alk. paper)

Internal design and typesetting by Letra Libre

Printed in the United States of America

∞™ The paper used in this publication meets the minimum requirements of American Na-
tional Standard for Information Sciences—Permanence of Paper for Printed Library Materials,
ANSI Z39.48–1984.

*This book reflects my intellectual encounter
with several generations of students
whose presence in the graduate programs
of the School of Journalism and Mass Communication
and the Communication Studies Department
has enriched my work and advanced the cause
of critical media studies at the University of Iowa.
To them I dedicate this book with admiration and respect
for their commitment to the permanent struggle
of critical scholarship.*

Contents

Introduction

Enriched by critical theory and the insights of cultural studies and rooted in the power of historical explanation, this collection of essays contributes to the theory and practice of critical studies in communication, media, and journalism.

Despite their impact on the research agendas of communication studies in the United States since the late 1960s—cultural studies, including feminism in particular—still serve as alternative theoretical perspectives and reminders of the potential of communication and media studies as a political project. For instance, when the consciousness-raising periods of radical sociology (informed by Critical Theory) and cultural studies (inspired by British Cultural Studies) during the 1960s and 1980s, respectively, energized the field, they launched Marxism into communication studies, where it lingered without being fully realized as a source of concrete, political strategies of change in the process and structure of societal communication. Instead, Marxism's critical vocabulary resulted in a shifting language of inquiry that continues, by and large, to serve liberal-progressive interests—including the need for self-criticism—without penetrating the ideological position of mainstream media studies. Indeed, hopes for the oppositional role of a critical scholarship that is feminist in orientation and reform-minded in its goals languish in the shadow of rising traditional visions of the field that perpetuate administrative research agendas and reinforce industry demands for procedural knowledge, including new definitions of journalism, to strengthen its ideological position and accommodate changing economic conditions.

Nevertheless, the need for critical studies persists. They are aimed at the historical relations between media work and ownership or between individuals in the process of communication and media as institutional expressions of social and political power and it is grounded in a critical the-

ory of the media that addresses the potential of liberating individuals—consumers as well as newsworkers—by challenging their traditional roles in the hegemonic relationship of media and society.

The following observations about the modern culture of communication address the centrality of communication in everyday life; they suggest the existence of a historical dimension of representations that continue to reproduce conformist interpretations of the dominant ideology, including the potential of change. The culture of communication constitutes an arena of practices with its own knowledge that bridges traditional academic disciplines and demonstrates the power of an interdisciplinary vision. It also defines and places communication studies within a larger field of intellectual inquiry with its own dynamic as an integrating concept. Critical communication studies, in particular in its pursuit of concrete goals, contributes to understanding human existence and a way of life by exploring the notion of experience through language and ideology or media and representation under the specific conditions of history. In this context, it is part of a modernist project grounded in cultural materialism, and committed to a progressive agenda for change.

These chapters are informed by the centrality of historical thought in the theory and practice of communication studies; they challenge the constraints of traditional uses of history and theory in reaction to emerging issues of power and class in particular. They are also grounded in an understanding of the migration of ideas—from European considerations of culture to American adaptations—into theoretical insights about communication. Indeed, contemporary communication studies have benefited from a broad theoretical discourse, including the contributions of German Critical Theory, French Structuralism, and British Cultural Studies among several disciplines; they have also gained from the development of interdisciplinary perspectives—like feminist theories—which have broadened the scope of intellectual activities and advanced the cause of theorizing, offering alternative explanations for the conditions of communication in society and providing new insights into media practices.

This collection, however, also serves as a reminder that a critical approach to the study of communication and media continues in the margins of the field, where notions of ideology, hegemony, power, or class inform the process of surveilling media practices and prepare a different basis for a political response to the crisis of public communication. The latter is particularly important, since the emergence of the "critical" in U.S. (mass) communication studies occurred without the political dimension of a critique of communication, media, and culture in society. Rather, it coincided with an exploration of Marxism through the adaptation of British Cultural Studies (more than Critical Theory) and the availability of a language of cultural criticism. The adoption of the latter in writings about media

and communication, however, constituted an oppositional gesture that masked rather than changed prevailing theoretical dispositions, which have failed to focus on the ideological in communication studies to address the institutional (and political) deficiencies of media practices. Thus, the provocative vocabulary of an ideological critique of media and culture is typically used to perpetuate traditional reformist ideas that avoid issues of power or class relations, for instance, in their pursuit of middle-class goals.

Indeed, Marxist scholarship is in decline, perhaps a casualty of the end of the Cold War but more likely a victim of a shift toward a new pragmatism that promotes technocratic solutions to institutional problems and favors a resurgence of traditional perspectives on media and communication. More specifically, a new alliance between industrial interests and academic pursuits promises significant changes in addressing the needs of the media appropriately with applied research agendas and relevant education.

The first part of the book, Historical Considerations, establishes the intellectual contexts, including the impact of European ideas and their relevance for the modern period of communication and media studies in the United States, when the development of the field was stimulated by the flow of alternative visions of the world. Thus, conceptualizations of communication that focus on collective notions of community or public interest, for instance, or understandings of media that emphasize their public nature and promote collective ownership emerge as ideologically different perspectives. They confront a theoretical environment that has been marked by the liberal-pluralist traditions of individualism, democracy, and freedom of expression and by the perpetuation of specific roles for the social sciences in advancing the cause of society.

These alternative visions of culture and communication came at a time when the ideals of a traditional relationship between democracy and communication had suffered from growing social and intellectual incompetencies caused by the breakdown of education and the process of economic and political marginalization of significant segments of society. Consequently, the vested interests of classical American sociology, which emphasize issues of individualism, freedom, and rationality, and contemporary proponents of American Pragmatism, whose cultural approach celebrates notions of pluralism, community and democracy, began to ponder the effects of the commercial and political marketplace on conditions of communication. The subsequent recognition of definitive and consequential differences of gender and race in particular challenged traditional perspectives on communication and society, based on notions of homogeneity, and contributed to the experience of fragmentation.

Together, these developments constitute a serious responsibility for the study of culture and communication to achieve workable solutions with the

assistance of British Cultural Studies, which helped to legitimate questions of ideology and issues of representation while introducing a new sensitivity to gender and race and promoting the notion of class.

Critical studies of communication and media are located at the center of those concerns. They face a traditional approach to communication and culture that rejects radical dissent, including a Marxist criticism of American society, relegating it to a literature of social criticism rooted in rhetorical studies, literature, political economy, and sociology while depending on a firm belief in consensual participation as democratic practice and in the exercise of political and economic power as an act of progressive intervention. Thus, considerations of class remain peripheral in terms of observing culture—for example, the life experience of individuals in their specific social and economic situations—or describing communication, for example, the nature and substance of a response to real-life conditions. Consequently, much has been written about the experience of media use among individuals, groups, or social elites with little, if any, consideration of class as a critical category of social scientific or cultural explanations of how media work within a capitalist society.

For instance, the self-serving critique of collective, socialist models of communication and journalism in post-Communist Eastern Europe by Western (American) experts is a celebration of the capitalist mode; it is also an appropriate example of ideological reeducation that lacks any social or cultural sensitivities. Instead, media organizations, including foundations, and a conformist journalism education establishment operate within traditional categories of the dominant ideology, reinforcing the values of capitalism and turning the ideal type of a democratic press into a dogmatic version of U.S. media practices. The latter ignores the cultural conditions of specific societies—including collective solutions to problems of societal communication, for instance—privileges private ownership of the means of communication in the context of promoting a free market system, replaces issues of class with definitions of audiences or customers, and problematizes participation as economic commitment.

In fact, in a social and political environment that insists on the primacy of the individual, communication research has been concerned principally with understanding those whose economic conditions or social status produced aggregates of individuals as audiences or readers. Their tastes, attitudes, and behavior are measures of success for political or commercial interests and their need to know. The emerging information has never empowered those subjected to the media but has provided those in control of media content with insights about the potential of illusion and the power of manipulation. In this ideological context, administrative research reproduces communication and media practices as problems of individual choice while marginalizing economically weak and culturally displaced individuals

whose inadequate competencies as consumers also restrict or deny participation in any kind of societal communication.

Therefore, critical theories of communication and media must be sensitive to the materialization of class consciousness and reveal the nature of class distinctions in the context of culture and politics. The notion of class consciousness implies community and solidarity, as well as collective action to serve class interests. It finds expression in the discourse of class, including potential competition between individual and collective expressions of interest within a particular class. The state of communication or media affect the sense of community and solidarity as well as the psychological mobility of individuals, thereby producing conditions for collective action and a state of flux among class members and across classes. In either case, class consciousness is bound up with class struggle, such as the weakening of class consciousness among workers through the lure of mediated realities (particularly in advertising) that deny class diversity and promise upward mobility.

The second part of the book, Critical Applications, addresses more specifically and concretely the historical conditions of media and journalism in the United States to suggest the possibility of alternative explanations. Journalism as a cultural product and journalists as cultural workers provide a suitable context for discussion of the specific historical developments of the relations of production and the nature of work in the context of media organizations and of the rise of private enterprise that has characterized the growth of journalism as an industrial concern.

Since industrial interests control access not only to products but also to the means of production and ultimately determine the conditions of work, they also define the function of the workplace and decide the structure of audiences. Critical media studies must acknowledge and address the complex relationship between the intentions of production and the practices of reception, including problems of fragmentation and alienation related to work and the increasing industrialization of the workplace. In particular, few examinations of media work exist on the impact of technology on newsworkers, for instance, or of class relations in the field of professional journalism and media organizations. This absence of a critical stance toward the authority of ownership over professional concerns is particularly apparent in an academic environment, where the education of journalists and other media personnel remains a major objective.

A growing need exists for a critical review of American journalism at a time when journalism itself is changing most significantly, redefining the parameters of the profession and articulating a new understanding of the public. More specifically, the realm of professionalism is being refigured by shifting demands on newsroom labor, no longer an exclusive terrain of editorial practices but frequently integrated into a system of customer services

that range from advertising copy writing to public relations assignments. Journalists are losing their sense of autonomy in a work environment shaped by the business interests of the press and conditioned by the impact of new technologies on newswork. Whereas the former confirms the ideological position of ownership, the latter constitutes an increasing industrialization of the profession. Both contribute to the alienation of journalists, either by diverting them from a traditional understanding of professional intent or by separating them from the products of their own labor. In addition, the dissolution of collective professional interests through specialization and the introduction of computers as an accomplishment of industrialization result in intellectual and physical challenges to journalists who must adjust to new demands on their editorial expertise and to the physical stress caused by the repetitive nature of their new tasks.

Their work is also directed by a new understanding of the public as a specific, economically viable segment of society with special requirements. There is no desire to identify the needs of the public with information deficits and knowledge gaps or the public's right to know with an obligation to provide a public service; instead, there is a growing commercial interest in privileging the role of the customer by responding to the wishes of a specific public. The result is a class-specific, politically focused patronage model of the press in particular whose allegiance has shifted from public service to service for a designated public. This development may contribute to a fragmentation of society by undermining notions of equality and may threaten the democratic process by privileging sources of information (news) and creating media realities that reflect bourgeois conditions of existence at the expense of responding to other groups in society. In fact, when cultural capital is redefined as the currency of leading social and political interests, its accumulation becomes a class-specific practice confined to potential contributors to the commercial environment.

For instance, the current initiative by several media foundations to create a new type of "public" journalism constitutes a major effort to shape the future of journalism (and of journalism education) in the United States by creating a new definition of public interest. Their calls for "public" or "civic" journalism have produced a range of responses from tales of cooperation and civic approval mixed with professional skepticism to outright rejection for fear of jeopardizing the traditional sense of editorial autonomy. The foundations' agendas for media reform signal an alliance between journalism and foundations that would have been inconceivable several years ago. In fact, the prominence of media foundations as powerful institutional forces in various professional and educational arenas of public life has never been raised as a political issue with potentially undesirable influences on the process of journalism or journalism education. At a time when industrial interests are served with increasing regularity by universities

eager to obtain private funding to offset shrinking state support, journalism education in particular may have become vulnerable to the specific agendas of media interests. At stake is the definition of journalism and its role in contemporary society, the nature of professional work, and the future of journalists.

Journalism represents a source of societal knowledge; it is organized to assist in the production of everyday realities under specific ideological conditions; and it serves to promote the private, political, and commercial interests of its owners. Its institutional authority advances the credibility of facts that create the truths that shape the world. Journalism resides in the cultural habitat of language from which it represents the social and political discourse of society. It is also a historical narrative, constructed by social, cultural, and political representations that further a particular explanation of the relations of society and accommodate a particular version of democracy.

But journalism is also about work and the conditions of intellectual labor; it determines the journalist as newsworker, whose practice reflects the nature and extent of freedom in the workplace, which dictates the content of newswork, reinforces dominant values, and institutionalizes dissent. Thus, journalism is a craft that rests in traditional expectations of the role of the media and is reshaped by the circumstances of employment. It reproduces the conditions of domination and generates a dependent, if not subordinate, intellectual practice. After all, journalism constitutes a social process that privileges those in control of the means of communication.

Thus, changes in journalism affect a range of social, cultural, and political issues, from the ideological substance of representation to the nature of professional work and its meaning in the realization of societal goals. They are typically brought about by social, economic, or political forces that control the media against oppositional constructions or different expectations of the relationship between media and society. To expose the controlling, one-sided explanations of media and journalism in particular and to propose alternative interpretations are among the primary goals of critical media studies.

Thus, the decline of journalistic authority in the United States remains a serious social and cultural issue that is only too often dismissed as the erosion of an elitist notion whose public credibility vanished long ago. Similarly, debates about the ignorance of the masses have been replaced by hopes for the public's wisdom and its desire for enlightenment. At the same time, technological change and economic necessities have pushed the practice of journalism beyond traditional expectations. As a result, the prevailing commercial interests of the media in an increasingly competitive environment have begun to transform the status and skills of the workforce and to undermine its authority while mass audiences have moved beyond the

reach of a traditional press to be replaced by the potential of an affluent, middle-class clientele with specific information needs. These developments are a reminder of a historical process in late capitalism that subordinates journalism as a cultural practice to the economic rationale of marketing and new information technologies.

More specifically, this section of the book approaches the lack of a labor perspective in the construction of a conventional media history and the ethnocentric approach to the culture of "otherness," ranging from the production of foreign news to an understanding of cultural diversity in the making of American journalism. Despite a growing sensitivity to issues of gender and race in particular there is a reluctance to redress the problems of an elitist, top-down explanation of journalism and mass communication history and to acknowledge the multicultural contributions to the development of the media and the idea of journalism in the United States.

By drawing attention to the antilabor bias or the ethnocentric attitude of (mass) communication history, these chapters also provide an ideological critique of the field. They promote change by encouraging alternative visions of history, and they anticipate the consequences of capitalism by utilizing the interpretive potential of history. Together, these inquiries into the nature and function of professional practices challenge an entrenched understanding of media in society and serve as examples of the emancipatory power of a critical approach to the field. In fact, critical media studies contribute to an emancipatory study of society based on the insights of Critical Theory and British Cultural Studies as they relate to communication and culture.

To this end, the book combines a variety of essays, most previously published, whose historical perspective on communication theories and media practices engages the field in a critical discourse at a time when academic and media interests have joined to legitimate the changing relationship between journalism and society while the influence of cultural studies on communication studies begins to fade with the impact of commercial and industrial interests on academic institutions and the rise of a new conservatism across disciplines.

These chapters were edited for this publication. Permission to reprint them has kindly been granted by the respective publishers of these journals and books (in chronological order, starting with the most recent).

"The End of Journalism. Media and Newswork in the United States." *Javnost/The Public* 3:3 (1996), 21–41.

"The Making of the Public Sphere. Class Relations and Communication in the United States." *Javnost/The Public* 3:1, (1996), 7–23.

"Authenticity, Communication, and Critical Theory." *Critical Studies in Mass Communication* 10:1 (1993), 49–69.

"Newsworkers, Technology, and Journalism History." *Critical Studies in Mass Communication,* 7:4 (1990), 346–365.

"The Foreign Language Press in American Press History." *Journal of Communication* 39:2 (Spring 1989), 114–131.

"The Return of the 'Critical' and the Challenge of Radical Dissent: Critical Theory, Cultural Studies and American Mass Communication Research." *Communication Yearbook/12.* Newbury Park: Sage Publications, 1989, 558–600.

"Comparative Media Research: The World According to America." *Critical Studies in Mass Communication 5* (June 1988), 129–146.

"Communication and Economic Thought. Cultural Imagination in German and American Scholarship." *Communication* 10:2 (1988), 141–163.

"The Dilemma of Mass Communication: An Existential Point of View." *Philosophy and Rhetoric,* 5:3 (1972), 175–187.

Part One

Historical Considerations

1

Contemplating Marxism— and Other Theoretical Challenges

The development of mass communication research is a process of adapting and integrating theoretical constructs that emerge from an intellectual exchange of social and political ideas in the historical context of American social theories and the recent challenge of Marxism. This chapter focuses more specifically on the idea of the "critical" that appears in the literature of mass communication research in the United States, informed by pragmatism and the practice of a positivistic social science and, more recently, expressed elsewhere under the influence of Marxism, particularly by Critical Theory and British Cultural Studies. Thus, the term *critical* refers to the rise of social criticism as it emerged from the nineteenth century with the advancement of science and the effects of industrialization. Although frequently linked to socialism and Marx's critique of political economy, social criticism should be considered in the social and cultural context of different theories that have as their determinate goal the improvement of society. Similarly, the idea of culture should be broadly interpreted to refer to the social context of human existence.

The study of culture and cultural institutions has been a concern of many disciplines, including interdisciplinary efforts in communication and mass communication studies; most recently, it has been expressed through an exploration of ideological representations and the process of ideological struggle with and within the media, emphasizing the relationship among media, power, and the maintenance of social order. The perceived need for an alternative explanation of media and communication in society stresses the importance of culture and cultural expressions and has focused on the work of British Cultural Studies as an appropriate alternative, although

3

earlier encounters with a critical, cultural tradition occurred in the American social sciences.

Throughout the intellectual history of the United States, European thought—particularly British and Continental philosophy—has continually influenced the development of the American mind. In fact, the rise of pragmatism as an American philosophy provides a vivid example of the fact that "the conglomerate manifestations of the American mind are the result of local adaptions, graftings, and crossings of the older loyalties and ideas that migrated from Europe" (Thayer, 1973, 228–229). The theoretical discourse at the beginning of the twentieth century involves a critique of the existing philosophical tradition; it coincides with the breakup of the old orthodoxies and replaces the domination of a classical-religious perspective with a reformist-scientific position.

In fact, American pragmatism seeks a reconciliation among morals and science (James), the adoption of a scientific practice based on the primacy of the community of inquirers (Peirce), and an understanding of the practical character of thought and reality based on a behavioral interpretation of the mind (Dewey, Mead). The appeal of pragmatism as a new foundation of social and scientific knowledge, however, rests in Dewey's (1931, 24) "almost revolutionary" suggestion that "Pragmatism . . . presents itself as an extension of historical empiricism but with this fundamental difference, that it does not insist upon antecedent phenomena but consequent phenomena; not upon the precedents but upon the possibilities of action. And this change in point of view is almost revolutionary in its consequences." When the idea of communication produced by such "adaptations and crossings" surfaces in the social science literature, it reflects a philosophical movement that struggles against Cartesianism in modern philosophy to develop a new position in which the social became "*the* inclusive philosophic category" (Bernstein, 1967, 133).

Among the pragmatists, Dewey's prolific writings on societal questions based on his interest in the social, his belief in the centrality of community, and his faith in the workings of democracy supply a theoretical context for the growing interest among social scientists in the social problems of society. Their activities have grown out of the realization that with an increasing concentration of political and economic power, the study of institutions and collective activities is an appropriate and necessary direction for social scientific inquiry. They resulted in efforts to disclose the predatory nature of American industry (Veblen), to render an economic interpretation of history (Beard), and to offer a sociological critique of traditional thoughts of individuality and morality (Small, Ross, Park) in attempts to expose and share with others their understanding of the harsh reality of American life. The emphasis in these inquiries is on the social process and the prospects for a perfect society that would be identical with a perfect democracy.

The notion of communication becomes a major theoretical issue and a measure of the success of a democratic society, since an understanding of culture, or society, was based on the process of communication. In fact, George Herbert Mead (1967, 327) described an ideal society as one "which does bring people so closely together in their interrelationships, so fully develops the necessary system of communication, that the individuals who exercise their own peculiar functions can take the attitude of those whom they affect." For Mead (1967, 327), who demonstrated in his own work how the self emerges through communication, it seemed plausible that under such perfect and ideal conditions "there would exist the kind of democracy . . . in which each individual would carry just the response in himself that he knows he calls out in the community." Since communication always involved "participation in the other," its problems and, in a sense, the problems of democracy remain a question of "organizing a community which makes this possible" (Mead, 1967, 327).

These notions were related to Dewey's (1925, 169) appreciation of communication as "uniquely instrumental and uniquely final. It is instrumental as liberating us from the otherwise overwhelming pressure of events and enabling us to live in a world of things that have meaning. It is final as a sharing in the objects and arts precious to a community, a sharing whereby meanings are enhanced, deepened, and solidified in the sense of communion." Such mystical and powerful explanation of communication also involved the idea of democracy. For Dewey (1966, 87), it is "more than a form of government," it represents "a mode of associated life, of conjoint communicated experience."

Thus, communication becomes the foundation of society and a necessary condition for the working of democracy; it is the nexus of a critical perspective on American culture. The evolving critique of society is also a critique of an atomistic view of the individual that had become incompatible with the ideas of democracy when it disregarded collective interests under the technological and economic consequences of a new era in American life. At the same time, industrialization and the rapid growth of society had also led to the creation of a "public" that was disoriented and unable to identify itself. Dewey (1954, 126–127) lamented the fact that "the machine age in developing the Great Society has invaded and partially disintegrated the small communities of former times without generating a Great Community." His goal, and that of others, was the perfection of the "machine age," which would eventually lead to a democratic way of life. They "saw the new machinery as a means to scale the obstacles to moral unity— ignorance, parochialism, and antagonism between classes. They believed that the new technology would encourage the growth of a mutual sympathy and a rational public opinion that transcended the boundaries of class and locality" (Quandt, 1970, 34). Dewey thought such development would

be aided by and through a process of expert inquiry by social scientists, whose participation would confer upon them a special status in society. He proposed (1954, 209) that "it is not necessary that the many should have the knowledge and skill to carry on the needed investigations; what is required is that they have the ability to judge the bearing of the knowledge supplied by others upon common concerns." A similar position was expressed by Albion Small (1910, 242) who felt consensus in society should be reached by "scientists representing the largest possible variety of human interests."

Thus, within the critique of society at that time, there was an emerging sense of the importance of intellectual leadership, specifically of the political role of social scientists as expert representatives of a variety of societal interests. That importance would dramatically increase in later years, when mass communication research became entrenched in the academic environment and catered to specific political and economic interests.

But regardless of the location of political or economic control over social research, a critical position vis-à-vis the process of communication and the role of societal institutions contains the notion of change. Pragmatism projects a definition of evolution (under the influence of Darwinism) that emphasizes the processes of gradual change, adjustment, and continuity. In contrast, a dialectical definition would recognize discontinuity, abrupt changes of existing structures, and even the prospects of regression, as Trent Schroyer (1975b, 108–109) has suggested. Its practitioners, who had acknowledged the problems of existing social structures, were ideologically committed to support continuity, and they responded to the needs and requirements of an urban, industrialized society by advocating various measures of adjustment. Among those practitioners are members of the Chicago School who share in the criticism of the economic and social injustices of society and provide theoretical and moral support for the just and humane distribution of material resources. For instance, Simon Patten, speaking about the "surfeited and exploited" in the language of a new economics at the turn of the century, stressed the importance of communication to help large numbers of Americans adapt to abundance: "His social concerns and the expressed need to decrease social and economic differences through communication and cooperation resulted in the development of economic rights that extended traditional political rights and were designed to protect individuals who were adjusting to the new American environment" (Hardt, 1988, 151).

Such positions were developed with a growing appreciation of the cultural context of political and economic decisions and their effect on the survival of the community as a cultural and spiritual resource. In the past, the American perspective on culture had been more closely related to a biological approach toward the individual and was less committed to emphasizing

the differences between natural and cultural disciplines than the German tradition, which began to influence American social sciences after the turn of the century. This position was reflected in the struggle against the biological bias of Spencer's sociological methods, which had occupied a generation of social scientists, whereas the trend toward a cultural analysis of social phenomena gained ground with the coming of the Progressive era in American social history.

The context of culture had become a significant feature of the sociological enterprise, particularly with the rising spirit of collectivism in American thought before World War I, when its theoretical position reflected European and American influences. Similarly, a cultural-historical approach emerged from the writings of political economists like Patten (1924, 264), who described the common ground of social research by insisting that "Pragmatism, sociology, economics, and history are not distinct sciences, but merely different ways of looking at the same facts. . . . They all must accept consequences as the ultimate test of truth, and these consequences are measured in the same broad field of social endeavor." Similarly, about ten years later Ogburn (1934/1964, 213–214) observed that although the "trend toward specialization and that toward the solution of practical problems are at times in conflict . . . [nevertheless, a] trend toward fluidity in boundary lines" had become fairly noticeable because of the changing conditions of society and the nature of the search for knowledge. Thus, the study of communication as a social phenomenon and a potential source of social problems defies disciplinary boundaries and invites investigations from a number of perspectives, including sociology, economics, political science, and psychology, as well as philosophy.

The critical perspective of social science scholarship emerges most clearly with an extended analysis of the American press, which had become a frequent target of criticism for social activists and critics within the social science enterprise. Indeed, the concern about the proper role of the press became widespread and was reflected in the *American Journal of Sociology*, which served as an important forum for articles on topics ranging from journalism education to press ethics and the effects of press coverage (Yarros, 1899–1900; 1916–1917; Fenton, 1910–1911; Vincent, 1905–1906). As a result, a diverse and critical literature of the media of public communication reflects scholarly interests and an articulated, reformist desire for a regular and systematic treatment of questions of issues related to the position of the media in American society. Although published two generations ago, these contributions to a critique of the media "remind contemporary readers of the universality of the problem and the number of issues still unresolved despite enormous efforts . . . to understand the workings of the communication process" (Hardt, 1979, 192).

The strength of the critique arose from an alliance between social reformers and social scientists on a need to scientifically justify reform activities. More specifically, reformers had "faith in the capacity of social science to translate ethics into action. They hoped to find in social science not merely a description of society but the means of social change for democratic ends" (Oberschall, 1972, 206). A critical position vis-à-vis the development of society also emerged with the rise of intellectuals in American society and their potential threat as an oppositional force to the established institutions of society. Commenting upon the role of American intellectuals, William James (quoted in Henry James, 1920, 101) suggested that "every great institution is perforce a means of corruption—whatever good it may also do. Only in the free personal relation is full ideality to be found."

This is the historical context for the contribution by members of the Chicago School, particularly Albion Small as an organizer of sociological research at Chicago; Edward Ross, who wrote extensively about the media; and Robert Park, whose humanistic perspective brought a strong cultural bias into the social sciences. Both Small and Ross were influenced by the activist sociology of Lester Ward, his distinction between physical and human evolution, and his development of a social theory that led to social reform. Ward had advocated collectivism at a time of laissez faire individualism and a planned society, when government interference had become commonplace. Under the influence of Georg Simmel and John Dewey, Park was interested in the problems of social process rather than structure and the potential of an enlightened public. Together, these contributions reflect the concerns of a generation of American social scientists who had witnessed decisive social and economic changes in their society.

Small was influenced by the writings of Spencer and Schäffle, which committed him to an organismic view of society. In fact, Small (1912, 206) advanced an idea of society as "a plexus of personal reactions mediated through institutions or groups. One among these reaction-exchanges was the state; but the state was no longer presumed to be in the last analysis of a radically different origin, office or essence from any other group in the system." Such a theoretical perspective is the basis for an extensive, contemporary critique of the social system, including communication and the media.

In his 1894 *Introduction to the Study of Society* (with George Vincent) Small developed a communciation model that appeared to be based on the biological analogies of Schäffle's theory of communication in which the press, among other systems, is "incorporated in nearly every division of the psycho-physical communicating apparatus" (Hardt, 1979, 199). The authors recognize the role and influence of the press as an instrument of communication between levels of authority, and given the pervasive nature of the press in modern society, they criticize the content and conduct of the

press while placing the burden of responsibility on society. Their writings anticipated major areas of mass communication research devoted to gatekeeping and two-step flow phenomena of the media.

Ross combined his scholarship with an intense engagement in the social issues of the day. He identified communication as an important social process and remained highly sensitive to the power of the press as a potential instrument of public manipulation. In particular, he deplored the influence of economic interests on the press through advertisers and, consequently, the commercialization of newspapers. On the other hand, he staked his hopes on the alertness and intelligence of the reading public to control press excesses and on the strengthening of corrective influences, which had to be provided by society (Ross, 1910, 303–311; Ross, 1918, 620–632).

Park's theory of communication was built on Dewey's notion that "society exists in and through communication" and the suggestion that communication also produces conflict and, potentially, collision with another mind or culture. This argument is a reflection of Simmel's subjectivist perspective, which had appealed to Park (as had the idea of "social distance," which influenced his extensive work on racial problems). Park's sensitivity to the role of the individual in society (also expressed through his work on the marginal man) shaped his definition of communication as a confrontational process. In his "Reflections on Communication and Culture," Park (1938, 195–196) offered the view that communication also fosters competition and conflict, but that "it is always possible to come to terms with an enemy . . . with whom one can communicate, and, in the long run, greater intimacy inevitably brings with it more profound understanding, the result of which is to humanize social relations and to substitute a moral order for one that is fundamentally symbiotic rather than social." Communication as a process of transformation involves a confrontation between individual and cultural differences and implies movement or change as a consequence of such exposure to communication when competition and conflict become conscious.

Park's discussion of the foreign-language press illustrates how minorities gain knowledge and understanding of their environment and, more important, of themselves. The desire to know creates unrest, even conflict, between generations and changed goals and perspectives. For instance, in talking about the foreign-language press, Park (1967, 143) concluded that the Yiddish socialist press, which made people think, "ceased to be a mere organ of the doctrinaries, and became an instrument of general culture. All the intimate, human, and practical problems of life found place in its columns. It founded a new literature and a new culture, based on the life of the common man." In short, a return to community was essential for retaining the stability of social relationships, and Park warned

against the potentially destructive power of technological society. He be-
lieved the media were means of creating fictitious communities and a false
sense of proximity. According to Matthews (1977, 193), for Park sociol-
ogy was "a humanistic and healing study, a 'science' in the older sense, a
body of knowledge and insight that made man more at home in the
world."

From these early sociological considerations emerges a pluralistic
model of society that offers an alternative to the potential excesses of indi-
vidualism and socialism in laissez faire and Marxist doctrines of the time.
Indeed, the articulation of socialization, cooperation, and balance describes
a process of change toward the accomplishment of democracy in the United
States. Throughout these writings, from the theoretical propositions of
John Dewey to the social scientific inquiries into the conditions of Ameri-
can society by Chicago sociologists, communication remains an abstract
idea, although the critical stance suggests concrete analyses of the media as
problematic in the context of exploring the notion of democracy. Such an
idea of communication describes a process that differentiates between those
in control of the technology (the operators of the press) and those receiving
the messages (the public) but that fails to recognize the effects of the cul-
tural and economic differences of the communication process on the work-
ings of society. Thus, in the minds of these critics, the Great Community, or
the ideal democracy, was populated by individuals whose interests, capabil-
ities, and understandings coincided with the essence of the community.
Communication becomes the vital, integrating, and socializing force in the
process of democratization and, as such, remains a major concept in social
theory and research.

A late attempt to offer an extensive and qualitative critique of the
media and their failure in American society to participate in the search for
the "Great Community" was the report by the Commission on Freedom of
the Press (1947). Although published after World War II, the reformists'
spirit and recommendations reflect the critical position of earlier writings
and signal the end of an era of critical discourse in American social sci-
ences. In fact, the commission report summarized the critique of previous
decades; it reaffirmed a belief in the free flow of information and the diver-
sity of ideas, and it reiterated the dangers of a press dominated by the ideas
of owners and those who control the press through economic or political
means. As an indictment of the contemporary media, the report is remark-
able; based on broad principles and general truths, it called for an "ac-
countable freedom" of the press. McIntyre (1987, 153) has suggested that
the "most enduring legacy of the commission is that it draws attention to
the connection between the continuing problems of mass communication in
a modern democratic society and some of the most fundamental and endur-
ing questions of modern political thought."

But the report also reflected an appreciation of human values and a sensitivity to the interdependence of human affairs that Haskell (1977, 16) identified with Dewey and his generation as a product of social experience. Haskell found that

> they experienced society not only in the vicarious, deliberate, rational manner of the social researcher—presumably always master of his data, holding society at arm's length as a mere object of examination—but also in the immediate, haphazard, unaware manner of the voter, lover, consumer, and job-seeker who is himself an object and onrushing element of the social process. Both kinds of experience prompted their recognition of interdependence.

Nevertheless, the report failed to persuade the media; instead, it remains a thoughtful and eloquent appeal by a group of scholars who were unable to overcome the political reality of their own positions vis-à-vis the commercial interests of the culture industry. If anything, the report continues to serve as a reminder that social institutions, like the media, and the economic interests that hold their future will not be moved by the intelligence or conviction of theoretical propositions. Instead, the fate of the commission report demonstrates the existing gap between intellectual positions and political practice, that is, the isolation of informed judgment from the public sphere and the inability of the media to consider the ethical dimensions of their professional practice.

Throughout critical writings about communication since the commission report, little disagreement exists over the notion that human nature cannot exist independent of culture. Rather, the question is how to deal conceptually with the historical components of social and cultural processes. Indeed, a strong movement among American social scientists at the beginning of the twentieth century reflected a sophisticated understanding and appreciation of the German historical school, including socialist writings. The most prominent exponents of a cultural-historical tradition in social science scholarship provided academic leadership in the critique of social and political conditions of society with works that responded directly to the reality of their age. In their writings, however, they sought to reach an accommodation with existing economic structures and political power, and their solutions to the problems of modern capitalism were based on the conviction that despite its failures, capitalism offers an appropriate context for the growth and success of a great society.

Thus, the first encounter with a critical perspective in the study of mass communication as a modern concern of American sociology reflected more accurately a tolerance for dissent within the academic establishment, and therefore within the dominant theoretical paradigm, than the emergence of an alternative—let alone Marxist—theory of society.

By the 1940s the decline of the critical approach to the study of society and communication led by the Chicago School was complete. According to Matthews (1977, 179), that decline had been a result of "an increasing concern with the scientific status of the field, reflected in the preoccupation with methodology; the rise of other sociology departments as centers of research and graduate instruction; the absorption of major European sociological theories; and changing concepts of the proper role of the sociologist in relation to the society he studied." Thus, a generation later traditional sociology had rediscovered nature and, under the influence of Talcott Parsons, embraced structural functionalism with its claim to move steadily in the direction of a theoretical system, not unlike classical mechanics (Parsons and Shils, 1951, 51). For instance, under the influence of Parsons (and Clyde Kluckhohn), A. L. Kroeber's concept of culture was significantly modified to restrict its definition to behavior shaped by "patterns of values, ideas, and other symbolic-meaningful systems" (Harris, 1979, 281), reflecting an idealist notion of culture and an attempt to accommodate a structural functionalist explanation of society. According to Harris (1979, 284–285), this emerging idealist cultural anthropology not only fulfilled "the conservative bias inherent in institutionalized social science" but was also prone to follow Parsonians who "accept the system as a given and seek to account for its stability."

Furthermore, continuing problems caused by the Depression, the increasing importance of the media as political and economic institutions, and the rise of fascism and communism in Europe helped to shift the focus of social scientific research. There was a loss of confidence in American society and only a promise of a rediscovery of the self through the work of J. B. Watson and Sigmund Freud and the help of psychoanalysis. This was also the time when modern science became a social and political force and a source of social knowledge, constituting a significant departure from the historical scholarship of the early twentieth century. These changes were significant and were accompanied by the decline of common sense and the rise of expert opinion represented by social scientists for whom society had become an object of study. According to Matthews (1977, 186), Park observed at the time that "scholars were being replaced by intellectuals, men of wisdom, knowledge, and balance by men with a drive for maximum conceptual abstraction and an outcaste sensibility."

In this context, the field of mass communication theory and research turned from a cultural-historical interpretation of communication offered by pragmatism and the work of the Chicago School to a social scientific explanation. An emergent series of scientific models of communication and mass communication, particularly during the late 1940s and throughout the 1950s, represented a decisive shift to a scientific-empirical definition of the field and served a number of immediate goals—specifically the defini-

tion of the field, the demonstration of its scientific nature, and its legitimation as a social scientific enterprise.

Thus, when Harold D. Lasswell (1948, 37) offered a "convenient way to describe an act of communication," he proposed what became an influential and considerably powerful formula for understanding communication. He identified not only the elements of the communication process—communicator, message, medium, receiver, and effects—but also labeled the corresponding fields of media analysis, audience analysis, and effect analysis. Lasswell's description reveals a primary interest in persuasive (political) communication and refers to organismic equivalencies within an approach that had been dominated by the intent of the communicator and the effect of messages. As such, his description of communication is reminiscent of the stimulus-response model, rooted in learning theory, which also becomes a significant force in mass communication theory. Focused on effects, this approach implies a concept of society as an aggregate of anonymous, isolated individuals exposed to powerful media institutions engaged in reinforcing or changing social behavior.

Equally important and fairly persuasive in its scientific (mathematical) intent is the work of Claude Shannon and Warren Weaver (1949), whose model described communication as a linear, one-way process. Their efforts can be traced to a series of subsequent constructions of behavioral and linguistic models of communication. As Johnson and Klare (1961, 15) concluded, "Of all single contributions to the widespread interest in models today, Shannon's is the most important. For the technical side of communication research, Shannon's mathematical formulations were the stimulus to much of the later effort in this area."

In the following years, mass communication research was informed by a variety of communication and mass communication models (McQuail and Windahl, 1981). Stimulated by earlier efforts and by the rise of psychological models that included aspects of balance theory and coorientation (Heider, 1946; Newcomb, 1953; Festinger, 1957), the models provided an attempt to order and systematize the study of mass communication phenomena (Schramm, 1954; Gerbner, 1956; Westley and MacLean, 1957). Their authors shared an understanding of the complexity of mass communication and its integration in society. At the same time, the impact of the models directed mass communication research toward an investigation of specific components and encouraged or reinforced a preoccupation with questions of communication effects. Furthermore, it accommodated the development and critique of research methodologies based on a theory of society that had been firmly established with the creation of mass communication models.

Consequently, the field sought to offer explanations for the stability of social, political, and commercial systems without developing a critical per-

spective of its own communication-and-society paradigm. Indeed, it was not until a widespread paradigm crisis reached the social science establishment, particularly in the 1970s and 1980s, that British Cultural Studies presented an alternative position.

Instead, the field of mass communication studies remained identified with the mainstream perspective of social science research. Both shared the implications of a pragmatic model of society. Their research related to the values of individualism and operated on the strength of efficiency and instrumental values in their pursuit of democracy as the collective goal of individual members of a large-scale, consensual society.

Paul Lazarsfeld emerged at this point as a definitive contributor to the field of mass communication research with his display of professional ingenuity and political astuteness. His interest in methodological problems, combined with the study of effects, resulted in a number of media studies that had a significant modeling effect upon the development of the field. At the same time, Lazarsfeld recognized the marketing potential of mass communication research; in his attempts to secure his research position between academic pursuits and commercial interests, he became particularly sensitive to the reaction of media industries to communication research. Lazarsfeld (1969, 314) realized that "we academic people always have a certain sense of tightrope walking: at what point will the commercial partners find some necessary conclusion too hard to take and at what point will they shut us off from the indispensible sources of funds and data." Lazarsfeld (1969, 315) considered contemporary criticism of the media to be "part of the liberal creed" and thought the media were overly sensitive to such criticism, whereas intellectuals were too strict in their indictment of the media. His solution to avert a possible disenchantment of "commercial partners" was to raise criticism to a legitimate activity using journalism schools as training grounds for media personnel.

Lazarsfeld engaged in a historical analysis of American society and concluded that political power is the result of relationships formed among citizens, government, and, most recently, mass media. He argued that such a "'three-cornered' relationship" produces "complicated and sometimes surprising alliances." His model assumes a separation of power, and he proposed that individuals were in control of their political and economic destiny, which would make them viable partners in any alliance of power. Specifically, his research strategy was built on the idea that such alliances shift depending on the issues and their varying implications; consequently, he intended to "keep the Bureau (of Applied Social Research) maneuvering between the intellectual and political purist and an industry from which I wanted cooperation without having to 'sell out'" (1969, 321). His sense of criticism was fueled by his intellectual curiosity and was supported and justified by his belief in the function of criticism within the liberal-pluralist system.

The beginning of World War II brought a number of German philosophers and social scientists to the United States, which enriched the intellectual climate in American universities through the addition of two European traditions: logical positivism and Marxism. Paul Lazarsfeld, as a "European positivist" who had been influenced by Ernst Mach, Henri Poincaré, and Albert Einstein and who felt intellectually close to members of the Vienna Circle (Lazarsfeld, 1969, 273), encountered members of the Frankfurt School—particularly Theodor Adorno and Max Horkheimer—within the first years of their exile. Lazarsfeld was not particularly familiar with Critical Theory but shared an interest in the problems of mass culture and the investigation of media content. Adorno's presence in the Princeton Office of Radio Research was based on a hope to "develop a convergence of European theory and American empiricism" (Lazarsfeld, 1969, 323), but the proposed vehicle for that undertaking—the music project—failed when Adorno gave instructions that "could hardly be translated into empirical terms" and funding by the Rockefeller Foundation was terminated (Lazarsfeld, 1969, 324). In his memoirs, Lazarsfeld (1969, 322) characterized Adorno as a "major figure in German sociology [who] represents one side in a continuing debate between two positions, often distinguished as critical and positivistic sociology."

The encounter with Adorno and Horkheimer was fruitful only in that it led to a 1941 collaborative publication by the Institute of Social Research and Columbia University's Office of Radio Research of a special issue of *Studies in Philosophy and Social Science* on the problems of mass communication. The issue included Lazarsfeld's frequently cited "Remarks on Administrative and Critical Communications Research"; other contributors were Theodor Adorno ("On Popular Music"), Harold Lasswell ("Radio as an Instrument of Reducing Personal Insecurity"), Herta Herzog ("On Borrowed Experience: An Analysis of Listening to Daytime Sketches"), William Dieterle ("Hollywood and the European Crisis"), and Charles Siepmann ("Radio and Education"). In a brief introductory remark, Horkheimer (1941a, 1) stressed that "some of our ideas have been applied to specifically American subject matters and introduced into the American methodological debate."

In his contribution to the issue, Lazarsfeld developed his understanding of the mass communication research establishment in the United States. According to Lazarsfeld (1941, 8–9), "*administrative research* . . . is carried through in the service of some kind of administrative agency of public or private character," whereas "*critical research* is posed against the practice of administrative research, requiring that, prior and in addition to whatever special purpose is to be served, the general role of our media of communication in the present social system should be studied." Lazarsfeld credited Horkheimer with the idea of critical research, but he did not pursue the

philosophical or theoretical implications of Critical Theory for media re-
search. Consistent with his own ideological position, Lazarsfeld's definition
of critical research ignored the historical nature of critical research in the
tradition of the Frankfurt School and failed to consider the role of culture
in the positioning of the media in society.

Indeed, Lazarsfeld and many of his contemporaries saw the problems
of the media in technological terms, dealing with the inevitability of indus-
trialization, the massification of audiences, and the effects of "mass" media
on people. In their activities, they adopted a technological rationale, which
Horkheimer and Adorno once defined as "the rationale of domination it-
self" (1972, 121) and which could only provide solutions consistent with
the prevailing theory of society. Furthermore, over time, American mass
communication research has remained insensitive to changing historical
conditions that have effectively defined the problems of communication in
society. Instead, research activities have projected an ideological position
that identified the major proponents of mass communication research with
the power structure of a society—which, in turn, had been exposed by
Horkheimer and Adorno who continued to attack its communication prac-
tice.

Later reviews of his work (Gitlin, 1981; Morrison, 1978; McLuskie,
1975; Mills, 1970) and Lazarsfeld's own discussion of his involvement in
the definition and organization of empirical social research support the
conclusion that under the intellectual leadership of Lazarsfeld mass com-
munication research was concentrated on the existing conditions of the
media and society. He was engaged in a search "for models of mass media
effects that are *predictive,* which in the context can mean only that results
can be predicted from, or for, the commanding heights of the media"
(Gitlin, 1981, 93). The role of the critical in this context of Lazarsfeld's
writings was still one of providing a scientific rationale for an adjustment to
the dominant forces in American society. It was not a critique of the politi-
cal-economic system or a challenge of positivism as a foundation of mass
media research at that time, nor was it an attempt to impose a new vision
of a (social) democratic society upon the political system, his Austrian ex-
perience with socialist ideas notwithstanding. Instead, critical research in
Lazarsfeld's view was identical with participating in the traditional pattern
of domination and control, where "three-cornered" relationships could be
analyzed in terms of influences and effects to produce a sense of real and
potential imbalances. His arguments represented an administrative research
perspective, as Gitlin (1981, 93) argued in his critique of the dominant par-
adigm in mass communication research. Elsewhere, McLuskie (1977, 25)
concluded that "Lazarsfeld's idea was to institutionalize critical research,
make it a tradition—in part to sensitize clients to criticism. But behind this
heuristic role was Lazarsfeld's agenda to force the critical theorist 'to sepa-

rate clearly fact from judgment.'" By doing so, Lazarsfeld protected the hegemony of administrative research.

Mass communication research during this period, with its intensive effort since the 1950s to produce a variety of mass communication models, had also sought theoretical unity and strength as it moved from a purely sociological concern to a multidisciplinary area of communication and mass communication studies that offered new opportunities for critical research. Lazarsfeld had recognized this trend, but he was unable to forge his critical research perspective into a major theoretical statement. Indeed, when he began to formulate his position vis-à-vis the reality of economic and political authority in mass communication research, Lazarsfeld offered a reading of Critical Theory and the Frankfurt School, which ignored the theoretical premises and their practical consequences (particularly as suggested in the work of Horkheimer and Adorno), whereas his own claims for critical research never left—theoretically or practically (politically)—the traditional bourgeois context of the social science enterprise. The notion of a critical position ultimately means a recognition of authority and a reconciliation with power; it also means working with the necessity for change within the dominant paradigm and arguing for the convergence of existing theoretical or practical perspectives. Thus, the critical research of Lazarsfeld is not based on a critique of society or engaged in a questioning of authority in the populist, reformist sense of traditional social criticism in the United States.

Consequently, Lazarsfeld's remarks about critical research represent the repositioning of traditional social science research *within* the practice of what C. Wright Mills has called abstracted empiricism (1970, 60). The notion of critical research (as opposed to administrative research) becomes a point of legitimation in the development of mass communication studies. It asserts the neutral, independent position of mass communication research in the study of society and establishes mass communication research not only as a field (and, therefore, as an administrative unit within universities) but also as a relevant and important *methodological* specialization of a branch of sociology in which the priorities of the method become the determinants of social research and the source of research agendas.

In this form, the accommodation of a critical position, as suggested by Lazarsfeld, within mass communication research may have served as a convenient strategy for defusing potentially controversial (since ideologically unacceptable) and challenging threats to the authority of the sociological enterprise in mass communication studies, including public opinion research. These threats arose from traditional social criticism, latent in American social scientific scholarship since the turn of the century, and post–World War II Western European Marxism, engaged as a theoretical force in the explanation of social changes and the historical conditions in Western Europe since the end of the war.

Lazarsfeld's contributions to media studies also created a sense of urgency in the search for knowledge about the process of mass communication and its effects on society. With its anticipated return to normalcy, society needed explanations and solutions to a variety of social, political, and economic problems during World War II and beyond. Combined with the persistent growth of mass communication research agendas involving conspicuous topics like children, advertising, pornography, violence, crime, and the media, Lazarsfeld and others produced spontaneous definitions and an extensive compilation of social problems.

In his reaction to Lazarsfeld's notion of critical research, George Gerbner summarized social scientific contributions to the identification of social problems (through content analysis) and concluded that the liberal-pluralist system, founded on a "community of publics," was endangered by the creation of mass markets and mass market research. Echoing C. Wright Mills, Gerbner (1964, 498) observed that the "dissolution of publics into markets for mass media conceived and conducted in the increasingly demanding framework of commodity merchandizing is the cultural (and political) specter of our age. This fear is now joined by a growing concern over the trend of social science research, especially in the field of communications. More and more of this research is seen to succumb to the fate of mass media content itself in being implicitly tailored to the specifications of industrial and market operations." In his review of the "consequential meaning of media content," however, Gerbner failed to clarify the fundamental ideological differences between the cultural criticism based on a Marxist critique of capitalist society, which he cited, and the critical position of (some) American social scientific inquiries into media content.

Mass communication research in this era typically confined its inquiry to specific conditions of the environment. It delved into relationships among people, investigated questions of social identity, and generally raised some doubts about the stability of individuals in their social relations. At the same time, however, there was a marked absence of questions about the role of the media in the process of cultural expression and ideological struggles and in investigating the structure of society, including the location of authority and distribution of power. Thus, Gerbner's "challenge for mass communications research" reflected his own commitment to a liberal-pluralist vision of society, based on the participation of individuals in a "genuine" public. He asked media scholars (1964, 499) "to combine the empirical methods with the critical aims of social science, to join rigorous practice with value-conscious theory, and thus to gather the insight the knowledgeable individual in a genuine public must have if he is to come to grips (and not unconsciously to terms) with the sweeping undercurrents of his culture."

Such a challenge is a confirmation of Lazarsfeld's call for critical research and a reflection of a democratic ideal that had characterized earlier reformist notions in American social science research. Although reform-minded in the sense of understanding itself as contributing to the betterment of society, mass communication research remained committed to a traditionally conservative approach to the study of social and cultural phenomena in which instrumental values merge and identify with moral values. Almost thirty years after Lazarsfeld's initial writings, Dallas Smythe (1969, vii) commented upon the "oversupply" of administrative research at the expense of critical inquiry.

Under Lazarsfeld's leadership, mass communication research in the United States had become a formidable enterprise that was deeply committed to the commercial interests of the culture industry and the political concerns of the government. Robert Merton (1957, 451–452) has summarized the major intellectual and theoretical conditions of the field, including the potential consequences of applied social research whose categories were shaped by "market and military demands." He acknowledged that "in the field of mass communications research, industry and government have largely supplied the venture-capital in support of social research needed for their own ends" and wondered whether such administrative research had "been too closely harnessed to the immediate pressing problems, providing too little occasion for dealing with more nearly fundamental questions of social science?"

Lazarsfeld's suggestion of critical research as a socially desirable goal within the limits of the dominant perspective of democratic practice is an anachronism. It appeals to a common-sense notion of criticism at a time when common sense had been replaced by expert opinion. In addition, by arguing the primacy of empiricism as the basis of social theory, Lazarsfeld successfully excluded Critical Theory from social theory (McLuskie, 1977, 26–33). His introduction of critical research represented a successful attempt to create a pseudoconfrontation of research practices that, in fact, occupy the same theoretical (and political) premises. It reflected an unwillingness to explore alternative explanations, which is not a unique characteristic of American mass communication research at that time. For instance, according to Robert Sklar (1975, 260), American Studies was similarly disadvantaged by its "reluctance to utilize one of the most extensive literatures of cultural theory in modern scholarship, coming out of the Marxist intellectual tradition," and he concluded that "to have left untouched such a potential resource exposes one of the essential causes of the problem of theory in American Studies."

Ultimately, however, the "reluctance" to utilize a Marxist approach to analyze culture and communication has its roots in the conservative tradition of the social sciences, including the field of mass communication the-

ory and research, whose practitioners continue to search for causes under-
lying the decline of political authority in American society. In their efforts
to explain and reaffirm the workings of the democratic system, particularly
with the emergence of new social movements and the pressures of a society
with increasing material needs, those practitioners established the media as
indicators of social integration. In fact, media research has claimed a signif-
icant share of attempts to preserve and support the ideological status quo
with explorations of declining credibility and legitimacy of the system and
threats to populism. Consequently, the prevailing theory of anticommu-
nism continued to identify a Marxist critique of culture and society as con-
stituting an adversarial, if not hostile, position that could only aggravate
the crisis of democracy.

Under these circumstances there was no room for the type of critical re-
search proposed by the work of Horkheimer and Adorno and suggested by
the introduction of Critical Theory. Indeed, the differences between Ger-
man *Sozialforschung* and American social science research methodology re-
mained profound and often surfaced with questions of empirical verifica-
tion that preoccupied American social scientists. Horkheimer, on the other
hand, had insisted on the critical nature of societal concepts by pointing to
the problem of value judgments. Thus, he suggested that (1941b, 122)

> the media of public communication . . . constantly profess their adherence
> to the individual's ultimate value and his inalienable freedom, but they op-
> erate in such a way that they tend to forswear such values by fettering the
> individual to prescribed attitudes, thoughts, and buying habits. The am-
> bivalent relation between prevailing values and the social context forces
> the categories of social theory to become critical and thus to reflect the ac-
> tual rift between the social reality and the values it posits.

Such a historical approach to mass communication research reflects
the fundamental differences between two intellectual traditions. Merton
once referred to those differences in terms of concerns about knowledge
and information. He (1957, 441) suggested that knowledge "implies a
body of facts of ideas, whereas information carries no such implication of
systematically connected facts or ideas. The American variant accordingly
studies the isolated fragments of information available to masses of peo-
ple; the European variant typically *thinks about a total structure of
knowledge* available to a few." Consequently, the approach to the study
of culture by members of the Frankfurt School (and their development of
an aesthetic theory that had originated during the early days of the Insti-
tute of Social Research) would be significantly different from American
concerns with mass society and mass culture. James Carey's (1982, 22)
view that "the term 'critical' did not so much describe a position as a

cover under which Marxism might hide during a hostile period in exile" alludes to the problems of Marxist scholarship as an alien phenomenon in this country. But it disregards the historical development of Critical Theory as a series of distinct philosophical perspectives by a number of German émigrés who were united in their criticism of contemporary bourgeois society.

Indeed, the *Dialectic of Enlightenment* (1972) represents a classic statement of a theory of mass culture whose impact on the American mass society debate, however, was felt much later than its original (German-language) publication in 1944. In a direct attack on the political values of American society and the role of the media, Horkheimer and Adorno (1972, 154) proposed that "in the culture industry the individual is an illusion not merely because of the standardization of the means of production. He is tolerated only so long as his complete identification with the generality is unquestioned. . . . The peculiarity of the self is a monopoly commodity determined by society; it is falsely represented as natural." They not only questioned contemporary manifestations of the media industry but also raised doubts about the values perpetuated in defense of the prevailing ideology. Whereas critical research (in the tradition of Critical Theory), with its speculative approach to contemporary culture and society, sought to challenge the theoretical basis of traditional social research, critical-administrative research was driven by methodological considerations and the immediacy (and potential threat) of mass culture phenomena.

This was the time when American mass communication research began to expand upon the pioneering work of Lazarsfeld, Carl Hovland, Harold Lasswell, and others, launching with increasingly sophisticated empirical methodology into what Lazarsfeld had called "administrative" research; members of the Frankfurt School saw market research that could only reflect "reified unmediated reactions rather than the underlying social and psychological function of the cultural phenomena under scrutiny," according to Leo Lowenthal (cited in Jay, 1985, 50). The problems of mass society, with its dreaded cultural and political consequences (particularly in light of Fascist and Communist threats from Europe), encouraged research into issues of collective behavior (Blumer), media and diffusion (Lazarsfeld), persuasion (Hovland), and propaganda (Lasswell) in search of empirical evidence to demonstrate the workings of a pluralist society in the United States. Others, like David Riesman, however, influenced by the work of Erich Fromm and psychoanalytic analyses of culture, dealt with the problem of historical change (*The Lonely Crowd,* 1950) in industrial middle America; C. Wright Mills railed against the "abstract empiricism" of the social sciences and the dogma of methodology and provided a scathing critique of advanced urban society (*New Men of Power,* 1948; *White Collar,* 1951; *The Power Elite,* 1956).

These studies focused on the importance of power and domination and on the socioeconomic distribution of property and influence with marginal impact on mass communication research, which had managed to retain a singularly narrow theoretical and historical base in its social scientific endeavors. Publications like *Journalism Quarterly, Public Opinion Quarterly, Journal of Broadcasting* and *Journal of Communication* in particular did not critically assess media research and social theory as the field was confronted with the potential of Critical Theory.

During the 1970s, however, a brand of social criticism emerged that was strongly related to an earlier critique of American society. Those expressions had ranged from the socialist writings of political economists and sociologists at the turn of the century to populist criticism to political and economic authority by publicists and muckraking journalists in the late 1920s to social criticism by social scientists beginning in the 1950s.

The introduction of Critical Theory as a competing social (and political) theory of society constituted a significant development in American social thought. It rekindled a debate between Marxism and radical criticism and signaled the beginning of a substantial body of Marxist scholarship after World War II, although not in mass communication research. The ensuing critique of contemporary American social theory and research practice also established the intellectual leadership of British, French, and German social theorists. Thus, the encounter with critical theorists provided opportunities for examining the form and substance of an ideological critique of society. Specifically, the cultural pessimism of Theodor Adorno and Max Horkheimer, together with the political critique of Herbert Marcuse and the theoretical inquiries of Jürgen Habermas concerning the role of communication in the struggle against bureaucracies and authority, gave American social theorists an alternative approach to issues of power, change, and the future of society.

This body of critical writings exemplifies an abiding commitment to the study of culture, including the complicity of the media industry in the ideological struggle, and to an analysis of the cultural process. According to Trent Schroyer (1975a, 223), the cultural critique of contemporary society stresses the "sociocultural consequences of stimulated economic growth that . . . transforms the human milieu into a technologically determined system, and systematically blocks symbolic communication by the superimposition of more and more technical rules and constraints deriving from rationalizing processes." Those are continuing concerns among cultural critics, and Alvin Gouldner (1976) in particular has traced similarities and differences between pragmatism (Chicago School) and Critical Theory in their analysis of the "cultural apparatus" and the "consciousness industry."

When Critical Theory reached the representatives of mainstream mass communication research in the 1970s, it had been a major theoretical event

for over four decades, constituting a considerable body of literature that reflected the extent and quality of the modernist debate in a number of disciplines. Beginning with Martin Jay's *The Dialectical Imagination: A History of the Frankfurt School and the Institute of Social Research, 1923–1950* (1973), the volume of original works by Adorno, Horkheimer, Marcuse, and Habermas, translations of German contemporaries; and secondary sources about the Frankfurt School increased dramatically, although subsequent readings and interpretations of Critical Theory by mass communication researchers remained a peripheral intellectual enterprise.

The marginal role of Critical Theory, or of any other radical challenge to traditional social theories, was revealed in the frequently cited *Public Opinion Quarterly* review of the "state of communication research." Berelson's (1959, 4) pessimistic statement includes no reference to Critical Theory as a potential source of theoretical stimulation; his consideration of "minor" approaches refers to David Riesman and Harold Innis, as well as to the "reformist" appproach of the Commission on the Freedom of the Press, and questions their legitimacy as scientific inquiries. Implicit in Berelson's general observations about the demise of the field is an accurate description of mass communication research as a passing interest among social scientists (e.g., Hovland, Lasswell, even Lazarsfeld, who turned to theoretical issues later in his career).

Unlike other fields, mass communication studies fails to specifically attract the work of social theorists but provides opportunities for specific research interests that are widely accepted, imitated, and published. Theoretical debates in other disciplines, however, are less readily reflected in the mass communication literature, an additional indication that the field had been project oriented and dedicated to the practical application of research methodologies.

In the same issue of *Public Opinion Quarterly*, however, David Riesman refers to a critique of society with the 1950 publication *of The Authoritarian Personality* and raises questions concerning research on broader cultural and societal issues. Riesman (1959, 11) mentions specifically the creative scholarly work of Lowenthal, while accusing the "scientific superego" of being "particularly effective in intimidating adventurous research, because the young were learning more about methodological pitfalls than had their elders—from precisely such mentors as Mr. Berelson." Indeed, Lowenthal, who had established himself with his application of Critical Theory to literature, was the most visible representative of the Frankfurt School in American mass communication research circles. He had collaborated with Joseph Klapper (opinion research and psychological warfare) and Marjorie Fiske (popular culture) and had contributed to a number of collected works edited by Lazarsfeld and Frank Stanton, Wilbur Schramm, and Norman Jacobs.

A later review of mass communication research by Davison and Yu was equally absorbed in the narrow administrative research tradition to assess or reassess the influence of other theoretical writings on the field. The authors (1974, 200–201) regretted the "lack of broad theorizing," wondering where the "elder statesmen, the philosophers of the communication field" were and why no names besides "Innis, McLuhan, Lasswell, and a few others" had been added to the roster. A few years later, Lerner and Nelson (1977, 1) proposed that the "story of communication research begins with the publication in 1927 of Lasswell's *Propaganda Technique in the World War.*" They acknowledged contributions by traditional communication researchers without attempting to provide a theoretical context for or a historical acccount of the last fifty years.

An acknowledgment of a much broader context of social theoretical work appeared in 1985 with a rather abbreviated and incomplete presentation of Critical Theory by Rogers, who dichotomized "empirical and critical schools of communication" (Rogers and Balle, 1985). He also managed to obscure the differences between Lazarsfeld's use of critical research and the concept of critical research in the spirit of the Frankfurt School and other Marxist positions. This lack of differentiation (even among members of the "empirical" school) weakens Rogers's assertions about the theoretical premises of those "schools" and makes no substantive contribution to clarify the position of Critical Theory vis-à-vis traditional theories of mass communication research; the author merely pleads for a dialogue. Indeed, for Rogers (1986, 115) the "Critical School" had "its Marxist beginnings as the Institute for Social Research in Frankfurt, Germany, in the early 1930s," where "critical scholars set themselves off from empirical scholars by objecting to the effects-oriented, empirically minded nature of most communication research."

The issue, however, was not a polarization of "schools" but reactions to a critical reexamination of the field, since the emergence of critical scholarship was the result of self-reflection about the conditions of a theoretical premise that missed the social (and political) realities of everyday life. The problem of empirical research, at least in this context, remained a secondary issue.

The question of critical research emerged more substantively with contributions involving Critical Theory and other Marxist approaches to mass communication research published in "Ferment in the Field," a special issue of the *Journal of Communication* (1983). Although the publication did not engage the field in a significant epistemological debate, Jennifer Daryl Slack and Martin Allor offered a particularly useful contribution to the discussion. The authors (1983, 208–209) acknowledged that "critical mass communication research is not a single entity, but rather a range of developing alternative approaches to the study of communication," and

they decribed the "critical" as an "appropriation of the term" from the Frankfurt School. Others were vague in their use of the terms *critical research* or *European-style* research (Haight, 1983, 232; Schiller, 1983, 255; Mosco, 1983, 237; Stevenson, 1983, 262), echoing, however, Slack and Allor (1983, 215), who suggested that the "central concern of all critical positions is the effectivity of communication in the exercise of social power." Dallas Smythe and Tran Van Dinh (1983, 123), commenting on the conditions of Marxist scholarship in communication studies, advanced a definition of critical theory that "requires that there be criticism of the contradictory aspects of the phenomena in their systems context." In his summary of the special issue, George Gerbner (1983, 362) extended the notion of "critical scholar" to include those "who search and struggle to address the terms of discourse and the structure of knowledge and power in its domain and thus to make its contribution to human and social development."

The presentation of critical alternatives to traditional mass communication research reveals that the choice is not between ideology and social science but that social science practice remains embedded in an ideological context. Although the language of orthodox Marxism, Critical Theory, and Cultural Studies is reflected in the "ferment in the field," providing a vocabulary and a focus for a critique of contemporary societal practices, it is frequently reproduced without further discussion of its consequences for the ideology of mainstream mass communication research.

The practice of collecting and adapting theoretical propositions and practical applications for the betterment of society, disregarding cultural or political origins and ideological foundations, constitutes an intellectual process of Americanizing ideas. It has occurred in the social sciences with the influence of European knowledge on American scholarship since the beginning of academic institutions in the United States and is particularly visible in Dewey's instrumentalism (1960), which seemed to acquire and apply suitable theoretical propositions according to the interests they served at the time. George Novack's (1975) confrontation of Dewey's liberal position vis-à-vis the political reality of his day is an appropriate example of a Marxist critique of pragmatism as a philosophical and political power in American society.

To realize the potential contribution of Critical Theory to a critique of contemporary society, mass communication research needs to explore the rise of Critical Theory in the cultural and political context of Weimar Germany. The attempts of Critical Theory to replace the preoccupation of traditional philosophy with science and nature by shifting to an emphasis on history and culture and its acute awareness of the relationship between epistemology and politics are particularly relevant issues. The writings of critical theorists offer the basis for an intensive examination of the critique

of modern society, including a discussion of its philosophical (and political) consequences for mass communication research. Such inquiry, however, remains incomplete, since the recognition of Critical Theory as the foundation of a critical theory of communication has been limited to the literature of social theory. Habermas (1981) in particular offered an epistemological justification for human emancipation. Indeed, taken as a critical position rather than a theory, Critical Theory embarks on a critique of the present and points to the potential of the future. For Habermas it involves an emancipatory interest with the potentiality of the human being at its center.

Communication is a central idea in the work of Habermas. It surfaces in *Knowledge and Human Interests* (1971), with his approach to language in the development of a critical social science, and culminates with *The Theory of Communicative Action* (1984a), which contains the normative basis of his social theory. In the latter book Habermas (1984a, 397) asserts,

> If we asume that the human species maintains itself through the socially coordinated activities of its members and that this coordination has to be established through communication—and in certain central spheres through communication aimed at reaching agreement—then the reproduction of the species *also* requires satisfying the conditions of a rationality that is inherent in communicative action.

Specifically, Habermas (1984a, xi) constructs the concept of communicative action from three "intertwined topic complexes: (a) a communicative rationality freed from the limitations of individualistic approaches of social theory, (b) a two-level concept that 'connects the lifeworld and systems' paradigms, and (c) a theory of modernity which accounts for 'social pathologies.'" He adds, "Thus the theory of communicative action is intended to make possible a conceptualization of the social-life context that is tailored to the paradoxes of modernity."

The route toward such a theoretical position leads through the application of a reconstructive science. In *Communication and the Evolution of Society,* Habermas (1979, 1–3) already asserted that the "task of universal pragmatics is to identify and reconstruct universal conditions of possible understanding (*Verständigung*). In other contexts we also speak of 'general presuppositions of communication,' but I prefer to speak of general presuppositions of communicative action because I take the type of action aimed at reaching understanding to be fundamental." Indeed, for Habermas, the "goal of coming to an understanding (*Verständnis*) is to bring about agreement (*Einverständnis*) that terminates in the intersubjective mutuality of reciprocal understanding, shared knowledge, mutual trust, and accord with each other. Agreement is based on recognition of the corresponding validity claims of comprehensibility, truth, truthfulness, and rightness."

Such conditions underlying communicative practice are based on a rationality that is determined by whether the participants "could, *under suitable circumstances,* provide reasons for their expressions." Habermas (1984a, 17–18) continues that "the rationality proper to the communicative practice of everyday life points to the practice of argumentation as a court of appeal that makes it possible to continue communicative action with other means when disagreements can no longer be repaired with everyday routines and yet are not to be settled by the direct or strategic use of force."

Since communicative practice occurs in the context of social and cultural structures, Habermas (1984a, xxiv) directs attention to the importance of the "lifeworld" as the context for symbolic reproduction. He identifies and describes three structural components.

> In coming to an understanding with one another about their situation, participants in communication stand in a cultural tradition which they use and at the same time renew; in coordinating their actions via intersubjective recognition of criticizable validity claims, they rely on memberships in social groups and at the same time reinforce the integration of the latter; through participating in interaction with competent reference persons, growing children internalize the value orientations of their social groups and acquire generalized capabilities for action.

And he continues to suggest that communicative action serves the transmission and renewal of cultural knowledge, social integration and group solidarity, and personal identification.

Habermas (1984a, 100) also defines the cultural context of participants in communication, the world of the actors, in terms of relations between the speech act and three worlds: the "objective world (as the totality of all entities about which true statements are possible)," the "social world (as the totality of all legitimately regulated interpersonal relations)," and the "subjective world (as the totality of the experiences of the speaker to which he has privileged access)."

Communication becomes a process of negotiation against the background of a shared culture, a lifeworld that offers the presuppositional condition for any meaningful participation. Indeed, culture, society, and the individual are structural components of the lifeworld in which communicative action serves to reproduce cultural knowledge, integrate individuals, and shape personalities. Habermas sees *culture* as the reservoir of knowledge from which participants in communication about the world take their interpretations; *society* represents the legitimate order through which participants secure their membership in social groups and afffirm their solidarity; and *personality* refers to the competencies that enable a subject to par-

ticipate in the processes of understanding while maintaining its own identity. The semantic field of symbolic contents, the social space and historical time, form the *dimensions* in which communicative actions take place (1984b, 594–595).

The media are part of the everyday activities of the lifeworld and function as "generalized forms of communication." According to Habermas (1984a, 406), the press, radio, and television have an enabling function. They free participants from their spatial-temporal limitations, provide availability of multiple contexts, and become instrumental in the creation of public spheres capable of serving authoritarian or emancipatory interests.

This perspective on communication and the media suggests that mass communication theory and research are invariably tied to the analysis of communicative practices, that is, to issues of communicative competence, understanding, and participation by individuals in their lifeworld. Daniel Hallin (1985, 142) observed that "for Habermas, all forms of human communication, even under conditions of mass dissemination, are essentially relationships between human subjects, derived ultimately from the elementary structure of dialogue." Habermas proposed that the study of the media must be a study of culture, the conditions of the lifeworld, and, indeed, the prospects for a public sphere that serves emancipatory interests. Such study is based on a perspective of knowledge that is committed to openness (truth) and the process of self-reflection. As Richard Bernstein (1985, 11) argued, "an emancipatory interest is basic in the sense that the interest of reason is in furthering the conditions for its full development; the demand for non-distorted communication becomes fully explicit. . . . Non-distorted, reciprocal communication cannot exist unless we realize and institute the material social conditions that are required for mutual communication."

Habermas has outlined a broad theoretical framework and provided a formidable agenda for communication research. The complexity of his work and the encyclopedic range of his intellectual effort offer a major challenge to U. S. practitioners of communication theory and research. Indeed, the problems of theoretical complexities and intellectual accessibility may have contributed to the failure of the field to participate in a critical assessment of his work. More likely, however, is the (intuitive) rejection of a theory of communicative action, because, as Richard Rorty (1985, 175) suggested, "the desire for communication, harmony, interchange, conversation, social solidarity, and the merely beautiful wants to bring the philosophical tradition to an end because it sees the attempt to provide metanarratives, even metanarratives of emancipation, as an unhelpful distraction from what Dewey calls 'the meaning of the daily detail.'"

In fact, the field of communication theory and research is most likely to support and follow Rorty, whose criticism of Habermas reveals a strong

commitment to the writings of American pragmatism. Rorty's (1985, 169) argument is based on the notion that "progressive changes" in society may tell the story,

> Without much reference to the kinds of theoretical backup which philosophers have provided for such politics. It is, after all, things like the formation of trade unions, the meritocratization of education, the expansion of the franchise, and cheap newspapers, which have figured most largely in the willingness of the citizens of the democracies to see themselves as part of a "communicative community"—their continued willingness to say "us" rather than "them" when they speak of their respective countries.

Such a perspective reflects not only the compelling influence of the pragmatist tradition but also reveals its continuing theoretical appeal. According to Habermas (1985, 193, 195), Rorty

> Wants to destroy the tradition of the philosophy of consciousness, from its Cartesian beginnings, with the aim of showing the pointlessness of the entire discussion of the foundations and limits of knowledge. . . . The stubbornness with which philosophy clings to the role of the "guardian of reason" can hardly be dismissed as an idiosyncrasy of self-absorbed intellectuals, especially in a period in which basic irrationalist undercurrents are transmuted once again into a dubious form of politics . . . [and] it is precisely the neoconservatives who articulate, intensify and spread this mood via the mass media.

This conclusion may very well describe the position of mass communication theory and research toward the Habermasian struggle to forge a path for the position of an emancipatory social science in a world in which the problems of cultural reproduction create tensions and social conflicts.

Not unlike Critical Theory a few years earlier, the introduction of British Cultural Studies as a European critique of contemporary society constituted a political challenge and a direct confrontation between liberal pluralism and Marxism as competing theories of society. Such a critique reflects not only a specific British interpretation of contemporary Western Marxism but also indicates the quality and intensity of an intellectual commitment to a critique of ideological domination and political power. The issue of adapting Cultural Studies to an analysis of the social and political conditions of American society is not only a commitment to the uses of history; it also requires an emphasis on ideological practice in the review of those intentions, interests, and actions that intersect in the spheres of cultural, economic, and political power—thus rendering a fundamental critique of the dominant model of society. According to Stuart Hall (1979, 330), this means gaining an understanding of "the 'subject' positioning

himself in the specific complex, the objectivated field of discourses and codes which are available to him in language and culture at a particular historical conjuncture." Implicit in this approach is the consideration of authority—that is, of people living and thinking an existence under specific conditions of domination that organize the ideas and beliefs of individuals through social institutions, including the media.

The rise of Cultural Studies has been documented by Hall (1980a) as it broke with mainstream British sociology to establish itself as an integrative academic field of study, retracing its roots through the interpretative branch of sociology (Max Weber) to the ethnographic discourse of subcultural theorists (Howard Becker). Similarly important was the impact of Western Marxist writings, from George Lukacs and Lucien Goldmann to Walter Benjamin and the Frankfurt School—particularly Horkheimer, Adorno, and Marcuse. Their texts "restored to the debate about culture a set of theorizations around the classical problem of ideologies. They returned to the agenda the key question of the determinate character of culture and ideologies—their material, social and historical conditions of existence" (Hall, 1980a, 25). Those writers also reaffirmed the importance of a holistic perspective and confirmed the critique of empiricism and its insistence upon isolated facts. In addition, Louis Althusser's notion of "ideological state apparatuses" (1971) and Antonio Gramsci's conceptualization of "hegemony" (1988) have helped build a rationale for the study of social practices within societies "as complex formations, necessarily contradictory, always historically specific" (Hall, 1980a, 36).

Cultural Studies employs but one of several strategies of cultural interpretation that have emerged from contemporary Marxist theory (Curran, Gurevitch, and Woollacott, 1982; Grossberg, 1984). It occupies a position opposed to economic reductionism, as exemplified in the cultural tradition of Raymond Williams and Richard Hoggart in particular, while stressing experience as the product of cultural practices. According to Grossberg, the "problematic of cultural studies is transformed, concerned with how a particular practice—signifying or social—is located in a network of other practices, at a particular point, in particular relations" (1984, 412). This means Cultural Studies locates the media and media practices "within a society conceived of as a complex expressive totality" (Curran, Gurevitch, and Woollacott, 1982, 27).

The media have become a major field of critical analysis since they dominate the cultural sphere in urban, industrialized societies. They are important because they help to produce an understanding of a social totality by bringing together and, if necessary, reconciling conflicting and confusing fragments of reality. The study of the media, and with it the question of power, constitutes an ideological issue, that is raised in an analysis of cultural practices within the larger, "complex expressive totality." That is,

media studies are involved in the issue of human practice. Williams (1977, 139–140) stressed such a holistic perspective as the underlying condition of a Marxist sociology of culture when he stated that "the most basic task of the sociology of culture is analysis of the interrelationships within this complex unity . . . [of] institutions, formations, and communicative relationships . . . insisting on what is always a whole and connected social material process."

The discursive approach to culture views ideology as "the power of a particular system to represent its own representations as a direct reflection of the real, to produce its own meanings as experience" (Grossberg, 1984, 409). Consequently, the conditions for individuals in their social and political environments are defined within the sphere of the media. Grossberg (1984, 409) argued that the "issue is not so much the particular knowledge of reality (true or false, mystified or utopian) which is made available, but the way in which the individual is given access to that knowledge and consequently, empowered or de-powered." The media function in several ways to maintain their cultural and ideological position. They provide and selectively construct social knowledge, they classify and reflect on the plurality of social life, and they construct a complex, acknowledged order (Hall, 1979, 340–342). The implications for an analysis of cultural processes are twofold: They indicate a return to the subject of experience and a struggle over the power of texts within a cultural and historical moment, and they imply a consideration of the ideological effect of the media as they necessarily and incessantly intersect with the social practices of groups and individuals in society.

The intervention of Cultural Studies in traditional media studies may serve as a measure of the fundamental changes involved in turning from a mass communication research perspective to a critical, cultural focus on the media and society. Specifically, by the 1970s American mass communication research had shifted its focus to audiences. Uses and gratification research (Katz, Blumler, and Gurevitch, 1974), however, retained its functionalistic character regarding the presence of an actively consuming need-fulfilling audience while struggling with the notion of the effects of texts and producers on audiences under specific cultural, social, or economic conditions. Similarly, the agenda-setting model (McCombs and Shaw, 1972, 1976) continued to perpetuate an effects model of the media while identifying itself with the traditional, theoretical assumptions of the uses and gratification approach (Shaw, 1979).

According to Hall (1980b, 118–119), Cultural Studies "broke with the models of 'direct influence' . . . into a framework which drew much more on what can broadly be defined as the 'ideological' role of the media"; it "challenged the notions of media texts as 'transparent' bearers of meaning . . . and gave much greater attention . . . to their linguistic and ideologi-

cal structuration"; it replaced the passive conception of the audience with a "more active conception of the 'audience,' of 'reading' and of the relation between how media messages were encoded, the 'moment' of the encoded text and the variation of audience 'decodings'"; and finally, it engaged in the study of the role "media play in the circulation and securing of *dominant* ideological definitions and representations." Thus, the vision of Cultural Studies is based on understanding communication as related to the historical process of which it is also an "indissoluble" part. It is also somewhat removed from conceptualizations in the literature of popular culture and mass society that define the analysis of culture as an investigation of a series of empirical facts about the media, their contents, and their effects on audiences.

Specifically, British Cultural Studies emerged from an intellectual climate created and sustained by a political discourse (as represented in the *New Left Review*) that operates on the assumption that Marxism as a social theory is quite capable of producing a change in the social and economic conditions of British society. Those debates—informed by the contributions of Western European Marxism, French structuralism, and the work of Althusser in particular—continue to serve as the intellectual resources for alternative political responses to the problems of British society, including the distribution of economic and political power and the role of the media.

British Cultural Studies has appealed to critics of American mass communication research because of its provocative investigations of contemporary social problems, demonstrating a sense of engagement of political practice and theoretical considerations in the public sphere. This represents a qualitatively decisive difference from a system in which the nature and extent of social research depend on the relationship among academic organizations, economic interests, and the political system. Hence, mass communication research in the United States located primarily within universities, encountered the practical effects of politicizing research (for instance, through the policies of funding social scientific inquiries).

In seeking alternative paths, American mass communication research may find the organizational aspects of the British Cultural Studies perspective in a climate of political engagement equally appropriate and useful for producing its own answers to socially important and politically relevant problems. At a different level, the reception and assimilation of such distinct theoretical propositions and research practices raise a number of questions concerning the ways in which they are transformed into a problematic that can be accommodated by a rather distinct, if limiting, U.S. system of academic disciplines. Although this issue has been underlying the study of communication and media practice in American universities for many years, the advent of British Cultural Studies on the American academic

scene has dramatized the question of disciplinary boundaries and academic compartmentalization of knowledge, including the construction and administration of appropriate social research agendas. Speaking of the study of culture, Ernest Gombrich (1969, 46) concluded that the "so-called disciplines on which our academic organisation is founded are no more than techniques; they are means to an end but no more than that." The arrival of Cultural Studies in the research literature of American mass communication studies has been a promising change following the earlier encounter with Critical Theory and the subsequent critique and exposure of the field to the work of Dallas Smythe, Herbert Schiller, Todd Gitlin, Stuart Ewen, and others—including critical European reactions to American mass communication scholarship.

British Cultural Studies belongs to an intellectual tradition in Western Europe for which the matrix of literature, literary criticism, and Marxism produces a convenient context for questioning cultural activities, including social communication. Such contextualization and the location of the problematic in the cultural process—specifically among cultural, political, and economic phenomena—restore theoretical complexity and descriptive power to the analysis of communication and media practice. Notably, the field of literary studies, with its curiosity about the process of social communication—including the role of the media—has moved freely among leading intellectual currents and created an awareness of British and continental European thought and its contribution to modernist and postmodernist debates. In the meantime, mass communication research, which proceeded with its narrowly defined, atomistic vision of communication and media, has revealed its own definitive and irreconcilable differences with the exponents of an ideological approach to the processes of culture and communication.

But the attraction of Cultural Studies as an alternative discourse about communication and media studies cannot alleviate a number of problems, including the accessibility of these ideas for studies that are conceptually rooted in the traditional sociological model of mass communication research. This problem is exacerbated by the atheoretical nature of the majority of mass communication studies, by the continuing isolation of traditional scholarship from other disciplines engaged in an exchange with Critical Theory and Cultural Studies, and, possibly, by an identification of Cultural Studies with a Marxist critique of society and thus with a devastating critique of the culture industry that threatens the traditional relationship between media research and commerce and effectively precludes the accommodation of radical criticism.

Suggestions for compromises presented in terms of cooperation or a merger of theoretical or methodological traditions persevere, however (Gerbner, 1983). They are also offered as a "return to the bridge building

between the social sciences and the humanities" or as a "cultural-empirical approach" (McQuail, 1984, 186) without specific reference to basic ideological conflicts. Indeed, there has been a noticeable (culturally specific) tendency to search for an underlying intellectual consensus. For instance, in his discussion of the development of sociological theories, Alvin Gouldner (1970, 17) referred to the process of discovering a common ground as an "Americanized version of Hegelianism, in which historical development presumably occurs not through polemic, struggle, and conflict, but through consensus."

On the other hand, the approval of a pluralism of critical approaches to the problems of the media and communication also continues to be couched in terms of methodological diversity, preferably as long as it excludes "an ideological approach" (Halloran, 1983, 272). Such a position is reminiscent of the arguments made by Howard Becker and Irving Louis Horowitz (1972) in the 1970s that "radical sociology" can be "good sociology" if it is purged of an ideological bias. There are reasons to suspect that "good" mass communication research would operate on principles derived from the traditional epistemology of media studies, which would also emphasize—to use the vocabulary of Becker and Horowitz (1972, 50–51)—"meaningful descriptions" and "valid explanations" of social phenomena, whereas an accommodation of radical criticism would be "a full exploration of possibilities" within the range of a dominant, liberal-pluralist theory of society.

Similarly, American cultural studies may have gained from Carey's (1975, 3–21) reconceptualization of the "transmission" view of communication, with its roots "in essentially religious attitudes" of American society, into a "ritual" perspective of communication—based on predominantly European sources—as an opportunity "to rebuild a model of and for communication of some restorative value in reshaping our common culture." Carey's explanation transcends the historical conditions of the social sciences and realizes an alternative perspective, that is, a cultural concept of communication identified with the traditions of pragmatism and the Chicago School. For Carey (1982, 30), an approach to cultural studies involves a definition of communication that "constitutes a set of historically varying practices and reflections upon them. These practices bring together human conceptions and purposes with technological forms in sedimented social relations." He (1982, 30) identifies the central problem of this approach as "that of meaning in order to contrast it with versions of communication that search for laws and functions and to focus on the hermeneutic side of the task." Such a perspective, however, still operates within the dominant system of meanings and values and can offer only a nostalgic vision of the potential of communication and the power of the community as long as it fails to generate a critique of its own tradition and an alternative

cultural perspective that overcomes the ideological conditions of the pre-
vailing theory of democracy.

Although it seems appropriate for American cultural studies to begin
addressing questions of contemporary culture (instead of problems of mass
communication), a need exists to develop theoretical propositions under
which the idea of "culture as a total way of life" (Carey, 1979, 424–425)
becomes a necessary and appropriate context for the study of individual
practice and collective action. Carey (1983, 312) has characterized the con-
dition of American cultural studies as being in a ferment concerning "its
ability to retain enough of the origins, insights, and tone of pragmatism
while it squarely faces the fact that societies are structured not only in and
by communications but also by its relations of power and dominance." To
be sure, discussions of power and domination, and considerations of
process and change as important principles of a cultural theory do not con-
stitute a commitment to a Marxist theory of culture but are rather a reflec-
tion of their usefulness for an analysis of contemporary culture. In fact, if
Marxist theory helps to stimulate a search for alternative theoretical posi-
tions, a need exists to clarify its relationship to pragmatism or to any other
theoretical foundation of American cultural studies. Certain conceptualiza-
tions of culture and cultural processes, like the treatment of language
(Peirce) and the role of communication (Dewey), are useful elements in a
theory of communication (and media practice), as they evolved from Prag-
matism. Other considerations—like the relationship among social, eco-
nomic, and cultural practices and the role of the media, the power of insti-
tutions, and the concepts of freedom and participation—continue to be
problematic, since they are defined in terms of dominant social and eco-
nomic interests and, therefore, remain outside the reach of radical change.
As Bernstein (1971, 228) observed in his sympathetic review of pragma-
tism, Dewey failed to be genuinely radical because "he underestimates the
powerful social, political, and economic forces that distort and corrupt"
and despite his intentions, "the consequence of his own philosophy is to
perpetuate the social evils that it seeks to overcome."

These forces are also grounded in an empirical-analytical approach to
the social and natural environment that is interested in technical control
and differs from hermeneutic or critical knowledge constitutive interests,
according to Habermas (1971, 195–197). American cultural studies, fol-
lowing Carey's argument in favor of pragmatism as a useful theoretical
context, still needs to resurrect a theory of inquiry that develops and sup-
ports a notion of radical thinking linked to an understanding of the consti-
tution of social life.

In the meantime, the emergence of a theoretical position and its domi-
nation is also a condition of intellectual leadership, particularly in its return
to an understanding of intellectual work (based on Gramsci's writings) as

involved in the collective practice of producing and sharing knowledge. Thus, the diversity and quality of theoretical insights gained by retracing the hermeneutic tradition of European thought, and the impact of Western Marxism and feminism on contemporary social theory, have influenced these joint intellectual tasks of formulating theoretical propositions and research projects under a Cultural Studies approach in Britain. In the past, the behavioral sciences have provided such guidance in the field of mass communication research on both sides of the Atlantic. The application of Western Marxism has gained some strength, and an extensive body of Marxist literature available in English translation adds a considerable voice to the theoretical discourse. Perhaps more important, however, are the political conditions of societies, derived from racist governments—and the prospects of environmental crises, which continue to draw social scientists and their professional concerns to the reality of human misery and global disaster with the realization that generations of scholarship and research have been unable to affect people's political and economic destiny. Consequently, these scholars have been willing to reconsider theoretical (and methodological) issues, which testifies to the domination of a particular (American) position and has resulted in critical reflections and the possibility of change in the theoretical assumptions governing mass communication research.

In fact, mass communication researchers hold considerable power as intellectuals engaged in the creation and defense of theoretical positions. They not only maintain the prevailing traditional values, providing an ideological defense of particular (class) interests, but are also indispensible in the struggle for alternative expressions. In recent years, proponents of Critical Theory and Cultural Studies have been deeply committed to the task of breaking with traditional notions of communication in society. They have redefined the realm of academic scholarship and professional specialization to engage in a pedagogical project by selecting problems and the type of research that deals with people's daily existence and also through a conscious intellectual engagement within the political structure of their societies. But there is a continuing need for such involvement, as Schroyer (1975a, 248–249) pointed out decades ago, because "the real process of enlightenment refers to the reinterpretation of their needs by the many people who are currently unable to do so. Thinking about ways in which communicative processes can be stimulated is crucial . . . [and] critical theorists must construct models for the activation of communication about human requirements and the ways in which institutions can be changed to meet them."

Under the leadership of American Pragmatism, social theorists had focused on the importance of culture and the idea that communication as a life process leads to democratic practice. This conclusion constitutes the be-

ginning of a critical position in social science theory and research within a liberal-pluralist tradition. Critical Theory offers a comprehensive modernist view of the cultural and political crisis in Western society and has had a modest and eclectic response from U. S. communication and media scholars. The subsequent success of British Cultural Studies has been a reminder that a cultural approach to the problems of communication and the media has remained a consistent and recognized theme in the literature of the field.

There can be no doubt that the problems of communication, including the operation of the media, are imbedded in the history of a culture. For this reason, an affinity exists with those mass communication studies in the United States that have had a strong cultural tradition. After all, the idea of culture and society in the context of mass communication research is defined through its assimilation of nineteenth-century European social thought into American practice; that is, by the effects of American pragmatism on the development of academic disciplines and their particular social concerns. Thus, the evolutionary concept of society with its own social dynamic, the emphasis on social forces, and the recognition that individuals may need the assistance and protection of the state in their encounters with the modern world are not only characteristics of the German historical school or of nineteenth-century European socialism; they also describe the theoretical thrust of the American political economy after the turn of the twentieth century. Pragmatism adds a dynamic vision of the new world to this perspective and provides the social context for the study of the media and communication.

Consequently, mass communication studies rose to academic prominence and political importance with the recognition of commercial and political propaganda as essential aspects of mass persuasion vis-à-vis an increasing need for the mediation of knowledge in a complex urban society. But the cultural approach of the field also shared the basic tenets of the social sciences of the time—namely, the belief in (1) a world that is knowable through the application of scientific techniques that stress the plurality and equality of facts, (2) the objectivity of expert observations, and (3) the power of empirical explanations. Understanding mass communication as a series of specific, isolated social phenomena, however, has resulted in narrow interpretations of communication and culture and in a conduct of media studies that lacks historicity.

This approach to communication and culture in the United States depends on a firm belief in a utopian model of society. It is based on a vision of consensual participation as democratic practice and of the exercise of political and economic power as an act of progressive intervention in people's advancement. Radical dissent, including Marxist criticism of American society, still remains outside mainstream mass communication research.

When it arises, it belongs to the literature of social criticism rooted in rhetorical studies, literature, political economy, and sociology in particular, from where it is unable to engage the field in an extensive and prolonged debate concerning the foundations of social theory and the false optimism of social inquiries into the role and function of communication and the media.

At the same time, the enthusiasm for an alternative explanation of communication in society, if sustained, cannot rest on the goodwill toward Cultural Studies and a calculated indifference toward the dominant interpretation of social structures. Instead, commitments to a critical approach, in the sense of a Marxist critique of society, will lead to a number of significant changes in the definition of media, society, and social problems, as well as in the organization and execution of research projects. They are changes rooted in radical ideas, uncompromising in their demands for rethinking the theoretical basis of mass communication studies and innovative in their creation of appropriate methodologies. Thus, Cultural Studies, not unlike radical sociology in the late 1960s and early 1970s, "finds itself providing the facts, theories, and understandings that a radical politics requires for its implementation" (Becker and Horowitz, 1972, 54). It also reflects the emancipatory power of a social theory that is grounded in the potential of individuals to rise beyond their social and economic conditions.

Since the traditional literature of mass communication theory and research restricts the imagination by its refusal to engage in critical reflections on human ideals as normative (or unscientific) issues and its denial of the historical process in the presentation of mass communication phenomena, it must be replaced with an emancipatory social theory that locates the inquiry about mass communication in the realm of the ideological and explains the role of communication and the place of the media through an examination of the cultural process. The result will also be a reconceptualization of disciplinary (and administrative) boundaries, with its theoretical (and political) implications for the definition of a field, in which culture as a way of life constitutes the framework for an interpretation of communication in society. Similarly, Sklar (1975, 260–261) argued in the 1970s that American studies, by turning to the works of Roland Barthes, E. P. Thompson, Eric Hobsbawm, Antonio Gramsci, Theodor Adorno, Walter Benjamin, Raymond Williams, and George Lukacs, would discover "an untapped powerful resource for the essential task of linking the forms of consciousness and expression with the forms of social organization."

But the discovery of Cultural Studies through exposure to a specific type of media studies in the United Kingdom and the subsequent preoccupation with critical research should not obscure the fact that no history of a systematic acknowledgment of Marxist scholarship by traditional mass

communication research exists in the United States. The reception of individual Marxist scholars by mainstream mass communication research has remained questionable, and their influence continues to be negligible on the field, which follows the path of an American social science in its rejection of a critical, Marxist approach to issues of the media and society. In light of these experiences and of the history of social criticism and radical critique in mass communication studies, the visibility of a Cultural Studies perspective must be considered a temporary phenomenon, whereas the notion of critical research will continue to be identified with traditional mass communication scholarship.

Indeed, there is always a chance that the critical will return as an accommodation of liberal dissent while Marxist thought again retreats into the shadow of the dominant ideology. In any case, British Cultural Studies as a cultural phenomenon holds its own interpretation; its language and practice are contained in the specific historical moment, which may have become accessible to American mass communication research but cannot be appropriated, adapted, or co-opted without losing its meaning. The dilemma of American mass communication studies continues to lie in its failure to comprehend and overcome the limitations of its own intellectual history—not only by failing to address the problems of an established (and politically powerful) academic discipline, with its specific theoretical and methodological requirements, but also by failing to recognize the potential of radical thought.

2

Looking for the Working Class: Class Relations in Communication Studies

The need for intelligent and compassionate answers to what the media and communication actually constitute in the making and remaking of society is widely acknowledged. The effort has spread beyond communication studies to an interdisciplinary struggle for explanations, typically rooted in traditional views of the relationship among individuals, the media, and society that privilege dominant social and cultural constructions of reality.

Although successful participation in bourgeois cultural practices is structured on class positions, there have been few considerations of the range of cultural practices across social classes, their sources of identity, and their representation in public communication. Since the emancipatory potential of communication studies is also contingent on its explanatory power, this chapter argues for a recognition of the interpretive potential of the concrete, historical processes of class and class relations in the study of communication. More specifically, this chapter locates communication studies historically between traditional social scientific treatments of class and the more recent notions of class and culture expressed by cultural studies and feminism, reviews the contribution of communication studies to class analysis, and argues for a turn to the political in the study of communication and class relations in American society.

Many years ago, Richard Hoggart (1970, 279–280) talked about the rising "classlessness" of the British media; similarly, in the United States the media have historically catered to mass audiences (at least since the late nineteenth century), not through a lack of identification with a specific class, but rather with appeals to the desire for social status and personal

success that characterize existential, bourgeois concerns and speak to the impact of modernity. These appeals are driven by bourgeois values and reveal a predominance of middle-class goals. How the working class experiences the impact of the media on its social reality remains a challenging question but recognizing class culture and privileging class relations in theorizing the media, culture, and society pose more fundamental problems in American communication studies.

This chapter addresses the need for recovering the reality of class relations as a historical condition of communication in American society at a time when the progressivism of late capitalism has succeeded politically and economically in placing corporate interests above individual welfare amid rising social and political inequities. It is grounded in a critical theory of society that draws on the collective experiences of a specific way of life that characterizes class differences that not only generate material inequalities and, therefore, reinforce class differences but also encourage and produce emancipatory demands. The media remain a significant arena in the struggle for liberation in which individuals constitute the agency of emancipation; their strength is expressed through cultural productions based on concrete social and economic developments and on the historical conditions of sexual, racial, and ethnic interests that represent the politics of diversity and equality.

Class remains a decisive factor in considerations of communication in late capitalist societies, where the antagonism between rich and poor supersedes common relations among individuals. Whereas culture helps to organize and form the social relations of a class and offers an understanding of those forms, it is also a response to change as, for instance, the way a working-class culture confronts threats to its stability such as the dismantling of its traditional structures by social and economic forces. The result is an expression of resistance, as well as the confirmation of existence under the hegemonic leadership of a dominant bourgeois culture. Class experience forms the concrete historical context for explaining the nature and quality of social practices and the conditions under which people live. According to Ralph Miliband (1991, 43), other factors may influence "the ways in which class is experienced; but class nevertheless crucially shapes the whole of 'social being.'" Thus, the idea of the working class is conceptualized within the social and cultural totality of society, where it resides in the concrete, collective experiences of material existence and cultural expressions and is separate from the bourgeois interests and experiences that have dominated definitions of communication, participation, and democracy.

Historically, traditional considerations of class and class consciousness have been rooted in the writings of Karl Marx, with his ideas of capitalism and modes of production, and the later work of Max Weber, which places individuals within commercial-class situations led by economic interests

and market conditions. Since that time, the issue of class structures in modern societies has resulted in contributions—mostly by Marxist and non-Marxist European social theorists—based on Marxian or Weberian perspectives (e.g., Bottomore, 1965; Dahrendorf, 1957; Gilbert and Kahl, 1982; Joyce, 1995; Miliband, 1991; Parkin, 1979; Poulantzas, 1974; Roemer, 1982; Scase, 1992; Szymanski, 1983; Vanneman and Cannon, 1987; Wesolowski, 1979; Wright, 1979, 1985).

The Marxian perspective relates to an understanding of class within an economic analysis of society and generates a theoretical claim that locates social class within the reality of productive relations and types of ownership and control. In fact, the interdependence of capitalism and social class provides the social and economic framework from which the relationship between producers and nonproducers emerges as the essential antagonism of the capitalist mode of production; however, it is also the source of social change, particularly when objective class relations develop into class consciousness. The concept of class, however, has found various interpretations, most of which are related to a diversification of the dichotomous Marxist theory of class (e.g., Dahrendorf, 1959; Giddens, 1973; Miliband, 1977; Mills, 1951; Sweezy, 1953; Wright, 1979).

In the case of a Weberian approach, class is related to the market situation or to an economic interest that creates and sustains class, in which property or the lack of property describes the particular class situation (Weber, 1946, 182–183). Weber (1968, 2, 937) distinguishes between societies based mainly on status and those based essentially on class, contending that "classes are stratified according to their relations to the production and acquisition of goods, whereas status groups are stratified according to the principles of their *consumption* of goods as represented by special styles of life." And whereas the latter is the predominant or preferred perspective, emerging from his emphasis on close Gemeinschaften, Weber recognizes that threats against status stratification under conditions of technological or economic change also activate considerations of class.

Marxian and Weberian conceptualizations of class overlap; contemporary neo-Marxist theory acknowledges the existence of capitalist and noncapitalist classes, whereas neo-Weberian conceptualizations differentiate among a variety of noncapitalist classes, according to Stephen Edgell (1993, 37).

Although communication studies lacks debates over class as a theoretical construct, discussions of the nature of class and the treatment of class antagonisms in the literature of related disciplines provide a cultural context for the study of class interests in the United States. For instance, in the late 1930s Robert Lynd (1939, 227) suggested that "social science plays down the omnipresent fact of class antagonisms [based on] the tradition that class divisions are un-American and that such differences as exist are

transitory and will be eliminated by a rising standard of living 'and the general movement of Progress.'" Almost sixty years later, Hout, Brooks, and Manza (1995, 824–826) concluded that class "continues to matter for U. S. politics," adding that the "rumors of a declining significance of class persist because previous research underestimated the importance of class in the 1980s and 1990s" and suggesting that "class differentiation itself remains a stable feature in the landscape of U.S. politics."

But however neglected or discounted, considerations of class have held their place in the history of American social sciences. In fact, class relations as a politicized concept were frequently discussed, according to Martin J. Burke (1995, 158), although with little agreement and as "an ongoing struggle to legitimate, or delegitimate, certain interpretations of the contours and consequences of American capitalism . . . [that] resulted in the partial naturalization, or renaturalization, of class antagonism in the arenas of public discourse."

The history of sociology is a major source for gauging the importance of class relations in response to problems of classification. Indeed, the contributions of Charles Page (*Class and American Sociology*, 1940), Milton Gordon (*Social Class in American Sociology*, 1963), and Michael D. Grimes (*Class in Twentieth-Century American Sociology*, 1991) provide a comprehensive discussion of class as a topic within American sociology. Their works combine contextual social considerations and analytical and methodological issues as they relate to the role of class in the scholarly work of American sociologists. Page in particular stresses the social and historical links between intellectual work and society, whereas others suggest the emergence of class as a "loaded" concept, based on its Marxist origins. The history of American sociology, then, is also a history of dealing with social and political inequality from a range of perspectives—most typically, however, in terms of strata or social stratification rather than class structure in a Marxist tradition, suggesting an emphasis on individual traits through status variables rather than an interest in class position and collective action.

Whereas American sociology incorporated many working-class concerns into its treatment of middle-class issues, the development of social history in the United States turned increasingly toward the experience of the working class. The results have been investigations of underprivileged segments of society, including African Americans and women, and their ways of adjusting to the conditions of industrialization and urban life.

The nineteenth-century struggle against capitalism has been described by several social historians, who seem to agree that the rise of wage workers created specific definitions of the laboring class as a dependent class vis-à-vis the new capitalists (e.g., Aronowitz, 1973; Couvares, 1984; Denning, 1987; Gordon, Edwards, Reich, 1982; Peiss, 1985; Rodgers, 1974; Slotkin,

1985). It also resulted in an emerging working-class culture that was different from, if not antagonistic to, the dominant class (Denning, 1987, 58). Earlier work by Eugene Genovese (1965) specifically had brought a Marxist perspective to the investigation of slavery, challenging at the same time the widely held view among social historians that some degree of autonomy was present among working class groups and individuals.

Influenced by the British work of E. P. Thompson and Eric Hobsbawm in particular (Johnson, 1978), American social historians studied the working class, moving beyond the story of organized labor to investigate the social and cultural complexity of working-class life. They turned away from the notion of class, however, as described in the work of Herbert Gutman (1973), which focuses on the distinction between culture and society, or in the studies of Linda Gordon (1976), who integrates Marxism and feminism in women's history. Instead of tracing the history of organized labor, labor history has been interested in the fate of individual members of the working class, including the importance of a gendered approach to labor. At the same time, however, Fink (1994, 188) noted the unsatisfactory treatment of twentieth-century working-class culture, suggesting that the literature on mass culture is "far stronger as social critique than as social history." On the other hand, communication studies has failed altogether to address the discourse of class relations and the role of a working-class culture as historical factors in the rise of media industries and their impact on defining the American way of life. Thus, a labor history component of communication studies barely exists (Hardt, 1995), and labor and social historians have yet to discover the site of media work.

Since the 1970s an American Marxist political economy of the media has evolved from the work of Dallas Smythe and Herbert Schiller, and, later, Vincent Mosco and Janet Wasko (1983) in particular; concerns about a class analysis also appeared in the writings of Armand Mattelart (1978, Mattelart and Mattelart, 1992). Almost twenty years later, the rise of Marxist perspectives in alternative paradigms of mass communication was acknowledged in a popular survey of the field (McQuail, 1994), but the reception to Marxist ideas and their application remains limited in American (mass) communication studies.

Instead, discussions of class and class relations within communication and cultural studies in the United States have been dominated by British social and cultural theorists, including media analysts. These works have been widely distributed through the increasing activities of international publishers like Sage and Routledge and have often experienced a sympathetic, if unenthusiastic, reading among critical media and cultural studies scholars.

For instance, in a comprehensive study that marks the beginning of this period, Anthony Giddens (1973) reflects on the development of the notion of class as a theoretical construct in advanced capitalist societies. He re-

views Marx, Weber, and a number of social theorists whose considerations of class suggest the centrality of the concept in twentieth-century social thought. Dissatisfied with explanations of the relationship between class and actual group formations, Giddens develops his theory of structuration, which builds on individuals' ability to draw on their lived experience of the real conditions of society. One of the attractions of this approach for communication studies is its recognition of agency and the emphasis on communication-information and discourse in social relations, including expressions of power and domination. Giddens proposes to abandon traditional Marxian and Weberian approaches to class in exchange for "combining a theory of class society, as an institutional form, with an account of how class relations are expressed in concrete types of group formation and consciousness" (1973, 110). Thus, capitalism emerges as a class society in which economic activities organize and divide people.

The relationship between determination and agency is also a major topic of earlier contemporary Marxist discussions, which began to have a particular relevance for cultural studies with the work of E. P. Thompson (1966), whose imaginative efforts in *The Making of the English Working Class* not only established a way of "doing" history but provided a theoretical basis—contained in the idea (Marx) that social being determines social consciousness—for feminist and cultural studies in Britain. Thompson relegated the Marxist insistence on the primacy of the economic in the determination of institutional forces and individual consciousness to its place among other social and cultural perspectives that characterize his narrative of productive relations as concrete, lived experiences.

This approach offers a new range of explanatory possibilities. In fact, Thompson (1966, 11) rejects class as a structure, reminding his readers that "class is a relationship, and not a thing." Class consciousness is embedded in the cultural conditions of society, that is, "class happens when some men, as a result of common experiences (inherited or shared), feel and articulate the identity of their interests as between themselves, and as against other men whose interests are different from (and usually opposed to) theirs." Therefore, "Class-consciousness is the way in which these experiences are handled in cultural terms: embodied in traditions, value systems, ideas, and institutional forms" (1966, 9–10). Thompson's perspective makes the discovery of social and cultural conditions in their historical contexts particularly important and relevant for communication studies in its efforts to establish the relationship between working-class life and the media and the role of the working class in the production and consumption of the media.

Raymond Williams (1966) provides additional arguments for a commitment to cultural analysis as an appropriate approach to class and to the role and functions of institutions in society, like education or the media.

For instance, his notion of culture as a way of life describes a social process that includes the ways in which individuals relate to each other, both through communication and in the context of relations of power and control. And although he warns that "it is foolish" to manufacture an artificial working-class culture or to interpret individuals in rigid class terms, he also suggests that it is important to recognize the production of working-class culture. Williams approaches the idea of class through an understanding of culture and language across classes as fundamental, shared experiences rather than distinct bodies of knowledge and (economic) interests. He sees class as a collective mode and the nature of social relationships as the distinguishing element between the bourgeoisie and working class; it is the total way of life. Thus, working-class culture is "the basic collective idea, and the institutions, manners, habits of thought and intentions which proceed from this. Bourgeois culture, similarly, is the basic individualist idea and the institutions, manners, habits of thought and intentions which proceed from that" (1966, 327).

Although Thompson relies on a more traditional, dialectical approach to what constitutes culture, both Williams and Thompson contribute to an understanding of cultural studies as being based on a conceptualization of culture as crossing social practices while embracing meanings and values that are both the distinct properties of classes in their historical conditions and the sources of their response to life. Both authors introduce *experience* as a pivotal concept in cultural analysis; as Stuart Hall (1982, 26) succinctly stated,

> It is, ultimately, where and how people experience their conditions of life, define them and respond to them, which, for Thompson defines why every mode of production is also a culture, and every struggle between classes is always also a struggle between cultural modalities; and which, for Williams is what a "cultural analysis," in the final analysis, should deliver. In "experience" all the different practices intersect; within "culture" the different practices interact—even if on an uneven and mutually determining basis.

In addition to confronting these intellectual contributions to British Cultural Studies and its impact on American social thought, communication studies also encountered a sustained argument for the study of class relations in the writings of Graham Murdock and Peter Golding (1977), John Clarke, Chas Critcher, and Richard Johnson (1979), and Nicholas Garnham (1986, 1990) in particular. Murdock and Golding examined the economic conditions of the British media, providing an analytical model for media research, and concluded at the time that "neither Marxism nor academic sociology has progressed very far in producing a detailed analysis of the role of mass communications in the production of class relations"

(1977, 20). Clarke, Critcher, and Johnson (1979) provided an exploration of sociological and historical treatments of working-class culture in Britain, including ways to conceptualize that culture in the intellectual and political climate of the time. Garnham argued for a political economy of mass communication, suggesting that to "understand the structure of our culture, its production, consumption and reproduction and the role of the mass media in that process, we need to confront some of the central questions of political economy in general, the problem of productive and non-productive labour, the relation between the private and public sectors and the role of the State in capitalist accumulation" (1986, 31).

Together, these authors provide a discussion of culture, class, and class relations that reflects the specificity of their historical conditions; their insights into the formation of class or the rise of class consciousness in and through the cultural sphere, including the economic formations and processes of media industries, are the insights of participants and observers in their own social, economic, and political environment. Their contributions may even link "intellectual inquiry and political action" (Garnham, 1990, 1) in an effort to move toward an accountability of academic practices.

These experiences are remote, however, in the social or political context of an American culture in which ideas of class and class analysis were problematic long before the advent of mass communication research in the 1940s. Yet, at a time of intellectual stagnation in communication studies, they encourage consideration of a Marxist critique involving issues of property, division of labor, and ideology to gain new and relevant insights into media practices.

The discourse of British Cultural Studies in particular provides unique interpretations of contemporary British society but is limited in its appropriation by an American communication studies tradition that has not embraced Marxism or privileged class differences in its representations of the media and society. On the contrary, the United States reinvented Marxism as a Communist threat against a bourgeois lifeworld as part of a larger process of self-definition through opposition that emphasized its ideological distance from any Marxist perspective. In addition, the American social sciences established a strong postwar presence amid the specific social scientific cultures of Western Europe, where a Marxist tradition of social thought became a major source of alternative visions of society; they also contributed to a dialectical definition of democracy with its tendency to essentialize the contrasting understandings of class and the social and economic consequences of class differences.

The intervention of feminist work in the process of cultural studies marked the beginning of what Sarah Franklin, Celia Lury, and Jackie Stacey (1991, 171) have called the "complicated and contradictory histo-

ries" of feminism and cultural studies from which culture appeared as a context for analyzing the condition of gender relations and the reproduction of gender inequality. The rise of gender as a category of social analysis has been accompanied by a sustained feminist critique of traditional class analysis (Abbott and Sapsford, 1987; Acker, 1973; Dex, 1985; Gamarnikow, 1983; Heath and Britten, 1984; Roberts, 1981; Watson and Barth, 1964; Wright, 1989a), supported by rapidly changing historical conditions of women as participants in the social and economic life of modern societies.

Whereas feminism introduces a variety of ideologically different approaches (and solutions) to women's oppression, it also offers a new perspective on cultural (and political) practices. As Andreas Huyssen (1986, 220) suggested in the mid-1980s, "The ways in which we now raise questions of gender and sexuality, reading and writing, subjectivity and enunciation, voice and performance are unthinkable without the impact of feminism, even though many of these activities may take place on the margins and even outside the movement proper."

In fact, feminist studies address the issue of class by extending Marxist theories of exploitation of labor in the workplace or at home to traditional terrains of inequality—including racism and sexism—to describe the reproduction of relations of dominance and subordination. Others (Daly, 1978; Ferguson, 1989; Hartmann, 1980, 1981; Lerner, 1986; MacKinnon, 1982, 1987, 1989; Middleton, 1974; Millett, 1971; Rich, 1977; Walby, 1986, 1990) have argued for developing conceptual frameworks outside class relations to analyze patriarchal conditions of society. Karen Hansen and Ilene Philipson (1990, 29) offer a comprehensive compilation of socialist-feminist thought in the United States and agree that "socialist feminists both inside and outside the academy have produced important ideas and made significant contributions to political movements and to the ways that people live their lives."

What has emerged from over three decades of coexisting interests of feminism and cultural studies is an anti-reductionist perspective of cultural studies; the notion of class folds into a complex system of social factors—like gender, race, and ethnicity—to reflect an integrative approach (Dines and Humez, 1995) involving collective, social, economic, and cultural components of class relations, as well as experiences of individual participation that constitute the complexity of any class analysis. For instance, Robin Kelley (1994) has addressed issues of race and class, as has the work of Richard D'Alba (1990) and David Roediger (1991); earlier work by Edna Bonacich (1980) locates racial divisions within a class-centered analysis of political antagonism, while Johanna Brenner and Maria Ramas (1984) offer a dialectical approach to class and gender. More recently, John Frow (1995, 107) offered an argument for the historical presence of

race, gender, and ethnicity "as an 'ideological' moment within the domain
of production . . . to indicate the way in which ideological values attrib-
uted to gender, race, and ethnicity work to structure relations of produc-
tion."

Issues of race and class have become problematized, especially in criti-
cal reviews of popular culture. For instance, Jhally and Lewis (1992) have
suggested that an "enlightened racism" supports the belief that middle-
classness provides the key to personal success. At the same time, however,
the autonomous effects of gender and race gain in popularity as social and
political spheres of analysis, whereras class loses its traditional position
(Wright, 1989b) and resurfaces with the rise of the "masses" in the dis-
course on the popular in contemporary culture. Pamela Creedon's (1993)
presentation of feminist work on gender, race, and culture in a collection of
essays that focus on women in mass communication reflects such a shift,
whereas Valerie Walkerdine (1996, 103) argues that class has faded from
cultural analysis and explains how "by the 1980s the working class no
longer existed as a viable entity."

Finally, the intellectual and interdisciplinary space of communication
studies between the traditional practices of a social scientific approach to
communication research and the historical-cultural analyses of cultural
studies and feminism is further defined by the presence of film studies. Al-
though peripheral to this discussion, film studies' concerns with material is-
sues of production and consumption and its theoretical insights into a
range of psychological, semiotic, and ideological aspects of film as commu-
nication constitute potentially significant contributions to communication
studies. Recent work by David James and Rick Berg (1996) addresses issues
of cinema and class in particular. Although class is not a privileged perspec-
tive of contemporary communication studies, the mediation of experi-
ence—typically accomplished through language and media—is dominated
by specific class interests, typically guided by self-preservation and rooted
in the existential anxiety of individuals.

In fact, the conceptualization of "mass" communication in communi-
cation studies constitutes an ideological construct that obscures working-
class interests by endorsing class-related biases that flow from the interests
of a cultural bourgeoisie. For instance, media enterprises construct realities
that preferably reflect middle-class visions of social and political life and re-
inforce a dominant conservative interpretation of being in the world; in the
process, they also obscure the possibility of difference—that is, of alterna-
tive realities—through exclusionary practices in public communication
when the reproduction of commercial intent compromises the creation of a
complex, contradictory representation of society. Whereas (white) middle-
class individuals find ample opportunity to identify with the mediated dis-
course of society, working-class individuals experience alienation in con-

fronting pervasive, dominant visions of the world that are subjects of communication in the bourgeois public sphere.

Moreover, in a social and political environment that insists on the primacy of the individual, communication research has been concerned principally with understanding those whose economic conditions or social status produced aggregates of individuals as audiences or readers. These individuals' tastes, attitudes, and behavior are measures of success for political and commercial interests and their need to know. The emerging information has not empowered those subjected to the media but has given those in control of media content insights about the potential of illusion and manipulation. In this ideological context, traditional communication research reproduces communication and media practices as problems of individual choice and marginalizes economically weak and culturally displaced individuals whose minimal competencies as consumers also restrict or deny participation in any kind of societal communication.

Thus, communication research focuses most significantly on the description and explanation of social relationships in the context of consuming (reading, listening, watching) media while responding to media content by relying on demographic characteristics, like income, occupation, or definitions of social standing expressed by education. If it has done so at all, this research has relied on an understanding of class in terms of status, occupation, or income—reflecting traditional social scientific visions that, according to E. O. Wright (1979, 7–8), represent "graduational" conceptions of class that are static, providing labels rather than describing processes involving various social forces. Nicholas Abercrombie and John Urry (1983), for instance, have suggested that class is typically equated with status and that, over time, in American society status is achieved not just through relations of production, but through consumption as well. Since social standing relies mainly on economic potential, it is drawn into the realm of industrial interests, which control access to products and to the means of production and ultimately determine the conditions of work. They also define the function of the workplace and decide the structure of audiences.

Meanwhile, the reinforcement of individualism as a reigning idea behind stratification in media research has been confirmed by a dominant functionalist perspective of communication research since the 1940s that has been guided by the practical demands of a growing commercial investment in media industries. Consequently, communication studies remains informed by progressive notions of change that adhere to ideological and political constructions of a social reality in the context of middle-class expectations.

The resulting mass communication literature creates a sense of individuals as participants in the commercialization of human existence, and culture surfaces as the "taste" or the "preference" of a traditional middle

class. For instance, when Herbert Gans (1974, 70) referred to class as a socioeconomic category, he was discussing a hierarchy of "class-cultures" to distinguish among publics with middle-class taste with no reference to a working-class culture or to the relationship between an emerging working class and the rise of popular culture in the United States. A more recent discussion of popular culture recognized the phenomenon of class-conscious cultural productions but did not theorize the notion of class or, more specifically, the contribution of an American working-class culture to a contemporary definition of popular culture (Mukerji and Schudson, 1991). Abercrombie, Lash, and Longhurst (1992, 133), on the other hand, suggested that whereas the imposition of commodification and massification may have had an effect on the historical move from folk to popular culture, culture is also a response to dominant forms and that it matters indeed "how the culture expressed by working-class groups relates to the situation in which they find themselves."

Consequently, much communication research has concerned media use among individuals, groups, or social elites with few considerations of the significance of media in the emergence of class formation and class consciousness. Observations by Warren Breed (1960, 193), that press policy "protects property and class interests, and thus the strata and groups holding these interests are better able to retain them," and by Herbert Gans (1980, 24), who wrote that "in eschewing the term 'working-class,' the news also brings blue-collar workers into the middle class, and by designating upper middle-class people as middle class, it makes them appear to be more numerous than they actually are," recognize the significance of class issues. They have failed, however, to stimulate the imagination of the field.

Since the media are surrounded by an aura of middle-classness, their production of working-class representations may satisfy political perceptions of diversity or commercial demands for variety rather than the expectations of the working class itself. For instance, in his cultural history of advertising Jackson Lears (1994, 325) reported about Sloan's Liniment in the late 1920s, which "appropriated the documentary authority of Lewis Hine's work when its agency hired him to depict the working-class beneficiaries of the product," illustrating the appropriation of images for purposes of bourgeois propaganda. The media support and reinforce a class struggle from above that appropriates working-class representations to meet bourgeois objectives and shatters working-class expectations, ranging from autonomy in the labor process to representation in the public sphere.

From the perspective of communication studies in particular, issues of communication in the public sphere raise questions about class relations and the cultural manifestations of social and political consciousness in society, such as the form and content of the public discourse that typically arises from inter-class activities. As Vincent Mosco (1983, 242) observed,

"Critical research recognizes that the social relations of communications are not shaped by domination alone, but also by the contradictions or conflicts that grow out of the evolution of the class system itself." Thus, expressions of working-class sentiments may well reflect middle-class values rather than a radical class consciousness. Such inter- and intraclass interactions, as they relate to communication, the media, and empowerment, may help to explain the hegemonic role of the dominant class and the process of seeking consent or cooperation among subordinate groups, including the working class and its reaction.

A number of authors in related disciplines have addressed the role of the working class in shaping American culture or, more specifically, the representation of working-class life in a bourgeois media world. For instance, George Lipsitz (1981) discussed class and culture in the United States based on a definition of the working class that merges economic and cultural components, thus combining the realization of class consciousness in the struggle against the exploitation of labor with expressions of self-identity in various cultural forms. Lipsitz (1981, 174) observed the working-class experience in the age of electronic media and the potential for resistance when "culture consumers relied on their own experiences to evaluate the images placed before them and sometimes drew conclusions directly contrary to the intentions of artists and distributors." Lipsitz (1981, 192) concluded that the culture industries "often unwittingly communicate class experiences and messages sedimented within old cultural forms" but that music specifically "became one of the main vehicles utilized by the working class, to transform marginal class experiences into a mass culture offering leadership and guidance to all classes."

A decade later, Stanley Aronowitz (1992) proposed a different contribution by the working class to American culture after tracing the displacement of that class in the realm of popular culture. His study of television programs in the United States (1992, 199–208) suggests that although "working-class identity is no longer an option" in a mass-mediated society, the continuing presence of "displaced representations of workers and their culture," particularly on television, "attests to the media's yearning for a source of vitality and renewal, which clearly cannot be derived within ruling-class relationships."

Both Lipsitz and Aronowitz not only acknowledge the presence of a working-class culture but also problematize its existence in a contemporary media environment in which displacement becomes a form of social recognition and exposure to working-class representations a potential source of resistance. Most important, however, they draw attention to the relationship among class, representation, and media practices in American society. These efforts seem more genuine and certainly more theoretically sophisticated and historically informed than the work produced in communication

studies on working class and media environments since the mid-1980s—a time when the concerns of such studies focused on gender, race, and ethnicity and produced a new sensitivity to the related issues of social class.

When the issue of class emerges with the rise of feminist perspectives in communication research, it reflects the importance of articulating culturally perceived differences in society. The results, however, seem to reflect a curiosity about the potential explanation of class differences rather than a class-conscious interest in developing emancipatory strategies for communication studies to reveal the nature of class relations (e.g., Butsch, 1992; Jordan, 1992; Press, 1989, 1991a, 1991b; Thomas, 1985).

For instance, Sari Thomas (1985) investigated the nature of religious television programs to find that the existence of working-class audiences alters the goals or the appeal of the gospel. She revealed (1985, 119) that "it is socially functional to emphasize piety and spiritual devotion over professional accomplishment and effective secular activity to members of the lower working class" but failed to draw any conclusions from her observations that "piety and spiritual devotion do not establish frustrating goals that might contribute to social unrest." Instead, Thomas (1985, 119) asserted that "it does not seem sufficient to view religion as a narcoticizing agent that monolithically induces compliance among the oppressed," thus ignoring or rejecting more sophisticated explanations of how television religion can be conceptualized to address a working-class milieu successfully in terms of extracting promises of money and faith.

Likewise, Andrea Press (1991b) studied the vocabulary of the morality of "working-class women in a middle-class world" in the context of television watching. No cultural context exists for what constitutes middle- or working-class women or for what accounts for their particular ideological positions or approaches to problem solving except that their responses seem to differ based on their abilities to translate personal experiences into abstract concepts. Press (1991a) applied a traditional sociological definition of class as status to her work. Although elsewhere (1989) she established the need for categories like class and gender to locate women's culture or to study media audiences, issues of class and culture remain unexplored.

Amy Jordan (1992) investigated media use in family settings by looking at social class and the perception and allocation of time. The study relied on earlier suggestions about the importance of social class in communication studies within family settings (Chaffee and McLeod, 1972; Lull, 1982; Messaris and Kerr, 1983) but conceptualized social class in terms of "a set of experiences and strategies for approaching life that is carried into the home and passed among family members" (Jordan, 1992, 376). Consequently, she found that the "temporal ideologies" of social classes are determinants not only of the frequency of media use but also of "how" they are used (1992, 384).

In a theoretically informed work, Leslie Steeves and Marilyn Crafton Smith (1987) demonstrate how one can study representations of women in prime time television from a class-specific perspective. Based on Wright's (1979) explication of the meaning of class and Zillah Eisenstein's (1979) critical considerations of a feminist class analysis, Steeves and Smith note the absence of American television studies of joint gender and class representations, although they acknowledge earlier work on television and magazines by Jane Feuer (1984) and Nona Glazer (1980), respectively. They conclude that both male and middle-class representations prevail across a variety of television programs. Although no indications suggest that representations of class reflect exploitation within relations of production according to a Marxist perspective, class references do reflect "popular, simplistic, gradational views, according to which the lower class is associated with dress and demeanor that imply less education . . . less progressive values and/or aspirations . . . and/or moral/promiscuous sexual values" (Steeves and Smith, 1987, 57–58).

From a similar theoretical perspective, Richard Butsch (1992) examined the way gender and age have been used by television to manipulate class, particularly working-class, representations throughout the history of domestic situation comedies. His work extends earlier studies of gender and class (Steeves and Smith, 1987; Ferguson, 1990) and suggests that "class is symbolically coded in gender terms, so that gender becomes a means of establishing class status" (Butsch, 1992, 387).

Although working-class series have remained in the minority through more than forty years of television series, many have become classic television fare. Butsch concludes a comprehensive review of television series by observing that "the stock character of the ineffectual, even buffoonish working-class man has persisted as the dominant image. In the prime-time tapestry he is contrasted to consistently competent working-class wives and children and middle-class fathers" (1992, 397).

In short, the work by Jordan (1992) in particular reveals class as a mode of existence, whereas Steeves and Smith (1987) as well as Butsch (1992) argue beyond their findings for studying the form and nature of class representations by popular media, particularly television, to understand the symbolic configuration of class relations. In addition, these studies tend to concentrate on conditions of reception, mostly by television viewers, at the expense of other communication environments and the potential of participation as authors or sources of public discourse. Most important, however, without a cultural or political context or an understanding of historical space, class is reduced from lived experience to a category of analysis. The result is a report on status in a middle-class world of (television) audiences.

Indeed, the utopian vision of democracy in the United States still rests on the notion of middle-classness at the expense of working-class interests.

Thus, whereas the accumulation of wealth and social climbing are tolerated, if not expected, social practices, the incorporation of a working-class culture into a broader understanding of culture, for instance, remains controversial if not undesirable. Although there was never any doubt about the social and political presence of a working-class culture in American society, the problem has been one of identification and representation in the production of mass culture where the recreation and reinforcement of a middle-class utopia have been more important than the recognition of class differences, cultural diversity, or even the possibility of change through class struggle. Consequently, the working-class culture continues to reside within the margins of the cultural apparatus and, at best, serves as a creative cultural resource in areas ranging from music to language to the popularity of specific pastime activities. The commercial appropriation of such cultural practices, however, does not transform working-class interests into middle-class aspirations typically associated with a consumer culture; rather it displaces and distorts original working-class attempts to define and maintain separate identities through cultural practices.

An understanding of modern society rests on an explanation of the social, economic, and cultural determinants of relations between classes; the sources of their respective identities, and their representations in the public sphere at specific historical moments. Such understanding also includes the context of collective human experiences expressed in class culture. In this sense I agree with Aronowitz (1992, 23) who suggests, with reference to Marx, that a theory of class struggle and class consciousness can be derived "from the crucial part played by communication for insuring the conditions for solidarity." Indeed, he continues that communication "is the condition for the constitution of a common cultural community without which political self-preservation is not possible." This last observation raises questions of political identity and self-preservation and is crucial for any politically meaningful discussion of class or, for that matter, the relations between communication studies, politics, and culture.

A number of possible reasons could explain why the idea of class in connection with communication studies has never been a major issue. In general, the existence and neglect of a working-class culture in the United States can be attributed to a strong, if not overwhelming, traditional belief in upward mobility; that is, the working-class experience constitutes a mere passage into middle-classness. More specifically, reasons also include the general neglect of class as a category of inquiry in traditional American sociology, the failure of media research to successfully identify with progressive attempts to act on the idea of social class as a distinguishing mark of contemporary social research, and the argument that the disappearance of work and the working class makes such analysis irrelevant, if not obsolete. Reasons are also linked to the antilabor bias of media organizations and

the disappearance of a labor press, particularly after the 1950s and reflected in traditional renditions of journalism history that privilege media ownership and reproduce a top-down history without regard for the rank and file (Hardt and Brennen, 1995).

In addition, the continuing decline of union activities, an ideological shift in the Democratic party toward centrist representations of bourgeois interests, and the centralization of the media at the expense of small, independent voices characterize the social and political environment of struggling working-class concerns. The representation of the social and political interests of the middle class by politicians and the media has become the logical place for most resources—including advertising budgets—to stem the pending threat of political destabilization through poverty, unemployment, and immigration as distinct forms of social separation. Immigration, for example, can be used to express and even to preserve identity, particularly in the case of immigrant ghettos. It is a form of class struggle that involves the dominant power structures in society which also control the cultural institutions—including media organizations, advertising, and public opinion polling. As a result, media culture is defined as an extension of the politics of domination and becomes one-dimensional and one-directional, even in its popular claims of diversity and multiculturalism.

In the larger context, the temporary failure of socialism elsewhere in the world has reinforced the social and economic status quo, particularly among intellectuals, who have been reluctant to deal with problems of class bias in their own work. bell hooks (1994, 148–149) observed that these conditions "made it easier to reject visions of communalism or of participatory economics that would redistribute this society's resources in more just and democratic ways" among African American intellectuals in their complicity with the dominant order in the commodification of blackness and their rejection of class issues. Academic and political practices seem to have been most effective in relegating economic issues—and with them considerations of class relations—to the margins of communication studies. In fact, the weakness of communication studies in matters related to economic determinants of culture and communication and, more specifically, to class and class consciousness reflects the traditional neglect of a class perspective in the social sciences and a Marxist interpretation of class relations in particular. It also signals a continuing reluctance to offer political solutions to theoretical insights into contemporary problems of media and communication.

Implicit in the definition of American democracy has been the perception of a classless society, which means Americans understand themselves in terms of a traditional ideology that champions equal rights and opportunities and recognizes economic and social inequalities as personal conditions rather than problems of class relations. This belief reflects an opti-

mistic social consciousness that celebrates the American spirit while disregarding the real conditions of society. Several decades ago, David Potter (1954, 103) observed that "by eliminating class diversity without being able to abolish class distinctions, abundance has only made subjective discrimination more galling, while making objective differentials less evident." The illusion of living in an egalitarian society is kept alive by a media system that "hides gross inequities from public view," according to Gregory Mantsios (1995, 409), and that provides messages "that obscure the nature of class realities and blame the victims of class-dominated society for their own plight."

The idea of social class as a historical site of social relationships in American society not only offers an opportunity for understanding the real circumstances of working-class men and women, including media workers and their ways of life, but also contains the potential for grasping contemporary relations between those who dominate through ownership and control of the culture industries and the working class. Positioning communication studies between social scientific and cultural studies practices produces considerations of class that reflect the historical conditions of those competing traditions. Both deflect the issue of class, either by concentrating on issues of status within a middle-class milieu or by effectively denying the centrality of class with a turn to issues of gender (or ethnicity) in cultural analyses of media audiences. As a result, the working class emerges from communication studies in the context of consumption—defined by media content, restricted to desires for a middle-class existence, and without a history. In fact, the gaze of communication studies is blurred by a number of biases, including those inherent in the social origins (gender, class, race, ethnicity) and positions (reputation, influence) of scholars within the field.

But an intellectualist bias is also present, according to Pierre Bourdieu, that produces the world as a spectacle rather than a practical problem and requires scrutinizing and neutralizing "in the very act of construction of the object . . . the collective scientific unconscious embedded in theories, problems and (especially national) categories of scholarly judgment" (Bourdieu and Wacquant, 1992, 40). The field of communication studies lacks such an engagement of reflexivity to provide insights into its epistemological unconscious and, thus, to offer a guide to the practice of research. The (non)treatment of class relations may well be located in a specific maze of biases that defines its workings.

Yet in the face of considerable global deployment of capital that affects the social and economic conditions of people everywhere and with an intercontinental concentration of media power affecting worldviews about such conditions, the issue of class resurfaces as a potential site of political struggle. Indeed, to engage in communication studies without acknowledging

the political dimension of its concerns seems problematic, especially in light of a history of political rationales that fueled both earlier work in cultural studies and feminism and critical political-economic assessments of media organizations.

Thus, a discourse about class is the result of political organization, agitation, and communication that involves a representation of class relations through the media and the articulation of alternatives that break with the routinized social and economic practices of inequality and unfairness. It is about change and the conditions for change as they involve reconstituting civil society to reflect moral demands for an inclusive, participatory public life in which communication means empowerment and freedom to take control over one's life, to articulate direction, and promote an emancipatory politics of change. It seems appropriate under these conditions to search for ways of liberating individuals and ascertaining identity and self-actualization for those who, by the nature of their class, have been systematically deprived of participation.

These issues are political. The emancipatory struggle of women may serve as a concrete example to implement a strategy of consciousness raising and political action, since it demonstrates that the conditions of existence in late capitalist society can be successfully challenged by appeals to the potential qualities of human life and the humanism of democratic principles. The struggle involving the interests of the working class pursues similar goals that lead to the emancipation of individuals from exploitation, oppression, and inequality and to a recognition of social and cultural diversity—including the demands of gender, race, and ethnicity, and their consequences for participation in societal communication.

After more than two decades of exposure to British Cultural Studies and an even longer acquaintance with the ideas of the Frankfurt School, communication studies has failed to help generate a political agenda that would have turned theoretical insights regarding the relationship among individuals, the media, and society into practical, emancipatory solutions for American media practices. This failure includes a lack of political sensitivity to issues of class and reflects a traditional reluctance to consider the consequences of class formations. It also indicates a reluctance to understand the importance of social and cultural history in the construction of a critique of media and culture. An absence of radical politics inside and outside the academy seems to marginalize theoretical Marxist concerns related to issues of class relations unless they are combined with politically and socially volatile topics of gender, race, or ethnicity; by approaching the latter as locations of class interests, issues of communication and class relations in American society can be linked successfully to sexual, racial, or ethnic politics. Aronowitz (1992, 67) concluded that "the inability of the left to place the egalitarian ideas in the forefront of public debate, much less polit-

ical solutions, accounts, in the main, for the absence of a clearly articulated discourse about class."

The failure of communication studies to create a need for public debates and to affirm political actions reinforces the reign of distorted communication and media power. The failure to seek alliances with working-class interests outside the academy, such as labor unions or media workers, in an effort to revitalize the field and express solidarity with political goals contributes to an isolation of the field and reinforces the status quo in teaching and research. Instead, the function of communication studies should be to operationalize the notion of class by working with the concrete historical experiences of individuals in studies that focus on the complexity of communication over time and within the social, economic, and cultural frames of lived experience by incorporating ethnographies of consumption into social and cultural histories of participation.

For instance, an integrative view of class that focuses on material interests and the concrete conditions of lived experience could follow Williams, Thompson, or the work of Bourdieu (1980, 1987)—whose idea of class is organized around experience-based concepts like habitus and symbolic capital, suggesting that class differences are based on material interests as well as on acquired dispositions (habituses). Bourdieu's work is sensitive to the cultural values of the working class and suggests that the reproduction of the dominant class depends on economic success and cultural investment ordinarily not within the reach of working-class individuals. Giddens (1973), by reaching beyond material interests, also insists on the contribution of lived experiences—that is, on how people structure their existence around those interests. A critical theory of communication and the media will reveal the nature of class distinctions in the context of culture and politics. Thus, the specification of class location, expressed in terms of middle- and working-class interests, rests on distinctive relationships with knowledge and culture; that is, the rise of a cultural bourgeoisie, whose possession of cultural capital both unites and separates it from the working class, constitutes a new historical formation vis-à-vis the working class.

The concept of class as a process rather than as a specific dichotomous or multiple, economically determined structure represents a means of organizing ideas about class, culture, and communication that responds to the historical process of participation in society by drawing attention to individual and collective experiences and consciousness. An emerging theory of class, culture, and communication raises questions about how interactive class processes provide the structure and content of communication and how class is reflected in social, economic, and cultural environments—including the lived experiences of class through gender, race, and ethnicity—while it contributes to constructing knowledge of a changing social totality. This approach assures the visibility of the American working class as a his-

torical fact and promotes the study of subcultures in communication studies. Recognizing and addressing working-class existence through frequently subsumed expressions, ranging from language to cultural productions, complete the experience of class as a historical narrative; they also correct the one-dimensionality of communication studies, which is ideologically committed to respond to the model of a middle-class society.

The resulting observations will confirm differences within class structures as they relate to the concrete commonalities of interests and experiences based in work and existence; they also reveal an increasing complexity of class structure, thus reducing the collective capacity of the working class, for instance, to organize in resisting exploitation. The observations should not, however, distract from the original appeal of class as a central element in the relations of power and control in society.

Current discussions of communication in society are dominated by a bourgeois perspective that ranges from conceptualizations of a public sphere to the history of media practices. Such a perspective has political consequences when particular ideas of communication and participation are being maintained to reinforce and perpetuate traditional middle-class expectations of society. The perspective also suggests that an agenda of class relations that informs communication studies surfaces in the guise of progressive definitions of community, democracy, or participation; meanwhile the media continue to represent commercially and politically viable middle-class interests, and the public sphere as a historically determined, privileged site reflects the consequences of a utopian vision of democracy and the powerful appeal of middle-classness as its ultimate attraction.

Specifically, the structure and content of a working-class way of life, including cultural expressions of working-class experiences and participation of working-class individuals in the process of societal communication through public media, remain desirable subjects of a critical analysis of communication and culture in American society. As an inquiry into problems of identity and representation of the working class, a critical analysis challenges the reigning definitions of individualism, participation, and communication in the public sphere, which dominate theories of the media and reflect the privilege of bourgeois interests. In an age in which class differences are confirmed by the bourgeois ownership of the means of communication, a need exists to combine the insights of labor history in particular, with its increasing sensitivity to gendered historical research, with the attempt by communication studies to provide a critical assessment of contemporary culture and communication dedicated equally to an accounting for class, gender, and ethnicity.

To assault traditional ways of defining the process of cultural production, ownership of the media—including issues of access—and participation in the discourse of society, communication studies must develop strate-

gies for recognizing class differences, identifying working-class concerns, and raising class consciousness by knowing and appealing to the strength of working-class interests and their contributions to the culture of society. Whereas a critical theory of communication and the media must be sensitive to the materialization of class consciousness and must reveal the nature of class distinctions in the context of studying relations between culture and politics, it must also relate to the need for concrete political practices.

3

Communication in the Media Age: An Existential Dilemma

Much of the contemporary literature on communication reflects thinking that focuses on communication as an observable and measurable *activity*. Within this conceptual scheme, definitions of communication have become as numerous as their applications in various theoretical and practical circumstances. For instance, cybernetics, information theory, game theory, and, more generally, system theory have significantly affected various theoretical approaches to communication. Subsequently, the application of scientific models and levels of analysis to communication activities has yielded convenient descriptions and a typology of communication theory and research but the latter have also detracted from a view of communication as a *relational* concept that embraces questions of human existence and lies at the base of what determines the state of the human condition.

This chapter attempts to provide a definition of communication as *relationship*, based on the social environment as the sine qua non of a contemporary theory of communication. It is based in part on the *Gesellschaft-Gemeinschaft* dichotomy in the work of Ferdinand Tönnies.

The societal realm of communication (*Gesellschaftskommunikation*) describes organizational and technical aspects and suggests that significant parts of the individual's reality that deal with those activities in society are designed to protect and advance society's artificial and arbitrary structure and to keep individual members of society isolated from each other without endangering its stability or growth. These features are related to what Martin Buber (1937) has called a basically dehumanizing factor of an individual's relationship with others in his treatment of the I-It relationship. Thus, moral codes, customs, and laws that help organize and direct the activities of individuals and groups in society are major components of *Gesellschafts-*

kommunikation, which, in turn, creates the political and economic realities of society. Extending Tönnies's concept, it describes communication as having an organizing function at the level of *Gesellschaft,* which moves individuals toward common goals without penetrating personal spheres of communication that fall within the realm of *Gemeinschaftskommunikation.*

Underlying *Gemeinschaftskommunikation* is the notion of understanding as a mutual basis for existence, which is not available in *Gesellschaftskommunikation* since it lacks the intimacy and spiritual unity of *Gemeinschaftskommunikation.* It is not merely defined as an artificial means of overcoming a lack of understanding or as a sole means of enabling individuals to make themselves understood but thrives where human beings not only live together in physical proximity but are also united in an intellectual or spiritual proximity. Or, as Tönnies suggests, *Eintracht,* representing a common will, becomes the key factor. Therefore, *Gemeinschaftskommunikation* transcends the limitations of *Gesellschaftskommunikation* and enriches the realm of interpersonal communication with a particular emphasis on mutual understanding. It approaches the ideal of what Josiah Royce (1913, 38) once described as his second condition for the existence of a genuine community: "a number of distinct selves capable of social communication, and, in general, engaged in communication."

Royce's concept of interpretation suggests the importance of a continual mediating process of cognition at the base of any community of individuals. For instance,

> In literal conversation our neighbor utters words which already express to us ideas. These ideas so contrast with our own present ideas that, while we find the new ideas intelligible, and, therefore, view them as expressions of a mind, we do not fully know what they mean. Hence, in general, our neighbor having addressed us, we in reply ask him, more or less incidentally or persistently, whether or not this is what he means—i.e., we give him back our interpretation of his meaning, in order to see whether this interpretation elicits a new expression which we expected from him. (quoted in Fuss, 1965, 113)

Here Royce reflects skepticism about interpersonal communication as an approximation at best of one's own thoughts and ideas yet he developed a concept of "community of interpretation" to constitute the framework of a social structure in which the metaphor of conversation "furnishes the best means of indicating wherein consists the relative but never immediate verifiability of the truth of an interpretation" (cited in Fuss, 1965, 114). Although Royce failed to explain what makes up the underlying rationale of his community of interpretation, his doctrine emphasized the importance of

communication as a social force capable of uniting individuals in an atmosphere of complete understanding and mutual respect.

George Herbert Mead (1967, 327), who studied with Royce, also stresses the ideal community as the one in which the interpersonal art of communication has been developed to a point, at which "the meaning of that which is said is here the same to one as it is to everybody else. Universal discourse is then the formal ideal of communication." He calls communication an organizing process in the community and relates its success or failure to the ability of individual members of the community to "enter into the attitudes of those whom they are affecting in the performance of their own peculiar functions" (1967, 328). Although it is not stated as a moral duty, as, for instance, in Royce's definition of the role of participants in the community of interpretation, Mead places the burden of responsibility on the individual, who must place himself or herself "inside" the other person to achieve universal discourse and, ultimately, a perfect democracy.

A similar view is expressed by John Dewey, whose philosophical frame of communication is closely related to Mead's. Dewey (1925, 6–7) explains that successful communication necessitates looking at the object of the conversation as the other would most likely see it and "assimilat[ing], imaginatively, something of another's experience in order to tell him intelligently of one's own experience." He speaks of a community of interest that must precede "normal" communication and thus echoes Royce's concept of the mutuality of interpretations. Dewey (1925, 219) says, "In so far as we are partners in common undertakings, the things which others communicate to us as the consequences of their particular share in the enterprise blend at once into the experience resulting from our own special doings."

Underlying these three prominent conceptualizations of interpersonal communication is the expressed necessity of participation in the other as a condition for understanding or for successful communication. There is also a strong suggestion that communication makes demands on the self that go beyond the manipulation of symbols (language and gestures) and require that individuals share the self with those involved in communication; in an ideal environment the result would be perfect understanding and concord in the sense of *Gemeinschaftskommunikation.*

Communication as a process facilitates the understanding of others through the social and political discourse of society. In the form of *Gesellschaftskommunikation,* communication does not involve an understanding of each other's existential situation; since it avoids an involvement of the self, it creates a sense of abandonment and dissatisfaction—especially among those whose participation in a more satisfying communicative experience as a member of a *Gemeinschaft* has been reduced by social and technological developments and by media strategies that have stressed communication with individual members of society. Apparently, time, space, and

great concern do not exist among individual or institutional communicators regarding accountability to individual members of respective audiences. In fact, those communicators seem minimally aware of the totality of audiences or of their being in definitions of communication and community.

Individuals confronted from birth with the communication of their total environment reflect the accumulation of those experiences in their own communication; they incorporate the history of their selves in the way and manner of their communication. This phenomenon makes them unique, despite the shared experiences of language, customs, and laws. The existential dimension of communication transcends the social process and forms the center of an individual's existence. It partakes in the development of the individual from a consideration of the self to interpersonal relations and their mutuality of interests to the more common ties provided by society. An individual is what he or she is in communication; existence is defined by an ability to remain in communication not only with others as a prerequisite to any participation in the social process but also with oneself as a source of genuine feelings for and appreciations of the environment. Plato said that the soul converses with itself, suggesting, perhaps, that the individual is involved in a continuous discourse with himself or herself and is beyond verbalization or other overt symbolic acts. In short, both *Gesellschaftskommunikation* and *Gemeinschaftskommunikation,* although distinct and useful designations of types of social communication, are insufficient for describing communication as an existential condition of the individual.

Karl Jaspers (1948, 338) called this level *Daseinskommunikation,* indicating the importance of communication for recognizing *Existenz.* In describing the difficulties of reaching this stage of existential communication, Jaspers said,

> The struggle involved is that of an individual for *Existenz*—at once that of the other and of the self. While at the level of empirical existence any weapon at all is acceptable, the use of cunning and deception is unavoidable, and the opponent is to be treated as an enemy on all fours with the entirely alien physical nature that resists all our efforts, the struggle for *Existenz* is infinitely different. It involves complete openness, unqualified renunciation of the uses of power and advantage, and concerns the other's self-realization as fully as one's own. In this struggle, both dare to dispense with concealment, to be completely themselves, and to submit to probing questions. (cited in Wallraff, 1970, 135)

Here the concept of *Daseinskommunikation* surpasses the state of *Gemeinschaftskommunikation,* which denies absolute satisfaction through a realization of one's limitations in every communication and creates a

sense of shortcoming that Jaspers (1970, 51) called the "origin of the breakthrough to *Existenz.*" Pointing beyond the boundaries of mutuality of interests and *Verständnis,* Jaspers maintained that "For man communication is a decisive source only in the absence of the final and unquestioned security provided by selfless objectivities: by the authority of state and church, by an objective metaphysics, a life-order accepted as morally compelling, and an ontological grasp of being as such" (cited in Wallraff, 1970, 135–136).

The importance of communication at this level is a decisive source of self-realization for the individual and presents a direct way of understanding the existential self that has been acknowledged by a number of other existentialist philosophers, including Martin Heidegger and Jean-Paul Sartre; Søren Kierkegaard also gave considerable thought to the problem of communication in lectures prepared in 1847 but never delivered. Heidegger, for instance, viewed communication as an ontological problem that could be fully understood only within the framework of *Dasein* and the study of Being in particular as a basic and irreducible concept (1956, 397). This view of communication suggests not only that an intimate relationship exists between *Dasein* and communication but also that the study of the total individual is the sine qua non of understanding any aspect of human communication.

Western philosophers since Aristotle have viewed the individual as being in the world, as conscious of the environment and capable of relating objectively to the *Umwelt.* The impossibility of such detachment (or posture) of objectivity, however, has been demonstrated by Heidegger, who believed *Dasein* and the world merge; since they cannot exist independent of each other, Being-in-the-world becomes an a priori mode of *Dasein* (1962, 78). Consequently, an individual can become himself or herself only through familiarity with the world, or differently expressed, Being is always Being-in-the-world. Included in this conceptualization is the notion of shared experience, or in Heidegger's (1962, 149) terms, the world of *Dasein* is a with-world (*Mitwelt*) and Being-with means Being-with-others (*Mitdasein*).

This premise is essential for better understanding the existential condition of individuals and their relationship to others and to the world around. First, the world inclusiveness of *Dasein* gives new meaning to discussing an individual's isolation and alienation from society and stresses the use of empathic skills in communication. If one accepts Being-with-others as a basic structure of an individual's self in the sense of "I-myself-with-others," problems of empathy and understanding of others become part of Being; that is, embedded in the irreducible with-structure of the individual is an understanding of others and the world, according to Heidegger (1953, 108). Second, the premise also reflects on the concepts of individual free-

dom and responsibility and, therefore, on responsible communication. Individuals cannot escape from being responsible for the actions (or words) of others if they choose to exist in this world because of the with-worldishness of the concept. And if individuals exist fully conscious of their world-relatedness and aware of the consequences of their communicative behavior, they may begin to grasp the meaning of their own existence.

As was recognized very early in Western philosophical traditions, the interpretation of objects and events in an individual's environment—including relationships with others—is based on language and, more specifically, on talk and hearing. But the basis of human communication lies in the discourse of Being, which is needed to translate the silent words of Being into human words. According to Heidegger (1947, 45), thinking brings the unvocalized words of Being into language, and language becomes the house of Being. This phrase implies the standing of an individual in the world, and as Vincent Vycinas (1961, 87) suggested, it does not stress the subordination of Being to the individual, since the individual is "applied by Being for the establishing of a house of Being—for establishing the language."

Hearing in the Heideggerian sense must be considered the existential openness of *Dasein*—individuals hear and understand others because they are in the same world. One hears because one understands. According to Heidegger (1956, 30), the German poet Hölderlin expressed the same thought when he said the individual is a conversation. And Irmgard Bock (1966, 87–88) suggested that only in and through language does the individual possess anything.

Discourse and hearing in these specific meanings are elements of authentic communication. They reveal glimpses of the authentic existence of individuals—a central idea of contemporary existentialist thought that has gained importance, since the far-reaching scientific and technological developments of this age have had profound effects on individuals and their desire for an authentic life. Egon Vietta (1960, 41) suggested that the "subjective man of today does not know of his original position within the world, but creates a picture of the world in his mind and confronts it. He is not in unity with the world, but torn from it; an isolated, worldless I."

Human communication reflects this state of isolation amid the triumph of science and technology. In discussing this development Heidegger (1953, 35) maintained that some time ago "*Dasein* began to slide into a world without depth," and "all things were reduced to one level, resembling a blank mirror, in which nothing appears, nothing reflects."

Thus, at the level of the spoken word, communication in contemporary society never transcends its inauthentic form to become discourse and hearing in their authentic meanings. Instead, communication becomes chatter (*Gerede*) and curiosity (*Neugier*), which conceal or lie about the truth of *Dasein* and lead to the never-ending pursuit of ever-changing, sensational,

unheard-of, and therefore desirable facets of life. The results of these changes are evident in media performance (definitions of newsworthiness, truth, and objectivity and the processes of simplifying issues and recognizing social problems), the form and content of interpersonal communication (matter-of-fact appeals, communicational distance, concerns for control), and, generally, the social behavior of groups and individuals in contemporary society (various types of marginal cultures, including religious sects). The particular dangers of this situation lie in the ambiguity of everyday *Dasein* and an atmosphere in which chatter and curiosity reign supreme, suggesting clarity and knowledge about the world when, in effect, nothing is actually understood.

According to Heidegger, chatter, curiosity, and ambiguity are the major characteristics of the inauthentic level of Being, when *Dasein* is cut off from itself. They also describe the state of individuals in mass society, who are prepared to lead average and secure lives, are left without major decisions, and are undisturbed and even protected by society in return for specific services and functions predetermined by the managers of mass society. The everydayness of *Dasein* depends on what Heidegger (1962, 164–165) called the neutral and anonymous forces of "they" (*das Man*). Since "they" are responsible for everything, nobody feels a sense of responsibility, and it becomes impossible to be oneself.

The result is a distortion of the only meaningful way of existence, because it denies individuals a free choice within the limits of their own range of possibilities, their own finiteness. Instead, social status, economic position, and accomplishments in society are measured by what others are or have; an understanding of oneself no longer rests in oneself but can be reached only by measuring economic or social distances between others and oneself. The phenomenon of "keeping-up-with-the Joneses" has long since turned into "*being*-like-the-Joneses" with the increasing standardization of buying habits and forms of living that characterizes mass society. Freedom of choice in private or public matters has been reduced to a conceptual construct of one's attempt to be like the rest of society.

In a sense, one must share a concern expressed by Leibniz long ago about the consequences of a new communication technology during the seventeenth and early eighteenth centuries. Leibniz feared that with the invention of printing and the subsequent production of enormous quantities of books that were left unread, individuals would face a breakdown in the dissemination of knowledge that would result in barbarism. These conditions are also present in the contemporary media culture, in which intellectual and technical elites—whose words rise to the level of truth—constitute the social and political reality of society and influence individual perceptions of knowledge and needs; they also determine the quantity and quality of the information flow in advanced technological societies. Or, as Heideg-

ger (1962, 164) described the channeling of literary and intellectual inter-
ests, "we take pleasure and enjoy ouselves as they take pleasure, we read,
see and judge about literature and art as they see and judge . . . we find
shocking what they find shocking."

Jaspers (1970, 48) made a similar observation when he said that

> In man's naive, unquestioning existence in community his individual con-
> sciousness coincides with the general consciousness of his neighbors. He
> does not ask about his being; the very question would open the rift. How-
> ever sure the instincts that tell him how to pursue his advantage, the basis
> of his sense of existence is still the entirety of common bonds and common
> knowledge. The substance of communal life, the world and the thinking of
> the people he belongs to—these are not other things subject to inquiry and
> proof and confronting a particular individual self-awareness. In naive exis-
> tence I do what everyone else does, I believe what everyone else believes, I
> think as everyone else thinks. Opinions, goals, fears, and joys are imper-
> ceptibly transferred from person to person because of an original, unques-
> tioning identification of all.

Thus, in the everyday Being-in-the-world, it is no longer the individual
who is there but the anonymous "they." Individuals yield to the pressures
of mediocrity and the processes of leveling that dominate their existence.
Seduced by words and pictures, they accept a pragmatic definition of com-
munication; nearly blind and deaf, they may never sense the lack of com-
munication and may continue without the experience of *Daseinskommu-
nikation,* which alone would allow them to fathom the depths of their
existence and the meaning of life. Only within the context of communica-
tion as a basic human phenomenon capable of transcending its social and
political levels of significance and acquiring a more central meaning in the
making of one's world can questions of ethics and responsibility be raised;
only within this context can they be answered.

The functions of the media are closely tied to the problems of
Gesellschaftskommunikation and reflect the importance society has at-
tached to the progress of science and technology. Specifically, the media are
driven by the forces of technology; they produce waste, a by-product of this
age that is beginning to cause enormous social and political problems, and
they mirror the state of the technoculture. Technical improvements to and
innovations of the media have led to substantial changes in their economic
and corporate structures; they have led to extensive cooperation and coor-
dination of media efforts and resulted in mergers and monopoly holdings
of multimedia property. The media represent the state of technology per se
while they suffer from the side effects of their own involvement in techno-
logical developments.

Another outgrowth of the media's function is their self-imposed duty to reflect the inauthenticity of Being. Content is selected and prepared to perpetuate and stimulate the chatter and curiosity of modernity; since the media contribute to the ambiguity of everyday communication, they make it difficult, if not impossible, for the individual to understand the workings of the social, political, and economic environments and to transcend the state of mediocrity the media have declared desirable. Leadership in attempts to transcend this level of communication is difficult to find among commercial media. Marginal media, on the other hand, may have discovered a mode of communication that is genuine and that reflects authenticity. In particular, off-beat publications tend to regard the meaning of life as something that can be measured in itself without regard for power, influence, and the success of others; they look at things as they are, not as they relate to a specific world or to the goals of society. This type of medium features the "unnewsworthy" news, the uneventful event, and provides a glimpse at the workings of *Gemeinschaftskommunikation;* it also disturbs, causes anxiety, and raises uneasiness, since it tries to confront audiences with the emptiness of their lives and the mediocrity of everyday existence.

What is suggested here is a search for a more meaningful description of alternative media and their functions in contemporary society in which meaningful choices will not delay or affect the progress of communication technologies and the growth of commercial media but will help individuals become aware of differences and discover their own modes of authentic communication.

The media are also searching for complete control over their cultural and economic environments, including audiences. The exertion of financial and political power to establish larger and more efficient communication enterprises, for instance, relates to the organization and control of audiences—brought about originally by technologies that helped introduce mass circulation newspapers to millions of people who, up to that time, had neither the time nor the financial and educational resources to read newspapers regularly. The appeal to a mass market was based on anonymity and objectivity, which became part of a magic formula for successful press organizations at the dawn of mass society.

These factors, although time-honored, are still important considerations for contemporary media. Audiences are per definition part of mass communication and therefore remain a prime area of interest for media management, which will afford them the treatment they expect. Audiences will undoubtedly conform in their expectations of media content and mode of presentation, and only at this level will media management measure their participation and react to them. Present media are refining and redesigning methods of controlling their audiences; much of their success will depend

on the speed and efficiency with which society will yield to their exploitation of the social and cultural environments.

From an existential viewpoint it can be said that individuals are at a stage of inauthenticity that is reflected in their communicative behavior. Their condition is the condition of a time that has placed tremendous value on the advancements of science and technology that are preparing the individual to accept an average life and collectivism as a modus vivendi. The media personify this age and reflect the individual's state of technological development. Their functions also respond to a need to preserve and intensify the level of inauthentic communication and the effect of mediocrity on an individual's existence and to gain absolute control over their technical and economic environments, including their audiences. The dilemma, as emphasized in the operation of the media, is that technologies cannot solve basic human problems. Furthermore, even a highly complex media system—with its legal, philosophical, social, and economic baggage and the impressive volume and intensity of its messages—cannot conceal the inauthenticity of social life. It is doubtful under these circumstances that the media will aid individuals in their search for an authentic existence. Whereas the media remain a significant institution in everyday life, they confine the individual to the ambiguous world of chatter and curiosity and cannot lead to a better understanding of the self.

4

The Decline of Authenticity: Modernity, Communication, and Critical Theory

The question of authenticity remains one of the major issues underlying the critique of contemporary social thought. It is found at various levels of social analysis, ranging from current hermeneutical projects of investigating the relationship between language use and the revelation of being through the authentic function of discourse; the search for individual identity, power, and personal security in the comfort of the community; and an encounter with traditional values to the disclosure of the reign of inauthenticity and the process of alienation. Indeed, C. Wright Mills (1959, 190) suggested several decades ago that the "advent of the alienated man and all the themes which lie behind his advent now affect the whole of our serious intellectual life and cause our immediate intellectual malaise."

The discussion of authenticity has moved through a postwar rediscovery of the potential of critical discourse within Western Marxism as a source of personal emancipation and the rise of liberal democratic practices in Western Europe, which were accompanied by an Americanization of the cultural and political spheres of everyday life. Mixed in ideological clashes were pronouncements of a more fundamental nature that signaled the end of capitalism, ideology, and modernism. Thus, the negation of the autonomy of culture has been accompanied by debates over the end of ideology and the consequences of a totalitarian system in which the destruction of modernism has resulted in the loss of the unique and the reduction of culture to an exercise in social control. It reflects a postmodern strategy of contesting the grounds of culture, or what Habermas (1983) called a reactionary antimodernist attack on progressive modernity.

The emergence of postmodernist explanations of the world that focus on the alleged loss of both the subject and history and on the consequences of late capitalism, with its oppressive consumer culture, provides the contemporary context for the presentation of a search for the authentic as a political and historical agenda of the threatened, manipulated, and repressed. The marginal individual and existence (and artistic creation) on the fringes of society are traditional intellectual and cultural themes that also accompany and characterize the rise of postmodernism; they are the launching ideas for an insightful critique of the contemporary conditions of society. In fact, in his defense of modernism, Marshall Berman (1988, 33) observed that the "mystique of post-modernism . . . strives to cultivate ignorance of modern history and culture, and speaks as if all human feeling, expressiveness, play, sexuality and community have only just been invented—by the post-modernists—and were unknown, even inconceivable, before last week."

Communication and the symbolic environment constitute the terrain of a critique of bourgeois modernity. They also play a major role in the emancipatory project; in fact, they *are* the conditions under which individuals struggle to "read" the text, to make sense of the cultural context and participate in the celebration of their own subjectivity. Doing so remains a struggle, however, over representations within the reigning discourse of ideology. Specifically the subject, and, implicitly, the issue of authenticity in postmodernist writings, surface, at least indirectly, with renewed questions about communication as cultural practice and the importance of the subject as a participant not only in a process of reading but also in the production of texts and images. The primacy of expression in reconstituting the specter of power and emancipation in the face of social, economic, and political calamities is an attempt to outline the possibilities for practical success under the existing conditions of society. Thus, a postmodern theory of communication, located in the border regions of high culture and mass culture and of individuality and massivity, focuses on the issue of representation and its historical and political dimensions.

According to Ian Chambers (1986, 216), "The debate over modernism/post-modernism is ultimately the sign . . . of a debate over the changed politics of knowledge, authority and power in the present world." This view acknowledges the hegemonic struggle over definitions (and positions) of modernism that succeed in mapping the terrain of a historical struggle involving a critique of bourgeois existence. Postmodernist arguments rely on the discontinuity of experience; they are an attack on modernist arguments in light of significant breaks in the social, political, and economic conditions of contemporary societies, but they are also a continuation of the modernist problematic—including the search for the authentic among the social and political debris of twentieth-century culture caused by

the fragmentation of the subject. Or, as Berman (1988, 345) sensed, "the perpetual disintegration and renewal, trouble and anguish, ambiguity and contradiction: to be part of a universe in which all that is solid melts into air."

In his critique of postmodernism, Alex Callinicos (1990, 145) suggested that "the funeral rites conducted by contemporary *Kulturkritik* for the autonomous, rational individual of modernity verge often on the apocalyptic," and he proposed that the "social theorist à la mode should be Baudrillard." Such an apocalyptic vision of the world is in part the result of the discovery of "mass" communication by literary criticism—that is, the production and dissemination of culture through ordinary, everyday technologies of information. It introduces troubling questions about form and standards and results in the production and reproduction of typologies of mass and high culture—without resolving the social and economic issues related to the institutionalization of meaning making through the media and public opinion. The vision is also a result of the failure of a critique of contemporary reality, grounded in the relation of the individual to the social and political conditions of existence, not only to explain but to create actual changes leading to human emancipation.

Postmodernism is the passionate voice of disillusionment, which has moved the struggle of the individual forward onto the plains of consumerism and participation in the persistent challenge of informed decisionmaking. The postmodern subject is perpetually engaged in concession, compromise, and determinations related to making sense of existing in the social and economic structure in which the media assist in the conduct of a commodity culture. It is a renewed quest for reality, with questions of belonging—spiritually or otherwise—and of the possibility of the authentic under the prevailing conditions of a lived ideology.

But postmodernism is also the intellectual context for a struggle over defining the world of "mass" culture, which has become the terrain of experience, reflection, and affirmation of being in the twentieth century. As such, it is the extension of an ongoing critique of modernism, or a "persistence of modernity," according to Albrecht Wellmer (1991), who sees postmodernism as a search for the description and definition of change. Similarly, when Callinicos (1990, 170–171) suggests that "the discourse of postmodernism is best seen as the product of a socially mobile intelligentsia in a climate dominated by the retreat of the Western labor movement and the 'overconsumptionist' dynamic of capitalism in the Reagan-Thatcher era," he is describing the lost battles of the past. Consequently, he feels "the term 'postmodern' would seem to be a floating signifier by means of which the intelligentsia has sought to articulate its political disillusionment and its aspiration to a consumption-oriented lifestyle" (1990, 170–171).

Finally, the issues of modernism and postmodernism are joined in the search for authenticity; the loss of the subject and its rediscovery in the sphere of mass culture, contaminated by the power of ideology and the structures of language and communication—which resist attempts to overcome the spectacle of mass culture—offer little hope for recovering the authenticity of the self in the sense of the humanist tradition but instead offer an illusion, a fractured mirror image that distorts, decenters, and reveals the possibilities of estrangement. It is at this point that Douglas Kellner's analysis of identity in a "postmodern image culture" provides a clue. He suggests (1992, 174) that "identity continues to be the problem it was throughout modernity, though it has been problematized anew in the contemporary orgy of commodification, fragmentation, image production, and societal, political, and cultural transformation that is the work of contemporary capitalism."

This chapter addresses the notion of authenticity as a problem of modernity, which surfaced particularly in the reaction of Critical Theory to an ideology of authenticity that has its philosophical grounding in existentialism and the work of Martin Heidegger, as well as in the intellectual reaction to Freudian analysis as it became a major influence on social theory in the 1920s. The chapter focuses on the centrality of communication in an analysis of authenticity and alienation and proposes that the idea of authentic communication, together with notions of the emerging subject, constitutes the basis for an extended social critique.

The definition of authenticity emerges from philosophical considerations of the modern individual and the problems of understanding the meaning and value of existence and coexistence in a world of powerful and competing interests. At the center remains the question of what it is to be a human being as a concrete way of entering into the world. According to Heidegger, individualization—or making one's existence one's own, separated from others, instead of surrendering to those powers or interests that manage everyday life—is the key to authenticity. Communication as an ontological problem appears for Heidegger (1947, 45) in connection with the discussion of Being-in-the-world (*Dasein*) and the necessity of looking at the world as one shared with others (*Mitwelt*). In these circumstances of being-with-others, problems of empathy and understanding become part of an individual's Being, whereas language as the house of Being provides the elements of discourse, which is the basis of human relationships.

The presence of authentic discourse, for instance, cannot be assumed, however, since the expression of truth as a result of the relationship of *Dasein* and Being posits the absence of the social, economic, and political conditions that promote conformity. Indeed, the problem of the subjective individual in the grasp of modern life is the deterioration of *Dasein;* it is the problem of superficiality, when language becomes idle talk (*Gerede*) and re-

sults in an existential ambiguity clothed in the certainties of chatter or curiosity.

It is reasonable to suggest that the media play a significant part in the promotion and legitimation of what Heidegger (1962, 164–165) calls the "they," reflecting the decadence of mass society, stimulating and perpetuating the art of chatter, and reproducing the inauthenticity of Being. In fact, the dilemma of the media is that the progress of communication technologies cannot solve basic human problems but tends to solidify the ambiguity of chatter and curiosity and, therefore, of media-controlled forms of social and political authority, which leads to further alienation of the individual (Hardt, 1972; see also chapter 3).

At the same time, a call for authentic discourse, that is, for the pursuit of a personal search for truth, remains but a lofty goal in the face of declining intellectual engagement and increasing cultural and political constraints. Furthermore, the potential of disillusionment works to cooperate with other forces to promote falsehood. As Karl Jaspers (1965, 187–188) explains, "Truth [i.e., the so-called truth of the community] is that which our conventional social code accepts as effective in promoting the purposes of the group." As a result, he suggests, "Community members are obliged to 'lie' in accordance with fixed convention. To put it otherwise, they must be truthful by playing the group's game with the conventionally marked dice. To fail to pay in the coin of the realm is to tell forbidden lies, for, on this view, whatever transcends conventional truth is falsehood. To tell lies of this kind is to sacrifice the world of meanings upon which the endurance of the community rests."

But Jaspers provides an aesthetic position in his *Existenzphilosophie,* which relies on the potential freedom of the individual to reject the truth of others and to reach true communication through the struggle to achieve selfhood. According to Hannah Arendt (1957, 542), Jaspers's idea of limitless communication, "which at the same time signifies the faith in the comprehensibility of all truths *and* the good will to reveal and to listen as the primary condition for all human being-together, is one, if not the central idea of Jaspers' philosophy. The point is that here for the first time communication is not conceived as 'expressing' thoughts and therefore being secondary to thought itself."

Jaspers attacks the effects of mass society, the pervasive influence of technology and technological thought, and—not unlike Walter Lippmann's concerns during the 1920s—the overwhelming complexity of modern existence and the inability of the individual to cope intelligently within the system. His response to the conditions of the age is contained in the hope that individuals will relentlessly strengthen the reality of *Existenz* through communication to disclose the possibilities of the self and to discover and confirm their authenticity. Such an undertaking is grounded in the belief in

freedom of choice, even in the face of historical circumstances that help to determine the human condition. It is also based on the notion of education as a source of political power and involves the need to accommodate a political system as a source of opportunities for achieving *Existenz*. Lippmann (1961, 155), on the other hand, places his trust in the authority of science and its ability to inspire cooperation in determining the nature of truth, since "the modern world can be civilized only by the effort of innumerable people who have a right to call science the discipline of democracy."

Such considerations of authenticity and issues of authentic communication emerge as social and ideological problems from the collective experience of the industrialization and urbanization of nineteenth-century Western societies and are stimulated, at least in Jaspers's case, by the rise of authoritarian ideas, like Nazism or Communism. They continue, however, to determine the response to the failures of contemporary cultures to address the increasing lack of a sense of self and the need for individual and collective freedoms to establish recognized domains of independent practice.

Underlying the discussion of authenticity, particularly in Heidegger's work, is not only an opposition to traditional epistemology but also an interest in the priority of the subject and a recognition of historical reality. Although this interest is shared particularly by Theodor Adorno and Critical Theory, existentialism becomes the focus of a critique of ideology especially, because it fails to produce a theory of action that acknowledges and involves the social and political realities of the historical moment. Thus, according to Trent Schroyer (1973, viii), Adorno seeks not only "to salvage the notion of subjectivity from the idealistic tendency of existentialism . . . but he also wants to show that this theory has become a mystification of the actual processes of domination."

The idea of authenticity implies relations with others and, therefore, suggests the need to deal with issues of domination and control, as well as egalitarian forms of social interaction. Adorno reacted to the attempts of German philosophy since the 1920s—specifically the existentialism of Heidegger, Jaspers, and others—by confronting contemporary problems of alienation in a critique of mass society that was based on sustaining the climate of an aura whose language accommodates and protects its users. It is a "jargon of authenticity," according to Adorno (1973, 6), that "overflows with the pretense of deep human emotion, (but) it is just as standardized as the world that it officially negates."

Adorno suggested that the jargon of authenticity fails to "express the relation between language and truth, in that it breaks the dialectic of language by making the intended object appear present by the idealization inherent in the word itself" (Schroyer, 1973, xiii). For Adorno, the danger of the jargon rests in its reception by individuals who continue to believe in

their own importance and the shared experience of an illusory reality through the power of communication. Citing Siegfried Kracauer's 1930 study of employees, Adorno (1973, 20) stated that

> The institutional and psychological superstructure . . . deluded the celluloid-collar proletariat, who were then threatened by the immediacy of losing their jobs. It deluded them into believing that they were something special. Through this delusion the superstructure made them toe the bourgeois line, while in the meantime, thanks to a lasting market boom, the superstructure has become the universal ideology of a society which mistakes itself for a unified middle class. They let themselves be confirmed in this attitude by a uniform mode of speech, which eagerly welcomes the jargon for purposes of collective narcissism.

For Adorno, the jargon of authenticity is aided by the development of communication technologies that provide a link between the individual and those historically specific others whose hegemonic interests result in the creation of a language that suits their particular goals. The jargon of authenticity "is ideology as language, without any consideration of specific content" (1973, 160). Consequently, communication between institutions representing the bureaucracies of commerce, politics, or religion and the individual is filled with assurances about the significance of buying into forms of participation without considering the real conditions of existence.

Herbert Marcuse (1964, 11) addressed the "absorption of ideology into reality" from a perspective of domination. He observed that

> the concept of alienation seems to become questionable when the individuals identify themselves with the existence which is imposed upon them and have in it their own development and satisfaction. This identification is not illusion but reality. However, the reality constitutes a more progressive stage of alienation. The latter has become entirely objective; the subject which is alienated is swallowed up by its alienated existence. There is only one dimension, and it is everywhere and in all forms.

Marcuse (1964, 23–24) analyzed advanced industrial societies, considering the consequences of advanced capitalism, the prospects of social change, and the effects of progress on the individual who is caught in the system of promises of a better life. Consequently, people

> Cannot imagine a qualitatively different universe of discourse and action, for the capacity to contain and manipulate subversive imagination and effort is an integral part of the given society. Those whose life is the hell of the Affluent Society are kept in line by the brutality which revives medieval and early modern practices. For the other, less underprivileged peo-

ple, society takes care of the need for liberation by satisfying the needs
which make servitude palatable and perhaps even unnoticeable, and it ac-
complishes this fact in the process of production itself.

Language, communication, and the use of media in the interest of sus-
taining and expressing the one-dimensional behavior of society play a sig-
nificant role not only in shaping a language of conformity but also in repro-
ducing an everyday environment in which political and commercial
interests are joined to dominate the discourse through assertion and desig-
nation.

The question of authenticity is caught up in the specter of a personal-
ized environment in which language and communication reflect a culture of
domination, assigned to express involvement or participation and status or
prestige in the course of individual recognition through group identifica-
tion. The issue of an authentic existence is raised not as a basic problem of
Dasein or *Existenz* in the contemporary world but as a question of a shared
experience in the everyday world of work and leisure through the creation
of a make-believe reality by media technologies, which serve to coordinate
the resulting involvement in terms of consumption-as-communication.

The critique of authenticity, then, involves the domination of lan-
guage as it appears in the columns of the press or in the presentations of
broadcasting organizations, which remain poised to strike against any so-
cial system of meaning under the guise of moral or political crusades, to
control alternative visions of society through assimilation or co-optation.
In this context, the acquisition of knowledge becomes a prerogative of the
media; it is a regime of the powerful whose ideas of knowing suggest a
form of "secular control—that is, a method of purposefully introducing
changes that will alter the direction of the course of events" (Dewey 1939,
100).

The sense of communication, which underlies the quest for an authen-
tic existence, is changed to include the presence of the media, reflecting the
institutional forces of society and resulting in the disappearance of the pri-
vate realm. Communication is no longer communion, as John Dewey
(1971, 169) would have us believe some years ago, but rather the participa-
tion in the fulfillment of economic and political expectations and practical
goals through strategies of public discourse based on a lifelong process of
socialization by media institutions. The reproduction of society through the
rise of science and technology has become an ideology of progress; it results
in the mystification of the process of liberation and continues to impede the
search for individual freedom, because it fails to overcome its own confine-
ment to the level of public communication where it serves to manipulate
and control without surrendering its authority to the real conditions of so-
cial communication.

Erich Fromm (1955, 102) offered an apt description of individuals in a capitalistic society in which they see themselves as part of a larger effort to define the meaning of their existence. Their private lives repeat the monotonous pace of work; indeed, "they read the same newspaper, they listen to the radio, they see the movies, the same for those on the top and for those at the bottom of the ladder, for the intelligent and the stupid, for the educated and the uneducated. Produce, consume, enjoy together, in step, without asking questions. That is the rhythm of their lives." His arguments reflect the conflict between human nature and society and the consequences of an industrialized society, which needs individuals who "cooperate smoothly in large groups; who want to consume more and more, and whose tastes are standardized and can be easily influenced and anticipated."

The problem of alienation not only emerges as a major threat to the experience of authenticity but develops as a process of estrangement that has become characteristic of industrial societies in which individuals remain out of touch with themselves. This process affects attitudes toward work and consumption and results in a leveling of differences in the acquisition of goods and the communication of feelings and ideas. According to Fromm (1955, 124), the individual "'consumes' ball games, moving pictures, newspapers and magazines, books, lectures, natural scenery, social gatherings, in the same alienated and abstractified way in which he consumes the commodities he has bought."

An individual's desire to exchange influences the understanding and practice of communication, becomes synonymous with notions of work, use, and employment, and loses its original dimension of sharing or participation, which contains a private or individualistic aspect. Expressed differently, in the experience of industrialized societies there is no meaning in work except in its outcome, wages, or money. Consequently, there is no meaning in the process of communication except as a profitable, expedient and immediate investment. For example, Catherine Belsey (1980, 43) observed that "as capitalism increasingly equates wealth with happiness . . . *interest* as intellectual curiosity or concern is gradually ceasing to seem distinct from *interest* as material or economic concern, so that *disinterested* (detached, having nothing to gain) is becoming synonymous with *uninterested* (bored)."

Alienated participation constitutes a reluctance, if not refusal, to join in the process of commercial and political communication and has led to a deepening crisis in society. Its most obvious example remains the political practice, that is, the election of candidates in an alienated society, in which the commodification of political choices reflects the practices of a consumer culture that expresses itself by responding to a large supply of a limited range of ideas.

Also underlying these developments are the felt need to conform and the suggestion that communication has turned overwhelmingly from the privacy of a shared conversation or the expression of individual thought to a ruthlessly public discourse initiated, reinforced, and manipulated by a false sense of participation, fair play, and even democracy, directing people in their attitudes and behavior toward others and society in particular. Thus, when it comes to relationships among individuals or even to the relationship with oneself, there is a strong, if not overwhelming, tendency to consider socioeconomic usefulness or market values instead of human qualities. Such considerations of selfhood are far removed from a "sense of self [which] stems from the experience of myself as the subject of *my* experiences, *my* thought, *my* feeling, *my* decision, *my* judgment, *my* action. It presupposes that my experience is my own, and not an alienated one. *Things* have no self and men who have become things can have no self" (Fromm, 1955, 130).

Under these conditions of alienated existence, the quest for an authentic life promises a desirable alternative for some. Yet since most individuals are unable to mobilize their productive and creative forces and search for external solutions instead, the question of communication carries particular importance.

More specifically, the question of an authentic life emerges from American social thought as a confirmation of the reigning democratic principles and the expression of the mutual interests and shared communities of values through which individuals would discover the self and be reinforced in their understanding of an authentic existence. Such theories emphasize the psychological nature of inauthenticity as a form of dissociation and the need to return to a genuine state of mind. George Herbert Mead (1967, 221), however, stressed the social process, the interaction with others in the development of the self and its reliance on the communal or societal environment. The result is a "civilized" society based on "a progressive social liberation of the individual self and his conduct" in which the individual's struggle is reflected in society's struggle and change. Under these circumstances, the potential of communication rests in the organization of an ideal community in which perfect communication will lead to a perfect democracy (Mead, 1967, 327).

Similarly, Marxism expresses the desire for the development of the individual through freedom in a world of increasing alienation; according to Marx, the individual is independent only "if he affirms his individuality as a total man in each of his relations to the world, seeing, hearing, smelling, tasting, feeling, thinking, willing, loving—in short, if he affirms and expresses all organs of his individuality" (cited in Fromm, 1955, 38). The conditions for the liberation of the individual, however, are provided by so-

cialism, which creates an environment of reconciliation and leads to the emergence of the rational and active individual.

Thus, notions of language, communication, and participation play a significant role in the construction of democratic realities, and the media of social and political communication in particular become the context and the rationale in the rise of a modern society guided by the idea of reproducibility. Mead (1967, 257), for instance, insists on the essential role of language and communication in the definition and the realization of the self and in the organizing process of community—including the media—which "report situations through which one can enter into the attitude and experience of other persons," whereas Marxist thought also treats language and communication as a social phenomenon arising from the need for social interaction. Thus, Gramsci treats culture as a unifying environment of individual modes of expression and as the basis for creating a "'cultural-social' unity through which a multiplicity of dispersed wills, with heterogeneous aims, are welded together with a single aim, on the basis of an equal and common conception of the world" (quoted in Forgacs, 1988, 348).

The problems of authenticity in an alienating society and the position of alienated individuals offer the context for Amitai Etzioni's (1968) detailed discussion of societal and political processes in an industrialized society. His predictions of an "active society" amid widespread debates about deplorable social conditions during the late 1960s raised hopes for the recovery of industrialized societies from the effects of alienation and inauthenticity. In describing current conditions Etzioni (1968, 646) observed, for instance, that

> inauthentic societies are less responsive than alienating ones in two ways: (a) There seem to be more limitations on the acquisition of valid societal knowledge and collective self-consciousness and, hence, on the mobilization of most members for political action; and (b) there seems to be a trend toward the increasing construction of the identity of the citizens around the rejection of some foreign power and the maintenance, in non-war years, of a semi-military mobilization of society which divides the members of one society from those of another.

Etzioni (1968, 620) differentiated between alienation and inauthenticity by suggesting that "it is the fate of the inauthentic man that what he knows does not fit what he feels, and what he affects is not what he knows or is committed to do. His world has come apart. The alienated man, in comparison, is likely to be excluded to a greater extent from all three societal sources of activation [e.g., to be conscious, committed, and hold a share of the societal power], laboring in someone else's vineyard, laboratory, or army" (Etzioni, 1968, 620). Thus, issues of authenticity and alien-

ation turn on the question of responsiveness; accordingly, "authenticity exists where responsiveness exists and is experienced as such," whereas the problem of alienation resides in exposure to the use of power and results in a type of response found in the conditions of modern industrialized societies.

Etzioni rejects, however, the negative or pessimistic view of society that underlies most discussions of authenticity and alienation in the Marxist tradition; instead, he offers an understanding of the relationship between the individual and society that is characterized by an emphasis on shared interests, and he provides solutions that are based on a "holistic education" and the "active experiences" of individuals, supported and reinforced by societal actions that strengthen cultural and political activities in contrast to habits of consumption. Etzioni believes in the power of social movements to initiate social change and in the need for an atmosphere of activation, mutually reinforced by personal and societal projects and based on the idea of sharing for the good of society. The result is an "active society" built on individual willingness to assume a public role in overcoming the inauthenticity of society.

This view, however, shares the false optimism of social critics whose response to issues of alienation and inauthenticity ignores the role of popular culture as a source of the co-optation and cultural determination of the individual. In fact, the destination of the individual in the symbolic space of social communication is shaped by the presence of the media.

The experience of authenticity as a personal reaction to contemporary issues concerning individual social and economic conditions has also been noted by a number of writers in discussing leisure. Karl Mannheim (1951, 269) insisted that leisure in industrialized societies "becomes increasingly the place for personality development and self-expression" of a democratic personality; more recently, Simon Frith (1983, 262) argued that it "has become the only setting for the (fleeting) experience of the self, for the exploration of one's own skills and capacities, for the development of creative relations with other people." Leisure is a form of temporarily retreating from the world, necessitated by real or imagined demands of the cultural environment on the individual to cooperate, participate, and help legitimize the system of power, which itself is used to complement the process of domination.

Underlying these discussions of the relationship between individuals and society, the consequences of industrialization, and the rise of class societies in which assertions of power determined the direction of progress are questions of instrumental reason, language, and communication. More specifically, concerns over the inauthenticity of the modern individual and the process of alienation are closely related to a crisis of culture; therefore, at least for Jürgen Habermas, they are beyond the problems of legitimation

and motivation and are related to issues of communicative behavior. Habermas recognized the centrality of communication in the definition of culture and produced a cultural perspective for communication studies in which the relationship of individual symbolic acts to the symbolic environment became the major focus of analysis. This was a significant departure from earlier considerations of culture and social structure that recognized the existence of subjective ideas or values (culture) vis-à-vis a world of objective phenomena.

The task of Critical Theory is to locate potential or existing failures in the process of social communication. Habermas began to raise the question of effective, that is, authentic, communication by describing four conditions of the domains of reality in which communication takes place.

The world of external nature consists of animate and inanimate objects that can be perceived and manipulated. The world of society refers to interpersonal relations, institutions, traditions, and cultural values that are treated either as external objects or as part of the observer's life environment but that are based on preexisting norms that determine the "rightness" of the communication. The world of internal nature refers to the subjectivity of the individual; it involves feelings and intentions, excludes others, and creates a personal sphere from which the individual can help to determine the effectiveness or truthfulness of the communication. Language includes the need for comprehensibility by adhering to principles of grammar, semantics, and syntax and involves the intentions of the speaker. Habermas (1979, 67) concluded that "for every successful communicative action there exists a threefold relation between the utterance and (a) 'the external world' as the totality of existing states of affairs, (b) 'our social world' as the totality of all normatively regulated interpersonal relations that count as legitimate in a given society, and (c) 'a particular inner world' (of the speaker) as the totality of his intentional experiences."

For Habermas (1979, 29) the prerequisites for a solution to practical issues are based on the assumption of communicative competence, that is, on "the ability of the speaker oriented to mutual understanding to embed a well-formed sentence in relations to reality." This means the development of communicative competence involves an atmosphere of shared knowledge, values, and trust and raises the question of authenticity in the context of the speech act. It creates an "ideal speech situation" (Habermas, 1970b) that insists on the equality of the potential participants in the discourse in terms of expressing their ideas and feelings, and prohibits privileged positions of enforcing or changing norms.

The contemporary condition of society is marked by the widespread existence of systematically distorted communication (Habermas, 1970a), caused by the overwhelming presence of science and technology (as ideologies) and a failure to question the facts and values of such ideological incur-

sion. Consequently, the problem of systematically distorted communication becomes the central issue of any critique of society, since individuals, laboring under assumptions of competence—that is, understanding, trust, and shared values—fail to achieve consensus or real communication because of the conditioning of the type and level of participation.

For instance, Claus Mueller (1973) discussed forms of distorted communication that impede the political process and described the modern arena of inauthenticity that has risen with the distortion of private and public communication and contributes to the redefinition of social and political participation. This writing suggests that the question of authenticity is inextricably involved in the problem of pure, ideal, and competent communication. It remains immersed in the larger issues of contemporary culture and in the reign of economic and political interests and, as such, confronts the problem of human emancipation in a search for comprehensive change.

Mueller (1973, 20) presented conditions of undistorted communication when he wrote that it "implies that those engaging in communication would not be separated by attitudes which create social distance and that they would be sharing similar or mutually comprehensible expectations and values." He added that boundaries between private and public language would merge with the public articulation of individual and collective deprivations and aspirations. There would be a freedom from past and present definitions and interpretations of vested interests that bias communication and a flexibility of the rules of interpretation to allow for integration of new information. As a result, "Channels of communication of society at large—as represented by mass media and educational institutions—would be accessible to all members of the political community, and there would be a structural possibility for competing ideologies to gain significant public expression" (Mueller, 1973, 20).

This is an important assertion of social and political goals; it is also a clear statement of situations in which authentic communication will determine the conditions of the social structure.

Communication theory of the 1930s to 1960s concentrated on the description and analysis of communication and media, guided mainly by liberal-pluralist principles and the tradition of American sociology. More often than not, the results were reformulated progressive notions about individuals and their communication environments—recalling the spirit of community, however, without challenging the ideological basis of the social and political system, which has occupied and manipulated the concept of community to create a false sense of equality and participation (Hardt, 1992).

Instead, communication research provides an analysis of social problems, suggesting changes within the existing social structure. Conse-

quently, questions of authenticity have become questions of authority, which continue to inform the literature of communication within the established realms of the social structure; that is, issues of personal and collective power and participation remain confined to the articulation of preferences and the choice of styles or forms of communication of the marketplace rather than those of the individual. Thus, communication effects studies of the 1930s and the cultural media analyses of the 1990s, although dominating communication research, have done little to discourage the political and economic process of replacing active participation in the social structure with consumption of media presentations. The authority of those who determine the agenda of media production is the authority of commodity production. It continues to encourage participation in the American way of life through exposure to the spectacle of diversified media fare, including a topical range of social and political problems that become a dramatic backdrop for the aspirations of a majority of people with no direct involvement in their struggle for survival. Therefore, the appeal to participation is an appeal to consumption of products or ideologies, and it exhausts itself in the relentless quest for commercial and political success. The appeal involves the use of the individual as an object in television, photography, film, or print media to create opportunities for control through the familiar. Gilles Deleuze and Felix Guattari (1987) called this the era of the production and reproduction of faces, which become important symbols of identification in the commercial and political consumer culture and a preoccupation of those engaged in creating public images. They are also a sign of how the intimate and the familiar are used to fabricate an atmosphere of trust and to encourage identification with the reigning ideology.

Communication theory is steeped in a philosophy of individualism that has accompanied the rise of a liberal-pluralist theory of society, including the media and communication, in which individualism is reconstituted in content matter that dwells on the individual experience or the image of the individual. The independence of the individual from the totality is an illusion, however, to be replaced by an understanding of the self as being in a relationship with others and by an insistence on the complementarity of such concepts as individual and society, including the location of the individual in the space and time of society and its effect on shaping individual consciousness. Yet, the realization of the individual depends on the existence of a humane society; until such time, "for the totally internalized individual, reality becomes appearance and appearance becomes reality. In asserting his existence, which is isolated and dependent on society, and indeed only conditionally tolerated, as absolute, the individual makes himself into an absolute cliché ... [while society] is developing by alienating and fragmenting this individual" (Frankfurt Institute, 1972, 48).

Individuals, treated as concrete, separate entities in the exercise of communication research following in the tradition of a positivistic sociology, merge into series of predictions with the arrival of public opinion polls and survey research. They seemingly surrender to the task of a social science that caters to a need for identity by explaining individuals in terms of their desire for conformity. This phenomenon is the result of an enlightenment project that originated in the Chicago School tradition and is based on confidence in the power of public opinion and the moral value of scientific practice. Since then, there has been a continuing intrusion into the private sphere, not in the sense of strengthening notions of social life by stressing the importance of communal expressions but rather in terms of replacing the private with the conditioning of mass society, therefore rendering the individual incapable of developing separately and, ultimately, denying the expression of a social life.

Hannah Arendt (1958, 54) has called this the mass phenomenon of loneliness and suggests that "the reason for this extremity is that mass society not only destroys the public realm but the private as well, deprives men not only of their place in the world but of their private home."

But the consciousness of such deprivation is lost or buried among society's claims to satisfy the needs of the individual, including the desire for identity and protection. Those claims embrace the notion of the individual as a welcome participant in the consumer society and reinforce a myth that is supported by political and economic communication. The resulting sense of being or personal involvement produces and reproduces commitment and, ultimately, preserves the status quo by building on the need to conform. Fromm (1955, 64) suggested that "people are willing to risk their lives, to give up their love, to surrender their freedom, to sacrifice their own thoughts, for the sake of being one of the herd, of conforming, and thus of acquiring a sense of identity, even though it is an illusory one."

This sense, however, is characteristic of the alienated individual, the inauthentic being, whose salvation is the comfort of the "herd," which becomes the source for individual solutions. It provides a context for the successful operation of the media, through which the alienated individual will find a place in society; indeed, the media become essential in the determination of the individual and, therefore, provide an important function in the organization and control of individuals and their relationship to social, political, and economic institutions. The media reproduce individuals as representations of a collective life that form the seeds of a collective memory. The media are an aspect of what Max Horkheimer and Theodor Adorno (1972) called the culture industry, which reduces the intellectual capabilities of individuals and exposes them to the power of social processes beyond their control. The resulting lack of symbolic space discourages the development of critical thought and denies the emergence of individuality; it

also leads to the individual misconstruing "the world, on which he is dependent down to his innermost being, mistaking it for his own" (Frankfurt Institute, 1972, 48).

The context for such developments is provided by the media, whose increasing technological finesse helps to shape the way in which individuals approach each other. It may be useful to recall that the work of Innis and McLuhan insisted on the significance of the relationship between types or forms of media technology and social interaction. More recently, John B. Thompson (1990, 238) argued that the "private lives of individuals can be turned into public events by being publicized through the mass media; and the public events can be experienced in private settings," indicating that "the nature of what is public and what is private, and the demarcation between these domains, are transformed in certain ways by the development of mass communication, and this in turn has implications for the ways in which political power, at the level of state institutions, is acquired, exercised and sustained in modern societies." Thompson's statement not only suggests the central role of the media in any modern theory of culture through their involvement in the process of society but also assigns the power of "demarcation" to societal institutions, including the media.

Recently, doubts about the effectiveness of the current system of media domination—that is, the degree to which individuals have become victims of social and economic powers through integration into the social structure and the extent to which they are incapable of reflecting about their own condition and acting on their own critical thinking—have led to a celebratory affirmation of individual power and determination. This view is grounded in the belief that involvement in social communication is based on individual decisions that may or may not support the intent of dominant social and political forces. Starting with Stuart Hall's (1980) theoretical notion of the potential for distinctively different treatments of preferred codes, individuals participate in the process of media communication by constructing sets of meaning from different (dominant-hegemonic, negotiated, and oppositional) perspectives, articulating a range of cultural and ideological positions vis-à-vis institutional desires for effectiveness and full correspondence.

The problem with the empowerment argument is that it finds satisfaction in the discovery of individual resistance to (or compliance with) the dominant social structure, including the media system, without questioning the historical-social situation from which this process emerged or dealing with more inclusive ideological concerns regarding the relation of the individual to society, the limits of personal growth, and the possibilities for real change. The result is a celebration of the individual as a significant concept in a theory of a democratic society, which may be based on recognizing the status of inauthentic action—that is, the masking of impotence or inability

through dominant or conformist behavior—rather than on the possibility of expressed authenticity.

The development of an aura of authenticity may well rest on conditions that encourage and result in the active participation of individuals in the organization and management of their own lives: control over the workplace in terms of involvement in the decisionmaking processes of labor and industry and the determination of their own destinies within their respective communities. Such control is based on knowledge, accessibility of sources of information, and education; it also assumes freedom from economic conditions, including the threat of unemployment, homelessness, and starvation. These developments involve the revival of political participation in an attempt to break through the stages of alienated existence and the inauthenticity of being in the world, which are continually reinforced by advertising and media communication. Fromm (1955, 295) observed that the individual consumer of commercial and political messages exists in a world that is hardly comprehensible.

> While he reads his newspaper regularly, the whole world is so alienated from him that nothing makes real sense or carries real meaning. He reads of billions of dollars spent, of millions of people being killed; figures, abstractions, which are in no way interpreted in a concrete, meaningful picture of the world. The science fiction he reads is little different from the science news. Everything is unreal, unlimited, impersonal. Facts are so many lists of memory items, like puzzles in a game, not elements on which his life and that of his children depends.

It reflects the loss of control over how the world—and the larger community, for that matter—is relayed to the individual, as well as the struggle for existence. The claim of the media to reflect the lives of their respective communities of audiences is realized in their service to specific social, political, or economic interests—for example, the boosterism of the local press and the unabashed patriotism of the national media, which supports a particular view of power and domination. Consequently, the general interest of the public is, in effect, the interest of those who claim to operate in the public interest without significant opposition, reflecting the inauthenticity of a system that prevails by using action to camouflage its own inadequacies in responding to the real needs of society.

At the same time, it is the task of civil society and the goal of a strategy of liberation to change the conditions of the individual as an object of the social process, because the transformation to an active subject is based on the idea that ultimately, conditions of the alienated individual can be overcome through efforts that relate to activities of the individual, as well as of society. They entail the creation of a nonalienated environment to increase the chances for the emergence of free individuals and rely on reclaiming

language and the realization of a symbolic environment in which participation becomes a mode of existence and leads to democratic practices.

The recovery of authenticity should begin with an understanding of the historical tension between the individual and the state, between the working class and the dominant forces in society. Here the emphasis must be on discovering and elaborating on issues related to how individuals cope with the conditions of domination and oppression, the process that has shaped society, and the various movements toward emancipation rather than on what specific societal developments have done to the individual.

An analysis of the path of modern culture also involves a study of the media and their effects in shaping and reinforcing definitions of social relations; this includes questions of intent, ranging from the power of commercial interests to the potential of social interests, issues of social action, and political struggle within the historical reality of the relationship between individuals and media institutions. Such an analysis focuses on sources of action and deals with the nature of institutions and their specific roles in the process of social communication, but most important, it discloses the goals of the dominant institutions by revealing the intentions of those who control the content, volume, and direction of media communication. Likewise, the study of communication and media as social use, including the interpretation of content and the strategies of response, reveals individual intent and provides clues about the positioning of individuals in social communication and vis-à-vis sources of political and economic power. An explanation of inauthentic communication in society rests on understanding the relationship of these spheres of social communication. At the same time, such explanation contributes to defining the potential conditions for emancipation, that is, the liberation of the individual and the possibility of an authentic existence characterized by the real nature of the self and the quality of participation in the world through communication.

More than two decades ago Raymond Williams (1975, 151) hoped for "an educated and participatory democracy [and] the recovery of effective communication in complex urban and industrial societies," with little success. Perhaps such hopes can be revitalized by turning to the role of art in the process of liberation.

According to the cultural analysis of Horkheimer and Adorno (1972), the autonomy of art, particularly during the eighteenth century, was a result of the artistic freedom from the dominant structures of the marketplace. Consequently, artistic expression reflected on the contradictions and dangers in society and provided a measure of qualitative differences, if not alternative choices, in the assessment of societal activities. More recently, however, the industrialization of society has resulted in the assimilation of art and artists into the dominant system where they maintain and strengthen hegemonic rule. The culture industry is the expression of the

commodification of art and a logic of commodity production and exchange. Indeed, according to Horkheimer and Adorno (1972, 125), "The development of the culture industry has led to the predominance of the effect, the obvious touch, and the technical detail over the work itself—which once expressed an idea, but was liquidated together with the idea." Thus, the culture industry becomes responsible for dealing with consumer needs and feeds society with an authoritative agenda of market-driven entertainment, subsuming art as an exchange value and committing itself to the manufacture of distraction.

Others—in particular Leo Lowenthal, Bertolt Brecht, and Walter Benjamin—however, have assigned a more emancipatory role to the potential of art as creative expression. According to Lowenthal (1987, 124), the technical conditions for the production of art have a revolutionary potential, thus, "art is the message of resistance, of the socially unredeemed. Art is in fact a great reservoir of creative protest against social misery; it allows the prospect of social happiness to shine dimly through." His analytical studies of literature provide an understanding of the role of the artist-writer and the significance of literary contributions not only in terms of their historical relevance but also as evidence of the social and psychological conditions of the individual and the struggle for survival in an alienated world. They also locate the site of imagination and with it the source of power to liberate the individual from suppression by a mass culture. Indeed, by separating art from the function of popular culture, Lowenthal (1989, 15) reminded his readers that "art teaches and mass culture is learned; therefore a sociological analysis of art must be cautious, supplementary, and selective, whereas a sociological analysis of mass culture must be all-inclusive, for its products are nothing more than the phenomena and symptoms of the process of the individual's self-resignation in a wholly administered society."

Lowenthal's approach to art is reminiscent of Brecht's development of the epic theater, which constitutes an attempt to confront society with the problematic of the human condition, placing the rational individual as a social being in the center of a narrative that stimulates and calls for action and participation. For Brecht (1974, 363), "Epic theatre is chiefly interested in the attitudes which people adopt towards one another, wherever they are socio-historically significant (typical)," which stresses the didactic nature of theatrical experiences and suggests that theater and the arts in general must recognize opportunities for observation and critique and contribute to social progress. Brecht pleads (1974, 368) for "a type of theatre which not only releases feelings, insights and impulses possible within the particular historical field of human relations in which the action takes place, but employs and encourages those thoughts and feelings which help transform the field itself."

Brecht's challenge to the traditional, Aristotelean performance reflects his concern over the narcoticizing function of art through illusions. By freeing the individual from illusions and the passivity of the assigned role of an audience, he revolutionized the sphere of social communication; his subsequent exploration of media technologies (like film and radio) led to theorizing about participation, particularly in his theory of radio, which exhibits elements of a democratic theory of communication. Brecht saw the potential of radio as a social system of communication, with full participation by its audiences, rather than as a distribution point. He advocated the formation of radio against a tradition of broadcasting that made no difference, and he (1967, 130) insisted on the recovery of the significant in the face of the inconsequential as a reigning attitude.

> We have a literature without consequences, which not only attempts to be without effects, but which tries hard to neutralize its readers by depicting things and conditions without their effects. We have institutions of learning, which timidly attempt to provide an education, which has no consequences and is the consequence of nothing. All of our ideology-forming institutions see their main task in keeping ideology from having an impact, according to an idea about culture which suggests that the formation of culture has been completed and needs no continuing creative effort.

Walter Benjamin (1969a, 154) reflected on Brecht's considerations of art and modern society, including the epic theater by suggesting that it aims to overcome the "abyss" of traditional theater by turning to a stage that "no longer rises from an unfathomable depth; it has become a dais. The didactic play and the epic theater are attempts to sit down on a dais." His discussion of art and aesthetics is based on Marx, whose insights into the consequences of commodity production—that is, the concealment of social relations—resulted in an understanding of bourgeois social relations as a personification of things and a materialization of individuals; the existing difference between appearance and concealed reality provides a basis for the analysis of capitalist societies and plays a significant role in the critique of culture. Benjamin offers creative possibilities for recovering the authentic individual and contributing to the dealienation of social relations. His proposals reach from the use of techniques of mechanical reproduction in the process of politicizing art and, therefore, activating defenses against the aestheticizing of social problems to the reorganization or functional transformation (*Umfunktionierung*) of the media of social communication to serve the purposes of a progressive society.

Benjamin's review of technical innovations in capitalist societies (1969b, 224) reveals the potential of reproducibility for the liberation of the individual when, "for the first time in world history, mechanical reproduction emancipates the work of art from its parasitical dependence on rit-

ual. To an even greater degree the work of art reproduced becomes the work of art designed for reproducibility. . . . Instead of being based on ritual, it begins to be based on another practice—politics." Benjamin reveals the consequences of technological advancement and its impact on aesthetic production and suggests its potential for the creative and politically conscious individual. According to Benjamin (1969b, 220–221), art becomes an instrument of communication through a process of reproduction that enables "the original to meet the beholder halfway, be it in the form of a photograph or a phonograph record. The cathedral leaves its locale to be received in the studio of a lover of art; the choral production, performed in an auditorium or in the open air, resounds in the drawing room." In another context, he described the possibility of a media system that could assimilate its audience by eradicating the differences between producers-journalists and consumers-audiences.

Reviewing the Soviet press of the time, Benjamin (1986, 225) observed that "the reader is at all times ready to become a writer, that is, a describer, but also a prescriber. As an expert—even if not on a subject but only on the post he occupies—he gains access to authorship. Work itself has its turn to speak. And the account it gives of itself is a part of the competence needed to perform it." It is important to remember the significance of Benjamin's contribution to the interpretation of art as it relates to its historically determined nature and its emergence as a new form of communication. His disclosure of the effects of technology on the internal structure of art, the destruction of the "aura," prepared the ground for accommodating the experience of collective rather than individual reception and suggested a conceptual change that affected not only the understanding of art, but also the sense of participation in the process of communication.

If for no other reason, the works of Benjamin, Lowenthal, and others provide a powerful rationale for the consideration of creative practices in the debate over issues of communication, the media, and society—especially as their aesthetic and psychological dimensions help to explain the historical circumstances of social relations. Art discloses the material and ideological foundations of society; it is a manifestation of human creativity and a mode of expression that lends visibility to the inner world. But it can also be the site of critical observation and analysis of the social conditions of society and, ultimately, a powerful means of participating in the emancipatory struggle of the individual. Questions of authenticity remain linked to issues of communication, which, in turn, are related to the problem of creative freedom to contradict the reality of the established order. The development of technological means of production and distribution for speech in all of its forms provides a historical explanation of emancipatory practices, but it is also a reminder that it is employed by dominant political

and economic forces to aestheticize their execution of power while denying individuals the conditions for an authentic life.

Finally, the experience of authenticity as a problematic of modernity challenges contemporary postmodernist thought. The intervention of art, with its revolutionary potential to provide emancipatory strength to explanations, new insights, and understandings of the limits of a commodity culture, also offers the potential of disclosure through the process of reflexivity as shared practice.

5

Communication and Economic Thought: Cultural Imagination in German and American Scholarship

The field of communication studies in the United States rests on a philosophy of society that emerged with the rise of the social sciences and became identified with specific theoretical and methodological perspectives that distinguished and characterized academic disciplines as they established themselves toward the end of the nineteenth century.

This chapter focuses on the contribution of economic thought to the understanding of communication and the media in American society. As such, it constitutes an exploratory analysis of an academic tradition rooted in European economic theories and their encounter with specific practical problems of social and economic growth in the United States. These problems, subsequently, spawned the development of a sociological approach to the study of modern society.

As an attempt to locate the idea of communication as a theoretical concept in the academic and intellectual milieu of an American culture, this inquiry is limited to the decades around the turn of the twentieth century—a major epoch in the U.S. social and economic history but also an important period for the advancement of social and economic theories of society. Industrialization, urbanization, and the impact of technology on transportation and information not only created visions of progress based on unlimited material resources and divine guidance; they also raised serious doubts about the perpetuation of models of society that ignored the complexity of social and economic conditions. It was a time of intellectual rebellion, a "revolt against formalism," as Morton White (1973, 43) has called it, that united social scientists in efforts to seek an understanding of their environ-

ment through a historical-cultural approach. White observed, "All of them insist upon coming to grips with *life, experience, process, growth, context, function.*" It was also a time when American scholarship in the social sciences, confronted with the consequences of modernization, emerged with an interpretation of progress that reflected the insights of historical scholarship in Germany.

The roots of economic thought in the United States, however, are English; they were used to apply theoretical propositions to the specific conditions of the American economy. The need to come to terms with the development of the new nation was far greater than the desire to contribute a uniquely American theory to a body of theoretical propositions that already existed in England, France, and Germany. Richard T. Ely (1938, 121) remarks about these activities of the academy: "Throughout the first half of the nineteenth century our forebears were, generally speaking, too much engaged in the stupendous task of 'subduing a continent' to reflect deeply on their activities."

Thus, topics like tariffs, state's rights, and banking represented economic political issues that needed explanations and solutions. Given their immediacy and the political climate of the day, these questions of political economy appealed to intellectuals and others who shared a burning interest in their country's social and political affairs. According to Frank A. Fetter (1943, 60), "In political economy they were all self-trained amateurs, who as it were, happened to wander into the field." Among them were journalists and ministers, whose treatment of the topics was frequently nationalistic in outlook and religious in tone.

The Weltanschauung of these early American economists was shaped by a mechanistic interpretation of the social and physical environment and an atomistic vision of the individual destined to act in accordance with the divine order. As Arthur L. Perry (1866, 1) suggested in a popular text of the time,

> Political economy is the science of exchanges, or, what is exactly equivalent, the science of value. To unfold this science in an orderly manner will require an analysis of those principles of human nature out of which exchanges spring; an examination of the providential arrangements, physical and social, by which it appears that exchanges were designed by God for the welfare of man; an inquiry into those laws and usages devised by men to facilitate or impede exchanges.

Such views—or versions of them—persisted throughout much of the nineteenth century, together with the suggestion that the economic system was static and could be reduced to a system of relations that could be discovered in a body of general principles or laws with universal applicability.

Here was the creation of a world in which the functioning of the economy represented a closed system conforming to the requirements of a static equilibrium. Although the nineteenth century was marked by a general development of individualism, that is, by the extension of political rights to a larger number of people, it was also a period in which the state—and business—began to interfere in the name of protecting or extending those rights. The idea of *laissez faire et laissez passer*—which originally belonged to the sphere of commerce—contained a hedonistic bias and referred to the type of "economic man" whose fate depended on the survival of the state.

The growing dissatisfaction with theoretical premises of classical economic thought as applied in the United States was met by the "discovery" of the individual and society as central to the conceptualization of political economy, which coincided roughly with the return of a generation of American scholars from academic training at European universities, specifically in Germany. Jürgen Herbst (1965, 8) recounted, "Soon after 1870 American students of the liberal arts and the social sciences began going to Germany in large numbers. . . . As the nation became industrialized, there was a need for specialists, scholars, and teachers trained in economics and statistics, and in allied areas of the social sciences and humanities." Among a group of American students of political economy (which included Henry C. Adams, Richard T. Ely, Edmund J. James, Roland Falkner, Joseph F. Johnson, Henry R. Seager, Frank A. Fetter, and Samuel M. Lindsay) was Simon N. Patten (1924, 53), who described the central idea of the historical approach encountered by these scholars: "A new standpoint from which to view social affairs was introduced by the German economists. They saw that society, and not the individual, was the center of economic activity; and that productive power depends more largely upon the organization of society than upon the material environment and not with nature."

Specifically, Patten referred to the teachings of the leading members of the historical school of political economy—Wilhelm Roscher (1817–1894), Bruno Hildebrand (1812–1878), Karl Knies (1821–1898) and a generation later, Gustav von Schmoller (1838–1917), among others. These scholars believed economic theory must be built on a historical foundation, that economics should be studied through an examination of the processes of culture, and that an understanding of civilization would ultimately lead to an understanding of the economic system. Roscher (1849, 182) admitted that "for us history therefore is not a means, but the object of our investigations." His approach suggested a belief in the idea of change and stressed the importance of "process" and "growth" as necessary conditions of an economic system.

Knies in particular influenced his American students. Ely, who came under his influence at that time, returned to teach a brand of Knies's economics: a historical, evolutionary economics with an emphasis on social re-

form. Ely maintained that economic laws are the product of an affluent environment and its effects on the underprivileged and the poor. Under his leadership, the American Economic Association was formed in 1885. Earlier, Ely (1884, 64) had written that "this younger political economy no longer permits the science to be used as a tool in the hands of the greedy and the avaricious for keeping down and oppressing the laboring classes." In addition, he (1938, 154) and some of his younger colleagues felt that "a new world was coming into existence, and if this world was to be a better world, we knew that we must have a new economics to go along with it."

The work of Knies reflects this perspective and confirms the centrality of communication in a theory of society. He was a student of the economics of transportation and telegraphy who placed communication and the press within a general framework of historical inquiry into the economic life of society, since political economy could never be complete in itself. Recognizing that the individual and his or her material and intellectual world interact to produce specific economic results, Knies held that communication, as a process of breaking down the isolation of individuals, contributes to the formation and development of society.

Knies presented his arguments about the significance of communication from the perspective of an individual's continuing need to perfect his or her abilities as a social being; the process of modernizing individuals' social and political existence also required new forms of public communication. Knies (1857, 18) observes "that particularly the railroads themselves have promoted in many ways a faster means of transportation for the traffic in news. . . . The goal was reached with the invention of the electric telegraph [which] turned out to be suited for the transmission of news with a speed that surpassed by far the efficiency of a locomotive."

The maturation of the social organism, according to Knies, coincides with the improvement of the social communication system, which would develop occupational roles and institutional activities dedicated to the collection and dissemination of information. He acknowledged the interdependence of the economic and cultural spheres of society, particularly in his discussion of news communication, which he defined as a means of creating and satisfying needs. Accordingly, Knies (1857, 67) argued that if "news is a commodity, it must have a certain value, an intrinsic value. But the intrinsic value alone is not inherent in the object itself, it can only be there if and as long as a human need exists for the news." The press in particular could be described as a technology in support of the need to remain in communication, accomplished in modern times through the presentation of news. At the same time, the transmission of news had become a significant private business, and Knies, recognizing its potential as a manipulative and influential force in society, argued for the exercise of professional responsibility and intelligent editorial decisionmaking.

Knies paid considerable attention to advertising, which had become a major economic and political factor, in discussions of the role and function of the press in Germany. A similar situation existed in the United States, where social and economic concerns about advertising surfaced in the economic literature at the turn of the century (Craig, 1985). Knies described advertising messages not only in relation to the economic welfare of the press but also in the context of the production and consumption of industrial goods which influenced the supply for and demand of specific commodities, stimulating consumption by providing for speedy inexpensive dissemination of information. According to Knies (1857, 52), "The goods which we see before us in our thoughts stimulate us in a manner similar to those times when we walk through warehouses and stores unwilling to buy anything, but leaving the place finally with heavy shopping bags." As a historian, Knies (1857, 50) recognized the value of the advertisement as a reliable source of information about the cultural and economic conditions of society and as primary evidence of "the communication of acknowledged facts, because it appears naive and not conscious of its power as historical evidence while submitting to contemporary controls at the same time."

Finally, Knies reminded his readers of the relationship between the press and the political system. He believed regular news reporting on public affairs had resulted in a widespread interest in public information and made newspapers a contributory force in the creation of modern states. In addition, large countries with widely dispersed populations and political and cultural centers needed communication networks; newspapers became the means by which individuals could participate in the life process of society. Consequently, advanced cultures also feature a cohesive and developed system of news communication based on high literacy and sophisticated technology. Knies also acknowledged that the economic basis of social communication systems, like the commercial press, discriminated against participation by the illiterate and the poor in society. He declared (1857, 55) that "not only those who cannot write or read, but also those who cannot pay, e.g., the extremely poor as [for example] those who lack disposable goods for such [a] relatively superfluous service, are excluded from the communication of news."

In his treatment of communication and society, Knies referred to his contemporary, Albert Schäffle, whose theory of society was based on the process of social communication. Although he never presented a unified theory throughout his writings, Schäffle (1873, 6) stressed the fundamental importance of communication as a binding force in society. He argued that progress and "the development of cultural community . . . of moral community . . . depends upon the development of a symbolizing technique and upon the adequate supply of steadily improving symbolic goods, upon the development of all forms of communication for intellectual intercourse in-

volving knowledge, appreciations and decisions." He (1881, 353) insisted that "the presentation, the production of symbols and their acquisition belong to individuals." They represent the key to an organismic theory of society in which communication became a necessary condition for the development of civilization. Schäffle demonstrated the need for coordination and control of communication in the production processes of advanced societies by suggesting that only symbols and symbolic systems enable people to create complex social environments. He urged that economics should increase its understanding of symbolic goods, since the production of symbols and their reproduction for mass consumption were significant aspects of the rise of a civilization.

Understandably, the press plays a major role in Schäffle's discussion of the commercial and intellectual life of society. He warned that the social sciences would be mistaken to ignore or neglect the study of the public, the public sphere, public opinion, and the press, which form a homogeneous system. Schäffle (1881, 444) asked,

> What else is the much debated public sphere, but an intellectual openness for social knowledge, appreciation and decision mediated symbolically through words, writing, and print to the masses. . . . What else is the public but a social mass, open, receptive, and reactive to the organs of social and intellectual activity. . . . What else is public opinion, but the expression of opinion, value and disposition of a general or special public? And finally the press—is it not the real transmitter in the intellectual exchange between the leading organs of society and the public?

Although Schäffle concluded that the press of his day was corrupt, a fact he traced to the economic organization of German society, he still considered it the most pervasive instrument of social communication. Thus, freedom of the press continues to be of utmost importance. But it could be guaranteed only if the production and dissemination of ideas remained free and undisturbed by capitalist or bureaucratic efforts to organize communication for financial gain or political control. This issue was a problematic issue at any time, but Schäffle blamed the deterioration of a free and undisturbed environment for social communication *also* on the adverse conditions of the social sciences, which had been unable to provide necessary insights into the manipulation by governments, journalists, and publishers. Specifically, he insisted (1881, 466) that an effective social scientific enterprise "would have put an end to charlatanism of government, to the cult of verbosity in the press, to the deception of the audience, to the contamination of journalism with literary scum, and to the paid sophistry and rhetoric." He not only echoed Comte's hope that progress in the social sciences would end the corruption of the public spirit but projected sentiments

reflected in the early writings of American social scientists, notably sociologists, and kept alive as a firm belief in the positive contribution of social research to the welfare of society.

A third contributor to the cultural-historical bias of German scholarship is Karl Bücher (1847–1930), who addressed the issue of communication in the context of an economic theory of development. In his theory of stages, Bücher described the advancement of Western society in terms of the role and function of exchange. Thus, transportation and communication require increasing significance in economic systems based on the exchange of goods and services, culminating in conditions under which private interests are forced to cooperate in maintaining and advancing communication systems. Accordingly, in such systems the press functions as a carrier of information and should be studied by economists and others interested in the workings of modern society. Bücher's theory of the press reflects Schäffle's discussion; he, too, stressed the importance of the transportation function of the press and its role in linking various segments of society while advocating a historical analysis of culture and social institutions.

Bücher also emphasized the problems of journalism in industrial societies. He suggested that newspapers as cultural phenomena arise from political needs to unite groups in a society and to maintain social and economic relationships, as well as from shared social interest in knowledge about the external world. Newspapers are private enterprises with overriding commercial interests, however, in which advertising, as a "child of the capitalistic age" (1926, 61), supports the diversity, quality, and quantity of social communication. Although he recognized the dangers of subversion by economic interests, Bücher also realized the historical conditions under which public demands for news and information were merged with private pressures for access to potential customers through the pages of newspapers. Thus, editorial content, while serving public interests, made advertising space more attractive to private interests. Bücher admitted that publishers' profit motives were an undeniable reality in the operation of the press system.

This dilemma of the press had been recognized by several writers. Knies and Schäffle had identified the shortcomings of a mass circulation press that operates without effective controls to protect the interests of the people in a free and open flow of communication, reflecting Karl Marx's sentiment that the first freedom of the press is *not* to be a business. In addition, Bücher noted that during their history, commercial messages—starting with the beginning of any economic system—had undergone qualitative changes. Specifically, advertising messages had moved from constituting part of a personal relationship between producer and consumer in early capitalist economies to being separate entities, void of individual ties and

without the sense of responsibility that had characterized commercial communication in preindustrial times.

Bücher provided by far the most extensive discussion of the press among German economists. Influenced by Schäffle, he began to formulate the practical consequences of his theoretical position. Since the press as a cultural phenomenon, created by the social and political needs of society, is also an economic enterprise, he addressed the resulting effects upon editors and journalists. For instance, he discussed the potential for abuse by economic and political powers and favored separating the advertising and news functions of the press. As a political economist, Bücher never doubted the historical necessity for commercial communication as the result of economic developments that help to define a modern society; at the same time, he also argued that only a free and independent press could contribute to the well-being of society. His approach to these problems remained located within political economy, and throughout his career he rejected the idea of a separate, scientific discipline for the study of the press *(Zeitungswissenschaft)*. In fact, Rüdiger vom Bruch (1980) provided an extensive discussion of a prehistory of *Zeitungswissenschaft*.

The German tradition of dealing with the political and economic consequences of communication and the media in modern society was continued by others. Max Weber (1864–1920) and Ferdinand Tönnies (1855–1936) included the study of the press and public opinion in their examinations of society, and Werner Sombart (1863–1941) considered the development of news and advertising within the rise of capitalism, placing the merger of business and newspaper interests at the time of the rise of industrial capitalism (1922, 396–418).

The evolutionary concept of society with its own social dynamic, the emphasis on social forces, and the recognition that individuals may need the assistance and protection of the state in their encounters with the modern world are characteristics of the German historical school that also describe Patten's theoretical perspective. His commitment to a cultural-historical approach is based on an organismic view of society. Patten explained (1899, 1) that "the adjustment of an organism to its environment depends on the mechanism through which the mind acts. The ingoing nervous currents create the conscious ideas by which knowledge of the environment is acquired." Much of his work seeks explanations for the impact of an economy of abundance on the social and cultural environment and how such an environment had affected economic life.

Although Patten (1924, 273–274) was "imbued with the German view" and, as with many American scholars, thought "the last word on all subjects was in German," he was also strongly influenced by American pragmatism. He argued further that to "apply pragmatism to economic thought means to test historical epochs by the results that flow from them,"

advocating "a change from prophecy and deductive laws to facts and statistics." Indeed, he proclaimed (1924, 64) that "pragmatism, sociology, economics, and history are not distinct sciences, but merely different ways of looking at the same facts. . . . They all must accept consequences as the ultimate test of truth, and these consequences are measured in the same broad field of social endeavor." In the spirit of a social reformer, Patten (1924, 244) wanted the economists of his age to stand on "the firing line of civilization," turning out a product that was "clear, concise and impersonal." Indeed, he saw his "real affinity with the journalist, the magazine writer and the dramatist." This identification also meant that "no fact is valuable to the economist unless it is also valuable to the journalist who summarizes events, the editor who comments on them and the reformer who uses them [in the mood of a] new economist."

Patten developed his concepts of culture and cultural lag with which he described the conditions of American society under which large segments of the population were prevented from adapting to abundance. Speaking about the "surfeited and exploited," Patten drew a scenario in which those who had too little were isolated and ignored by those who lived in affluence. Communication became a major force, since it provides an atmosphere of cooperation and a context for understanding. This notion, although not directly expressed, appears in his definition of culture, which Patten described (1908, 77) as "the perfecting of intercourse with one's group." It includes the notion of change, suggesting that traditional values must be replaced by new ideals that should emerge from a culture based on cooperation and the fair use of America's resources.

Patten (1924, 325) traced the history of these conditions, explaining that "Evolution is thus from struggle to cooperation, from personal control to social control and from concrete rules to abstract principles. The growth of social control is from persons to words, from words to artistic expression and from art to religion." Although he does not directly suggest that social control would move from religion to public opinion during the last phase in the development of modern states, he stresses the power of public opinion within the range of economic theory. Patten argued (1924, 323) that "this blending of individuals in a multitude of associations keeps opinions mobile and makes thought plastic. Out of each group some element of public opinion comes which rises into a principle and thus gets validity which no argument can oppose." Social control rests on opinion. The development of thought rather than activity, however, renders the prediction of changes or forms of control that would follow specific structural changes in society very difficult.

The cultural milieu and the conditions under which people exist are determinants of media effects, according to Patten, who illustrated this idea with a specific example of press coverage and its reception in different cul-

tures. Patten observed (1899, 3) that the "newspapers of Europe, in describing the American massacres, used substantially the same facts and words, and thus created the same sensory impressions in all their readers. Yet the effect of these dispatches in the different countries differed widely, because the motor reactions created by the same news differed in the various countries; one nationality was indifferent, another merely grieved, while a third was angry and wished to interfere."

Patten's social concerns and the expressed need to decrease social and economic differences through communication and cooperation resulted in the development of economic rights that extended traditional political rights and were designed to protect individuals who were adjusting to the new American environment. His "bill of economic rights" included communication rights like "the right to publicity" and the "right to decision by public opinion." Other rights were the right to security, an open market, customary prices, a share in national prosperity, cooperation, wholesale standards, leisure, cleanliness, recreation, and the right of women to earn an income (1924, 330). These rights reflected Patten's priorities in the struggle for a "new civilization" with improved industrial relations and higher incomes, and they created new forms of social control by individuals who enjoyed freedom of thought and movement (1980, 178–188). He argued his case (1924, 333) for cooperation by appealing to both oppressor and oppressed, pleading that "from brute strength to majority rule is progress, but still more comes when minorities through compromise and toleration displace the need of majority coercion."

In this respect, Patten's work is reminiscent of Henry George (1829–1897), who also stressed the need for cooperation. George (1981, 21–22, 76) defined political economy as being "concerned with human action" and the rise of civilization as "the growth of this cooperation and the increase of knowledge thus obtained and garnered." It was George who campaigned as a journalist against the control of transportation and communication (the Associated Press) by private corporations, advocating nationalization for the public good. He dedicated his work to changing U.S. economic conditions, which had enriched few and impoverished many.

Patten's influence was widely acknowledged. It reached from Thorstein Veblen, who disagreed with Patten but appreciated the importance of his work, to Walter E. Weyl *(The New Democracy,* 1912), editor of the *New Republic.* He also influenced John A. Hobson, a British economist and social critic, whose *Imperialism: A Study* (1902) was "a powerful—and in some cases definitive—influence on Lenin, Hilferding, Kautsky, Luxemburg, Bakunin, and on virtually all later significant treatments of the subject," according to Philip Siegelman (1967, v). With his cultural perspective and his concerns for public welfare and economic and social reform, Patten accepted and supported the involvement of sociologists in the social change

movement; he could appreciate an exploration of society without the limitation of the field of economic thought, which had remained largely committed to issues of the production, distribution, and consumption of wealth.

In his criticism of economics, Veblen provided an explanation for the failure of the field to examine social problems in the United States. He charged (1900, 255) that economics had become a "taxonomic science"—that is, "the earlier, more archaic metaphysics of the science . . . becomes a metaphysics of normality, which asserts no extracausal constraints over events, but contents itself with establishing correlations, equivalencies, homologies and theories concerning the conditions of an economic equilibrium." As Lawrence Nabers suggested (1978, 78), Veblen concluded that no new policies emerged "toward business, the state, the position of individuals in the economy, or the apodictic certainty of progress." The result was a failure to participate in an evolutionary study of economic processes. Those engaged in a historical study of economic and cultural processes, like Patten and others, became identified with a group of social scientists—notably sociologists—who had embarked upon a critique of deductive methods and static analysis of society that marked economic thought around the turn of the century.

Patten was among nine social scientists whose 1905 meeting at Johns Hopkins University resulted in the establishment of the American Sociological Society. The others were Albion S. Small, Edward A. Ross, Thomas N. Carver, Franklin H. Giddings, Samuel M. Lindsay, William G. Sumner, C.W.A. Veditz, and Lester F. Ward; they had joined about fifty individuals at the December 27 meeting, according to the official report ("Organization," 1906). Lester F. Ward, who was elected president of the society had proclaimed a few years earlier (1902, 498) that sociology "concerns itself primarily with the question of the public utility of enterprises. Its standpoint is the good of society;" he suggested further that the "modern interest in sociology is chiefly due to the obvious sterility of political economy."

Ward influenced Small and Ross in particular, with his distinction between physical and human evolution and his development of a social theory that led to social reform; he advocated collectivism at a time of laissez faire individualism and a planned society when government interference had become commonplace. An enemy of biological sociology, he suggested (1892, 134–135) that "man and society are not . . . under the influence of the great dynamic laws that control the rest of the organic world. . . . The fundamental principle of biology is natural selection, that of sociology is artificial selection."

Patten, not unlike Ward, distinguished between biological and social evolution and argued that individuals had achieved progress through a sophisticated level of control over their environment and, subsequently, had

moved to a new stage of social progress: an economy of pleasure and a life of abundance. Although he never published in the *American Journal of Sociology*, Patten's interests coincided with those who identified the task of sociology with the search for plausible solutions to the mounting problems of an urban, industrialized nation. Among that group were Small (1854–1926) and Ross (1866–1951), who had written about the relationship between sociology and economics in the *Journal of Political Economy* (1895) and the *Quarterly Journal of Economics* (1899), respectively.

Their work reflects the concerns of a generation of American social scientists who had witnessed decisive social and economic changes in their environment. Their contributions, however, are informed not only by an encounter with the industrialization of the American continent but also by their understanding of the writings of major German social thinkers, including Knies and Schäffle. For instance, according to Small (1912, 206), Schäffle (and Spencer) advanced an idea of society as a plexus of personal reactions mediated through institutions or groups. One of these reaction-exchanges is the state but the state was no longer presumed to be, in the last analysis, of a radically different origin, office, or essence than any other group in the system. Such a theoretical perspective allows for social and economic change in society and provides a basis for an extensive contemporary critique of the social system.

A shared understanding of the importance of communication and the function of the press in society that transcends particular cultural and political differences was present between Germany and the United States in the linking of communication and political power. From the writings of Small and Ross, however, a pluralistic model of society emerged that offered an alternative to the respective potential excesses of individualism and socialism in laissez faire and Marxist doctrines. Indeed, the locus of political, social, and economic power was assigned to competing interests among groups, whereas socialization, cooperation, and balance described the processes that would lead to a democratic form of life.

In his major writings, Small reiterated Schäffle's organismic theory of society. Since Small considered communication a necessary condition for the development of society, it became central to his own theoretical work. Accordingly (Small and Vincent, 1894, 246), "The development of society depends upon a free, rapid, and accurate communication of physical impulses throughout the organism." Small and George Vincent developed a model of communication in *An Introduction to the Study of Society* (1894, 216) and argued that "every social communication is effected between individuals, and every individual is a part of many different channels in the social nervous system." Moreover, the press "is incorporated in nearly every division of the psycho-physical communicating apparatus, and is almost as general in its scope as the post office itself" (1894, 223).

Consequently, Small emphasized the systematic character of social communication processes and the pivotal position of the press as the collector and disseminator of information. Small and Vincent acknowledged the economic dependence of the press, its tastes, and its prejudices, as well as its relationship with the public. Such an assessment of the print media as powerful instruments of social communication implies their importance as objects of scientific study. And Small insisted that the search for social improvements in society must involve a critical investigation of the existing press system. He placed responsibility for the media system on those who participate in the communication process in society.

Ross also described communication as a necessary condition for the growth of society. He introduced (1938, 137) a comprehensive definition of communication that embraced "all symbols of experience together with the means by which they are swung across gulfs of space and time. It takes in facial expression, attitudes and gestures, tones of the voice, speech, writing, printing, the newspaper, telegraphs, telephones, radios, railways, automobiles, airplanes, and whatever else facilitates mental contacts."

Ross discussed specifically the economic and technological determinants of public communication systems and concentrated much of his scientific analysis—and personal observation—on the effects of modern media, including the movies. In his discussion of communication effects, particularly on children and juveniles, he anticipated valid concerns of contemporary media research. Since he recognized the dangers of an ahistorical existence of modern individuals, he warned that newspapers in particular may contribute to a loss of both tradition and a sense of history by exclusively treating contemporary events. Ross blamed capitalism, with its control and abuse of the press, for this condition. Not unlike Bücher, he identified the irreconcilable functions of the press as public servant and private salesperson and advocated their separation through the establishment of endowed or publicly owned newspapers to liberate the press from economic pressures. Ross was most interested in a search for a democratic system of communication in which access to truthful information, fairness, and a belief in the freedom of expression would lead to social justice and a democratic way of life.

Both Small and Ross published widely, and their contributions appeared regularly in the *American Journal of Sociology*, where issues involving communication, the media, and society received considerable attention during this period. Small edited the *American Journal of Sociology* from its beginning in 1895 until 1926. The early issues were filled with articles on methodology and social problems, because Small (1916, 726) saw the task of sociologists, at least in part, as rescuing reformers from the "benevolent amateurishness" that surrounded them by providing a methodological basis in facts. The press became a regular topic of articles as early as 1895

with "The Guidance of Public Opinion" by J. W. Jenks, a political econo-
mist (1895). The article is typical of many that would follow throughout
Small's editorship. It is critical of the press, which is defined by the profit
motives of its proprietors, since according to Jenks (1895, 168) a newspa-
per "independent in stating its views on public questions" could not exist
as long as the press relied on "circulation and advertising." Victor Yarros, a
self-proclaimed "independent radical" and later editor of the *Literary Di-
gest*, submitted three articles condemning commercialism and sensational-
ism and advocating the idea of endowed newspapers (1899, 1909, 1916,
respectively), whereas Francis Fenton launched a forerunner of the media
effects studies with his two-part article, "The Influence of Newspaper Pre-
sentations upon the Growth of Crime and Other Anti-Social Activity"
(1910, 342–371; 1911, 538–564).

Whereas American sociologists contribute to a critical examination of
urban America, economists became increasingly aware of their potential
role in guiding society. Particularly after World War I, some economists re-
garded the war as "a milestone of social change and therefore of social
thought" (Dorfman, 1949, 488). Their demands for a reconstruction of tra-
ditional economic doctrines, the application of psychology in economics,
and a consideration of the issues of social control, however, were met with
skepticism. As Joseph Dorfman found (1949, 494), "The relevance of their
theories to economic practice in peacetime was still questioned; the motive
behind this thinking still seemed suspect; and the value of their authority
remained equivocal." Nevertheless, the intellectual ties between American
sociologists and economists remained close and became most visible with
the emergence of institutional economics, a term widely used in the United
States in the 1920s and 1930s. Veblen, together with Wesley C. Mitchell
and John R. Commons, provided theoretical formulations and practical as-
sistance for the criticism of traditional economic theory, particularly "its
presumptions concerning human motivations and the universality of capi-
talist institutional factors" (Dorfman, 1949, 352).

With a growing interest in the regulatory and administrative roles of
government in trade practices, trade union developments, and public utili-
ties, economists began to scrutinize a variety of institutions, including
newspaper advertising and, later, broadcasting. These interests and con-
cerns were reflected over time in economic journals—particularly in the
Journal of Political Economy, the *American Economic Review,* and the
Quarterly Journal of Economics, where the range of articles included de-
bates on theoretical issues and studies of particular industries, notably
manufacturing, banking, and farming. Little was published about the press
during the early years of the twentieth century, perhaps an indication of the
influence of traditional economic thought on a range of academic concerns
and topical issues.

Although the commerical use of the press had been a topic for a number of years following the emergence of government regulations and advertising texts, it did not appear as an economic issue until 1901, when advertising was defined by Emily Fogg-Meade (1901, 218) as "a mode of education by which the knowledge of consumable goods is increased." She argued for the social good of advertising and claimed (1901, 236) it *"is* a force working toward social improvement. It is a means by which the tastes and habits of the masses are revolutionized, and novelty, variety, and harmony introduced. Advertising . . . from the standpoint of the consumer has a social justification." On the other hand, she agreed (1901, 242) that with the education of consumers and improvements in the information system of society, advertising could eventually be abolished. Although she recognized the value of education and information in modern society, she failed to specify the conditions under which the function of advertising ceased to be important. Fogg-Meade's presentation was followed ten years later by a contribution on the problem of postal deficits and advertising (Haney, 1911). At about the same time, the *Quarterly Journal of Economics* carried an article about the U.S. paper industry (Hess, 1911), its only contribution to an economic perspective on communication and the press in American society during this period. Equally sparse was coverage by the *American Economic Review,* which, except for a note about problems in the U.S. radio industry during the 1920s (Childs, 1924), made no major contribution to the idea of communication as an aspect of the cultural-historical debate among economists.

A critical appraisal of the role and function of advertising in the United States appeared in the 1925 issue of the *American Economic Review* following the annual meeting of the American Economics Association (Clark, 1925; Hotchkiss, 1925; Moriarty, 1925; Cherington, 1925). The appraisal reflects support for and criticism of advertising, emphasizing educational values while pointing to the abuses and failures of advertising practices. Most interesting, perhaps, was the notion—not previously expressed in economic theory—that information had an economic value and that advertising as *"information* about goods and services is in itself an economic utility"* (Hotchkiss, 1925, 18). The discussions concluded with a recognition of the power of communication, since there was concern that advertisers might be unaware of the consequences of their communication, which could produce discontent and unrest among the working-class population in particular; the argument was also made that the education of consumers should not necessarily be left to the advertising profession (Cherington, 1925, 41). In short, debates were over a discovery made almost a generation earlier by exponents of the cultural-historical tradition who had considered communication a necessary component of theory building and the key to an understanding of society.

A review of the periodical literature and the major treatises of early American economic thought, particularly between 1880 and 1910, reveals the separation of a cultural-historical orientation from the older, traditional discussion of economics. The inauguration of a sociological approach and the establishment of the American Sociological Society illustrate the movement within political economy to address contemporary issues in American society. Indeed, representatives of that position were among the foremost social critics of their time.

The context of culture was a significant feature of the sociological imagination and was prominent among political economists whose social and political concerns led to an analysis and criticism of contemporary society. Their theoretical standpoint reflected both European and American influences as pragmatism became a major force in American social philosophy and, in its challenge to the Cartesian tradition, focused on the idea of the social, specifically on the role of the community and communication.

Charles Peirce had proposed that "the real, then, is that, which sooner or later, information and reasoning would finally result in, and which is therefore independent of the vagaries of me and you. Thus, the very origin of the conception of reality shows that this conception essentially involves the notion of a community, without definite limits, and capable of a definite increase of knowledge" (quoted in Wiener, 1958, 69). Dewey, who had come increasingly under Peirce's influence, stressed the social component and claimed that "when communication occurs, all natural events are subject to reconsideration and revision; they are re-adapted to meet the requirements of conversation, whether it be public discourse or that preliminary discourse termed thinking" (1929, 138). The emphasis on community suggested, particularly to Dewey, a democratic way of life in which scientific inquiry is accessible and relevant to society. Indeed, he felt that "freedom of inquiry, toleration of diverse views, freedom of communication, the distribution of what is found out to every individual as the ultimate intellectual consumer, are involved in the democratic as in the scientific method" (1939, 102).

Thus, the intellectual perspective of the "new" social scientist had been shaped by the emergence of evolutionary theories in Europe, with their emphasis on process and change (Hegel, Marx, Darwin, Spencer), and by a dynamic vision of their own world in the making (Peirce, James, Dewey). That perspective resulted in the rejection of ideas that reduced individuals to scientific constructs in the guise of *homo economicus, homo sociologicus,* or psychological man. Instead, the social scientists' consideration of economic life in the United States became part of a much broader approach that stressed the active and dynamic nature of the social and cultural environments of individuals and their participation in society. Communication as a life process of society, and the press as an example of the transporta-

tion of knowledge and information over space and time, are important aspects of such cultural interpretations of society. They had been prominent features in the writings of German political economists and appeared in the works of their American students. The engagement of Patten, Small, Ross, and others, however, also reflected the ideas of a generation of social scientists who had witnessed the birth of the Industrial Age and felt committed to contribute to the betterment of society. The practical issues of communication and the media provided a specific context, whereas pragmatism offered the necessary tools for an inquiry into the cultural fabric of society. They lived in changing times, and their work was a direct response to the social and political realities of their age.

There is a difference, however. Whereas the German approach to the study of culture and society remained within the historical, speculative, and philosophically oriented realm of academic scholarship, the American versions became increasingly empirical, behavioristic, and scientistic in their considerations of the role of communication and the media.

At the same time, a transformation occurred from the discussion of democracy, freedom, and equality as important concepts in a utopian model of a pluralist society to its realization through an empirical description of its features in the social and political environments. Stuart Hall (1982, 61) talked about the "installation of pluralism as *the* model of modern industrial social order." The decades between the influence of European—notably German—scholarship on a developing social science tradition in the United States and the period when the work of Patten, Small, Ross, and others had stimulated the field sufficiently to engage in a search for an American response to the challenge of European social theories were a time when the idea of pluralism was "written into social science" (Hall, 1982, 61). The result was the type of communication research identified with Paul Lazarsfeld and the behavioral science approach that has dominated the field, particularly since the 1940s. Implicit in this perspective is a return to the individual as a measure of influence (and media effects) and to an unchallenged assumption of shared cultural and social values across American society. Finally, there was an emerging sense of the political role of social scientists as expert representatives of a variety of interests in society. Small, for instance, suggested that consensus in society should be reached by "scientists representing the largest possible variety of human interests" (1910, 242).

Since then, economists have reconfirmed the importance of communication in the study of society. The work of Canadian economist Harold A. Innis on the impact of communication on the economy—although rarely acknowledged by other economists—remains a significant contribution. Although Fritz Machlup (1984, 15–18) asserted that economists have a history of dealing with the question of knowledge and information, his review

of that literature is restricted to a few examples of subjective and uncertain knowledge without reference to economic thought around the turn of the century.

There is indeed a tradition that maintains that the importance of information, communication, and knowledge for economists and social scientists lies in their power to help to define and understand the structure and organization of society. That tradition blossomed with the emergence of a cultural approach to economics shaped by compassion for the working individual and the conviction that capitalism, despite its failures, offers an appropriate context for the growth of a "great society" (Wallas, 1914). Both the German academics and their American students sought to reach an accommodation between existing economic structures and political power; they offered explanations of social processes and solutions to the problems of modern capitalism within the boundaries of needs defined by established institutions. The Marxist challenge to German social thought in the 1930s (by members of the Frankfurt School) was foiled by the rise of National Socialism, resulting in the emigration of its critics. In the United States, traditional sociology rediscovered nature and (under the influence of Talcott Parsons) embraced structural functionalism, whereas communication research followed the route of atomistic positivism in its search for democratic practices.

A few decades ago, Norbert Wiener (1948, 161) observed that "in a society like ours . . . in which all natural and human resources are regarded as the absolute property of the first business man enterprising enough to exploit them, these secondary aspects of the means of communication tend to encroach further and further on the primary ones." Fifty years later, little has changed. The ownership of the means of communication remains with business and industry, economists explore the economics of information, and communication research observes the impact of the economic system on the media industry. In either case, there is too little understanding of the cultural milieu affecting the communicative competencies of individuals, the social and economic equality of groups, and the nature of participation in contemporary society. When social scientists turned from economics to sociology about one hundred years ago, they left an environment of stale theories for the challenges of social inquiry and the promise of finding useful answers to the economic and social problems of their societies. Today, the study of communication is rarely practiced in the spirit of reform and with compassion for the working individual—but when these conditions prevail, informed by a history of culture, they become a challenge to the imagination.

Part Two

Critical Applications

6

The Making of the Public Sphere: Class, Culture, and Media Practices

The idea of the public sphere has occupied communication research and media studies in the United States at least since the early work of Jürgen Habermas, which is represented by the publication of *The Structural Transformation of the Public Sphere* (issued in Germany in 1962 but not published in translation until 1989). That idea replaced older notions of the public and generated renewed interest in conceptualizations of public opinion that contributed to explanations of the political communication process; it is still attractive to reform-minded social scientists in pursuit of democratic ideals and media scholars in search of alternatives to a commercial system of public communication.

Past discussions of culture, the media, and society yielded a specific, class-conscious understanding of the public sphere that marginalized or excluded working-class interests. Thus, questions of participation in the bourgeois public sphere or about the historical conditions of a working-class public sphere, or about the ways in which both middle- and working-class experiences have contributed to the making of an American culture are rarely at issue. Rather, conceptualizations of the public sphere in American cultural and communication studies represent yet another example of a specific, middle-class perspective on the making of a theoretical framework. The observations in this chapter address the historical conditions of constructing the American public sphere as a middle-class project and suggest that the failure of communication studies to consider class as a historical condition of the American social structure has perpetuated and reinforced a dominant middle-class perception of the media, work, and relations between media and society that marginalizes working-class concerns and distorts the democratic vision of the public sphere.

The reception to Habermas's speculative notion of the public sphere grew into an intellectual cottage industry that produced a range of books and articles about the possibilities of a reconceptualized, modern public sphere (Calhoun, 1992; Fraser, 1989, 1990; Hohendahl, 1979; Peters, 1993). These works became the cornerstone of reformist writings on social relations in society and on the need for addressing the relationship between the media and society (among others, Curran, 1991a, 1991b; Dahlgren, 1987; Garnham, 1990; Golding and Murdock, 1991; Keane, 1991; Kellner, 1990; Lichtenberg, 1990; Peters and Cmiel, 1991). Many of these writings contain a new urgency based on the realization that the specter of political impotence, social marginalization, and increased alienation—with their roots in a loss of access to power and participation in public affairs—is somehow related to the functioning of communication and the role of the media in contemporary industrialized societies. Indeed, Habermas is celebrated as a potential source of explanation when it is argued that a "more catholic conception of (mass) communication, appreciative of its gloriously raucous as well as soberly informative qualities might make Habermas's theory of communication even more useful for theorists of the democratic role of the media" (Peters, 1993, 567).

Such theorists, however, also seem to submit without further discussion to the fact that Habermas addressed the rise of the public sphere in bourgeois society without acknowledging the presence of class conflicts or the possibility of an alternative working-class public sphere, which arose with the proliferation of organized labor, union activities, and the collective social life of the working class in the United States and elsewhere. In fact, the subtitle of his book (1989) suggests that the "Inquiry into a Category of Bourgeois Society" becomes the only category in subsequent discussions of the public sphere in which the identification of the bourgeois public sphere through institutional sources of public opinion, like the media, and the political realm in general purposefully restricts discussions about the public discourse of society.

On the other hand, it becomes appropriate in any extended discussion of communication in bourgeois society for the media to remain a legitimate concern in conceptualizations of the public sphere when ownership and control of media technologies by corporations continue to be guided by industrial interests. Applying the idea of the "public" to media processes or practices becomes problematic and challenges both the meaning of democracy and guarantees of a "public" discourse in the United States. For instance, Giles Gunn (1992, 216–217) suggested that "even when the term 'public' can overcome the onus of privilege and exclusion it sometimes acquires, it nevertheless always implies selectivity." Indeed, "Its monolithic nature is a myth and, like other mythic ideas, is highly susceptible to manipulation." Because it may interfere with middle-class interests, as is often

argued by media critics, the term does not seem to raise more fundamental questions of working-class participation.

Such an oversight seems to relate to the failure of many contemporary writings to locate their analytical insights about the nature of the public sphere and political realities within a concrete historical moment. The meaning and content of the public sphere rely on a specific social and cultural history of society particularly since the historical conditions of an enlightened European—especially German—*Bürgertum* and its experiences with independence and freedom during the eighteenth and nineteenth centuries were different from social and political developments in the United States, where production and economic growth evolved almost undisturbed by European traditions, like class consciousness and labor relations. For instance, in his preface to the American edition of *The Condition of the Working Class in England,* Friedrich Engels observed that "American public opinion [in 1885] was almost unanimous on this one point: that there was no working class, in the European sense of the word, in America; that consequently no class struggle between workmen and capitalists, such as tore European society to pieces, was possible in the American republic; and that, therefore, socialism was a thing of foreign importation, which could never take root in American soil" (cited in Feuer, 1989, 489).

Indeed, widespread discussions have taken place concerning class and class differences in the United States during the nineteenth century with the growing realization of social and economic differences in society; at the same time an understanding existed of the unique American situation in which ideas of upward mobility and cooperation between ownership and wage earners diluted the original European tradition of class distinctions. More fundamentally, no clear agreement had been reached over the meaning of class, according to Martin J. Burke (1995, 165), who concluded his study of "contested interpretations" of class and class relations with the observation that "when, where, how, and why Americans wrote and spoke about classes involved institutional and ideological exercises of cultural and political power," resulting in diversity and disagreement.

In fact, the fundamental difference between developments in the United States and those in Europe manifested itself in the shifting relationships between state and society, that is, between an increasing encroachment of the state on society and a growing disengagement of society from the state. These were American and European experiences, respectively, that would produce different conditions for public discourse and result in particular definitions of the public sphere. In addition, notions of community surfaced in American social and political theory and provided yet another, more specific relationship between private and public practices based on knowledge and communication. For instance, the work of John Dewey (1927) attempted to overcome problems of industrialization and urbanization

through a return to issues of communication and participation that inform the ideas and ideals of a Great Community. Consequently, distinct understandings of the role of individualism and personal choice, the intervention and privilege of industrial concerns, and subsequent definitions of participation helped to shape a different notion of the public sphere in American political practice. At the same time, these were pure reflections of American middle-class concerns, expressions of optimism, or of a utopian spirit that characterized progressive social thought earlier in the twentieth century. There was no room for an independent working-class culture, although it existed throughout that period of American history.

Thus, the present dilemma of conceptualizing an ideal public sphere is linked to an understanding of theoretical concepts like communication, participation, and democracy and to their origins in the cultural, political, and economic history of the United States. By exploring these specific historical conditions, questions about the American public sphere as a bourgeois construction of the contemporary cultural reality will emerge to challenge the conceptual premises of media studies.

In the field of media studies, ideas of access to the means of communication, which inform definitions of participation, and the rise of the media in their social and political functions, which describe practices in the public sphere, are based on comprehending the historical relationship between technology and democracy in particular. The United States holds the distinction of having invented, mastered, and propagated the merger between technological advancement and democratic practices long before other, particularly European, societies had fully grasped the meaning of that relationship during the 1920s. "Mass" communication and the impact of popular culture play a major role in the negotiation of the social and political definition of progress and its circulation in American society, whereas the European confrontation with the machine has also been articulated in the intellectual context of merging (oppositional) political goals and artistic expressions. Thus, considerations of media technologies also belong to the cultural sphere.

The American success with integrating technology into society became a model for Europeans as early as the 1920s, only to be interrupted by World War II. Radio, film, and the automobile in particular expanded the intellectual and physical horizons of individuals and liberated them from the tyranny of localism. This process was accompanied by the notion of "Americanism," which acknowledged the successful application of technology to the making of a modern version of democracy. It allowed for freedom of movement, speech, and beliefs within a social, economic, and political framework marked by the results of industrialization, which symbolized an auspicious shift of economic power. Thus, the success of Americanism and Fordism also indicated a historical epoch in which rela-

tions of production changed, based on "an inherent necessity to achieve organisation of a planned economy" that would replace the old vestiges of feudalism in Europe, according to Antonio Gramsci (1971, 279).

During the 1920s such observations were not only a typical consequence of the celebration of technological advancements; they were also observations about the process of industrialization and the rise of a commercial mentality that ultimately accounted for major changes in the appearance, structure, and experience of American society, including a growing working class. But the preoccupation with technological innovations and the celebration of industrialization also displaced the working-class concerns with control of the means of production. Instead, much was made of the potential liberation of working men and women and their mobility under improved economic conditions.

Thus, the evolution and confirmation of private interests energized the development of the press, and the subsequent emergence of new public media (e.g., film, radio, and television) has typically been identified with the commercial rather than the social or cultural realm of society, which remained a source of intellectual and critical thought about the allegiances and responsibilities of the media. Indeed, the press prospered as a private enterprise that had joined the marketplace and that operated, much as any other industrial concern, for profit and expansion. Most important, however, the industrialization of communication was a middle-class success that catered to middle-class aspirations, tastes, and material preferences and served as a model for subsequent developments of societal communication in the United States and elsewhere.

By the beginning of the twentieth century, the United States had moved ahead of its European competitors in steel and oil production, which, together with the automobile industry a few years later, became of central importance to the economy. The growth of cities, fueled by prospects of real prosperity and the potential of moving up into a middle-class existence, contributed the widespread optimism that anyone could make it in America. At that time, Americans opted for economic prosperity, and capitalism becomes the preferred context for the rapid and uncontrolled industrialization of society. Although a rising wave of social criticism articulated the consequences of the American dream, individuals did not argue with success, especially when industrial development created affluence and satisfied the dreams of millions of new and old immigrants; many members of the working class share the conservative ideals of a middle-class existence. Some joined the middle class, whereas others were still preoccupied with the dream after two or three generations of hard work and rising frustration.

This view of American mobility became the official ideology, which relied on economic and political power to bring about democratic solutions

to problems in relations among people. Stanley Aronowitz (1992, 25) observed that the "American popular, as well as sociological, imagination remains solidly infused with the idea that America is set off from all other societies, virtually, by the opportunities it affords for vertical mobility." Whereas one result of that idea has been the emergence of status as the popular and social scientific category of location, its economic and political consequences have also produced definitions of communication and participation that are closely tied to the dominance of the middle class.

During the nineteenth century, middle-classness became the essence of American society and has remained a formidable cultural territory, the root cause of anxiety among politicians and the permanent goal of each cycle of immigrants and otherwise disadvantaged and forgotten people. The potential of economic success and personal advancement and the promises of middle-class status became features of political and commercial crusades that penetrated religious groups, ethnic minorities, and urban and rural communities alike.

A remarkable crusade of commercial interests, guided by the desire for stability and security, characterized middle-class existence. Although the same middle class had recognized the power of revolutions, it was not to turn into a revolutionary class itself. Instead, it shared the values of commerce—that is, devotion to property, acquisition of wealth, and the maintenance of social status and mobility. Government policies supported these activities and generally protected the interests of capitalism, the "foster child of the special interests," according to Woodrow Wilson (1913, 57–58), who also identified "big manufacturers, the big masters of commerce, the heads of railroad corporations and of steamship corporations" as "masters of the government." Their success, however, was based not only on the political practices of the government, but also on American workers' positive predisposition toward capitalism.

Observations from abroad were particularly clear on issues related to the U.S. working-class experience, because commerce and industry could safely ignore the class consciousness of the working class as an obstacle to profits and economic expansion. Werner Sombart (1976, 20), a German political economist, observed in 1906 that "emotionally the American worker has a share of capitalism: I believe that he loves it. Anyway, he devotes his entire body and soul to it. If there is anywhere an America where the restless striving after profit, the complete fruition of the commercial drive and the passion for business are indigenous, it is in the worker, who wants to earn as much as his strength will allow, and to be as unrestrained as possible." Another German social theorist, Wilhelm H. Riehl (1990, 255), suggested in his 1861 work on civil society that theoretical considerations of working class existence were limited to the "Old World." He concluded that once "a proletarian arrives in the New World, where there is as yet no historic soci-

ety in the process of disintegration, he abandons all theoretical questions about this social existence and once more simply attempts to exist unreflectively—at least if he does not intend to go hungry." Such sentiments of the working class, however, contrasted with the total exploitation of the worker, who, according to Sombart (1976, 112), was "lacerated in the harness of capitalism or has to work himself so quickly to death as in America."

Upton Sinclair (1907, 252), a contemporary American observer, formulated his own assessment of the American middle class in terms of "an organized system of repression" and suggested that "in the world of ideas it has the political platform, the school, the college, the press, the church—and literature. The bourgeois controls these things precisely as he controls the labour of society, by his control of the purse-strings." These institutions produced a crusade that was meant to reinforce the ideas of the dominant class as universal ideas among people, who were engaged in their own drive for a better life, additional opportunities for personal growth, and middle-class prestige.

At the same time, however, the rise of modernism in the United States had created a generation of intellectuals and artists who offered creative alternatives to the authority of conventions by accepting alienation as a condition of existence on the margins of bourgeois society (Bradbury and McFarlane, 1976; Crunden, 1993). Yet, there was no lasting effect of such an elitist stance, which considered politics suspect and reality debatable. Instead, the press as a middle-class institution conquered the public arena and celebrated the authority of the fact; it responded to its own perception of the power of public opinion and collaborated in the boosterism of American values by reflecting middle-class beliefs and reinforcing a middle-class perspective on the world without significant critical opposition. Consequently, the interests of business penetrated the working-class consciousness with assertions about commerce and industry as genuine sources of personal prosperity and a good life. In any event, participation in consumption promised status, and commercial propaganda effectively dispersed potential resistance to consumerism as a way of life.

For instance, advertising in the form of colorful trade cards depicted the lifestyle of a middle class and celebrated technological progress as personal achievement. Sombart (1976, 112), who addressed the psychological influence on the worker to think that "he was not an enemy of the capitalist system but even a promoter of it," argued that inducements were provided by a system of financial rewards and personal acknowledgments for contributions to the improvement of industrial processes. Likewise, Gramsci (1971, 286) suggested later in the 1920s that the change to a "new type of man suited to a new type of work and productive process [is still] at the stage of psycho-physical adaptation to the new industrial structure, aimed for through high wages."

These observations also foreshadowed the potential self-destruction of the American working-class consciousness which negated itself by rejecting the conditions under which it was formed to embrace technology as an expression of progress—only to lose its identity and sense of place when work became an externalized function. Among the results of this process of transformation was a form of participation based entirely on individual contribution, if not on the sacrifice of knowledge and working skills to serve technological or industrial progress and industrial efficiency without the experience of work as personal involvement. Such participation was grounded in a historical situation in which, according to Gramsci (1971, 286), "American workers unions are, more than anything else, the corporate expression of the rights of qualified crafts and therefore the industrialists' attempts to curb them have a certain 'progressive' aspect." Consequently, there was neither empowerment nor control over the means of production. Instead, participation evolved into a social practice rooted in the ideas of capitalism which direct the material interests of workers along a path of economic and social inequality. Max Weber (1946, 280) once noted that although individual conduct is governed not by ideas but by material and ideal interests, "very frequently the 'world images' that have been created by 'ideas' have, like switchmen, determined the tracks along which action has been pushed by the dynamic interest." Indeed, that "dynamic interest" has continued to guide social and political thought, which remains preoccupied with the fate of the middle class as the ultimate fulfillment of the American promise. It has produced a social and cultural context for definitions of equity, fairness, and participation that now affect contemporary issues of democratization and, therefore, readings of the potential of a political public sphere without regard for the existence of the working class, which represents the concerns of race, ethnicity, and gender.

Since the late nineteenth century, when a climate of economic expansion, industrial growth, and personal entrepreneurship predominated in the United States, the interests of business and industry have prevailed over expressions of social consciousness and public welfare to dictate the content and direction of American civilization. The realm of culture, specifically the field of media practices, has contributed to the success of commercial interests through accommodation and compromise. In fact, "Industrial culture rests on the industrialization of culture," according to Norman Birnbaum (1969, 113), who also suggested that "a system of symbols, of consciousness, of sensibility, of preconscious and unconscious meanings, has been assimilated to the imperatives of machine production, market organization, and bureaucratic power."

For instance, in the United States industrialization has been accompanied by a surrender of political power, which changed into the hands of

business and is administered by politicians whose allegiance to progress and economic strength outweighs social considerations; few have contemplated the rules of capitalism, which reward economic success but respond to social concerns with paternalistic gestures. Thus, problems such as unemployment, welfare, and even poverty and illness have been recast in terms of personal shortcomings rather than societal problems by those entrenched in the traditional attitudes of a business community in which the strong survive and the weak are cast aside. Consequently, the idea that poverty is a sign of idleness or even a sin reflects a popular conservative notion that haunted nineteenth-century America and continued into the twentieth century, recently visible in media coverage of political reactions to social legislation—like social security and health care—despite advancements in social legislation and welfare. That idea reflects a deeply held belief in the American spirit, which replaced ideas of class and class consciousness with a doctrine of equal rights and equal opportunity.

The result has been a discernible blind spot in American public life, where the response to the need to assist others in the pursuit of employment, education, and good health has been reduced to a litany of the private goals and expectations of the dominant representations of the middle class, including personal qualifications. Progressivism recognized inequality yet has continued to operate within the political and economic system and has been content with recognizing and deploring aberration. There has been a growing reluctance, if not refusal, to share any burden or responsibility in the interest of the common good. In fact, the idea of the common good seems to hold up best in the context of national crises or emergencies, called on by political or spiritual leaders, when a way of life is threatened and authoritative assurances are sought to protect the social and economic status quo of the middle class. Under these circumstances, the public willingness to surrender rights and responsibilities to a central institution, such as the state or the church, increases in defense of the dominant class interests.

Despite declining political power, the middle class becomes the major target of and primary reference group for commerce and industry. Buying power and a potentially sizable market for consumer goods guarantee yet another form of participation in the affairs of modern society, this time through the shared experience of consumption. Marketing and advertising create and appeal to the need for self-confidence, physical well-being, and mobility in a consumer society, whereas politics offers a rationale for consumption as participation in the political process. Both appeal to feelings and imply that individual happiness and the well-being of the national economy are identical goals. Again, the notion of participation emerges in this context as an invitation to share in the values of a free-market ideology and to identify personal aspirations with the political goals of society.

The activities of the American popular press are located at the center of these developments, which involve the interests of a growing middle class at the expense of other concerns involving the working class, for instance. Since the press represents possibilities for enlightenment and continual education about society, including class relations and conflicts, its practices are significant historical markers in tracing the nature of the public sphere and its inclusiveness of social and cultural diversity. Thus, by the end of the nineteenth century the expansion of the newspaper business marked the conclusion of a major shift from a political press—with its peculiar, often personal agendas, party loyalty, and individual editorial leadership—to a market orientation that focuses on the commodification of news, supports the business interests of media owners, and reflects the structural changes of industrialization that had led to commercial consolidation.

The future of the twentieth-century press has been marked by a succession of newspaper mergers and closures and the rise of the "one-newspaper town" in the United States. A. J. Liebling (1975, 60) talked about the "end-of-a-newspaper story [that] has become one of the commonplaces of our time, and schools of journalism are probably giving courses in how to write one: the gloom-fraught city room, the typewriters hopelessly tapping out stories for the last edition, the members of the staff cleaning out their desks and wondering where the hell they are going to go." It was a significant change to a "new" journalism that, according to Michael Schudson (1992, 153), has become the "antithesis of association or community"; it has also narrowed the potential of the public sphere and strengthened a press of middle-class interests, less involved in the political discourse of the community of readers and more committed to profitability and economic survival. The neglect of the community at large at the expense of class differences, ethnic diversity, social conflict, and the potential for widespread participation in public discourse has created a press committed more to popularity than to accountability.

For instance, James Lemert (1984) explained that the contemporary commercial press has avoided "mobilizing information" that directs attention to controversial activities while presenting patriotic and unifying material. In addition, the American press has been plagued by the homogeneity of the intelligentsia, which directs and identifies with media practices that reflect their ideological uniformity, according to Noam Chomsky (1979, 9)—who had determined earlier that "the mass media are almost one hundred percent 'state capitalist.'" This reality leaves many readers—and therefore parts of the community—in search of ways to locate and participate in social and political practices that are controversial and unpopular by media standards and challenge the established political system. The problems of the working class vis-à-vis commercial and industrial interests, the changing relations of production, and the dilemma of organized labor

remain major unexplored topics of social and political significance. Thus, whereas the press has confirmed and reinforced its representation of commercial interests, the influence of the total community has been further diminished by a prevailing social and political structure that seeks to relegate public interests to issues of consumption, thereby making them middle-class concerns. By doing so, the media have excluded the working class, which has typically not been conceptualized in terms of consumption but has distinguished itself socially and culturally through other values that have emerged from its sense of community, like family relations.

Therefore, the problem of access to the public sphere, that is, the lack of diverse opinions and perspectives and the failure of a responsive press, cannot be solved by appealing to what has been called "public" journalism. Discussions of "public" or "civic" journalism have addressed the practice of journalism in contemporary society (Charity, 1995, Rosen, 1996). They have appeared as a rhetoric of change that claims neither theoretical depth nor historical consciousness but insists on the need for a new understanding of journalism. The result has been a collective appraisal of the relationship between journalists and their publics that appeals to common-sense solutions without a sense of history. No consideration has been given to contextual issues, such as major social and economic changes in relations between publics and their media or the reaction of media ownership to social and economic shifts in society. Instead, there has been a preoccupation with the surface phenomena of content matter and topical concerns rather than with structural constraints caused by the changing objectives of media enterprises that may have contributed to the demise of newspaper journalism since the mid-1960s. Missing has been a critical examination of the underlying assumptions of journalism, professionalism, and freedom of expression—particularly in light of historical social, political, and economic developments that have continued to deconstruct traditional views of journalism and are leading to a different understanding of the role of journalism in American society.

Thus, in the face of major institutional changes that have redefined notions of "the public" and the idea of "work" among journalists, proponents of public or civic journalism have promoted a new definition of journalism to respond to the demands of the public and the desires of the industry with a combination of positively endowed concepts (the public and journalism) to project the scope of their undertaking. Yet, there are limitations to the definition, which does not encourage the pursuit of public interest journalism under new forms of ownership and public participation or a new understanding of professionalism that frees journalists from editorial control and acknowledges their professional independence. Instead, the definition remains ideologically committed to an approach to journalism as a business that relies on the satisfaction of its particular consumer-commu-

nity, redirects journalistic practices accordingly, and offers temporary relief from the symptoms of a deeper social and economic crisis.

Without freedom of individual practices, the power and responsibility of professional journalists are severely restricted; they are not representatives of diversity and, in fact, have never been independent historical agents of change in the American media system. Instead, they have been subordinate to editors and managers of the press and have lacked autonomy. Perhaps they share a position as modern intellectuals, which André Gorz (1976) has defined as belonging not to the working class or to the power structure, but to the dominant capitalist system. The ownership of the press, on the other hand, has prevailed with an autonomous understanding of freedom based on invoking property rights in pursuit of its own goals; ownership has not only controlled content but throughout the history of the American media has interfered with the organization and activities of newsworkers. Thus, working-class interests surfaced in the organization of media activities and became a relevant topic of social and historical research.

More specifically, the conditions of contemporary newsroom work are largely an outcome of the history of labor-management relations in the industry. The organization of workers and the history of labor unions in the United States provide an excellent case study of the erosion of political power and the demise of a public role for the working class. As early as the nineteenth century, the power of organized labor dissipated or was redirected to help accomplish the process of industrialization. Consequently, the goals of the business community became those of the working class, whose sense of solidarity dissolved while its fading class consciousness was replaced by a belief in the prosperity of a middle-class existence. The latter became a public objective of securing what Gramsci (1971, 12) has called a "spontaneous" consent by the masses "to the general direction imposed on social life" by those representing the dominant group.

Thus, from the very beginning labor disputes were never widely supported actions; they were seen as local or regional responses to a specific issue or as the expression of a grievance rather than as an ideological battle over control of the workplace, the rights of workers, and the responsibilities of employers. There are strikes, committed union members, and concessions. The story of unions, however, is rarely one of working-class victories; instead, it is still a story of accommodation and compromise at the expense of freedom and control over workers' own destiny, when the promise of affluence becomes more important than the long-range consequences of industrialization for workers and their union activities.

The press has no effective labor representation of its workforce except among printers. Journalists are treated as newsworkers; despite promises of professionalism, their middle-class background or ambitions are deflected

and ultimately squashed by the social and economic realities of newswork. They are producers of news stories, with serious constraints on the language, style, and content of their reports. Newsworkers have virtually no chance to act freely and independently in the typical fashion of intellectual workers. Even those who organized in the American Newspaper Guild formed their union outside the ideological goals of the working class. Daniel Leab (1970) reported on journalists' reluctance to join a trade union or be identified with a non-professional workforce, although forming a professional organization seemed reasonable for most editorial workers. A more radical view, like Sinclair's (1936, 421) idea of "one organization of all men and women who write, print, and distribute news to take control and see to it that the newspapers serve public interests," was initially rejected.

By and large, newsworkers have remained utterly dependent on media management and have created a paradox in American journalism by working within a definition of freedom of the press that belongs to press owners rather than to the independent and professional practices of journalists. Newsworkers face an antilabor and pro-business climate that silences their voices but rewards compliance with the rules of corporate journalism and submission to public interests claimed by the press. Such interests, for instance, are those of the business community that lead to public discussion of union activities by openly antiunion newspapers. News reports focus on violence rather than on issues and on cases of unlawful behavior and loss of control rather than on the orderly process of civic protest.

Unfortunately, the United States has no history of a major labor or leftist press capable of using its political interests to balance the views of business elites and refute the nonpartisan claims of the mainstream media. There is, however, a distinguished history of an organized left-wing critique of the social and political conditions of American society. Publications ranging from the *Daily Worker* to journals like the *Liberator,* the *New Masses,* the *Nation,* the *New Republic,* and the *Partisan Review*—especially during the 1920s and 1930s—and the *National Guardian* since the late 1940s have reflected the intellectual and political commitment of American writers to the socialist cause. Max Eastman's challenge to writers characterizes the spirit of this involvement in the cause of justice and freedom. "Your place . . . is with the working people in their fight for more life than it will benefit capital to give them; your place is the working-class struggle; your word is Revolution" (quoted in Aaron, 1961, 41).

Yet, agonizing over the conditions of the working class does not produce immediate changes; nor is the mainstream press attracted by a radical view of society and the conditions of working people. Indeed, antilabor attitudes among newspapers remain widespread, causing Liebling (1975, 170) to worry "for the newspapers' sake, about their custom of ruling, in

every strike, that labor is wrongheaded, as if they were a panel of arbitrators appointed by a High Power." The result has been a public image of organized labor and union activities that fits the narratives of commerce and industry in their efforts to discredit and reject unionization. It has been labeled un-American, with particular reference to foreign-born labor leaders, and has been identified with the activities of anarchists and the Communist party. For instance, by the end of the nineteenth century Engels (1989, 495) had realized that the predominance of foreign-born socialists among union activists was unacceptable to Americans and suggested that they " become out and out American" in order to succeed in uniting the American working class.

Patricia Sexton (1991) has chronicled the periods surrounding both world wars, when labor unions and radical left-wing parties became a favorite target for raids, arrests, and deportations despite a lack of legal authorization. She concluded (1991, 138) that the "excesses of the Russian revolution had frightened the world, but nowhere else were the reactions of business elites used with such force and abandon against the whole spectrum of political opinion on the noncommunist labor-left." Conditions for leftist political opinions did not improve after World War II, when the Cold War era led to a further erosion of civil liberties. Indeed, the failure of socialism in the United States has been noted by authors like Joseph Schumpeter (1942), David Potter (1954), and Daniel Bell (1960) who encountered a prevailing positive attitude toward capitalism among the working class and its alignment with capitalist interests throughout recent history.

Issues of control are not only defined in terms of political and commercial domination of media structures or properties but also involve language and the construction of reality. The development and use of a specific language by the media and the interpenetration of language and experience in the presentation of reality are significant events in the making of dominant worldviews. The commodification of information and entertainment by the press and the rise of advertising with its consumption-oriented language—accompanied and encouraged, if not strengthened, by the educational process—lead in due course to the production of a public language that is plain and uncomplicated. That language is easily grasped, appeals to the simple mind, and accommodates the limited language abilities of the foreign-born population. Its common vocabulary reinforces the sense of shared ideas and collective experiences of reality and increases the acceptability of a particular worldview among readers.

This process involves the observation, accommodation, and co-optation of public speech and has resulted in the production of a mediated public language that facilitates an understanding of the world among the middle class whose language occupies the pages of the press. The particular media vocabulary caters to an ideological position; the result has been de-

scribed by Howard Zinn (1973, 239), who observed that "words like vio-lence, patriotism, honor, national security, responsibility, democracy, free-dom have been assigned meanings difficult to alter." In the 1990s this lan-guage has continued to dominate the public discourse and reinforces the use of familiar expressions that help to define social, economic, and politi-cal realities for media audiences whose representation occurs in the selec-tion and use of language by the media. In this case, participation occurs through familiarity with a language that reveals and obscures, is intelligible and deceptive, and, ultimately, advances the ideas of those in control of the media. This is yet another form of participation that accommodates the so-cial and political status quo through language and, therefore, through "one of the most important means of initiating, synthesizing, and reinforcing ways of thinking, feeling, and behavior which are functionally related to the social group" (Bernstein, 1973, 63).

The language of newspapers not only becomes a technique for direct-ing and channeling social communication; it also constitutes an attempt to arrange reality in ways that reflect the ideological position of the press. In this context, new forms of narration—such as cartoons, photographs, color, and large headlines—that privilege immediacy often replace textual explanations. The result is the perfection of an efficient language of social communication that attempts to be unambiguous, accessible, and easy to reproduce in the private realm, politics, and advertising. It is also a lan-guage of control in which single words or phrases and stereotypes replace the difficult, speculative, and creative narrative that reflects the complexity and diversity of everyday life. But the emergence of a public language, which Herbert Marcuse (1964, 103) described as a ritual-authoritarian lan-guage, is troublesome because it becomes "itself an instrument of control even where it does not transmit orders but information; where it demands not obedience but choice, not submission but freedom. This language con-trols by reducing the linguistic forms and symbols of reflection, abstraction, development, contradiction; by substituting images for concepts."

Yet, the reduced or impoverished vocabulary of the press constitutes a necessary and sufficient preparation for entering into the public discourse. Consequently, newswork represents the efficient use of language; it is not only employed to accelerate instruction or information but also facilitates the training and replacement of newsworkers. Therefore, the language of the press also emerges as a tool of subordination with which newsworkers are separated from their work by managerial decisions about the definition of journalistic practices.

The result is not only the control of professional expression and the loss of power through the alienation of work but also a homogeneity of popular culture and the promotion of a form of cultural identity based on the sophistication of the public discourse. Whereas the former processes in-

volve the question of identity and the value of work, the latter conditions involve the problems of status and personal power. The outcomes of these changes, that is, the separation from work and the acquisition of cultural capital, constitute yet another condition of participation grounded in the social and economic circumstances of society.

In either case, however, the Industrial Revolution of the nineteenth century dismissed its children into a society shaped by structural changes that had been introduced by the process of industrialization, which, according to Rodgers (1974, 233), "is essentially a story of values, not inventions." The success of that story, however, demands persuasive narration and a sympathetic audience; the former appears in the form of editors like E. L. Godkin, whereas the latter consists of the leadership of well-educated members of the middle class for whom laissez faire and a free market are essential for the survival of society. In the process, according to John Morton Blum (1967, 27–28), industry and "the structure it imparted to society threatened the satisfaction of persisting aspirations for individual success and freedom. While capitalism adapted to the demands of a massive market, its institutions acquired privileges and immunities which earlier generations had designed for the benefit of the common man." Both the common individual and the industrialist yearn for prosperity and stability, but it is the world of business and industry that secures its own place through consolidation, whereas individuals' attempts to organize their collective interests remain only partially successful. When government is advised to help restrain dissent and protect property, it is directed against those whose fortunes do not coincide with the growth of industrialism. Among them are members of the working class in the urban centers of America who have great hopes for their future in the ranks of a growing middle class.

This process of urbanization and industrialization is accompanied by the process of alienation, however, as the pressure of work performance and the sense of personal isolation begin to affect the climate of society. Karl Marx (1975, 324–334) had provided a classic observation of the estrangement of workers and of their production, which moves from economic factors into the realm of the social world where the manifestations of self-estrangement are found in the relationship among the individual, others, and nature. The effects of the self-estrangement of individuals, who are directed by their own action and its consequences and who experience themselves and others as an abstraction, constitute one of the central issues of capitalism. Thus, alienation includes the denial of one's own history; individual experiences rather than social or cultural encounters become objectified. Erich Fromm (1955, 129) suggested that in industrialized societies an individual's sense of self "does not stem from his activity as a loving or thinking individual, but from his socio-economic role," and he concluded that a person's "sense of value depends on his success: on whether he can

sell himself favorably, whether he can make more of himself than he started out with, whether he is a success."

Since the result of alienation is a growing sense of failure in the face of the increasing pressures of the workplace, for instance, or psychological discomfort and sickness, the consequences of industrialization become transparent and problematic in a society fixed on the idea of work. In fact, the problem has been diagnosed as excess labor, and books like George Beard's *American Nervousness* (1881) blame the conditions of the nineteenth century—particularly its high-pressure education, overspecialization of labor, speed of work performance, and the general tempo of the times—for the neurological and physical complaints of a generation of Americans.

Rodgers (1974, 106) described this phenomenon and concluded that the "long campaign against overwork served as the intellectual side to a conspicuous expansion of free time and free-time activities," which suggests the demotion of work from an essential to an instrumental virtue. The result is a new outlook in which play and leisure time become work, and work is play. Such changes are accompanied by increasing appeals to diversion through entertainment—particularly with the rise of the tabloid press, dime novels, film, radio, television, and personal computers, which have become the most successful instruments of recreation and distraction in the 1990s. More specifically, after completing a major phase of industrialization during the 1910s, the problem of work as a social process had been successfully identified with the idea of collective responsibility and was considered a necessary and sufficient condition for economic advancement, happiness, and well-being, when the notion of leisure becomes just another aspect of everyday existence. The merger of work and play into a new philosophy of American life became part of a middle-class ideal. At the same time, the liberation from toil and the potential of less work and more leisure time were equally appealing alternatives for the working class.

Further mechanization and the rise of technology are accompanied by shorter work days, better pay, and the prospects of conspicuous consumption, which Thorstein Veblen, among others, identified with the nature of the leisure class and, therefore, with notions of freedom. As Dallas Smythe (1994, 237) suggested, they are also accompanied by the realization that the "uses of technique (in the sense of machines of ever-growing sophistication) in capitalism have been linked with alienation of people, with specialization of functions of people, and with hierarchical arrangements of people in bureaucratic structures."

The process of alienation continues with the replacement of human contacts by media environments. In fact, the notion of individualism is easily shifted to become part of the vocabulary of commerce and industry, where individualism has more to do with the subjugation of others than with social or private concerns. This process redefines the understanding of

freedom and individualism in a consumer society in which participation is legitimized by commercial practices.

The press participates in shifting attention from production and work to entertainment by preparing its readers to accommodate leisure time as yet another opportunity for consumption. In fact, the media acquire a major stake in the commercialization of leisure and become less interested in the pursuit of social needs than in the profitability of their products—for example, the success of dime novels, tabloid newspapers, comics, video, radio, television, and computer games. Theodor Adorno (1975, 15–17) addressed the impact of the culture industry on leisure, the commodification of leisure, and the transformation of the profit motive onto cultural forms; he suggested that the culture industry should proclaim "you shall conform, without instructions to what; conform to that which exists anyway, and to that which everyone thinks anyway as a reflex of its power and omnipresence. The power of the culture industry's ideology is such that conformity has replaced consciousness."

A changing attitude toward work and the development of new labor-saving technologies have encouraged individuals to access the media for purposes of information and education as well as distraction, play, and recreation; they have also encouraged the routinization of leisure time. But the media provide access only for those whose prosperity, education, and class status ensure regular use, whereas those with less economic and educational capital are either restricted in or deprived of their utilization. Consequently, the accessibility of increasingly sophisticated information and entertainment is accompanied by a process of separation of individuals as participants in the affairs of state and community. This separation has become a disturbing feature of late capitalist societies in which a generous supply of information and entertainment competes for audiences' limited financial and educational resources. Under such conditions, print media are becoming the domain of a new, affluent, and literate middle class, whereas electronic media—especially radio, television, and video—serve the needs of an impoverished majority. The creed of equal opportunity crashes into the state of personal qualification, including financial solvency.

Throughout these developments in the social environment, ranging from the industrialization of work to the institutionalization of leisure, the issue of class remains buried in the margin of American culture. Communication research, even in its most modern or postmodern cultural studies mode, continues to operationalize media-and-society problems with an implied middle-classness reminiscent of a traditional sociological approach to class as status in society. There is no sustained interest in a working-class culture per se or in its real or potential contribution to the breadth and diversity of the social environment. Since the definition of the American public sphere has been conditioned by a dominant middle-class perception of

society, questions of communication and media in society have been confined to bourgeois concerns rather than liberated to include working-class issues of representation. As a result, it is possible that recent forays by communication studies into issues of gender, race, and ethnicity have been based on typical middle-class anxieties or perceptions of civic duties and responsibilities that are liberal-progressive reactions to social and economic conditions of society rather than on political considerations of class and class consciousness.

7

The World According to America: Ideology and Comparative Media Studies

The development of comparative and international communication research, like communication theory and research in general, has been shaped by the role of the United States in creating the political realities of international politics and conducting foreign affairs since World War II. The political and commercial consequences for the practice of social communication were significant issues in debates among European intellectuals and accompanied the emergence of the social sciences in Western Europe in the nineteenth century. Subsequently, American scholarship adapted those ideas and definitions of communication to the specific needs and conditions of its environment. Communication and mass communication theory and research thus became embedded in the social science apparatus, notably in the contributions of American sociology.

A concern with issues of communication appeared in the social reform movement of the late nineteenth century, when the social sciences confronted the problems of industrialization and urbanization in the United States (Hinkle and Hinkle, 1954; Quandt, 1970) and explored the role of communication in society. But the significance of communication as a social phenomenon and the reception of the media as influential cultural, political, and economic institutions also stimulated an interest in communication across cultural and political borders and in the description of media systems in a variety of national settings.

This chapter describes the rise of comparative and international communication research within the context of the history of communication and media studies in the United States, explores its dominant ideological

perspective, and suggests the potential of a discursive approach to the study of cultures. There have been three significant and interrelated stages in the development of communication research: a descriptive phase of communication and media systems that ended before World War I, a period of intense social scientific engagement that was felt most dramatically through the end of World War II within the context of war (propaganda) and industrialization (advertising), and a stage of maintaining and reinforcing social scientific methods, particularly within the context of finding solutions to contemporary social and political problems.

The first phase of communication research was dominated by the description of communication phenomena, the preparation of research agendas, and the definition of communication as a shared, participatory activity. These developments suggested the importance of the media in a democratic society and their role in the creation of a "great society." Social scientific explorations were accompanied by the growth of specialized, professional interests that became institutionalized in journalism education at the college and university levels (Birkhead, 1982; Harvey, 1908; Lee, 1918) and that legitimated the social role of journalists while catering to newspaper industry demands for training and research.

In this practical, professional atmosphere, comparative and international communication research was limited to descriptions of foreign media systems, the rise of international news agencies, and the work of American foreign correspondents (Cannon, 1924). Many articles in publications such as *Harpers Weekly,* the *Nation,* the *Literary Digest,* and *Saturday Evening Post* reviewed coverage of various countries. Titles of these articles ranged from "Experiences as a War Correspondent" (Dinwiddie, 1904) and "War News—Its Cost and Collection" (Mels, 1904) to "Changes in the French Press" (1906) and the "Development of the Press in China" (1909). Typically, these studies assessed foreign media structures within the context of the institutional history of the American press and the working environments of its journalists.

The second phase of communication research, which ended after World War II, was characterized by the introduction of social science research methods into the field of journalism. There was an emerging identification with social science research practice in journalism research, which was reflected in an emphasis on questions of media effects, increasing methodological sophistication, and a behavioral, positivistic approach to the study of communication phenomena—including the workings of journalism in society. The communication potential of new media, like film and radio, was tested and reviewed with regard to their capacity to raise social and political issues (e.g., the Payne Fund Studies between 1929 and 1932, carried out by Blumer [1933], Blumer and Hauser [1933], and Peterson and Thurstone [1933], and the analysis of Orson Welles's *The Invasion from*

Mars a few years later by Cantril, Gaudet, and Herzog [1940]). These and later studies by leading social scientists like Lazarsfeld, Lasswell, and Hovland created an atmosphere of confidence about the social, and possibly political, significance of a scholarly pursuit of communication problems. They also provided a definition of the social effects of the media and, consequently, strengthened the effects research that would guide the field through the first decades after World War II (Hovland, 1953; Lasswell, 1927, 1960; Lazarsfeld, 1969).

During this time, international and comparative communication studies—inspired by social-psychological and sociological research—concentrated on the problems of war propaganda and psychological warfare, although descriptive analyses of media systems continued to be offered by media experts and journalism research. Typical studies during this period described the role of technology in international politics, the techniques of war propaganda, and the position of the U.S. press in world affairs, including the professional role of correspondents. The works generally reflected a preoccupation with a domestic American perspective of the role of communication in the world and an attempt to assess the function of the media as windows to the world (Clark, 1931; Desmond, 1937; Lasswell, 1927; Lyons, 1937; Smith, Lasswell, and Casey, 1946).

Foreign correspondents in particular provided historical accounts and current information about the foreign press that helped to shape an American perspective regarding the political and cultural qualities of media systems in other regions of the world that was also reflected in the scholarly literature. For instance, in his discussion of teaching comparative journalism, J. W. Cunliffe (1925, 15) insisted that "the American press is and always has been more democratic in its appeal than the European press, from which it took its rise." Similarly, regarding the South American press, J. Edward Gerald (1931, 222–223) concluded that "Latin temperament, growing pains of a comparatively youthful press, underdeveloped commercial and industrial facilities, illiteracy, lack of constructive journalistic literature—these are among the handicaps of South American journalism when judged by North American standards." In his assessment of the Chinese press, Vernon Nash (1931, 448) approvingly observed the "steady swing towards American types of affirmative headlines" and the attempt to "adapt the pyramid style of make-up to a Chinese page, producing a striking improvement in appearance." Finally, the editors of a worldwide symposium that included representatives from Italy, France, Germany, and the Soviet Union suggested almost apologetically that several pieces "contain much nationalistic propaganda, but this element is so obvious that it was thought best to include them for the sake of the objective facts set forth in them" (*Journalism Quarterly*, 1933, 265).

Among the classic works of this period is Raymond Desmond's *The Press and World Affairs* (1937, vii), the "first detached study of the contemporary press as it operates on the broad stage of international affairs." Desmond, a former foreign correspondent, argues that press systems must be understood in terms of their cultural environments. In his introduction to the book, Laski (1937, xxiv) credits Desmond with having identified the relationship between the press and society as to suggest that news systems are reflections of social systems, concluding that "there will be no vital change in the one unless there is also a vital change in the other." Whereas Desmond did describe a number of national press systems, he also assessed the quality of those systems and their objectives on the basis of an American experience.

Since the end of World War II, international and comparative communication research has retained and strengthened its political significance. According to Lucian Pye (1963, 13), "After the war, the growing field of communications research continued to be delicately balanced between the scholars' world and that of government officials and private industry." The political interest in the forms and functions of foreign media systems persisted. The threat to the "free" world was far from over, with the beginning of the Cold War and with the shift of U.S. economic and political interests from the recovery of Western Europe and Japan to the developing worlds of African, Asian, and Latin American countries.

These postwar developments resulted in the extension of news-gathering networks, sometimes with the assistance of the U.S. government (Renaud, 1985), and stimulated media coverage of the ideological struggle and the respective spheres of American influence, sometimes with the help of journalists who also worked for the government (Loory, 1974). In those times of political and economic expansion, there was a continual need for explanations of the social and cultural realms, particularly of Second and Third World countries. Such explanations were offered by comparative and international communication research based on the social and political values of Western societies that reflected confidence in the role of the United States as a model democracy.

A best-selling exposition of theoretical issues during the late 1950s was *Four Theories of the Press,* subtitled "The Authoritarian, Libertarian, Social Responsibility and Soviet Communist Concepts of What the Press Should Be and Do" (Siebert, Peterson, and Schramm, 1956). The book contrasts American values and democratic ideals underlying the notion of press freedom with social and political conditions of the media in other parts of the world, particularly the Soviet Union. Its acknowledgment of fundamental theoretical differences between American and Soviet societies rests on an idealized, if not politicized, understanding of the workings of the American media system and seems to express the Cold War mentality of the 1950s.

Specifically, when Wilbur Schramm (1956, 145) describes the irreconcilable differences between the Soviet Union and the United States, he suggests that the "concepts of man are completely different." One views "man as a mass, malleable, unimportant in himself, in need of Promethean leadership," the other as "intelligent, discriminating, perfectly able to purchase by himself in a 'free market place of ideas.'" One favors "a selfappointed dictatorship, conceived of as 'caretakers' of the people against untrue or misleading ideas [and] extreme, complete control by ownership, Party membership, directives, censorship, review, criticism, and coercion," the other favors "the self-tightening process of truth in the free market place, with the tiniest minimum of government controls."

Such comparisons not only indicate the level of anti-communist feelings in the 1950s but also point to the real or potential political mission of the social sciences. As John Peters (1986, 536) remarked, "Such cooperation with the American military industrial complex was [not] surprising for a social scientist of this period"; what was surprising was the fact "that much of the self-understanding of postwar communication research did come into being within the context of a clear political project."

As an American statement concerning freedom of expression and the free flow of ideas in the marketplace, these philosophical renderings also seem to support or reflect the general thrust of U.S. foreign policies beginning with a 1946 United Nations Resolution calling for an international conference on freedom of information and reconfirmed in Article 19 of the Universal Declaration of Human Rights. Whereas the former provides that "Freedom of Information implies the right to gather, transmit and publish news anywhere and everywhere without fetters" (United Nations, 1946, 176), the latter affirms the right of individuals "to seek, receive and impart information and ideas through any media and regardless of frontiers" (Brownlie, 1971, 110). In fact, editorial comments of *The Economist* ("Freedom of Information,"1948, 701) about subsequent activities of the U.S. government are of particular interest in light of the most recent developments concerning the free-flow debate. The article reveals that "it was the impression of most delegates that the Americans wanted to secure for their news agencies that general freedom of the market" and suggests that "they regard freedom of information as an extension of the charter of the International Trade Organization rather than as a special and important subject of its own. And the stern opposition which they offered to Indian and Chinese efforts to protect infant national news agencies confirmed this impression."

Given the instability of postwar conditions, there could be little doubt that social science research would continue to contribute to the intelligence-gathering activities of the U.S. government. According to a contemporary source, the need for information ranged from descriptions of media systems

to the effects of political and economic structures on media content and ownership to the organization of international communication across ideological barriers (Smith and Smith, 1956). More specifically, Smith and Smith (1956, 13) concluded that these "military considerations, with their economic and political implications, undoubtedly helped to account for the fact that there seems to have been more study and writing on international communication and opinion in the past ten years than in the previous twenty-five or fifty. Yet much of this writing appears a bit old fashioned— as if, for example, the writers were still living in the period of the Second World War." In addition, the authors (1956, 17) criticized the lack of a conceptual apparatus for international communication research and concluded "that no very adequate *general* theoretical model of the *international* communication process has yet developed."

Another major consequence of increased demands for knowledge about the world outside the United States was the participation of a number of disciplines—among them anthropology, political science, psychology, and journalism—in expanding the boundaries of social science research and, thus, in creating an interdisciplinary horizon of mass communication and journalism studies. The accounts of foreign correspondents in the literature of comparative media systems were replaced by the observations of traveling social scientists (often supported by agencies of the federal government), and the organization of research activities appeared under the headings of "international," "cross-cultural," "cross-national," and "intercultural" communication research in the respective literatures of the field (Codon, 1973; Samovar, 1976; Sarbaugh, 1976; Schneider, 1979). In a citation study of international communication research, Kent and Rush (1977) identified over two dozen perspectives on international communication, most emerging after 1950. They also listed Wilbur Schramm, Raymond Nixon, and UNESCO among the most frequently cited sources in their sample, suggesting a reliance on liberal theoretical visions of the role and function of the media abroad combined with the application of specific social scientific methodologies.

Such practice, however, not only reveals political faith in an ethnocentric perspective on the workings of media systems in other parts of the world, but its heavy dependence on English-language sources also exposes a lack of linguistic and cultural knowledge. During those years, the use of secondary literature often dominated over original or native sources of information. Consequently, Anglo-American sources helped to form the basis for an analysis of all types of foreign media and their political contexts, such as James Markham's prize-winning account of Soviet and Chinese media developments in *Voices of the Red Giants* (1967). Although the use of primary materials, including contributions by native media experts, have increased significantly since the 1980s (Martin and Chaudhary, 1983), ex-

amples of political and cultural bias can still be found in the literature, such as in a discussion of African media in terms of a four theories perspective on press freedom (Merrill, 1983) and presumably in the material of international and comparative communication courses at American universities.

Throughout the 1960s, communication research concentrated on the media and their functions in specific political environments, with a particular interest in the workings of communication systems in developing nations. In his introduction to a series of studies, Pye (1963, 8) suggested that in view of the American "tradition of explicit concerns" about a free media system, "both in theory and in practice . . . it is fully within the evolving tradition of political science to ask: 'What is the role of communications in the political development of the new countries?'" At the same time, however, political science in the United States had also been drawn into the East-West conflict. American political science, in the words of Peter Worsley (1972, 27), "had been dominated . . . by an obsessional concern with the rivalry between the United States and the Soviet Union which has reflected itself in the proliferation of bipolar political models of the world social system: 'democratic' v. 'totalitarian,' 'pluralist' v. 'monocentric,' 'authoritarian' v. 'liberal.'"

During those years, international communication and media research were prone to exhibit a political bias that disregarded the autonomy of cultural and political systems, particularly outside Western models of society. Thus, evaluations of foreign media systems were based on political concepts (e.g., freedom and democracy) and professional values (e.g., news and objectivity) that had traditionally characterized the relationship between the media and politics in the United States. For instance, when John Merrill (1968, xiii) argued for the inclusion of the Soviet system in his descriptive account of the international elite press, he was conscious of "however much it might tend to go against the grain of our national and ideological loyalties" and warned that by concentrating on "'our kind' of quality paper, we would . . . be retreating into a peaceful, but antirational harbor, where our world consciousness shrinks while our provincialism grows."

The majority of studies described or analyzed a single media system. Those studies were typically restricted to an investigation of specific political, social, or economic indexes and often offered typologies and models of political communication or comparisons of media organizations within a nation (Hachten, 1981; Nixon, 1960). Regional and worldwide surveys of communication networks were—and still are—less common, although attempts were made to assess the quality of press freedom in many countries, reflecting a concern shared with professional organizations (and propagated through organizations like the International Press Institute). According to Carter Bryan (1964, 32), most scholarly efforts during the 1950s and early 1960s remained "purely subjective and unsystematic as to research

procedures, although certainly they have helped in evaluating the directions of press freedom and control among nations." But he assured his readers that although "there are those who would dispute the findings . . . it is interesting to note that no better procedure has been developed and that other systems of assigning a country's freedom/control evidence no startling departures" from that study. Later, the University of Missouri Freedom of Information Center periodically issued the results of a survey that indicated degrees of press freedom in various countries (Lowenstein, 1966, 1967), which typically ranged from very high (the United States) to very low (the Soviet Union). These analyses are blatant examples of an ethnocentric bias toward an American definition of political democracy and the ideological nature of comparative and international communication research in the United States.

An increasing number of communication and media studies in non-Western societies typically stressed a modernization perspective that dealt primarily with the connections between economic power and political decisions as they relate to the cultural institutions of society. Communication and media specialists, in fact, are never far behind various attempts by Western societies to provide development aid in the form of social scientific expertise. Focusing on the Third World, they identify specific stages of development that best describe the rise from traditional to modern societies based on a variety of existing models of social change that were created and applied by American and other Western social scientists. Although this type of research concentrates not only on the effects of economic and social changes but also on psychological aspects of individuals in the process of integration, it rarely provides a historical context or a culture-specific explanation of such development. Instead, these studies use a mechanistic approach. Propositions about the state of development are based on sets of factual information—such as degrees of literacy, media development, and economic growth—that were marshaled in support of a modernization theory (Lerner, 1958; Pool, 1963; Rogers, 1969).

The inadequacy of such a theory to explain social change within a particular society rests not only in its failure to account for international movements or influences, including the problems of capitalism as a world power, but also in its inability to deal critically with the complexity of the economic, political, and cultural forces that produce communication in society. Moreover, and perhaps most important, modernization theory provides a Western explanation for Third World development and, thus, remains suspect of political and cultural biases that are reinforced by and reflected in the application of positivistic methodologies to complex structures of social life. A tendency remains, then, to display a significant cultural bias that not only detracts from the work but makes it rather useless for the study of cultures other than one's own.

Robert Nisbet (1969, 202) aptly described comparative analyses as a way to reassure

> Western intellectuals about the developmental rightness of their own society—or, rather *of those elements in their society that were "modern" in contrast to those elements held to be retrograde.* On this basis of comparison, large sections of social organization . . . could be contemptuously dismissed as archaic, as destined to be dissolved in the long run by the process of development that had already elevated to ascendancy in the West technology, rationalism, equality, and related qualities.

In a more recent critique of theories underlying the role of the media in national development, Peter Golding (1974, 39) attacked "the ethnocentric use of the characteristics of West European and North American society as goal-states from which calibrated indices of underdevelopment can be constructed." In addition, he (1974, 51–52) pointed to an ahistorical view of development that "resonates" through media research, resulting in a "conception of developing countries emerging from static isolation, requiring an external stimulus to shake them into the twentieth century" and conceiving of "the future as a bigger version of the present, the liberal theory of progress; modernism is the accumulation of more consumer goods and the adoption of values and ideals tried in the western world." Golding's observation certainly pertains to the perspective of U.S. media research in the field of development studies.

The subsequent emergence of dependency theories provided a critical appraisal of the models of development from a Third World perspective and represented a political alternative for many Third World specialists. As suggested at that time, "Dependency theory emerged as a healthy antidote to the mindless optimism of the orthodox 'modernization' theory of economic growth and development, as exemplified by W. W. Rostow and his *Stages of Growth*" (Weaver and Berger, 1984, 60). Dependency theory rests on the assumption that cultural identity, economic growth, and political independence can be achieved only after overcoming domination by the advanced industrialized nations. Informed by a Marxist approach, this theory stresses historical and structural patterns that form a basis for relations among internal and external social forces, breaking with the traditional approach of viewing the patterns of change within a society. Instead, dependency theory identifies the international and cross-cultural nature of economic forces and their effects on cultural and social structures. In addition, it encourages methodological shifts as a result of criticism regarding the conduct of social science research in and by Western nations (Schiller, 1969, 1976). Generally, however, the concept of dependence as an aspect of a more comprehensive theory of imperialism has been used to account pri-

marily for the economic structures and relationships between developed and underdeveloped nations. The result has been an emphasis on economic determination of the social conditions of dependence at the expense of other social and cultural forces.

Finally, a number of authors have dealt with the notion of power and cultural domination in studies of media ownership and distribution of information, particularly in the aftermath of the debates surrounding the New World Information Order. Although these efforts focus on the influence of material culture on developing nations, they also trace the distribution of Western media products around the world in news-flow studies or analyses of the dissemination of television programs. They lack insights, however, into the cultural and political conditions bearing on the reception or integration of those programs into the respective social systems (among many, see Gerbner and Marvanyi, 1977; Hester, 1971; Read, 1976; Stevenson, 1980; Weaver and Wilhoit, 1981).

Since comparative and international communication research is located in the mainstream of what Lazarsfeld (1941) called administrative research, it has remained sensitive to the concerns of U.S. foreign policy and has anticipated U.S. involvement in international affairs. The field may have helped to define and direct cultural and social policy in the past, and its influence may be similar to that of reporters and correspondents whose foreign policy–making role Bernard Cohen (1963, 46) has described as "legitimated essentially by practice, and not by a well-understood body of 'theory.'"

The debates concerning the New World Information Order and the issue of a free flow of information, for instance, have focused attention on the role of UNESCO as an agenda-setting clearinghouse of communication and media studies. Indeed, many years ago the work of Schramm—particularly *The Process and Effects of Mass Communication* (1954), *Mass Communications* (1960), and *Mass Media and National Development* (1964)—received worldwide attention, at least in part because of U.S. domination of UNESCO and its Department of Mass Communication, which also sponsored Schramm's study of the role of the mass media in development. These activities coincided with widespread dissemination and acceptance of American social science research methods throughout Western Europe after World War II. As a result of these political conditions, Jeremy Tunstall (1982, 141) concluded that UNESCO not only reflected "less than the best" of American social research but also operated with an American vocabulary, and "ideas like the 'free flow of communication' reflected American notions of free trade and a 'free marketplace of ideas' transferred, with 1945-vintage optimism, onto the world scene. At that time no other nation either believed in, or had begun to consider, what an international 'free flow of communication' would look like."

When other societies, including Third World nations, began to address the imbalances in the communication flow that resulted in the 1980 report by the International Commission for the Study of Communication Problems (*Many Voices, One World* [UNESCO, 1980]), the climate for American leadership in issues of communication and media practice had changed. The report reproduced a selection of classic American models of communication (UNESCO, 1980, 285–287) but adopted a definition of communication that allowed for cultural differences and suggested that "communication effects vary according to the nature of each society" (1980, 15).

In a subsequent American review of these developments that set forth the "new" context for the formulation of U.S. policies, Jonathan Gunter (1979, iv) warned that an isolation "on 'information order' issues could prove dangerous because the U.S. has major interests in open international communications," including "access to foreign news and the dependence of U.S. business and defense upon secure lines of communication." In addition, a "greater long-term interest is promotion of the deeply held values of pluralism and diversity of expression in a world where communications will be overwhelmingly financed and operated by governments." The important and, it seems, unavoidable relationship between government policies and research agendas has also been noted by others (McPhail, 1981; *Media, Culture and Society,* 1985; Nordenstreng, 1984), and the significance of these changes in global communication policies—including the U.S. political concerns—were reflected repeatedly in a series of articles in the *Journal of Communication* (1974, 1977, 1978, 1979, 1981, 1984). Nevertheless, the U.S. position on issues ranging from news flow to the dissemination of mass culture products and communication technologies became politically unpopular among many UNESCO member nations, despite U.S. social science researchers' efforts to provide supportive interpretations.

During these years, international and comparative communication research continued to be conducted in a social scientific tradition. But that tradition fails to consider historical growth as an indissoluble process that cannot be dissected into empirical parts or facts and prefers to treat communication and media studies as a series of specific, isolated social phenomena. In this context, the field suffers not only from a cultural bias but also from a social scientific bias toward searching for laws governing the relationship of media and society. As a result, empirical research techniques obscure cultural differences. It comes as no surprise, finally, that the United States emerges from many comparative analyses as having the freest media system (Lowenstein, 1967) or as providing people with existential conditions for the most interesting and highly satisfactory way of life (Gallup, 1976).

The field reveals more about its own culture, including the preoccupation with the self, than about other cultures and their understanding of the world, including the U.S. position as a communication and media power. Examples of ethnocentricity can be traced through many comparative media and communication studies in the United States, where the theoretical rationale of comparative and international communication research still resides in the traditional paradigm of communication research.

Alex Edelstein's review of the field (1982), for example, describes a behavioral science approach to American comparative communication research that remains rooted in a narrow social scientific perspective. The book fails to provide a systematic review of alternative, historical, or cultural approaches to the study of society and, therefore, fails to deal with the epistemological problems involved in an analysis of context-bound social phenomena (Kang, 1986). Although Edelstein observes shortcomings and gaps in comparative communication analysis, he does not speculate about possible reasons for a lack of continuity in comparative research. For instance, it would have been most informative and even useful for understanding the history of comparative communication studies if Edelstein (1982, 17) had explained why being "mindful of the spirit of idealism, the strong faith in social science as a contributor to social justice and reform, and the intellectual drives that sought cross-cultural validation" is helpful in understanding the American approach to comparative studies but cannot excuse theoretical weaknesses. In his assessment of the modernization research conducted by Lerner (1958), Schramm (1964), and others—which Edelstein (1982, 21) calls not entirely "misguided" but rather restricted in its explanatory power because of the "state of [the] art" of theory and methodology—he ignores the relationship between politics and social science research and disregards the existence of theoretical alternatives, including Marxist theories and qualitative, hermeneutic approaches to the study of cultural phenomena. Edelstein's work constitutes a perfect example of the type and quality of (self-)criticism that accompanied the growth of comparative and international communication studies in the 1980s.

After all, it is not difficult to imagine that the critique of modernization in capitalist societies (for instance, by Horkheimer and Adorno) has political and cultural consequences that extend beyond national boundaries. Consequently, an understanding of modernization as a historical development in capitalist societies affects any definition of the relationship between industrialized countries and the Third World. The absence of any sustained discussion of theoretical and methodological alternatives for communication and media studies speaks to the ideological narrowness of the field and to the political success of applied social science research at the time, which could ignore these alternatives in its literature. As long as the goals of com-

parative and international communication research coincide with government interests, there will be little need to develop alternative, comprehensive understandings of theoretical and methodological issues.

Hitherto, the explorations of foreign media systems and international communication had shared the view of communication as transmission, or "as a process of transmitting messages at a distance for the purpose of control" (Carey, 1979, 412), and of language and the media as independent aspects of material life. If, however, communication as a social and an individual activity has a specific history, it must be explained through its relations to political, economic, and cultural forces in society. As Stuart Hall (1979, 319) has argued, "Culture, knowledge and language have their basis in social and material life and are not independent or autonomous of it." Such an approach takes into account the contextualization of communication and acknowledges culturally differentiated readings of or receptions to the media. It provides the outlines for a discursive approach to the study of international and comparative communication and suggests that it is simply not sufficient to explain the culture industry in technological or economic terms or to assess media influence in terms of the distribution of messages or the accessibility of messages across national borders.

As some comparative media research indicates, these explanations invariably result in crude measures of political economy with rather limited explanatory powers. They fail to inform us of the ways the media and media messages are used in a variety of cultural settings. A cultural studies approach leads to identifying and describing the means of communication, their social and material production, and their relations to other productive forces and to the social order in which they operate. Such an approach also includes considerations of values and beliefs held by individuals and organizations as they may pertain to the use of language, the mediation of socially relevant experiences, and the definition of professional roles in media organizations.

Since communication plays a crucial part in the hegemonic struggle for social and political control, a discursive approach can be fruitful in locating and analyzing sources of communication. The failure of public participation in the media system illustrates a trend toward centralized control of communication, a trend that is also occurring in nations that have always maintained the separation of state and press as a principle of their political philosophy and as a basis for defining democratic practice. Contemporary media not only offer an introduction to the social and political culture of people, but as instruments of political power they operate within and through the cultural sphere of societies. Never indifferent or neutral in their societal contexts, they reflect the ideologies of their owners, who produce the realities in which individuals live and to which they react in their social roles.

When the comparative study of communication and media systems moves beyond the level of political or economic analyses of media systems to reach the cultural level of human existence, it positions the media within the broader range of culture, politics, and economics. Consequently, any study of media effects on the cultural spheres of society addresses the existing and expressed conditions of people, including their lived experiences. It emphasizes the importance of historical processes as sources of understanding people in their relationships to social and political institutions—including the media—and understands that an audience's knowledge includes "not only multiple realities, but also multiple histories of accumulated significations, whose importance to the interpretation of the media messages cannot be neglected" (Salinas and Paldán, 1979, 93).

To understand the workings of communication in a variety of cultural environments, an informed research perspective focuses on forms of participation, since political democracy is characterized by participation in the diverse systems of social communication. Political democracy is impossible to achieve without cultural democracy, however, and an analysis of cultural democracy requires focusing on communication as an individual and collective process within the social structure to explore the nature and extent of differential readings and understandings and their potential contribution to a representative perspective on culture.

Implicit in the question of cultural democracy is the problem of the relation between society and cultural work (individual productivity) and the impact of capitalism. This represents a vast but necessary area of inquiry for comparative and international communication research in the United States. Such inquiry involves tracing the rise of cultural production and the culture industry through successive stages of economic development (from commercial capitalism to monopoly capitalism) to understand how cultural production has come to occupy such an autonomous role in society and why the media exert such influence over other sectors of social life. It necessitates examining the roles of authors, artists, and intellectuals—including journalists—and their contributions to society as an effort to identify the effects of increasing commercialization on their works. The suggestion that the "culture industry tends to make itself the embodiment of authoritative pronouncements, and thus the irrefutable prophet of the prevailing order" (Horkheimer and Adorno, 1972, 147) points to the major role of the media as actual (in industrialized countries) and potential (in developing countries) forces in social communication. Furthermore, it implies a dependent relationship between intellectuals and owners of media and, thus, confirms the notion of domination by those in control of mass production, including the media.

The study of comparative and international communication research invites the consideration of power as a pervasive theoretical element in the

analysis of cultures. Such study also provides a rationale for a critique of mainstream communication research. The consequences of a pluralistic view, for instance, suggested to Hall (1982, 59) that the "model of power and influence being employed here was paradigmatically empiricist and pluralistic: its primary focus was the individual; it theorized power in terms of the direct influence of A on B's behaviour; it was preoccupied . . . with the process of decision making." At the same time, the traditional Marxist model of power, which acknowledges structural relationships, remains confined to the deterministic base/superstructure approach at the expense of recognizing the significance of autonomous cultural practices.

More recently, the exertion of power in capitalist societies has been explained in terms of establishing and maintaining particular meanings against attempts to articulate and gain new meanings in support of group or class interests. Such an ideological model of power replaces the presence of force or coercion with the notion of ideological struggle.

The discursive approach represented by British Cultural Studies has introduced a model of communication that suggests that power resides within the structures of communicative practice. Comparative and international communication research needs to take a closer look at the communicative practices of intellectual and technical leaders and those producers and disseminators of knowledge and at the social conditions and the public demands made upon them as producers of specific definitions of knowledge. A few decades ago, Znaniecki (1968, 82–83), in his writings about "men of knowledge" and their various social roles in the process of modernization, described the rise of "diminutive sages" who were "ready to tell the public from the pulpit, the platform, the newspaper column, the pages of a magazine, the radio broadcasting center, what they ought to think about everything important that is going on in the cultural world."

A cultural approach, as suggested here, stresses the role of journalists and media managers in their respective societies and demands an assessment of their effect on the types and forms of social knowledge. At the same time, this approach also suggests that ideas like "truth," "freedom," and "objectivity" should be taken "from the standpoint of the men, who believe that they understand this system [of knowledge], who are actively interested in it and regard it as containing objectively valid knowledge about the object matter to which it refers" (Znaniecki, 1968, 7). This emphasis on individuals as active participants in a system of knowledge stresses the importance of analyzing the intellectual and bureaucratic leadership and the justification of its ideological position.

This perspective also includes the role of audiences, subcultures, and groups in society as creators of autonomous cultural practices. More important, it proposes to comparative and international communication research that a study of cultures should begin with an understanding of the

use and interpretation of cultural productions by a socially, politically, and ideologically conceived audience, as well as by experts on and leaders of cultural knowledge. In this context, the study of cultures refers to the study of meaning and its ideological apparatus and to processes of change in societies. The study ranges from exploring the autonomy of cultural practices to analyzing the dominant institutions in society. Thus, when cultures gain form and substance in language, they also reveal their power in the articulation of interests and the creativity of collective cultural practice that are reflected in the nature of the ideological struggle.

This approach to comparative and international communication research requires what C. Wright Mills (1970, 2) called a "historical scope of conception and a full use of historical materials." As an essential condition for the practice of social research, the study of cultures should rely on the historical consciousness and methodological sophistication of the investigator, which will capture the essence of contemporary conditions as they are revealed through a study of their social and political roots. Furthermore, since the life of people and societies is not a fixed state but a series of interrelated processes, knowledge about others—including other cultures and civilizations—is located in the context of time as well as in the prevalence of specific cultural and ideological perspectives.

As long as the historical contextualization of communication phenomena is an academic ritual that describes a specific situation prior to an investigation or provides a chronological account of a series of events, it is meaningless, since it remains a presentation without context and, therefore, without relevance for the actual study. There is no substitute for an explanation grounded in the history of those social and political forces through which the media gain their own form and content, their intention, and their effects in the process of public communication. The question of communication, including the issue of communicative competence as a prerequisite for the participatory role of the public, is crucial for understanding the role of the media during various stages of cultural, political, and economic development; its answer may yield important insights into the contemporary position of the media in relation to the public and the dominant power structure in any society.

In other words, comparative and international communication research should explain the power of the media in terms of their specific historical conditions, their internal organization, creation of cultural products, and mediation of social knowledge, all of which interact with each other to create new forms of communication and offer alternative realities to their constituencies. Such analyses should also take into account the role of individuals and groups in the creation of their own realities based on their own experiences, including the reading of media texts within their cultural environments. Robert Park (1972, 109) referred to the integrity of cultural

processes when he suggested that one can "transport words across cultural marches, but the interpretations which they receive on two sides of a political or cultural boundary will depend upon the context which their different interpreters bring to them. That context, in turn, will depend rather more upon the past experience and present temper of the people to whom the words are addressed than upon either the art or the good will of the persons who report them."

History as a record of human experience is a source for understanding the meaning and importance of social phenomena, including the role and function of the media in society. In addition to the view of the media as symbols of power and profit or as a measure of political and commercial interests and success, questions of human needs and the relationship between individuals and the media as a potential source of societal reform are equally important for comparative and international communication research. The presence of social trends, the rise and fall of cultural epochs, and the impact of politics and economics on social communication raise questions about the mechanics of these changes and about the involvement of particular groups, including elites, in decisionmaking processes.

In the past, comparative and international communication research has generally operated in reaction to specific events or policies rather than as an independent intellectual enterprise committed to the development of theories of media systems in a variety of cultures, since it has shared the "sources of intellectual poverty" that have governed the understanding of communication as a field of study (Peters, 1986). This tradition has compounded the problems of a field that is identified with mainstream social science research; that operates in the politicized environment of administrative, sponsored policy research; and that has failed to participate in the search for a broader theoretical foundation for the study of media, politics, and culture.

8

Alien Culture, Immigrant Voices: The Foreign-Language Press in Journalism History

The evolution of foreign-language newspapers in the United States represents an important episode in the history of the American press, beginning with the initial waves of immigration during the eigtheenth century and continuing throughout the social and political upheavals of the nineteenth and twentieth centuries. America was in a state of becoming, and according to Oscar Handlin (1951, 3), there could be no doubt about the "impact of the immigrant upon the society which received him, of the effect upon political, social and economic institutions of the addition of some thirty-five million newcomers to the population of the United States in the century after 1820."

But the presence of diverse cultures and languages, which have helped shape the social and political conditions of society and contributed substantially to the creation of an "American" culture (Handlin, 1959, 117), has hardly informed the ensuing narrative about the emergence of a democratic press system. Consequently, the immigrant, or foreign-language, press in the United States has received "scant attention" (Miller, 1987, xi) as a historical phenomenon or in view of its cultural and political contributions, just as it has been either completely ignored or severely neglected in the cumulative writings of an American press history. Indeed, a review of U.S. press histories reveals a common failure to consider immigration and the formation of an ethnic press as constituent elements of an American culture and addresses the need for a cultural history of the media that must break with current practices.

This lack of consideration of immigrant cultures in the construction of an American press history is consistent with the treatment of Native

Americans and African Americans and their respective presses in their own struggle for self-definition (Murphy and Murphy, 1981, vi; Dann, 1971, 11–13). It indicates a general lack of interest in minority cultures and their contributions to society and continues to reflect negatively on press historians and their understanding of American culture. E. D. Hirsch (1988, 98) has suggested that "To acknowledge the importance of minority and local cultures of all sorts, to insist upon their protection and nurture, to give them demonstrations of respect in the public sphere are traditional aims that should be stressed even when one is concerned . . . with national culture and literacy." These historical accounts give no appropriate acknowledgment of the foreign-language press as a constituent form of cultural diversity. Instead, these press histories are predictable, standardized, and encyclopedic treatments of the growth of English-language newspapers in the United States. As a result, our collective sense of the history of journalism and journalists and our contemporary understanding of the relationship between the press and society have relied exclusively on writings about the evolution of an English-language press in the United States.

Today, with millions of immigrants still seeking a place in American society, the foreign-language press has regained its presence among American media after finding recognition and strength by catering to the demands of its new readers. According to a newspaper account by Albert Scardino (1988, 21), the flood of immigrants in New York City has been met by "ethnic newspapers packed with classified ads and stories of crime and corruption, with one eye trained on the mother country and the other on the Mayor's office."

By drawing on the treatment of the foreign-language press, this chapter offers a critique of the received historical reality of the American press and the perpetuation of an ideological position that discounted or eliminated the "foreign" element in the formation of an American press history. The chapter will be focused on a number of comprehensive press histories that have appeared since the late nineteenth century to relate the story of American journalism. Many of these works served as standard college texts for generations of journalism students. This chapter concentrates upon the problematic of such narratives, since they continue to be produced and are available as summary statements of the rise of the American press. The publications of Emery and Emery's revised edition of *The Press and America: An Interpretive History of the Mass Media* (1988) and Folkerts and Teeter's *Voices of a Nation: A History of the Media in the United States* (1989) are a case in point.

This chapter is also a critical response to James Carey's (1974) observation about the deplorable state of journalism history and the way it has been handled by press historians, as well as an attempt to elaborate on the

notion of a cultural history and to describe some consequences for the conduct of press history after more than two decades of this debate.

Since its beginnings the writing on American press history has remained an unreflected celebration of the English-language press and its predominance since colonial times (see Bleyer, 1927; Hudson, 1973; Lee, 1923; Payne, 1920; Thomas, 1970). Neither the social and political phenomenon of immigration—including experiences with political exiles in the United States and the continuing problematic of immigration laws during World War II and during the 1970s and 1980s, for instance—nor the emerging sociological literature about the role of the press in the lives of ethnic groups and political minorities affected the writing of press histories, or profoundly challenged the working concept of an "American" press history during the latter part of the twentieth century (Emery, 1962; Emery and Emery, 1988; Jones, 1947; Mott, 1962; Tebbel, 1974). On the contrary, over several decades a small group of press historians defined the nature of journalism history and maintained its influence on the historiography of the field.

Throughout those years, historical treatments of the press remained limited to descriptive, biographical presentations of newspapers, publishers, and leading journalists of the day that were usually devoid of social, cultural, and political contexts, and that lacked appreciation for the importance of history as a source of understanding the current conditions of people and their institutions. That is, a host of differentiated social, economic and political movements or activities were forged into a one-dimensional picture of the world by a pervasive but narrow treatment of the white middle-class press in America. These constructions of a national newspaper history were, at best, dominated by acknowledgments of British influences on the development of the press.

The result was a production of press histories that lacked concern for the practice of journalism as an interactive social process involving journalists and readers in their specific political, economic, and social environments. Although press historians frequently realized the importance of concurrent social, economic, and political processes for historical analyses of journalism, those insights were confined to the prefaces of their books and remained inconsequential for subsequent narratives. That is, a tradition of well-meaning editorial observations about the social or political nature of the development of newspapers had no particular effect upon the subsequent conception of an American press history.

For instance, after George Payne (1920, xiii) remarked in his introduction to his monograph that "the history of journalism in America cannot be separated from the development of the democratic idea" he reminded his readers that immigration had been a factor during America's industrial phase (1920, 255), but he failed to account for the role of immigrant cul-

tures—including their press—in the creation of a democratic society. In fact, the evolution of a "democratic idea" in American society became synonymous with the rise of the English-language newspaper in the United States. A few years later Willard Bleyer (1927, iii) promised that his book would "furnish an historical background sufficient for an intelligent understanding of the American newspaper of today." Although his press history is interspersed with a description of important epochs and typically features significant representatives of the press, the impact of immigration and political exile as cultural and political factors in the social development of American society and its press remains undisclosed. Robert Jones, too, acknowledged the problematic of accounting for the effects of existing historical conditions on the growth of the press. He explained his understanding of historical analysis (1947, xv) by stating that "where an obvious connection exists between a marked development in American journalism and events taking place at the same time in other fields, it seemed desirable to sketch, in descriptive outline, the posture of affairs and the shape of national movements concurrently under way, if they affected journalism importantly." Jones's approach successfully reduced the nature of historical analysis to an elaboration on "important" affairs with which the author hoped to contextualize or enhance the description of the press. The resulting enumeration of significant events denies the sense of history as cultural process and reduces its power of explanation when it fails to consider the potential of cultural diversity.

Under these conditions naive description replaces historical explanation, and the search for "obvious connections" glosses over cultural differences and, therefore, avoids areas of foreign or minority cultures. Over time, the ideological positions of foreign-born journalists and their press—ranging from radical, socialist, and Communist movements around the period of World War I to antifascism after 1939—became intellectually challenging perspectives that affected the shaping of the American mind. The subsequent treatment of the foreign-language press and its contribution to an American press history, however, typically resulted in curiously narrow excursions into the realm of demographic data that would yield statistics concerning the size or growth of this phenomenon but failed to consider the role of different immigrant cultures, their specific social and political circumstances, and their struggles against acculturation or domination by an English-speaking environment.

Furthermore, these accounts also excluded potential problems of competition and economic domination of foreign-language newspapers by an "American" press operating in ethnic communities. In citing the work of Albert Kreiling, Carey (1974, 5) recalled an interpretation of the black press as a record of black consciousness; similarly, the history of the foreign-language press as an expression of ethnic diversity, with distinct social

and political goals, cannot be expressed by enumerations of newspaper ti-
tles or presentations of statistical data on the growth or decline of such a
press. But it is significantly easier and theoretically more expedient to re-
duce diverse groups of immigrants to a mass of potential consumers, whose
exposure to the American press—a fate they shared with the notion of
women as audiences—could only lead to their designation as a new class of
readers (Mott, 1962, 598–599). The clear implication is that immigrants—
and other minorities, including women—would experience participation in
the democratic system and social acceptance as useful and significant con-
tributors to an American society, primarily through their role in the eco-
nomic process. Thus, immigrants appear to be determinants of the rise of
cheap newspapers and increased circulation and generally help to account
for the growing popularity of the press.

Similarly, problems of acculturation and assimilation surfaced only
with descriptions of competitive newspaper practices, when English-lan-
guage newspapers catered to the (cultural) ignorance of immigrants by
adapting a style and language of journalism that overcame cultural and lin-
guistic barriers and, therefore, resistance to the English-language press and
its commercial-political message (Mott, 1962, 507; Payne, 1920, 363–364).
No consideration is given in the historical accounts of an emerging mass
circulation press, for instance, to a vivid and articulate foreign-language
press that would resist cultural domination and detest intellectual compro-
mise. In fact, the writings about a foreign-language press in the United
States typically assume a definition of immigration as permanent displace-
ment, thereby excluding the possibility of temporary migration and with it
the status of guest workers (preferred by thousands of people), which
would drastically affect the role of the ethnic press in the American envi-
ronment. The existence of culturally determined understandings of journal-
ism and the appearance of qualitative differences among journalistic prac-
tices based on social and economic premises of immigration, however, seem
irrelevant to what turned out to be a predictable success story of American
newspaper proprietors.

Consequently, there was also a general absence of informed, critical
judgments of the use of language by an emerging American press system. In
fact, the press's commercially inspired "democratization" of the language
may have contributed significantly to the current level of illiteracy and to
the general lack of knowledge about the world through its constant at-
tempts to simplify the world of words and things in its efforts to dominate
economically and, ultimately, politically.

Such a one-dimensional approach to the history of the American press
is also surprising in light of continual ideological and political controversies
surrounding immigration during the early twentieth century. Those contro-
versies are reflected in a series of publications and, perhaps more impor-

tant, in theoretical debates among American intellectuals who considered cultural pluralism versus melting-pot theories in the books and literary and political magazines of the time (Grabo, 1919; Grant, 1916; Kallen, 1915; Mayo-Smith, 1895). Among them were appeals for strengthening the foreign-language press and ideas that "the foreign-language press [be] fostered rather than discouraged, not only to afford Americans an opportunity to learn of their neighbors [by reading at least one foreign-language newspaper] but also as a means to genuine Americanization of the foreign-born and their acquaintance with the spirit and ideals of the Republic" (Grabo, 1919, 540).

But these visions of cultural pluralism were attacked by others who argued that "immigrants adopt the language of the native American; they wear his clothes; they steal his name; and they are beginning to take his women, but they seldom adopt his religion or understand his ideals" (Grant, 1916, 81). Such rhetorical attacks were followed by political demands to restrict immigration, which resulted in literacy tests and ended with the quota system in the 1920s when religious and racial prejudices—which had been based upon dogmas of Anglo-Saxon superiority—had gained sufficient political support.

American press historians who worked before or immediately after World War I did not reflect on the problems of acculturation despite large numbers of immigrants and their presses and the fact that foreign-language newspapers provided an important interpretive function throughout the period. Handlin (1951, 180) concluded that in "the columns of their journals they read or heard read reports of the important incidents of the day, rendered in a manner that made meaning." Such creation of meaning and, therefore, participation in the social and political activities of society offered historians considerable opportunity to explain the foreign-language press phenomenon and its function in society. Instead, American press historians may have felt uneasy about cultural differences and problems of equality all along. Perhaps they had already sided with Frederick Turner (1920, 22–23), for whom "the immigrants were Americanized, liberated, and fused into a mixed race" to dispel any cultural theory that might have considered American institutions products of foreign ideas. Among the consequences of such a position was the notion that immigrants were only too willing to discard their language and culture, including their presses, and to join Americans in their habits of reading newspapers. It was ideologically consistent to select those facts that supported and maintained a belief in the dominant role of the English-language press in American society.

The writings of press historians throughout the past century also raise questions concerning their understanding of historical knowledge. During this time, historical positivism in the United States was challenged by the

New History, and static notions of historical truth were replaced with a new confidence in the liberating power of science and reform. In particular, when Charles Beard and Carl Becker questioned traditional ways of constructing historical knowledge, they "fatally undermined the historian's confidence that he can tell the historical truth about the past" (Strout, 1958, 29). At the same time John Dewey (1938, 238–239) challenged the use of history to understand contemporary problems with his statement that "changes going on in the present, giving a new turn to social problems, throw the significance of what happened in the past into a new perspective." American press histories never conceived of history as an explanation of contemporary conditions of newspapers and their proprietors but pursued the historical "truth" about journalism and the press. Later, when academic history—laboring under the myth of objectivity and the academic fetish of specialization—continued to dominate the quest for knowledge, journalism history engaged vigorously in what Carey (1974, 4) has called "the solemn reproduction of the achievements of the past" to reinforce circulating ideas about the positive contributions of the American press to the nation-building efforts of society.

For instance, a review of press histories reveals an uninterrupted preoccupation with the collection and enumeration of facts, which are presented as overwhelming evidence of the growth and well-being of American newspapers, the free-enterprise system, and freedom of the press. Throughout their various narratives, press historians concentrate on conflict and sensationalism (not unlike the newspapers and the editors they describe) and on the distribution of political and economic power to define the qualities of editorial leadership. An emerging "truth" features the evolution of an English-language press in the United States that reveals the industrial nature of journalism and projects its positive, social, economic, and political values in support of a burgeoning society.

In their own fashion, these press histories claim to succeed in explaining developments within the newspaper industry through the presentation of facts but whereas these treatises may have been ideologically consistent and professionally ambitious, they were hardly intellectually engaging studies of the press as a cultural phenomenon. In their historical narratives they fail to realize the consequences of a cultural perspective that rests in communication or to recognize the participation of individuals and groups in defining the nature of an "American" culture and in shaping its cultural institutions. As a result, no recognition is given to the foreign-language press and its role in the social communication of society.

There are exceptions. For instance, in times of national conflict the foreign-language press could expect to receive attention from press historians, particularly when ideological issues were at stake. Thus, when foreign-language newspapers experienced severe government censorship during both

world wars, based on the threat of internal subversion, the issue of freedom of expression as a necessary condition of an American press system elevated the plight of (mostly) German-language newspapers to a common cause.

For instance, Emery and Emery (1988, 296–298) continued to issue brief reminders of the problems of censorship for the foreign-language media during both wars. They also defined (1988, 249–250) the foreign-language press as an alternative press in an effort to identify socialist newspapers that included parts of the immigrant press. But no explanation was given for the evolution of that "alternative" press and its social and political role in American society. Emery and Emery's identification (1988, 265) of culturally differentiated and politically diverse newspapers, for instance, cannot replace a scholarly commitment to explore the historical nature of such a press in the 1920s and its current status. In general, their account of the press contradicts their own definition of journalism history as "the story of humanity's long struggle to communicate" (1988, v). In this case, humanity still consists of the proprietors of English-language newspapers and their struggle to reach paying readers rather than of men and women in their different social roles and the uses they made of the press. As a result, immigrants and other minorities were marginalized, and the story of the suppression of cultural minorities, the infringements of their freedom of expression, and their treatment as second-class citizens remains untold in this textbook example of journalism history.

Earlier, Edwin Emery's programmatic statement that "the title *The Press and America* reflects the emphasis placed upon correlation of journalism history with political, economic, and social trends" (1962, v) had prematurely signaled the emergence of an interpretive approach to press history. Indeed, the realization that an understanding of communication must be a central concern for press historians could have led to a theoretical breakthrough in the reconceptualization of an American press history. Unfortunately, the resulting practice of providing a chronological description throughout the various editions of Emery's work continues to deny the integrative nature of history and disregards the complexity of interrelated cultural, political, and economic processes in society. That approach also raises the question of the nature of interpretation (as opposed to narration) in journalism history. In the 1988 Emery and Emery text, interpretation seems to describe the discretionary use of historical events and the efforts to contextualize historical developments of the press in support of a dominant ideological position on the press, freedom, and democracy in the United States. In the process, "interpretive history" lapses into a familiar event-oriented, decontextualized, and "factual" mode of relating the story of journalism as a news account. In any event, such forms of historical explana-

tion can still be considered insufficient unless they are governed by the need to solve contemporary problems.

Folkerts and Teeter (1989, v) make equally sweeping statements about their book as a "product of many voices" by suggesting that their work "views these voices within a social, political and economic framework and considers the impact of owners, audiences, journalists, technology, and government. Within this framework, the voices of blacks, women, immigrants, and other minorities speak convincingly, as do the voices of media corporations that produce metropolitan dailies, mass circulation magazines, and television news and entertainment." Their treatment of the foreign-language press follows similar patterns, however. The authors (1989, vi) refer to the impact of immigration on American cities, but the voices of immigrants are barely audible in their presentation of the "ethnic press." Furthermore, no evidence exists of "the seriousness" with which generations of immigrants "fought for increased recognition," although the authors use the problem of wartime censorship to create an awareness of the legal persecution of largely German-language newspapers and their editors after 1914.

In summary, these standard works on American press history have dispensed some information about the existence of a foreign-language press. They note, at least in part, the political and economic situation of that press system in the context of specific historical conditions (such as immigration and war) but they fail to recognize the particular cultural conditions of the readers and their support for the social and political goals of their press. They also ignore the opportunity to reflect on the cultural diversity of the American press and to investigate the interaction among these press systems on various cultural, economic, and political levels. In this sense, these histories of the "American" press remain incomplete; they lack an expressed understanding of the relationship among all journalistic components of social activities (including the role of the minority press) and are incomprehensible as historical narratives without a grounding in the cultural environment of their time. They explain little about contemporary issues in journalism and, thus, share the problem of being limited and limiting resources.

A generalized and incomplete treatment of the foreign-language press in the most prominent press histories is particularly unsatisfactory after the publication of Robert Park's *The Immigrant Press and Its Control* in 1922. That book was based on material gathered by the Division of the Immigrant Press of Studies of Methods of Americanization, and Park considered it as supplementing an earlier work, *Old World Traits Transplanted,* which he had coauthored with Herbert A. Miller in 1920. *The Immigrant Press and Its Control* is part of an eleven-volume series prepared under the direction of Allen T. Burns and sponsored by the Carnegie Corporation. Park's

work came at a time when restrictionist immigration policies were already in place, when the fear of radicalism among immigrants became a political issue to help to advance and defend more restrictive measures, and when social scientific inquiry into issues of Americanization had received political attention and support.

Park offers a comprehensive sociological analysis of the foreign-language press in the United States. He outlines the position of that press and its founders and collaborators in the social history of America and the history of political emigration and describes the precarious commercial and political realities of those press organizations.

Park's theoretical considerations are defined by the question of social communication, that is, the use of language and the participation of the reader. When he writes (1922, 251) about a "natural" history of the press, he suggests the importance of the political and cultural developments of society in which personal circumstances and interests play a decisive role: "Since the press reflects, more or less accurately, the interests and social conditions of its readers at the period of issue, its history can be illuminated by some knowledge of the people who established and supported it. This is what is meant by the natural history of the press." This statement indicates Park's appreciation of the stream of culture that carried people and their institutions through time and of the role of history and the necessary relationship between sociological and historical analyses of society.

Although Park's study is far from complete and at times resembles more a collection of descriptive data than an analysis of specific social circumstances, the immigrant press emerges not only as a platform for specific, identifiable political interests but also as a forum for unknown readers who through language and culture participated in each other's lives. He proposes (1922, 49) that such communal existence is based upon the conditions of immigration, since "national consciousness is inevitably accentuated by immigration . . . [and has] manifested itself first of all in exile, the refugee, and the immigrant." According to Park, this condition was responsible for the initial success of the foreign-language press, its rejection of social-cultural changes and outside attempts—including the journalism of the English-language press—to assimilate foreign ideas.

Economic pressures, however, together with a long-term reorientation of readers, led to fundamental changes in the foreign-language press, which began to reflect the presence of the American environment. Park comments on these changes, referring to the complexity of the cultural, economic, and political processes that also affected people's daily lives. He suggests (1922, 356) that "every newspaper tends, in the long run, in the mere struggle for existence, to become something that it perhaps did not intend to be. This again is the natural history of the press."

Park was interested primarily in the process of Americanization when he observed the development and collapse of the foreign-language press in American society. His analysis rests on an understanding of the importance of culture and cultural institutions as codeterminant elements of a theory of change that led him to conclude (1922, 468) that the "immigrant wants to preserve, as far as possible, his heritages from the old country. These are represented pre-eminently by his language and his religion. At the same time he wants to participate in the common life and find a place in the American community. In these two motives we have at once the problem of the foreign-language press and its solution." For Park, the solution rests in his belief in the workings of a pluralist democratic system to which immigrants would contribute their own share of ideas, thus adding to the cultural and political diversity of society.

These progressive pronouncements, however, also assist in a political interpretation of press history in which journalism as the guardian of democratic ideals occupies center stage in public life. This ideological perspective has prevailed in much of the writing about the press and has continued to guide journalism education and much contemporary media research.

Although his book became a classic work in media sociology, Park's promotion of a cultural analysis of the immigrant press was unsuccessful. Bibliographical references to his book appear in some historical works about newspapers, but his findings are not included in the texts of those press histories. Even when Lee (1923, viii) acknowledged in the preface to the second edition of his own press history that "*The Immigrant Press and Its Control* by Robert E. Park fills a long-felt want," he does not elaborate on the meaning of a cultural theory of the press and its consequences for writing press histories or on Park's contribution to reconceptualizing journalism history. Over sixty years later, when cultural analyses received much scholarly attention, Emery and Emery (1988) and Folkerts and Teeter (1989) reduced Park's work to a bibliographical reference.

A second sociological analysis of the history of the American press appeared in 1937 with Alfred McLung Lee's *The Daily Newspaper in America: The Evolution of a Social Instrument*. In his preface Lee acknowledges the importance of a natural history of the press, but he also warns of the complexity of such an approach. When he proposes (1937, vii) that "the natural history of the daily newspaper has the dramatic properties but none of the comparative simplicity of a biography or a novel," he exposes, perhaps unwittingly, the familiar dramaturgical concept of American press historians: a biography of the great man or his newspaper, illustrated with selected anecdotes and offered as a composite part of regionally organized descriptions of newspaper developments.

Lee (1937, 88) identifies the foreign-language press as an immigrant press and documents the growth and decreasing stability of its daily

newspapers with the aid of relevant statistical material. His analysis sup-
ports Park's earlier observations about the proximity of the immigrant
press to the cultural, political, and economic network of immigrant activ-
ities. Lee finds (1937, 174) that "foreign-language dailies have been
started as adjuncts to steamship agencies, immigrant banks, political par-
ties, fraternal organizations, and nationalistic movements, and occasion-
ally as independent business ventures." In addition, Lee analyzes the
short-lived phenomenon of the radical German workers' press in the
United States, which—like the party press in general—overestimated the
strength of its ideological position and chose to remain above the style
and content of many English-language newspapers. According to Lee
(1937, 191), the radical political press soon succumbed to the mass circu-
lation press, since "sensational journalism, the journalism of Scripps,
Pulitzer, and others, kept the masses of workers more satisfied with the
dailies in the English-language field."

In their sociological analyses of the foreign-language press as part of an
immigrant culture and a "hostile" phenomenon in an emerging pathology
of the American press system, Park and Lee suggest that a history of the
press cannot rely on information about journalistic activities. Instead, it
will gain from an appreciation of cultural diversity in a historical-sociologi-
cal analysis that acknowledges the complexity of human existence and
moves the practice of historical studies beyond a faithful reinforcement of
visions of society that are based on the material accomplishments of an
emancipated white middle class.

Although the literature on immigration is divided on whether editors of
the foreign-language press used their professional skills to encourage Amer-
icanization or to discourage their readers from immersion in the new envi-
ronment, there is a strong sense of the fact that "the foreign-language
press . . . has been an educational agency without equal among our immi-
grant population" (Smith, 1939, 191). Indeed, one of the most important
functions of the foreign-language press has been to encourage people to
read, to become informed about the world—here or abroad—and, ulti-
mately, to become better citizens. William Smith observes (1939, 190) that
foreign-language newspapers, by "printing the news about America, which
they must do in order to circulate at all . . . have prepared the readers for
American citizenship. Even the advertisement of American goods is an
Americanizing influence."

In their 1988 edition, Emery and Emery include descriptive material
about the contemporary Spanish-language press in California. As a recog-
nition of an existing immigrant press, however, their presentation is not ex-
haustive (since significant numbers of other foreign-language newspapers
are found in California); further, their well-intentioned reference to this
phenomenon fails to yield a discussion of foreign-language newspapers and

their position in contemporary American culture. Instead, their treatment of the Spanish-language press (and other media) appears rather arbitrary and superficial as a regional example of the contemporary immigrant press. This is particularly tragic for the Latin American press in light of its political importance, but its casual treatment also serves as an example of how in the United States press history continues to be conceived as and reduced to an accidental production of facts. The result is paradoxical, since concrete examples of the diversity of opinions and social and cultural differences among the American media—which are also examples of a functioning democratic system—have fallen victim to a brand of historical writing that for many decades has understood itself as the purveyor of democratic principles, particularly of freedom of expression and the press.

Folkerts and Teeter (1989, 531–558), on the other hand, ignored the existence of a contemporary immigrant culture and its press (as well as other minorities) and explored current organizational and technocratic problems of the mainstream media under the heading "Troubles in Paradise." In neither case did the authors question the adequacy of their findings within the cultural dimension of their task by suggesting the existence of serious research deficits on immigrants and the foreign-language press, for instance.

There are various explanations for the all-embracing, uncritical, and politically positive view of the world of journalism that characterizes historical treatises throughout the twentieth century and help inform our collective knowledge of the press in America. Specifically, these press histories are barely distinguishable in their basic conception, outline, and execution. They rely on descriptions of what their authors consider the most important political and economic developments among the most powerful and influential press organizations. They also imply a completeness or finality of their descriptions that lends authority to their arguments. Such an elitist narrative typically progresses in a chronological order and keeps close to the received history of the press at the center of a technological revolution. The result has been a celebration of a technological and commercial rationale for the emergence of the American press at the expense of social and cultural considerations. Consequently, the conceptualization and writing of press history remain committed to the perpetuation of a belief in the American revolution that is grounded in visions of pluralism and democracy, lived and experienced through journalism as the manager of public opinion.

The cultural perspective of Park and the reformist movement of the 1920s, which reflects such theoretical positions and has regained popularity as a source of contemporary thought about alternative views of communication and media in society, however, may be inadequate for the development of a cultural history of journalism as advocated by Carey (1974) in

his provocative article on the problems of journalism history. The reasons lie in the nature of pragmatism as a philosophy that places undue emphasis on the subjective nature of practice and fails to consider the historical consequences of capitalism and its effects on conceptualizing a theory of society. As a result, it cannot offer real alternatives that carry the potential for radical change.

For instance, sufficient evidence exists in Dewey's writings to conclude that he (along with other writers) recognized the importance of an economic determinant in the evolution of cultural and social phenomena. In *Liberalism and Social Action,* for instance, Dewey (1935, 90) attacks the failure of traditional liberalism to recognize that the control of "material and mechanical forces" would be "the only way by which the mass of individuals can be released from [the] regimentation and consequent suppression of their cultural possibilities." He also advances the idea that "socialized economy is the means of free individual development as the end."

The assessment of the democratic nature of American society by Dewey and others still suffers, however, from an inability to recognize social and cultural restrictions as an insurmountable theoretical problem of their own time, beyond acknowledging the dependence of individual and group practice on the material nature of society—for example, the political consequences of a class society, and the ideological power of the capitalist system, including the press, which prevented different developments. Their calls for political democracy are limited to observations about the need for economic democracy, with little understanding of the intellectual and cultural conditions of people. Thus, when these social theorists address problems of democratic reforms, they assume a level of education, a degree of commitment to cooperation, and a general belief in the achievement of economic goals that reflect the detachment of a bourgeois intelligentsia from the social and political reality of everyday life in the United States. Consequently, they express their confidence in the future of American society by developing democratic ideals based on their own beliefs in the power of intelligence and social action and in the workings of a democratic system.

Others, like Walter Lippmann, who had observed the inability of the majority to grasp the complexity of the world, understood people's inability to participate in any meaningful decision-making about society despite the existence of a free press. But in the end, his solutions also remained unworkable forays into the world of neo-Platonic humanism that assert the power of the individual to make intelligent (mature) decisions in a world dominated by the work of technocrats. Despite these theoretical debates and critical observations about the demise of the democratic spirit in America, there has been a continuation of the dominant ideological system—maintained and reinforced by the application of social scientific methodolo-

gies—which stresses the role of the individual and the service character of the state within a pluralistic structure of society.

But scientific posturing will not relieve the need to remain in touch with the social and political realities of the day. Therefore, a cultural history of journalism, encouraged by the tradition of progressive thought in America and founded on lingering Jeffersonian ideas of the press in a representative democracy, will eventually falter and collapse over the failure to recognize the demise of individualism, the ineptness of economic determinism, and the social and political consequences of a dominant power structure. In fact, cultural history as critical history challenges existing theories of society; it exposes and reassesses ruling assumptions of liberal pluralism that have determined observations about the role and function of the press in the development of the United States and considers the varying tensions of cultural, political, and economic conditions in contemporary society.

The writing of a cultural history of the press under these theoretical conditions, then, involves an understanding of the press as a medium of societal communication in everyday life, as a social and political institution with its own educational and informational objectives, and, at the same time, as a medium that defines, expresses, and reinforces a way of life. Indeed, the practice of a cultural history of the media requires a completely new look at contemporary journalism that will include analyses of the role of individuals in social communication, assessments of the importance of the media in the daily lives of people, and studies of the function of experts and special-interest groups in the conduct of the media to explore the political, economic, and social dimensions of the relationship among the state, journalism, and society. Such an approach also demands a new sensitivity to expressions of cultural identity while it examines the variety of media and their use in social communication. In other words, a search for answers to contemporary problems of the media and society is hardly encouraged by the dominant readings of a journalism history caught up in the redundancies of institutional and personal biographies.

For instance, a review of the press histories since the nineteenth century, including the works of Emery and Emery (1988) and—perhaps to a slightly lesser degree—Folkerts and Teeter (1989), fails to produce meaningful descriptions of working journalists and printers or to reveal their existential conditions throughout the centuries and do not offer collective biographies of readers as participants in public communication or class-specific interpretations of social communication, including the encounter with journalism and the press as a capitalist enterprise. These historical renditions of the American press do not consider the material conditions of individuals or the economic and cultural determinants of society as they shaped the image of public communication and established the norms of

participation in that process. In fact, press history turned into an argument for private enterprise and its success on the road to defining democracy. It is indebted to laissez faire theories of society, and its fixation on personalities reflects a preoccupation with a notion of individualism as a measure of personal success that could rely on the government to protect the economic interests of individuals. Indeed, this genre of American press history as a description of "journalism in paradise," to paraphrase Folkerts and Teeter, suggests that public expression has always been the prerogative of privileged publishers.

In addition, a persistent interpretation of history exists as the need to operationalize the idea of an "American" press. The result has been a narrow definition that successfully glosses over notions of social and political diversity and ignores the complex nature of culture and language. Instead, press history as a process constitutes a reaction to the political reality of a dominant English-language press and evolves as a celebration of its power in the name of democracy. The history recognizes a principle like freedom of the press without exploring the nature of that freedom and the relationship between freedom and truth or objectivity. It also promotes the press as the "fourth estate," turning it into a champion of the people without examining the social and political conditions under which the press operates among them. The fact that the foreign-language press and other alternative and minority newspapers played a significant role in the strengthening and the defense of political freedom, as well as the possibility that this press continues to fulfill important cultural and political tasks in American society by occupying a different role than the English-language press in the minds of its readers, remains unexplored.

At the same time, as cultural diversity continues to pose a serious problem in media research, the variety of languages throughout the immigrant media in the United States demands expert attention, although the fugitive nature of many press products may complicate the collection of relevant materials. Under these conditions it seems likely that previous press histories also reflect an ethnocentric bias that reveals a failure to overcome linguistic and cultural barriers and to enrich our understanding of American society through close analyses of foreign-language sources, including newspapers and research reports. Although no evidence exists of the use of foreign-language skills by press historians, contemporary historians can rely on monographs, articles, and unpublished dissertations in such fields as foreign language studies, literature, history, and political science, in addition to communication and media studies. For instance, the work by Sally Miller (1987) indicates the way accessibility to the foreign-language press can be achieved, if only as an introductory exploration; and the three-volume annotated bibliography by Dirk Hoerder and Christiane Harzig (1987) on the immigrant labor press in North

America provides an additional example of interest in such publications abroad.

There are no simple solutions, because the problem of American press history is not only its narrow interpretation of relevant historical material and the subsequent neglect of respective cultural sources, including the foreign-language press, or a technical failure to absorb such foreign-language sources but also involves the insistence on an ideological position that favors an elitist, institutional history of the press based on a specific idea of democracy. In a logical continuation of this ideology, press or media history will turn into a history of media technologies that reinforce the notions of the progress and success of the political system. The contribution by George Gordon (1977) is an example of such an ideological product, and the work by Folkerts and Teeter (1989) moves in that direction with its focus on technocratic problems of media operations in society.

A cultural history of journalism also requires an understanding of the traditional ideological bias of American press histories; it must take into account the current conditions of the press, which raise questions about hegemony, manipulation of power, and participation as a problem of communicative competence with its own economic, cultural, and political conditions. But a cultural history of journalism is also about the writing of history and personal engagement; it is not enough to rely confidently on a display of professional competence or to plead for a broader vision of history. The success of journalism history rests on an ability to engage the imagination and to break through the complacency of the field by exposing the sources of media power and manipulation and by tracing the failures of the political system to protect the cultural integrity of individuals and to foster their abilities to communicate.

A cultural history of journalism exposes the reigning ideology in society, raises questions about the exercise of freedom of the press, and tests its validity as a cherished and celebrated principle of society under current economic and political conditions. Such a history also helps to clarify the position of groups or individuals in their cultural and political environments vis-à-vis societal institutions, like the press, and analyzes the relationship between labor and management, like editorial workers and the ownership of the press, by identifying and comparing various periods throughout the development of the press. By ignoring people—including the working class, which was made up of immigrants and their cultural differences—and by omitting an assessment of the social and political contributions of immigrant cultures and their newspapers as supportive or oppositional forces in society, press historians have made a travesty of journalism history.

Thus *The Press and America* (Emery and Emery, 1988) and *The Voice of a Nation* (Folkerts and Teeter, 1989) are examples of the persistence of a

traditional notion of American press history, complete with all that is dead wrong with that approach. This brand of press history not only establishes and reinforces the entrepreneurial character of newspapers and the political mission of the press and its paternalistic position vis-à-vis its readers without accounting for its one-dimensional perspective, it also legitimizes the teaching of journalism as a form of industrial production.

9

Against the Rank and File: Newsworkers, Technology, and the Construction of History

The pace of recent technological changes, often accompanied by pronouncements about the dawning of a new information age and its consequences for society in terms of media exposure, has produced an extensive literature on communication and technology. Much of this writing has been preoccupied either with the accommodation of current industrial concerns or with the problems of media technology and its effects on audiences as consumers. The literature has tended to reflect and reinforce preconceived ideological notions about the beneficial nature of technology in producing effective and financially successful media systems. On the other hand, the impact of technology on the status of journalists, that is, the biography of media workers as participants in and potential casualties of an advanced technology, has yet to be written in terms of a history of journalism that is committed to creating a keen sense of newsworkers' collective position in the development of media institutions.

In the context of developing a critique of contemporary journalism history this chapter will explore the extent and the ideological nature of historical explanations of technological change by focusing on the contribution of American media history to an understanding of technology in the workplace. For over a hundred years newsrooms, like factory floors, have been a laboratory for technological innovations and a battleground of economic and social interests; current arguments concerning specific adjustments of the editorial workforce to electronic news processing technologies are a continuation of the traditional confrontation between newsworkers and the management of media industries.

This chapter focuses on the impact of technological change on news-workers as a historical problem of understanding the internalization of technology in the practice of journalism and offers observations about the condition of American journalism history. It also attempts to contribute to a critical understanding of the profession and its role in the rise of a media (culture) industry during the last century. Furthermore, an exploration of the nature of journalism history that emerges from accessible standard texts (or textbooks) contributes to the myth of the American press and raises questions about its ideological foundations. Finally, an appreciation of the potential of critical journalism in the United States must begin with an understanding of its history. The textbooks have been aimed at a mass market and continue to seek status or acquire credibility as major sources of journalism history; they are also examples of the use of history in the public sphere and, therefore, are legitimate objects of professional concerns, comments, and criticism.

An encounter with the history of communication technology as an expression of institutional power also promises to render meanings and explanations of contemporary editorial practices. A need exists to articulate a critical history of the relationship among media, technology, and workers to help move the discussion of the nature of journalism history as a problematic beyond narrow, if not one-sided, considerations of technological innovations as entrepreneurial problems and to encourage the critical practice of journalism and journalism education.

For the past hundred years, the expert testimony of journalism historians in particular has helped to shape our thinking about the position of the press in American society. That testimony is concentrated in the major press histories published during that time; those works have been widely circulated as texts in journalism programs and as major sources of information about U.S. media (Emery, 1962; Gordon, 1977; Hudson, 1973; Jones, 1947; Lee, 1957; Lee, 1923; Mott, 1962; Payne, 1920; Tebbel, 1969; Thomas, 1970). The resulting interpretations of the role and function of journalism have guided the development of journalism and mass communication studies and have provided the ideological context for traditional social scientific inquiries into the phenomenon of public communication.

Interpretations of the past become facts of the future, and the predominance of a single ideological position in the current production of journalism history, as reflected in recent contributions (Emery and Emery, 1988; Folkerts and Teeter, 1989), raises serious questions about the creation of historical consciousness and self-understanding of journalism in contemporary America. This is particularly true since media historians have largely failed to reflect on the nature of their work, their theoretical assumptions, and the potential for diverse—if not alternative—interpretations of history (Hardt, 1995).

In fact, theoretical debates over the ideological nature of historical writing—for example, questions of interpretation, or visions and uses, of history—have been rare in the emergence of journalism (or media) history despite the pivotal position of history as a source of theoretical and substantive knowledge of the media and professional journalism. Press histories typically explain occupational roles and confirm the relationship between journalism and society; they tend to reinforce the dominant view of the foundations of American journalism and remain unchallenged, since journalism education in the United States is not apt to problematize historical interpretations of the media and their institutional position in society by challenging the established canons of journalism history.

This development is quite consistent with the inherent lack of self-criticism in professional programs, where questions of "what is" and "what ought to be" are likely to be met by an idealist vision of practice that is indebted to the received history of the profession as a story of the struggle (and success) of the ownership of the press. In fact, the mythical owner-operator of the colonial press is born again as a contemporary media "baron," to borrow Ben Bagdikian's term, representing the creation and continuation of the "fourth estate" as a significant economic force and a formidable business interest in society. Consequently, it cannot be assumed that the benefits for society evolve from the uninhibited practice of journalism; rather they evolve from the economic process of providing access to political and commercial messages with the help of communication experts. Under these circumstances, it seems plausible that the education of journalists will soon cease to be a central concern of university-level programs and will be replaced with the training of public relations experts, whereas the writing of journalism history will turn into a political exercise in nostalgia, supporting the myth of journalistic freedom and independence for use in the promotional material of media industries.

But reasons for the paucity of theoretical debates can also be sought in the professional preoccupation with facts and chronological descriptions of events, or fascination with a narrative of power and influence, reflecting the impact of social scientific thinking and the presence of technocratic ideals that continue to define the boundaries of historical explanation. The systematic neglect of the historical grounding of theory in an emerging social scientific culture that has permeated journalism and mass communication education in the United States and the perceived need for statistical material as a substitute explanation to help produce a contemporary image of the media have also helped to undermine an interest in journalism history, which followed its own path in developing a literature about the media and their relationship to society.

The result of these developments has been an absence of demanding reflection and articulation of competing or oppositional interpretations of

history from journalism and mass communication studies. Among other things, this absence has led to a lack of alternative interpretations of history—for instance, based on gender or ethnicity or on conditions of the working class, including printers and newsworkers. This situation has also contributed to the creation of a sterile intellectual atmosphere that seems to characterize journalism and mass communication programs in the United States, whereas related areas of scholarly inquiry, like communication studies, have undergone a series of theoretical reconsiderations under the impact of neopragmatism or Marxism. In fact, journalism education has remained at the periphery of innovative ideas if the content of *Journalism Quarterly*, including its book review section, is a fair reflection of an editorial vision of the interests and directions of the field.

There are exceptions, however, notably James Carey's intervention (1974) on the side of a cultural history of journalism. His critique was informed by an interpretation of history, including the responsibilities of historical analysis, that draws on external sources and by doing so exhibits the qualities of an interdisciplinary approach to the field; it also led to the unflattering suggestion that the history of journalism as a cultural process involving the relationship of audiences, journalists, and media institutions may be too important to be left to journalism historians whose activities are largely confined to biographical studies. The response to his attack was modest and, in itself, an indication of the intellectual condition of the field; after more than two decades the results of his suggestions appear equally unimpressive.

Indeed, recent media histories (Emery and Emery, 1988; Folkerts and Teeter, 1989) have continued a tradition of historical writing that not only expounds on dominant liberal-pluralist ideas of journalism, media, and society, but remains conditioned by an established, almost formulaic conception of media history as a (news) story about institutions and their leaders that has dominated the writing of journalism histories by generations of authors whose devotion to journalism has overshadowed their understanding of historical narrative. Specifically, the development of American society has been marked by racial and ethnic conflicts; its history is a chronology of internal struggles that passed through a civil war and continued to accompany the U.S. development during the twentieth century. But whereas newspapers with specific racial and ethnic affiliations reflected such conflicts in their coverage and their competition for readers, press histories have been dominated by considerations of white, middle-class interests that tend to support the impression of a homogeneous press engaged in economic battles while ideologically united behind a specific notion of democracy.

Little effort has been made to correct this impression of a unified, emerging American media system by recalling the cultural and political

struggles in which numerous publications and their journalists expressed their commitment to different, if not oppositional, ideas about democracy. This includes the foreign-language press in particular, whose contributions offered cultural and political alternatives, and the black press, which fought for independence and recognition of its own cultural heritage. Such struggles also included survival in the workplace and the emerging conflict between the need for professional integrity and the industrialization of the press.

Under these circumstances of recurring middle-class interpretations, it seemed plausible for a historical narrative of the press to turn the story of technology into an explanation of the success of the dominant press system while disregarding the consequences of technological change for newsworkers and their interests in professional autonomy and economic justice. The fascination with technology as a lifestyle and a dedication to the idea of progress continue to permeate contemporary treatments of technology and communication, which tend to concentrate on industrial issues and on habitual adjustments by audiences to the advancements of electronic media.

For instance, Ithiel de Sola Pool (1983) raised questions about "technologies of freedom" without considering the changing mode of freedom for those individuals who process information in modern societies, that is, he failed to differentiate between control of technologies and freedom from technological control. Instead, he advocated the protection of new communication technologies from political and regulatory authority through consistent adherence to First Amendment principles. In his analysis of the development of new electronic media technologies, Pool (1983, 251) proposed a framework for the conduct of media industries that favors those who are already in control or who are potentially capable of acquiring and sustaining media properties. And he used the "commitment of American culture to pluralism and individual rights" to plead for the freedom of an industry to disseminate information in a society that seems entirely in the ban of current (and future) media fare.

Likewise, Frederick Williams (1987, 129) promoted "an understanding of . . . human and communication technology interaction," elaborating on technological developments and consumer reactions, as well as on the effects of some technologies on editing skills, while failing to link technological progress with changes in the communication workplace and the professional existence of newsworkers. Even Ben Bagdikian (1971), in his earlier assessment of the American media, restricted his discussion of the impact of new print technologies in news organizations to the reaction of labor unions and observations about general resistance to the idea of radical change. He concluded (1971, 303) that "electronics have no morals. They serve free men and dictators with equal fervor. Their use in transmitting

human ideas depends on those who design the machines and control their use, and in the United States this ultimately will depend on the general public." Those who operate the "information machines" and the effects on their professional practices received scant attention. Instead, the author idealized the self-rightening process of an American market culture.

Nevertheless, the emergence of newsroom technologies created conditions for newsworkers that defined their role as producers of specific images and appeals rather than as independent sources of cultural and political enlightenment. Their professional values relied on acceptance in the marketplace; thus, the question of ethical principles underlying the conduct of editors and reporters surfaced in earlier press histories as a source of considerable debate, whereas press and media technologies appear in chronologies of progress that tend to support the picture of a nation moving toward the creation of an information society.

For instance, Edwin Emery (1978, 261) suggests that technological advances helped speed the information flow, "for wherever an American went into the expanding nation, he wanted the news which an aggressive press corps was producing," but his accounts of the "race for news" lack an acknowledgment of the changing nature of newswork and its effects on journalists. Although Emery sees that media technology was indispensable for the rise of specialization in newsroom labor, he fails to deal with its consequences for the workforce. Similarly, Frank Luther Mott (1942, 499) observes that the advent of telephones in newsrooms led "within a few years" to specializations that "were designated by the names 'leg men' and 'rewrite men.'" But he, too, ignores the consequences of years of intensive technological changes for an emerging definition of newswork during the late nineteenth century.

A few years later, Robert Jones (1947, 583–584) was equally oblivious to the impact of technology on newsworkers when he wrote that "a newspaper reporter . . . revisiting his former haunts, would be confronted with much new mechanical equipment, but aside from learning to use a typewriter, he would be able to use the same basic skills, writing his story, the headline for it, or the editorial comment upon it. . . . As for a printer of the same period, for him it would be an unknown world." A similar view was expressed by John Hohenberg (1973, 473), who felt that "there are still many newspapers on which John Delane and Horace Greeley could work without a great deal of instruction." Even more recently, Emery and Emery (1988, 214) continued to summarize newswork as becoming "sophisticated with the use of the telephone, the typewriter, and a rewrite staff" without elaborating on the condition of newsworkers who were forced to reinvent their professional existence in light of such technologies.

These observations share a view of media technology as inevitable mechanical advancement and totally disregard the human consequences of

ownership and control, like the impact of communication technologies on the work environment, the definition of work, freedom of choice, and, ultimately, the professional status of individual newsworkers.

There were exceptions among the dominant narrative of the press. For instance, William Bleyer (1927, 397) provides a more thoughtful and sophisticated observation about technological change, suggesting that "the mechanical devices in due time changed the whole character of the American newspaper. By telephoning the bare facts of the news to rewrite men in the newspaper office, reporters and correspondents tended to become news gatherers rather than news writers." And he concludes that "there was a constant danger of sacrificing accuracy for speed." Bleyer seems to understand the problems of an impeding technology and indicates that fundamental changes affected the work of journalists and produced sets of different newswork expectations. He also belongs to a small group of concerned journalism educators who supported the call for organizing newsroom labor in attempts to improve working conditions and to formulate minimal requirements to meet the professional expectations of reporters and journalists. But his conclusions remain isolated and were reduced to a largely contemporary expression of concern when subsequent historical accounts disregarded his observations.

Alfred McClung Lee (1937) proceeded along similar lines of analysis and introduced the notion of staff efficiency as a major criterion governing the deployment of media technologies. He related the beginnings of the use of telegraphs, telephones, typewriters, and faster printing technologies and suggested (1937, 629) that "the systematization occasioned by these mechanical devices and by business office demands for efficiency made 'old time' reporters bemoan the passing of 'rugged individualism.'" Newsworkers became part of the news machinery, designed to produce materials faster and more accurately than competitors. In other words, copyreaders and rewrite men, as they multiplied in number and their practices evolved, became another evidence of more systematic management. According to Lee (1937, 643), they gave "news-handling some similarity to an automobile manufacturer's assembly line." John Hohenberg (1973, 478) also raised the question of mass production and asked why news should not be as standardized as "autos, food, and clothing," which are "snapped up by an eager public." He concluded that "it is perfectly obvious, under the new technological dispensation, that the responsible editor is bound to be under pressure very often to take pre-packaged, mass-circulated material and dispense with much of the staff-originated news."

Lee's contributions remained exceptional for another reason. His professional distance from the press, combined with his analytical skills as a sociologist, produced unusually perceptive observations about the history of the American media and provided an example of the potential for differ-

ent interpretations but kept him apart from mainstream journalism historians.

For instance, the struggle of the labor movement and the resulting organization of newsworkers in the American Newspaper Guild was a significant event arising from a crisis situation in the newspaper industry; it also offered a unique opportunity for press historians to provide insights into the relationship between newsworkers and communication technologies, including reasons for publishers' frequently hostile reactions to organized newsroom labor. Although working conditions continued to be a significant issue (in addition to salaries) in labor-management disputes, the problems of newsworkers and their adjustment to the requirements of a technology-driven media system remained largely unexamined, except for a rather extensive treatment of the formation of unionized newsworkers by Lee (1937). Other press historians provided only cursory descriptions of this development. In fact, even labor historians have failed to dwell on the foundation of the American Newspaper Guild, according to Daniel Leab (1970, 3), who concluded that "the ANG [has not] fared better at the hands of journalism historians." He argued that the organization of newsworkers into an effective labor union received news coverage only when the move was considered to endanger freedom of the press and, later, when red-baiting reached the height of popularity among publishers and conservative journalists.

Instead, a reading of standard journalism history texts over the years will confirm that the history of American journalism is a biography of power. Consistency and continuity are found in the description of the emergence of newspapers (and other media) in the United States, which concentrated on the activities of individuals who founded and operated media enterprises. As such, these histories celebrate the success of individuals and their rise from the obscurity of the print shop or the business world to the operation of the press—and, by extension—to becoming significant participants in the political arena. Although American press history has been characterized by local and regional developments of newspapers and the importance of community journalism as evidence of social and political status in a developing society, much of the historical treatment is devoted to the advancements of urban journalism and the role and function of newspapers in the economic and political environment of a burgeoning society.

This development of American journalism (and its historical treatment) may have been codetermined by the fact that when journalism grew out of the printing trade, the ambitions of individuals were confined largely to attaining commercial success and material benefits rather than intellectual satisfaction. Printers were not necessarily educated individuals, and in any event, independence of mind and intellectual curiosity were hardly required for practicing the type of urban or community journalism that demanded

facts without interpretation and devotion to reader interests without regard for intellectual integrity. Press histories picked up on the fact that publishers, by their very nature, focused on the creation of an interchangeable labor force to produce factual accounts; the variety of media technologies available since the late nineteenth century helped to support the impression of progressive ownership and masked the underlying problems of endless competition among individuals and against machines. Under these circumstances, journalists as skilled laborers were subjected to a succession of technological advances under conditions of producing and trading stories as commodities, which further defined their place within the media system and, therefore, reduced opportunities for independent judgments, expressions of ideas, and editorial creativity while increasing managerial control.

Observations about the working conditions in American newsrooms can be found mostly in autobiographical accounts of former newsworkers. For instance, Charles Lindstrom (1960, 22–23) has provided a haunting description of the newsman, "caught by the cutting edge of creeping deadlines and lashed to the newsroom clock in the pit of circulation unlimited, a cavernous maw nearly filled with ads, gewgaws, divertissement, and fiction. The pit must be further filled with the issue of reporters' typewriters, with 'news of the moment,' or store-bought features." The result was "hypertension reporting, hypertension writing, and a tense and captious relationship between newspapers and their readers." For Lindstrom, technology had become the cause as well as the excuse of the modern press. A collective history of newsworkers may exist in the biographical and autobiographical writings of former journalists (Brennen, 1993); however, their voices are not heard in the sweeping accounts of the advancement of the media throughout the last century.

By contrast, a presentation by Anthony Smith of various technologies and their effects on the role of journalists in Britain is highly suggestive of how journalism underwent significant changes to reorganize the world for readers. According to Smith (1978, 161), "The advent of shorthand . . . transformed the business of reporting into a kind of science," and it became "the first of that long series of journalistic techniques which at first seem to promise the reader the complete recovery of some semblance of reality." He provided an example of how media technologies helped to fragment the flow of life to establish the production of serviceable units of reality that had little resemblance to a sense of time or history. In fact, Smith (1978, 167–169) found that "the telegraph created a pressured world within journalism. It made possible the idea that a daily newspaper should encompass the events of a 'day,'" despite the fact that such "boundaries hardly correspond with the conceptual and cognitive categories accepted elsewhere." And he concluded (1978, 167–169) that the "techniques of journalism have come to consist in skillful filling of pre-defined genres, each of which stands

for a certain definition of the audience's needs. . . . The task of indoctrination, as it were, has been taken from the journalist and given to the product."

Although Smith's observations pertain to newspaper developments elsewhere, they illustrate the need for this type of creative explanation of and sensitivity to the historical conditions that affect newsworkers as well as the cultural environment of the media. Instead, the narrative stream of American journalism history has featured a particular preoccupation with the accomplishments of publishers and the expertise of some editors, the impact of their products on the culture of society and the rise of new media technologies, the publishers' economic rivalries and finally the politics of media operations in more contemporary times. But the historical treatment of technological change as an event in the history of (mass) communication does not explain subsequent developments of the media. Michael Schudson (1978, 35) notes that technological change "appears as a kind of reflex in histories of journalism," supporting the observation that press histories are event-oriented descriptions that include the specter of changing technologies with little assessment of their effects on the media. One assumes that this includes newsworkers as a group of individuals closely involved in the production of news and information who continue to play a minor, perhaps even insignificant role in the conceptualization of an American press history.

The answer to why journalism historians have largely ignored newsworkers as participants in the creation of an American press and as a fundamental source of historical evidence related to issues of technology and a changing media industry can be found in the cultural milieu of American historical writings and the character of press histories in particular (Hardt, 1995).

The current position of journalism history has evolved in an intellectual climate that celebrates the symbiotic relationship between technology and democracy. For instance, Carroll Pursell (1980, 23) has argued that "the role played by technology in bringing us to our present state is both obvious and too little studied." Her discussion of "democratic technology" summarizes a scholarly tradition of analyzing the role of technology in the development of American society. She proposes that the institutional force of technology has turned into an authoritarian threat that must be understood to appreciate the need for a return to the traditional values of technology that underlie the idea of democracy in the United States.

The invention of the printing press has been credited with breaking down monopolies of knowledge and democratizing the pursuit and accumulation of knowledge by large numbers of individuals for the enrichment of the public mind. On the other hand, the establishment of the press created new monopolies of power when proprietors determined the access to

their printing presses and controlled the content of the public agenda. In particular, the commercialization of the press and, later, of all media was an immediate threat to the independence of journalistic pursuits; such a danger to journalism continues to exist as long as business interests dictate the boundaries of acceptable professional engagement. The growth of media properties has only exacerbated the problem of a privileged class whose economic power over employees, particularly newsworkers, is officially sanctioned and strengthened by constitutional guarantees of freedom of the press.

Journalism historians have considered the rise of the American press to be an expansion of a democratic technology, suited for the small community in which editors as owners-operators of the local press also maintained a social relationship in their respective communities. At this stage, technological achievements remained within their realm of mechanical efficiency and mutual benefit. The editors contributed to an idyllic state of the American dream in which the machine became a participant in the creation of the good society. When industrial concerns prevailed, however, and the specter of a mass society redirected the technological imagination to advance economic and political interests in the name of progress, the requirements of mass communication produced different conditions—among them a model of authority over questions of structure and content of the media that differentiated between owners-managers and newsworkers. Under these conditions media technologies advance the cause of media enterprises, usually at the expense of the professional development of newsworkers who would become part of the technological solution rather than of the democratization of the workplace.

Nevertheless, in this context historical accounts of journalism in the United States have remained identified with the notion of the press as a democratic technology and as an expression of individual enterprise, craftsmanship, and local ingenuity at the expense of pursuing a legitimate inquiry into the potential oppression of newsworkers by a rising media technology.

One of the major reasons for such a perspective is the fact that the received history of the American press is grounded in the interests and allegiances of its authors, whose middle-class values permeate the comprehensive press histories published during the twentieth century. They reflect a shared bias toward history as the story of institutions and their leaders and share a frequent, if not unanimous, admiration of the free enterprise and entrepreneurial ingenuity that ultimately led to the establishment of "great" newspapers and to the evolution of newspaper chains and group ownership of the media.

The writing of press histories has been an exercise in producing evidence of the success of the First Amendment and the democratic system of

government. Specifically, the perception also exists that American press histories would have difficulties reconciling notions of internal conflict or contradictions regarding First Amendment ideals with the image of the press as a leader in the nation-building efforts of society. Similarly, questions of First Amendment freedoms are always raised in terms of the press rather than of newsworkers whose activities seem to be subsumed under the notion of a free press. The result has been a collective recognition of media enterprises that provides an ideologically strong and conformist idea about the power of the press as a democratic institution. Consequently, when the historical narrative concentrates almost exclusively on the rise of the press as a major political institution in American society, it not only reinforces the status of the industry but also adds credibility to the practice of journalism history in support of the status quo.

For over a century, press historians have delivered the "facts" for presenting the American press as the prototype of a "free" media system. The perpetuation of this myth gained new significance with the political developments after World War II and the role of the United States in world affairs, when considerable emphasis was placed on freedom of expression, free flow of information, and the values of a free press system as essential elements of an exportable democratic ideology. More recently, these ideas became important aspects of an emerging political stance vis-à-vis Eastern European countries, when notions of transferring journalistic know-how became synonymous with sharing the myth of journalistic freedom and media independence.

But whereas volumes of American press history reinforce the notion that content is a major determinant of the definition of a free and democratic press—and press historians rely heavily on descriptions of newspaper contents to argue their points about the state of the press—few questions have been raised about the specific functions of newsworkers and their freedom of expression within the workplace. Instead, content as product and, therefore, as part of the free-enterprise system becomes the story of entrepreneurs and their success (or failure) as peddlers of objective and truthful accounts of the day's events. The production itself, the process of indoctrination of journalists, and their exploitation as cheap labor are part of a barely visible foundation of American journalism history. Newsworkers remain anonymous, although recognized, elements of the production process; they are trivialized as individuals and marginalized as a class of workers with professional or quasi-professional aspirations. Leab (1970, 6) quoted an editor who described newsworkers during the 1920s and early 1930s as individuals who "give all that is in them to the service of their employers and when they are old and worn out, they are cast adrift like battered wrecks." He added, "The luckier ones die young. I myself was a machine and the men I worked with were cogs."

No chapters on "reporters" or "journalists" are found in the standard histories of the American press that assess the conditions of newswork—including the constraints on intellectual contributions—or acknowledge newsworkers' countless sacrifices to technological advancements throughout the industrialization of journalism. A reading of assorted introductory texts to journalism, the media, and mass communication, which provide the basis for many professional journalism programs, compounds the impression of one-sidedness by revealing a corresponding failure to treat the history of the newsworker. References to contemporary sociological (that is, ahistorical) treatments of professional issues within descriptive accounts of media institutions provide the only information about newsworkers. The same texts, which represent a genre of journalism and mass communication literature designed to provide a substantial number of university-level courses with introductory material about the media in the United States, tend to rely heavily on standard journalism histories for their historical presentations; they suggest the pervasiveness of such historical writing and its potential influence on understanding the place of media history (Berger, 1988; Biagi, 1988; Black and Whitney, 1988; Harless, 1990; Merrill, Lee, and Friedlander, 1990; Wells, 1987).

Subsequently, the evolution of mass communication has been a story of individuals like Gutenberg, Marconi, Morse, and Bell and their impact on the growth of the media in modern society. It is a history of great men (rather than great women) whose inventions produced a new world of media and communication. In other words, when the printing press replaced the quill, the telegraph deposed the messenger, and telephone and radio communication became instant recorders of distant events, media ownership helped to create the need for information and supplied the mounting demands for participation through social, economic, and political knowledge. The enlightened leadership of publishers like Greeley, Pulitzer, and Ochs, among others, proved to be an important story for press historians.

Indeed, it was easy to imagine technology as the answer to societal problems, and press histories charted the course of media technologies and their applications (or effects), which would enable society (as consumers) to experience the world as sequences of events and to overcome time and space. The idea of accessibility emerged as a major consideration expressed in terms of a democratization of the media, involving technologies of dissemination of information and manipulation of large audiences. In such a powerful narrative, modes of production and consequences of modernization for newsworkers, including their accomplishments in the name of a progressive press, remained undisclosed details of an industrial concern.

This articulation of a dominant ideological position as it related to issues of property, freedom, and progress, however, may have also been the

result of specific professional experiences in journalism or in academic ap-
pointments of press historians in schools or departments of journalism.
Specifically, American press historians since the 1920s became particularly
vulnerable to industry criticism when they joined journalism faculties, la-
boring in an academic environment where the proximity between industrial
interests and educational concerns is felt most directly and in which the
pressure to deliver positive intellectual and professional support to the
training of newsworkers may have been considerable. Mass communica-
tion programs in the United States have been notorious for their general
lack of constructive media criticism (and even of the teaching of critical
skills); the increasing dependence on external support—often from media
industries—including the pressure of local media and communication orga-
nizations, has placed journalism education at the center of disputes about
the relationship between business and universities, the mission of profes-
sional training in an academic setting, and the potential threat to the inde-
pendence of criticism in society. The dismal failure of local and state press
councils, for instance, to obtain expert encouragement and critical support
from journalism and mass communication faculties ultimately supported
the position of media owners whose reluctance to criticize each other has
been long evident.

Such criticism seems equally unexpected from journalism faculties.
Nearly two decades ago Michael Ryan (1979, 4) quoted a journalism fac-
ulty member as saying that "faculty criticism of a news medium . . . would
certainly anger the medium criticized and possibly the media in general.
The primary role of a journalism faculty is to teach the principles of jour-
nalism to students." And he asked rhetorically, "If faculties began acting as
judges of the media, would their teaching roles suffer?" This statement not
only reflects the tenuous relationship between journalism education and
media management but also confirms the problem of introducing criticism
as a legitimate aspect of teaching the "principles" of journalism.

Thus, it may not be surprising that under these prevailing historical
conditions press histories ignore working-class issues and questions of
labor practices (reflecting the antilabor attitudes of publishers). Instead,
these histories concentrate on the contribution and future of technological
innovations in the media market, which would be considered important is-
sues of an evolving American media industry. For instance, the appearance
of USA Today, which defies a traditional understanding of journalism with
its blatant appeal to feelings, its lack of depth, and its uncritical acceptance
of the social and political status quo, drastically changed the landscape of
American journalism with no sustained critique from journalism and mass
communication programs—not to speak of a critical review of its impact
on the definition of the American press by media historians. Emery and
Emery (1988, 627) mention the technological miracle of launching such a

national newspaper, with its regional printing plants and satellite transmissions, and report the extensive promotional costs of the enterprise, but they fail to introduce the problematic of a newspaper chain whose efforts to centralize editorial production may have reduced local newspaper journalism to the collection and distribution of human interest material.

The result has been an ideologically uncontroversial and positive preoccupation with the press by journalism historians. The preoccupation is based on the biographical and highly descriptive character of their work, which seems to expand on narrow and well-defined topics with little regard for the cultural environment that remains the major source of fundamental issues concerning problems of meaning and control in the making of American journalism.

Indeed, it has been the practice of American journalism history to advance the notion of history as a decontextualized event. Amid frequent references to times, places, and people, readers of press histories rarely get a sense of culture. They remain isolated from the social, political, and economic concerns of the community of newsworkers and their readers, for instance; from the idea of an American culture that is based on historical diversity within the nation's boundaries, and from the economic realities of industrialization as historical conditions of change. Instead, the tendency persists to reproduce the fragmentation of time—initially caused by media technologies—by converting historical narrative into a chronology of events that combines successive facts into a story of newspapers and their proprietors with no reference to the cultural milieu. When periodization in journalism history is driven by technology—that is, when the age of printing is followed by the age of broadcasting and the age of computers—the result is a presentation of history as a series of interlocking technological inevitabilities about media institutions and their political and economic relationships to each other. It is the creation of authors whose implicit philosophical positions also reflect a firm belief in progress as the engine of democracy and in technology as a means of seeing the future. Thus, press histories are filled with facts about the rise of newspapers and the success or failure of their owners, whose notoriety becomes a badge of independence and reinforces ideas about the nature of the press as an expression of individuality and about the temptation to engage in hero worship as a full-time occupation. Media histories still make little sense of the political and cultural realities of life in the United States and of the world publishers, editors, and newsworkers share with the rest of society.

Similarly, the production of introductory textbooks for media and society courses, which provide the first opportunity for a critical review of the cultural history of the press, perpetuates the inadequacies of institutional histories by offering contemporary description and media statistics that lack historical grounding and, ultimately, result in the fragmentation of

knowledge and the confusion of factual reporting with critical understanding.

The conceptualization of media history as institutional biography has strengthened the view of journalism as a powerful and influential institution in American society and helped in the teaching of journalism as a profession by claiming its own tradition and place in the history of the nation. That conceptualization, however, has also resulted in isolating historical writing about the media from an environment that explains their very existence and, ultimately, has separated media history from the context of American historical scholarship.

In fact, journalism history has had an uncomfortable relationship at best with the long and distinguished tradition of American social history. Since it has consistently disregarded the importance of the working class and the problems of labor in an industrialized society, journalism history has produced a truncated view of significant sites of (mass) communication development. Without denying individual efforts in recent years to produce a relevant cultural history of the media and their workers, comprehensive histories of journalism have still failed to recover class-related evidence about the lives and professional concerns of newsworkers. More typically, human and professional relationships are reduced to purely economic considerations, when salary demands and competitive wage scales dominate the writing about the conditions of newsworkers and determine the definition of labor relations in economic terms, while ignoring cultural and political determinants of the professional environment.

Press histories are still based upon the notion of property as a historical marker and are, therefore, ideologically committed to focus on the perpetuation of political and economic power. It is only logical that under such ideological conditions press and media histories will turn into histories of media technologies that reinforce the notions of the progress and success of the political system. This is the predominant approach to American journalism history; it is the practice of a top-down history in which questions of ownership dominate definitions of newswork and technological change.

The fact that newsworkers lived with their exploitation, rose in opposition during the years of the labor movement, and possibly underwent significant ideological changes in their approach to journalism that may have consequences for the contemporary status of the profession needs attention from social historians with an intellectual commitment to the advancement of journalism history. Equally important for an understanding of contemporary newswork is the question of the historical conditions under which media technology was internalized by newsworkers and became part of the rationale for journalism as a profession. More specifically, the acquisition of specialized skills can only partially define the realm of newswork, which also consists of intellectual curiosity and creative freedom—unless the ques-

tion of professionalization has become another effort to control journalists and their access to the media.

As it stands now, the history of journalism also reinforces the division of labor between intellectual and manual work with its particular approach to the position of newsworkers. In the process of transformation from a craft orientation among printers and editors to a division of labor between printers and journalists, for instance, the positioning of educated labor interests against owners becomes an important aspect in the struggle for control over content and versions of truth. More specifically, the physical and ideological separation of journalists and printers created workplace conditions that enhanced managerial control over the labor force through the acknowledgment of specific forms of knowledge and technological expertise. Thus, journalists appear isolated from printers and press operators and their particular interests because of their designation as a professional labor force.

But the process of professionalization also affects the content and goals of the media and suggests fundamental changes in the responsibilities of newsworkers and the nature of the press, which becomes more interested in hearing its own authoritative voice echo in the public sphere than in producing an active and critical public. As a theoretical context, such a division of labor—with the consent (and perhaps encouragement) of media owners—suggests an inquiry into the legitimation of journalists (as opposed to printers) through the process of professionalization. In addition, the process may have other consequences; Daniel Hallin (1985, 140), for instance, wrote that professionalization in American media transforms the political discourse and "narrows discussions to questions of technique and effectiveness," which also suggests significant limitations on what a public can expect from its media.

The conflict between newsworkers and media management has never disappeared; it has taken new forms, however, with the changing structure of American society. The belief in progress has given way to faith in production, which rests more than ever on the abilities of the workforce—including the professionalization of journalists—at a time when the media industry has consistently gained economic and political ground with the emergence of an information society. The drive toward technological perfection requires making adjustments to the workforce and increases control over journalistic "output" at the expense of diversity, human creativity, and the type of intellectual discourse that ultimately benefits the needs of society. The histories of the press document—inadvertently, to be sure—the demise of a great idea: from journalism that serves the interests of society to media organizations that serve the interests of those who control them. They fail to explain—advertently—however, why contemporary journalism suffers rather than benefits from the technological advancements of the media and why society is the ultimate loser.

A cultural history of journalism, then, shifts its focus to the process of communication in society, including the experience of newsworkers, the cultural and political perspectives of journalists as participants in the labor process, and the relations between reporters and their public. As I have said elsewhere (Hardt, 1989, 129; see also chapter 8), such a history "exposes the reigning ideology in society, raises questions about the exercise of freedom of the press, and tests its validity as a cherished and celebrated principle of society under current economic and political conditions." The realization of a working-class perspective of media history, with its emphasis on the experience of the workplace and the introduction of technologies and their effects on the definition of participation in the community, would contribute significantly to the demystification of the profession and of the relationship between the American media and their labor force in contemporary society. Journalism history needs the substantive insights of a social history that embraces the concerns of a working class history to move beyond its marginal status within the field of historical inquiry.

American press history represents the "celebration of a technological and commercial rationale for the emergence of the American press at the expense of social and cultural considerations. Consequently, the conceptualization and writing of press history remained committed to the perpetuation of a belief in the American revolution that is grounded in visions of pluralism and democracy, lived and experienced through journalism as the manager of public opinion" (Hardt, 1989, 125; see also chapter 8).

In fact, the success of journalism history rests on an ability to engage the imagination and to break through the complacency of the field by exposing the sources of media power and manipulation and by tracing the failures of the political system to protect the cultural integrity of individuals and to foster their abilities to communicate. A cultural approach to journalism history will help to expose not only the conditions of newswork but also the meaning of professionalization in the context of accommodating newsworkers while satisfying the demands of commercialization; more important, perhaps, such a historical analysis will contribute to describing the current position of newsworkers facing technological innovations and to redefining newswork. As part of an inquiry into the status of intellectual and manual work in the United States and the role of journalists in the enlightenment process in a democratic society, the history of newsworkers raises specific questions about control over processes of generating and legitimating knowledge, of creating political and economic realities, and of defining norms of participation in society.

10

The End of Journalism: Media and Newswork at the Close of the Century

The decline of capitalism and socialism as the dominant utopias of the twentieth century has been accompanied by a collapse of their respective ideological constructions of communication, participation, and democracy, including the role of the press and the function of journalists.

Proclaiming the end of journalism—following earlier, more provocative pronouncements about the end of ideology (Bell, 1960), history (Fukuyama, 1992), science (Horgan, 1996), or the world (Leslie, 1996) for that matter—is more than a belated polemic concerning the current dilemma of journalism in the United States. It is a also reminder of a historical process in late capitalism that reveals the subordination of journalism as a cultural practice to the economic rationale of marketing and new information technologies. As a result, widespread agreement seems to exist among professionals that "mass communication as we know it is dying" (*News in the Next Century,* 1996, vi), not only because of the introduction of an inexpensive and accessible communication technology that offers more choices to some but also because of fundamental changes in the meaning of journalism. Whereas the latter are rarely addressed, the former is ceaselessly promoted by media conglomerates that demonstrate a ferocious appetite for controlling larger portions of the traditional media spectrum and for the financial promises of the Internet—whose virtually limitless potential for social empowerment, however, is no guarantee of freedom from domination by the profit orientation of private corporations. In either case, commercialization dictates the nature of journalism and prescribes the limits of public interest.

American journalism—predicated on the principle of a free press that combines notions of technology and democracy to demonstrate the potential power of a free flow of ideas—is also a cultural practice that is tied to the specific historical conditions of society and is subject to the social, economic, and political developments by which society is shaped and defined. Yet, over the course of the last century the utopian vision of journalism as an independent fourth estate, based on the accomplishments of journalists rather than on institutional claims of the press, has been gradually replaced by a commercial solution whose economic consequences have trivialized the traditional, social, and cultural codeterminants of journalism—including journalists, newswork, and the pursuit of public interests.

This chapter constitutes a critical reading of historical representations and contemporary observations of relations between the press and journalists that identify and define the conflict between the ownership of the means of communication and intellectual labor regarding the practice of journalism. As such, it reflects on the narratives of journalism histories and contemporary periodical literatures, which—like other cultural products—evolve in the context of specific professional experiences and beliefs; they are the expressions of the social, political, and economic conditions of specific historical moments and represent the ruling ideas of the time.

The chapter also suggests that the dilemma of contemporary journalism, frequently addressed in economic terms and focused on the changing nature of media ownership, is the end product of a preferred cultural construction of journalists. Such a construction is a historical phenomenon that has its roots in the making of American journalism and the relationship between the institution of the press and the individual contribution of labor. In fact, the idea of journalism as a cultural practice has undergone significant definitional changes related to shifting notions of work, including technological advancements in the workplace, and the predicament of a volatile market economy as media interests merged with the politics of mass society.

The press has rarely been a facilitator of intellectual labor free from a business-oriented paternalism that has directed journalists in their work. Thus, this chapter focuses on the inadequacy of a labor perspective by considering newsworkers and their changing visions of journalism vis-à-vis the construction of their professional roles by the institutional authority of the press. The social and political consequences of a hegemonic approach to professionalism are the demise of traditional notions of journalistic practices and the rise of corporate power and control over the contemporary role and function of journalists, the manner of "mass" communication, and the purposes of the media in general.

Such conclusions have serious consequences not only for the profession, including professional education, but also for society and the relation-

ship of information, knowledge, and democracy. They suggest not only a new system of gathering and distributing information but, more fundamentally, a new authority for defining the nature and type of information that provides the foundation of social and political decisionmaking and a new partisanship that embraces the patrons of commerce and industry. In this sense, the partnership offers a new understanding of democracy as private enterprise rather than public endeavor, when the extent and quality of information—including its specificity and accessibility—depend more on the social, economic, and political needs of commerce and industry than on the requirements of an informed public.

When journalism serves society in the role of information broker, it has been strengthened by its history and fortified by the perpetuation of its myth, which rests on a belief in the availability of truth, the objectivity of facts, and the need for public disclosure to create and sustain the idea of journalism as a necessary condition for a democratic way of life. Although journalists have played a key role in the advancement of their own cultural and political legacy over the past century, they have frequently been co-opted and deceived by media ownership in its attempts to obtain the confidence of large audiences for political and economic gains.

In particular, journalism histories and reporting textbooks in the United States reinforce an emerging myth of the press as a paternalistic, top-down, cultural phenomenon that allowed journalists' labor to proceed under the protection of First Amendment guarantees that were couched polemically in the name of the press and, ultimately, in the name of democracy. As a result, much has been written about journalistic work, the process of news gathering, and its underlying purpose of serving society and catering to the principles of enlightenment and progress. These writings have strengthened popular versions of the relationship between the press and society by disseminating concepts like "fourth estate," "voice of the people," and "watchdog of society" without direct reference to the role of journalists or the relations between journalists and these claims of the press. Instead, they not only suggest an idealist construction of such relations but reflect an authoritative assertion of power over representations of people and public opinion—including an implied, self-defined, historical obligation to represent and protect the social and political interests of ordinary citizens.

Nevertheless, the myth of a strong and impartial press operating in the interest of society has prevailed throughout this period, strengthened, no doubt, by self-promotion—including the writing of a celebratory journalism history—and occasional journalistic accomplishments that had more to do with indulging individual, unfettered activities of enterprising journalists than with collective corporate action based on the social consciousness of press ownership. Such an image of the press includes the labor of journal-

ists whose role has been successfully contained within the organizational media structure through a ritual of appropriating not only journalists but also audiences, the obvious accomplices of journalists in their search for societal truths.

Appropriation describes the historical process of incorporating journalists into the system of information gathering and news production while dominating the conditions of employment and the definition of work, including the determination of content. Appropriation involves the reinforcement of traditional myths representing notions of institutional power and expert communities and suggesting journalists' active involvement in the activities of the fourth estate and its "professional" practices; it is a process that confers status and, combined with the promise of upward mobility, reflects effective social and cultural incentives for individuals in their quest for personal recognition and success.

Tracing the creation of such myths may serve as an important source for understanding the history of journalists and the limits of their practices, since the process reveals the interests of the press and its effect on the prevalent public definitions of journalism. Those definitions also provide a measure of control over audiences in their consideration of the potential role of the press in society.

Thus, the history of adopting the fourth estate and its subsequent treatment in American journalism literature provide an appropriate example of how a specific institutional image of the press prevails, embracing the class-conscious social and cultural origins of the concept and revealing the proximity of its bourgeois interests to issues of class and privileged standing in society while disregarding the issue of labor. The notion of the fourth estate has served to explain the role and function of the press in the United States for most of its history, although the notion was originally used in England to refer to the standing of journalists within a class-conscious society vis-à-vis the nobility, the clergy, and the commons, which constituted the traditional estates and their entrenched interests.

The idea of "estate" reflects a consciousness of social differences that became a major political issue in Europe during the nineteenth century, when democratic movements demanded equality and representation by challenging traditional definitions of the state and the privileges of the ruling classes. Thus, in a footnote to his "Critique of Hegel's Doctrine of the State" in 1843, Karl Marx (1975, 124) explained that "an 'estate' (*Stand*) is an order or class of men in civil society which is distinguished by trade, profession, status, etc. In the sphere of political society 'Estates' (*Stände*) is a term used to designate that body which in the field of legislation represents the various particular interests of civil society."

With the beginning of industrialization two different theoretical models of social and political change appeared in Germany to explain the emerging

working class. One was based on claims of Karl Marx and Friedrich Engels that the division of society into working class and bourgeoisie is a historical necessity; the other one was based on an argument by Wilhelm Heinrich Riehl that traditional class distinctions are insufficient explanations of social transformation. Riehl's designation of the fourth estate as "a class of the classless" or "the negation of all classes" (1990, 231) incorporates the proletariat, among others, and represents a conservative attempt to deal with the process of "socially organized discontent" (1990, 232). It reflects the consequences of social change, when individuals break away from or are rejected by traditional forms of the social order and are temporarily united in a struggle against historical continuities of society. The fourth estate represents the process of entering modernity, with all of its dire consequences, for those who seek salvation in the ways of the past. For Riehl (1990, 257), "The fourth estate is with us, like it or not, and since factories are also with us, and since journalism is with us, and since the world is no longer the world it once was, its impact will not be merely transitory."

Regardless of any particular theoretical position, however, the consequences of industrialization became a major topic during the late nineteenth century and were the focus of debates about a new social order. Whereas Marx talked about the potential of class consciousness among workers, Riehl (1990, 253) addressed the consequences of possessing "labor but not property" as an indication of cultural disintegration rather than social consolidation. Both positions contributed to the "social question," which deals with the relationship between middle-class interests and the emergence of a large and potentially destabilizing working class and occupied political economists in nineteenth-century Germany.

Designations by class or class analysis were never common in the United States. Journalists did not see themselves as representatives of the working class and were not categorized by social theorists or politicians as class-conscious workers or members of a specific estate. Instead, journalists were regarded as belonging to and representing the ownership of the press rather than being part of an intellectual proletariat, as was the case in Europe. Thus, the origin of the term *fourth estate* as it relates to the practice of journalism belongs to a European tradition of estates, particularly to the British fondness for class distinctions. When the concept reappeared in the U.S. journalism literature, it signified the perceived and argued standing of the press among other institutions in society.

Accordingly, it was Thomas B. Macaulay who described the press bench in the British House of Parliament as the fourth estate, thus granting social standing and prestige to representatives of newspaper proprietors who had a growing interest not only in the political affairs of Parliament but in political life itself. The term rose to prominence by the mid-nineteenth century and signaled the recognition of the press in the realm of pol-

itics and confirmed journalism's rise from its disreputable beginnings as a source of gossip and entertainment to its role among political institutions as a credible mover of information and public opinion.

In fact, George Boyce (1978) provided a treatment of early British newspaper developments and offered a useful and extensive appraisal of the concept. After tracing the mythology of the fourth estate through British press history, Boyce concluded that as an ideological construction it legitimated the status of journalists within the political system and their opposition to state control of the press. The idea of the fourth estate gained respectability and credibility in a climate of commercial and political interest in the potential of information; and the British press, "with its head in politics and its feet in commerce," succeeded in promoting the fourth estate as a useful myth, which served to sell papers and political influence (Boyce, 1978, 27).

At the time the fourth estate appeared in the American press vocabulary, it was also employed to secure recognition, status, and, ultimately, power within the political establishment. Despite the fact that the term acknowledges social differences, if not a class structure, and reflects a political standing in society, it was appropriated and used to describe a democratic process. For instance, a number of contemporary dictionary definitions reinforced the institutional nature of the term. The fourth estate is "a group other than the clergy, nobility or commons that wields political power" (*Webster's*, 1971, 899); it was found "formerly in various jocular applications . . . now appropriated by the press" (*Oxford*, 1989, 407) and has become a "traditional, almost cliché term for journalism and the press" (Connors, 1982). A more recent entry suggests that "the term pays tribute to the power of the press, which is thus ranked with the three traditional 'estates' or orders of medieval and early modern society—the nobility, the clergy, and the commons" (*Encyclopedia Americana*, 1993, 675).

According to Herbert Brucker (1949, 30), "Some time in the early nineteenth century this unofficial designation of Fourth Estate became attached to the press." He suggests that "sincere editors use the term when pouring out their hearts about their profession; and publishers who don't like a Wages and Hours Act find in it a convenient shield against the future." Almost twenty-five years later Brucker argues (1973, 82) that the conception of the press as a fourth estate provides an understanding of the place of information in a democracy and confirms its independence: "ideally, journalism is a neutral agency not associated with any of the other estates that make up the body politic."

The work of John Hulteng and Roy Paul Nelson (1983) is perhaps typical of the use of the term in U.S. journalism literature, where it reflects the idea of an independent press vis-à-vis other institutions, including the government. This usage is also consistent with earlier interpretations mani-

fested in journalism histories. For instance, George Henry Payne (1924) devotes a chapter to the "rise of the fourth estate" that deals with the beginning of journalism in the United States. According to Payne (1924, 59–60), "the veritable creation of a new Estate" that represents a new power based on the idea of the liberty of the press, whose rise suggests that "henceforth the history of the country is not of kings and battle, but largely of that power and of those wielding it." Finally, Leonard Levy (1985, 291) concludes that the "most common libertarian principle of a free press espoused by newspapers revealed their watchdog function as the Fourth Estate."

An understanding of the business side of the press as a fourth estate is reflected in the editorial positions of trade publications. For instance, the *Fourth Estate,* established in 1894, carried in its masthead a quote attributed to Carlyle (in "Heroes and Hero Worship, Lecture V") that read, "Edmund Burke said there were Three Estates in Parliament, but in the Reporters' Gallery yonder there sat a Fourth estate more important far then they all." The quote appeared opposite the designation, "A newspaper for the Makers of Newspapers and Investors in advertising." In 1927 the *Fourth Estate* merged with *Editor & Publisher,* whose position had been strengthened by a merger in 1925 with *Newspaperdom,* a trade magazine for small-town weekly newspapers. Thus, when *Editor & Publisher* emerged from the late 1920s as the strongest trade publication in the United States "serving the journalistic field," it primarily addressed the "makers of newspapers" and embraced the idea of the fourth estate as a condition for business. Similarly, in 1911 Joseph Medill Patterson, later publisher of the New York *Daily News,* wrote a play *The Fourth Estate,* which reflects on the standing of newspaper publishers in the world of business and high society.

The term *fourth estate* also entered legal and philosophical interpretations of the First Amendment in efforts to clarify the position of the press. A well-known contemporary interpretation was rendered by Supreme Court Justice Potter Stewart (1975, 636), for instance, who suggested that the primary purpose of a constitutional guarantee is to create a "fourth institution outside the Government as an additional check on the three official branches." He added, "The relevant metaphor, I think, is the metaphor of the Fourth Estate," and he referred to the British usage of the term to argue that the survival of "our republic" would be impossible without an autonomous press. Similarly, James Boylan (1986, 37) reported that Harrison Salisbury had described the publication of the Pentagon papers by the *New York Times* as an occasion on which the newspaper had "quite literally become that Fourth Estate, the fourth co-equal branch of government." More recently, Bernard Schwartz (1992, 132) claimed there were indications that Americans "had a concept of the press similar to that

attributed to Burke by Carlyle," and he agreed with Levy that by the time of the First Amendment, U.S. newspapers had achieved a "watchdog function as the Fourth Estate."

These authors acknowledge the preferred position of the press to act in the name of the public and its right to know. They represent a point of view that accepts or favors a strong and independent role of the press, with no indication, however, that the consequences of industrialization in particular had also produced the rise of large political constituencies that were important to political and commercial interests and had the attention of the press. As a result, social and political diversity was quickly appropriated, processed, packaged, and labeled by the press as an expression of public opinion, disregarding issues of autonomy and representation. There was no reflection of social, racial, and economic diversity and its consequences in a democratic society—when the press seized the role of supporter, defender, and upholder of public interests—but rather a specific, self-indulgent mission and an awareness of the political importance of representation. As a result, the preferred interpretation of the press as a fourth estate is repeated in the general literature of journalism and political appraisals of the press throughout most of the twentieth century. Not to be outdone and searching for an independent identity, the broadcasting industry adopted the term the *fifth estate* during this period; according to Judith Waller (1946, 3), radio "has become the Fifth Estate, a factor in the life of the world without which no one can reckon."

With increasing media criticism and a more sophisticated understanding of the relationship between media and society, however, the idea of a fourth or even a fifth estate, for that matter, has run into severe problems related to the social and political consequences of power, influence, and responsibility. For instance, among contemporary issues surrounding the notion of a fourth estate is the problem of accountability, which raises questions about the nature of representation, including competence, compatibility, and the consequences of acting on behalf of the public. Lucas A. Powe Jr. (1991, 291) expounded on the fourth estate model of the press as set forward by Potter Stewart and suggested that "whether and how the press is to be held accountable represents the important intellectual gulf between the right-to-know model and the Fourth Estate model of the press." A more detailed attack on the fourth estate model that not only provides power without responsibility, but also assumes a passive audience came from Patrick M. Garry (1990, 127). He acknowledged the typical characterization of the press as "an agent of the public, in a separation of power scheme, that functions to check abuses of governmental power" and recognized that the press also becomes an independent participant in the political process and "serves an equalizing function between government and a disorganized and helpless society."

At issue is the problem of identifying the interests of the press with those of the public and whether such a model will ultimately weaken the democratic process. At stake is the relationship between the media and their respective publics, that is, how the media define service and accessibility in ethnically and economically diverse communities. According to Garry (1990, 131–133), the fourth estate model "effectively enhances and magnifies the power of one of the participants in the communication process—the owners of the mass media—with apparently no thought of imposing on the press concomitant responsibilities to assure that the new protection will actually enlarge and protect opportunities for expression." Instead of providing a forum for public issues, it seems that "the fourth estate model theory creates a fourth bureaucracy with substantial power and quite separate from the general public." Similarly, John Merrill (1974, 117) raised the question of how a fourth estate, or a "fourth branch of government," is constituted and for whose benefit, calling the idea "not only mythical, but almost farcical."

Since its introduction, the term *fourth estate* has helped to reinforce the widely accepted notion of a powerful press and to restore confidence in the political position of the press and its right to express and represent public interests. The enthusiasm for a term that also confirms an extra-legal, privileged, and elitist position of the press has faded in recent years, however, perhaps in part because of public dissatisfaction with media performance and the failure of the media to provide moral and substantive leadership for the people they purport to represent and in part because the relationship between business and politics, which includes the media, has become too obvious to support a separate claim. Instead, the media have adopted a patronage model; they are responsive to those who seek their services, that is, advertisers and their respective consumer-audiences. Journalists are caught up in this process; they reproduce the conditions of patronage and are reduced to advance the task of advertising departments, as the fourth estate has no desire to speak for the "estateless" but rather speaks in a paternalistic fashion, whereas those who "possess labor but not property" (Riehl, 1990, 253)—including journalists—are reduced to objects of commercial greed and political manipulation.

Whereas discussions surrounding the emergence of a fourth-estate model of the press have focused on the institutional representation of such an estate, the position of journalists as members of the estate and their relations with the ownership of the means of communication have not been problematized; even critics of this model have disregarded issues of intellectual production (journalistic practices) as a separate problematic. By dealing with the press as an inclusive concept, however, considerations of intellectual labor become neutralized and serve the antilabor interests of the media rather than the interests of working journalists and their particular

concerns as they relate to the conditions of labor, freedom of expression, and the relations of production.

The conditions of journalism in modernity and the contemporary task of the media are shaped by the rising importance of information, the impact of technology, and the commodification of knowledge. The inevitable shift to an information society has made different demands on journalists and their relations to each other and to their institutions and affects the notion of work itself when information and knowledge, rather than property, constitute social and political power (and divide society into classes). Consequently, "Work comes to be less and less defined as a personal contribution and more as a role within a system of communications and social relations," according to Alain Touraine (1995, 188), who also observed that "the one who controls exerts influence on the systems of social relations in the name of their needs; the one who is controlled constantly affirms his existence, not as a member of any organization, element of the production process, or subject of a State, but as an autonomous unit whose personality does not coincide with any of his roles." The result is not only an increasing sense of alienation but a changing perception of what constitutes journalism and, therefore, public interest and social responsibility at the dawn of the twenty-first century.

And yet, in the past the celebration of technological progress obscured or concealed the fate of journalistic labor, particularly in historical accounts that shaped the understanding of journalism in society. Thus, mainstream narratives of American journalism history introduced the use of new media technologies as an institutional accomplishment while disregarding its effect on working journalists. Specifically, Emery (1978), Hohenberg (1973), Jones (1947), and Mott (1942) remained oblivious to the impact of technology on newsworkers but agreed that media technologies are essential elements in the trend toward specialization within newsroom labor. More recently, Emery and Emery (1988) attributed the distinctness of newswork to communication technologies without elaborating on the conditions of newsworkers who have been forced repeatedly to reinvent their professional existence in light of encroaching technologies (Hardt, 1990, 351). These observations in standard journalism history texts support popular beliefs—and a form of crude capitalism—that media technology is an assertion of inevitable progress; they are produced in the spirit of endorsing an institutional history of the press that refuses to problematize the rise of media technologies and totally neglects the human dimension of labor, like the impact of technology on the work environment, the definition of work, freedom of choice, and, ultimately, the professional status of individual newsworkers.

This development is documented, however, in the unwritten collective biographies of American journalists and their loss of control over defini-

tions of work and, ultimately, their professional identity; it appears in more recent observations by media historians about news and the changing conditions of labor. Thus, when news evolved as a central value of American journalism during the 1870s, according to Hazel Dicken-Garcia (1989, 60), it resulted in a shift from "news *persons* to news *selling,* and an editor-centered, personal structure gave way to corporatism, focused on advances in technology, increased competition, large circulations, diversification, and advertising as a means to profit." Similarly, James Carey (1969, 32) observed three decades ago how the rise of objective reporting, for instance, demanded technical instead of intellectual skills and resulted in a "conversion downward" for journalists.

The subsequent introduction of new communication technologies, ranging from the telegraph and telephone to computers not only strengthened management control but also increased the anonymity of the work process and reduced journalists' expectations of recognition for their unique intellectual and creative contributions to the profession. In fact, according to Marianne Salcetti (1995, 49), the contributions of newsworkers since the late nineteenth century have been "increasingly bordered, and in turn valued, by their technological place in the production process of gathering, writing, and producing news." On the other hand, whereas Douglas Birkhead (1982, 220) talked about the fact that "the journalist as professional seemed to extend the rationality and efficiency of technology into the newsroom," Charles Derber (1983, 327) warned that the "technicalization" of professionals must lead to "ideological proletarianization," and Yung-Ho Im (1990, 112) acknowledges a decisive change in the status of journalists when he concludes that "reporters, as a newly created breed of newsworkers, still carried the old label of journalists, but without as much individual voice and discretion . . . as journalists of the earlier days of personal journalism."

The "downward conversion" reflects commercial considerations of the marketplace that focus on the technical expertise of information retrieval rather than on the competence of critical analysis; the latter has been shifted to educated consumers or left to experts whose ideological perspectives, even if oppositional, seem agreeable to management, because authorized dissent helps to legitimize the dominant power structure. Hence, intellectual requirements of contemporary journalists are replaced by technical knowledge to comply with corporate media goals, which divide the workplace, fragment the reportorial process, destabilize journalists' professional worth, and alienate them from their own labor. All the while, decisions regarding the definition and treatment of news are centralized in a media bureaucracy dominated by specific management concerns. Under these circumstances, some observers have noticed that "professionally trained journalists . . . could become increasingly less necessary to the process of

gathering and distributing information" (*News in the Next Century,* 1996, 21).

In other words, contemporary journalists encounter growingly routinized work situations and a definition of professional autonomy that is "bordered" by the technical aspects of news production and dissemination that constitute their concrete experience of the labor process. This understanding of work has prevailed in American journalism for some time—long enough to have created an atmosphere of diminished expectations among journalists—despite institutional efforts by the press to counterproduce a positive, empowering image of professional standing and social responsibility by identifying with journalism as a public service and appropriating journalists as executors of the public will. Journalists, however, have grown less committed to their choice and place of work and remain autonomous in their personal life and in their attitudes toward a specific engagement in the public cause of journalism. As William Solomon (1995, 131) observed, "like their counterparts of more than a century ago, today's newsroom workers increasingly are coming to view their work as combining a sacred public trust with a temporary job."

Despite the undisputed theoretical and historical importance of the role of journalists in the democratic process, no sustained public debate has occurred in the United States about safeguarding their professional practice for the sake of a free and independent flow of ideas, regardless of the proprietary economic and political interests that represent the ownership of the press. Indeed, in a society in which historically property rights have been protected far more than other rights, including the right of expression, press ownership dictates the type and quality of journalism, as well as its purposes, and typically sides with propertied interests. Thus, when the activities of the media occupy the public imagination because of their perceived effects on society, journalists are frequently viewed collectively by society as members of the media establishment. Consequently, as long as they are identified or identify themselves with the institution of the press, journalists will be defined in terms of private rather than public interests. In fact, corporate media authority treats journalists as newsworkers rather than as free-floating intellectuals not only by appropriating their professional aura but also by obstructing or blocking possibilities of professional alliances among journalists or with their audiences in defense of journalism as an intellectual contribution to the discourse of society. As a result, journalists have been subject to a history of subjugation by those in control of the means of communication who have used the idea of professionalism to validate their own commercial purposes and to enhance public perceptions of the press as an institution.

Specifically, traditional histories of the press have constructed journalists as an anonymous labor pool whose activities were subsumed under var-

ious descriptions of the press or the accomplishments and control of its owners (Hardt, 1990; see also chapter 8). For instance, the formation of unions and the operations of organized newsroom labor have been actively discouraged, if not opposed, by press ownership since the 1920s, when such activities began; a few years later, news organizations started to regulate professional conduct and discouraged journalists from joining civic organizations. In the 1990s, whereas some publishers remain suspicious of what has been called "public" journalism, a "hot, new secular religion" (Stein, 1995, 18–19), which admonishes journalists to become positively involved in community affairs, others use the appeal of "civic" journalism to boost their service to clients—disguised as "the public"—in attempts to promote image and sales while appeasing critics.

Indeed, when public journalism has become a rallying cry for media critics, it has been for making journalism more public and, therefore, more responsive to the needs of the community. This effort has been spearheaded by Jay Rosen's (1994) attempts to organize newsworkers behind the idea of community as a relevant category of journalistic concern. Still, the discussants of civic journalism typically represent the interests of media management or journalism education rather than journalists, whose concerns have always been on the side of public curiosity and the need to know. Thus, at best, considerations of public service reflect a continuing struggle between media managers and journalists over defining the nature of work and work environments; at worst, they indicate different ideological positions on relations between journalism and society. In either case, the collective economic and political power of media proprietors persistently prevails over the professional sentiments of poorly organized, dependent newsworkers.

The notion of professionalization became a major ideological force of press management in the separation of newsworkers from their fellow employees and the public. The former were regarded as sufficiently different in their practices, whereas the public was constructed as an objectified source and destination of information rather than a cultural context of subjective experiences and participation.

Indeed, the evolution of "professionalization" as a strategy of separating shared labor interests among printers and editorial workers by promising social status and professional independence remains a major source of explanation for the diffusion of the editorial labor process and management's continuous domination of twentieth century journalism. The organization of labor interests among journalists as a potential weapon in a fight for independence was successfully quelled when professional status became a myth carefully constructed by press ownership to isolate and defeat union activities in the wake of mounting pressures by organized labor. Edward Herman (1996, 120) observed that, after all, "professionalism was not an antagonistic movement by the workers against the press owners, but was

actively encouraged by the latter." He characterized professionalism as a "badge of legitimacy to journalism" that divided the varied interests of labor in media industries. This is also an appropriate example of how professionalism in modern society evolved into an ideology that, according to Peter Meiksins (1986, 115), more generally "exercised a powerful hold over significant portions of the workforce and placed formidable barriers between those occupations which define themselves as 'professions' and other types of wage-labour."

In this context, deprofessionalization as a consequence of deconstructing institutional representations of journalists may help restore creative and intellectual autonomy to individuals in their roles as journalists at a time when a persuasive, symbolic process of negotiating representations of reality and making social knowledge is replacing the model of privileged journalistic discourse based on independent notions of truth and objectivity. As a result, journalistic practice would be situated close to literary craftsmanship and its intellectual standards, as Theodore Glasser (1996) has argued.

But the question of professionalization is ultimately tied to the changing notion of work; whereas intellectual labor originally constituted a personal, autonomous contribution to the advancement of knowledge and the spread of information, for instance, its contemporary version of editorial work under the control of media management becomes a technical requirement within an information system designed to serve an elitist clientele rather than the public. In this context, journalists seem to lack the power of a professional class whose policies and practices should matter enough to warrant First Amendment protection of intellectual autonomy against the influence of media organizations, for instance, to affect editorial decision-making. A U.S. Supreme Court decision (Cohen v. Cowles Media Co.) in 1991, however, guarantees the power of publishers to reduce significantly the professional autonomy of newsworkers. Thus, private business interests prevail over potential public concerns regarding the need for professional independence and occupational integrity and result in the defense of institutional rather than individual welfare.

The changing definition of news has become a major issue in ongoing debates among journalists and in a literature that deals with the consequences for the press of business philosophies and management styles. Recently, for instance, Doug Underwood (1993) provided a detailed analysis of how a marketing approach to journalism is reshaping contemporary media. Although he is highly critical of such trends, Underwood suggests that the daily press can still present an independent, analytical, and in-depth alternative to television; unwilling to give up on the press, he pleads with press ownership to adjust profit margins, reject the formation of media conglomerates, and embrace the "traditional values of public service

and the principles of public trust that are the bedrock of the profession" (1993, 181). It seems highly unlikely that the ownership will follow his advice; on the contrary, with a labor market saturated with inexperienced journalism (and other university) graduates as sources of cheap labor and unemployed journalists with expert standing, media management will continue to dictate labor conditions and extend its reach into new media markets—especially with increasing competitive pressure from new media, such as computers and information services like the Internet. As a result, the need is increasing for seeking maximum profits to absorb competitors or reinforce their current hold on their own market, particularly among newspapers as circulation losses continue to plague the industry (Fitzgerald, 1995).

More specifically, since the mid-1980s business news sections increased, and newspapers like *USA Today* have been founded to cater primarily to the business traveler as news agencies have found the business news market to be the most lucrative aspect of their various services. Such developments have come at the expense of strengthening and expanding hard news and news analysis. The emphasis on business affairs was the first step in reinforcing media ties with advertisers, only to be followed by further packaging and marketing of the press to comply with advertisers' and readers' demands for commercially safe and reader friendly content. For instance, Sears executives have suggested that "a strong partnership" with newspapers depends on their response to the specific needs of retailers: "Whether you're a department store or a newspaper, the recipe for success in the years ahead is the same: continual self-analysis, hard work, an open mind, excellent people, lots of patience, and, more importantly, a strong customer focus" (Consoli, 1995, 25).

The process of news gathering has typically been informed by an understanding of existing social and economic inequities in society; however, the rapidly shifting imbalance between accumulations of wealth and the growth of poverty accommodates representations of political and economic strength and prescribes considerations of class, gender, and race as economic categories of consumption that redefine the adversarial function of the press and result in a friendly alliance with business and industry. Indeed, the key to understanding the dilemma of contemporary journalism lies in its definition by the ownership of the press; such definition, however, is always self-imposed and generally serves owners' immediate political and economic interests. As Milton Friedman (1970) observed, businesses are responsible only for making profits and obeying laws. Consequently, the commodification of news—that is, news as an industrial product, remains immune to traditional demands for socially responsible content but is guided instead by market requirements and the standard legal restrictions governing defamation and invasion of privacy. In this sense, the manufac-

ture of news no longer demands professional involvement but can be accomplished by a cheap labor force that is computer-literate and attuned more to packaging information than to exercising analytical skills.

In fact, the process of deskilling—introduced by Harry Braverman (1974) as an explanation of how technology (or scientific rationality) has transformed the status and skill of the modern workforce—continues to affect contemporary labor, also threatens journalism, and, ultimately, devalues journalistic labor power. As a historical phenomenon, the process of deskilling moved from the creativity of personal journalism to the routines of objective reporting, when events rather than ideas directed professional practice. Im (1990) examined Braverman's deskilling thesis in the context of arguing for a labor process approach as a conceptual framework of a labor history of journalism that would address issues of work and class.

More recently, however, the reproduction of information has overshadowed earlier developments and now determines the nature of journalistic labor. This shifting notion of skills raises questions about the nature of professionalism at a time when the threat of unionization has been diminished, if not eliminated, and the large-scale replacement of newsworkers with cheap labor has become a real alternative under changing definitions of newswork. The process of deskilling (as a managerial practice) confronts individual journalists everywhere and has yielded responses ranging from attempts to preserve or redefine skills in an effort to satisfy the demands for a new type of journalism to active resistance and, finally, to resignation from the profession.

Journalists, however, have never challenged the organization of media power directly and collectively in part because their ideological position—that is, a shared belief in the virtues of capitalism and the subordination of subjective notions of professional practice to technological demands—has been maintained with organizational consent, if not urging, and in part because traditionally journalists have constructed labor problems in terms of individual, local conditions rather than systemic, class-related issues. They also compensated in other ways, ranging from a short-term commitment to journalism or physical mobility to engaging in unrelated external activities. For instance, Bonnie Brennen (1995, 104) reported on the use of period novels as a type of creative protest against the debasement of individuals and suggested that during the 1920s and 1930s "a sense of class-consciousness encouraged journalists to contest their oppression and challenge the dominant hegemony of the newsroom." More recently, the rise of newsroom activism has been another example of how individual journalists, through informal professional relations, have struggled against race and sex discrimination in the workplace and, frequently, in opposition to imposed management structures on the flow of information within the newsroom (Byerly and Warren, 1996).

Such activities may be locally contained, but examples can be found of nation-wide trends among newsworkers that may lead to an increased sense of political awareness and that suggest that in the long run, dissatisfaction among the dependable and loyal, if critical, rank and file will become particularly troublesome for management. Published findings of a national survey by the Human Resources Committee of the American Society of Newspaper Editors (Stinnett, 1989) provide a good example of this dilemma. The survey's discussion of the newsroom, including a characterization of newsworkers, reflects management expectations but cannot hide discontent among journalists. What emerges is an individual who "feels involved in the community, professes the religious values of the whole society, and maintains a deep love and respect for journalism. Many are willing to make personal sacrifices, if necessary, to stay in the newspaper business" (1989, 27). Although professional aspirations concern the opportunity to write rather than to occupy an intellectual role that would include "having an impact on society" (Stinnett, 1989, 31), the accompanying wish list of important tasks is led by an analysis and interpretation of complex problems, investigative work, and fast dissemination of information to the public (Stinnett, 1989, 67). These ideals are severely affected by low pay, lack of recognition, low job satisfaction, and the feeling that the press is "adequate but not outstanding" in its pursuit of community issues.

Also, journalists have a weak sense of longevity regarding their positions despite better education and job preparation through journalism education. A recent nationwide "newspaper departure" study suggested that over 60 percent of employees who leave newspapers also leave the industry because of a lack of "fairness in promotions; involvement in decision-making; opportunities for advancement; supervisor concern for employees' personal success; fairness in pay; equitable treatment; and contributions in value" (*Editor & Publisher*, 1995, 23).

Some time ago, authors like Breed (1955), Gans (1980), Gitlin (1980), and Sigal (1973) commented on journalists' practices and positions in newsrooms; together with other, more recent observations and laments they seem to substantiate current findings (e.g., Weaver and Wilhoit, 1996) that newsworkers are caught unhappily in a work situation that leaves little room to maneuver. Emerging from the practices of contemporary advertising and public relations efforts is a new type of journalism that promotes the construction of corporate realities at the expense of a common-sense desire for a fair and truthful representation of everyday life. Its ideological role resembles the political task of a Soviet-style press, with its specific goals of organizing and propagandizing the masses to maximize socialization in an effort to centralize political power through participation in the commercialization of social differences to form a "consumer" culture. In this process, freedom of expression is reconstituted as an institutional right

of freedom of the press with claims of representing individual interests that sound not unlike earlier claims of centralized political systems, such as those in Eastern Europe under Soviet rule, to speak collectively for society. One of the dangers of the anticipated or realized business mentality of the media is that content, which represents an expression of freedom, will be defined by those who seek to serve the public as consumers rather than society as the participant in and source of democratic power.

In its ideal version, the press fulfills public duties and pursues private goals as a vehicle of journalism and business; its investment in the social and political life of society, uniquely protected by a constitutional amendment, constitutes a significant contribution to the working of democratic principles regarding the pursuit of knowledge and the need to be informed. In reality, however, the commercial impulse of the press—supported by law and barely controlled by the ethical considerations of its owners—also guides journalistic practices, whereas the desirable balance between responsible journalism and profitable business is rarely accomplished. In fact, contemporary economic and political developments, summarized most appropriately by the notion of "deregulation"—introduced and practiced since the Reagan administration—have resulted in the privatization of public property, like the recent FCC auction of public airwaves, and prepared the stage for the demise of public broadcasting.

More fundamentally, however, ideas of responding to public concerns and representing a public trust are being absorbed or replaced by the strength of private interests, signaling the end of government intervention and public control of excessive commercial power. This process confirms an era of privatization—pitched at home and abroad, particularly in the newly established democracies of Eastern Europe, as the key to a free-market system—which is flawed by an utter disregard for the public good, including the protection of workers, among them journalists. Media organizations in many parts of the world are heavily affected by these developments in the United States, from where a CNN version of journalism has conquered the global airwaves and makes its endless rounds as media everywhere seem to reconceptualize traditional understandings of news and public responsibility in light of increasing commercialization while mistaking private enterprise for democratic practice.

Many years ago, television network news departments were considered public service operations and were divorced from the profit-driven entertainment divisions until someone recognized the earning potential of news. Likewise, the press is undergoing a substantial changeover under the unofficial leadership of the Gannett newspapers and their successful experiments with translating the image and reality of television news onto the printed page, recognizing that a target clientele rather than the public interest will maximize profits. The result has been a significant shift towards the

recognition of business interests in the approach to American journalism—first by management, which used to acknowledge the importance of news and critical analysis as a central mission of the press, and second by newsworkers, whose traditional expectations have been redirected to marketing goals.

Pressure from advertisers, long recognized as a hazard of aggressive journalism, has become a regular succession of requests that generally lead to cooperation and collaboration as a (community) service. In other words, although none of these occurences are new—newspapers have dealt with them before—they are now widely received as guided opportunities to help promote business and improve the standing of the press in its community. Such a community, however, is limited to the community of affluent readers and businesses, both major clients of the information industry. Moreover, in a world in which work is disappearing rapidly, according to William Julius Wilson (1996, 133–134), the media are being used by corporations to exclude the poor from sharing information about a shrinking workplace by not advertising in African American neighborhoods, for instance, thus effectively isolating people from jobs and information about those jobs.

Indeed, the press has joined the electronic media, particularly television, and incorporated older practices of the magazine press aimed at providing business with a reliable, credible, and effective forum for the dissemination of commercial information. Additional downsizing of media corporations, mega-mergers, and an increasing lack of competitors will strengthen these developments and assure their continuation into the twenty-first century. The losers will not only be newsworkers who refuse to cooperate or who retire from the press, but also the public, which will be robbed of the professional skills of newsworkers to undertake the surveillance of business and politics as a matter of public interest.

Left to their own decisions in managing the future of the press, owners have made a series of decisive moves to remain competitive in the media market and to comply with the demands of their major customers, affluent readers, and advertisers. As a result, investigative reporting, analytical writing on social, economic, and political issues, and confrontational stances have been largely replaced by a notoriously placid, if not socially and politically irrelevant, coverage of events. David Burnham (1996, 11) has suggested that American news organizations "tend to be passive and unreflective. Although independent-minded investigative reporting often is celebrated by journalists, it is in fact a rare phenomenon. Despite the self-congratulatory rhetoric, the basically acquiescent nature of daily journalism is a problem that has long been observed by a handful of astute observers." In addition, there is no review of media practices, amid a lack of historical consciousness, or a return to self-criticism and welcome public scrutiny of press performance. Thus, Underwood (1993, 133) concluded,

"Sadly, there are no signs that newspaper executives—fixated on their own market surveys, financial plans, and budgeting problems—are showing much inclination to scrutinize their counterparts in other industries, let alone the affairs of the media themselves."

Above all, journalistic enterprise (or freedom) has been replaced by strict control of the production line which caters to issues of lifestyles, soft news, and entertainment in response to reader interests. In serving the goals of business, traditional barriers between editorial and advertising departments have been removed with the help of editors who either recruit or order journalists to contribute expertise, including their writing skills, to promotional campaigns. Increasing demands on the labor of journalists by advertising departments have shattered traditional boundaries between editorial responsibilities and advertising sales and led to reconceptualizing journalism, frequently against the will of individual journalists and their understanding of what constitutes professional engagement. Consequently, public relations firms, often staffed with former journalists, produce the news, and journalists, forced to abandon their traditional roles, collaborate in the dissemination of directed information that is created by advertisers and thinly disguised as news. This practice in particular has spread to many newspapers, where it has replaced journalistic priorities regarding the application of reportage, investigation, and news analysis; it also undermines the professional rationale of journalism and has led to increasing job dissatisfaction and unrest among journalists.

At the same time, the prevailing practice of academic journalism programs in the United States reflects a continuing reliance on the notion of professionalism as an organizational category of labor when journalists serve in subordinate roles amid decreasing job security and changing interpretations of work and professional freedom in their organizational environment. The consequence of such a media-centered definition of professionalism has been a qualitative shift from education to training in accordance with a more general trend among colleges and universities to cooperate with the specific demands of business and industry regarding job preparation. Thus, any recognition by media organizations of particular educational institutions as certified sites of professional instruction reinforces an alliance with media interests rather than with the needs and interests of journalists, who have yet to define an independent, educational agenda that reflects their own understanding of the public role of journalism and the nature of their profession.

These are the conditions of late capitalism under which the press intends to advance for its own benefit and that of its customers when definitions of the role of journalism in American society have finally been rewritten by the public relations practices of the press. The fourth estate model of the press has never been more outdated than in the current era of political

and economic dependencies among major institutions in society, when a technology-driven information and entertainment culture has converted the labor process into a limited and highly controlled activity, leading to the homogenization and degradation of labor—including the media, news-work, and journalists, respectively.

The demise of journalism as independent, intellectual labor may also be related to journalism and media studies having ignored class positions and embraced assurances of social status, since class and class relations remain significant issues in contemporary considerations of public communication, including journalism (Hardt, 1996a, 1996b; see also chapters 2 and 6 respectively). Thus, initially journalists shared both proletarian and bourgeois characteristics and expressed expectations of middle-classness. But among celebrations of robust individualism in the liberal-pluralist atmosphere of 1920s America, the struggle to recognize the collective interests of newsworkers was lost to the efforts of media organizations to redefine their workforce in terms of professionalism, isolating it successfully from other, noneditorial workers while supporting and reinforcing the denial of the economically expressed working-class conditions of newsworkers. In the 1990s, finally, the drawn-out struggle over maintaining the status quo of professionals, including the quasi-independence of editorial work, failed with the adoption of a patronage model of the press that understands journalistic labor in terms of routinized technical tasks responding to specific commercial interests, such as the production of nonidea, nonevent-centered narratives. Such narratives cater to the entertainment interests of consumers, thereby satisfying advertisers' demands for noncontroversial contextual material to help maximize the impact of commercial messages.

Alternative solutions will not be offered by the commercial marketplace; at best, they may be introduced by a new type of media practice through periodicals or more likely, electronic publications rather than daily newspapers that have the determination and direction that mark ideologically committed journalism capable of providing a point of view for an enlightened readership. This may constitute the only viable journalistic alternative based on the quality and sources of information and objectives that decide questions of public service and social responsibility. Such a solution, however, also relies on a critical general public and its growing desire for more comprehensive information and analysis, which suggests that journalistic success depends on the cultural and economic competencies of a democratic society to support its rising need for journalism and explains the necessary alliance between journalists and their respective publics to reclaim the pivotal role of journalism in the making of democracy.

Jürgen Habermas (1996) promotes the idea of a deliberative democracy based on the centrality of communication—which embraces equal opportunity, participation, and the autonomous process of forming opin-

ions—as a desirable alternative to existing (and applied) conceptions of democracy. Such a model of democracy represents a procedural ideal that promotes an ideal speech situation, the core of Habermas's theory of communicative action. Similarly, it could be argued that the inadequacy of existing media theories resides in a failure to rethink relations between the media and democracy in terms of the potential of communication as a social process that privileges participation and exchange and the autonomy of journalists; in the latter instance, journalism emerges as a responsive cultural practice, administered in a professional manner that is successfully insulated from the control of media management and is sensitive to the need for public participation in constituting social knowledge.

On the other hand, by becoming their own agents commercial and government institutions will continue to produce information packages that serve their specific purposes, with increasing opportunities for direct access to consumers and citizens and bypassing traditional systems of news processing while challenging alternative sources of information and analysis. In fact, this is the dawn of a new partisanship of traditional media, the result of a larger political process of bargaining and compromise to promote and protect selfish interests rather than public participation that will shift the balance between private interest and public responsibility toward a patronage system that considers information a privilege rather than a right as it replaces the specter of a nineteenth-century partisan press. Consequently, a professional vision of journalism ends at a time when American society needs a critical reportorial force; instead, a new journalism is emerging in a form of "mass" communication that will benefit commerce and legitimize the function of advertising in the "commercialization of culture," as Matthew McAllister (1995) has suggested.

The demise of the fourth estate has been long in coming when one recalls the impressive literature of press criticism that has accompanied the economic and technological developments of the press over the past century. But whereas market forces shaped and strengthened the media as a cultural, political, and economic institution in the United States, journalists, whose intellectual labor has lent professional credibility to the process of public enlightenment, have been exchanged for wage labor in the evolution of the information society. Michael Schudson (1995) once declared that news is culture and is therefore apt to change, although he did not know how. The political and economic developments since the late 1980s in particular suggest that news will fit the requirements of a patronage system in which journalists will serve the interests of an affluent and educated commercial class consisting of businesses and their clientele as a new type of partisanship and a new understanding of public interest will begin to dominate the public sphere.

References

Chapter 1
Contemplating Marxism

Althusser, Louis. 1971. *Lenin and Philosophy and Other Essays*. London: New Left Books.

Becker, Howard S., and Irving Louis Horowitz. 1972. "Radical Politics and Sociological Research: Observations on Methodology and Ideology." *American Journal of Sociology* 78:1 (July), 48–66.

Berelson, Bernard. 1959. "The State of Communication Research." *Public Opinion Quarterly* 23:1 (Spring), 1–6.

Bernstein, Richard J. 1967. *John Dewey*. New York: Washington Square Press.

Bernstein, Richard J. 1971. *Praxis and Action: Contemporary Philosophies of Human Activity*. Philadelphia: University of Pennsylvania Press.

Bernstein, Richard J. (ed.). 1985. *Habermas and Modernity*. Cambridge, Mass.: Polity Press.

Carey, James W. 1983. "The Origins of the Radical Discourse on Cultural Studies in the United States." *Journal of Communication* 33:3 (Summer), 311–313.

Carey, James W. 1982. "The Mass Media and Critical Theory: An American View." In Michael Burgoon, ed. *Communication Yearbook 6*. Beverly Hills: Sage, 18–33.

Carey, James W. 1979. "Mass Communication Research and Cultural Studies: An American View." In James Curran, Michael Gurevitch, and Janet Woollacott, eds. *Mass Communication and Society*. Beverly Hills: Sage, 409–425.

Carey, James W. 1975. "A Cultural Approach to Communication." *Communication* 2:1, 1–22.

Commission on Freedom of the Press. 1947. *A Free and Responsible Press*. Chicago: University of Chicago Press.

Curran, James, Michael Gurevitch, and Janet Woollacott. 1982. "The Study of the Media: Theoretical Approaches." In Michael Gurevitch, Tony Bennett, James Curran, and Janet Woollacott, eds. *Culture, Society and the Media*. London: Methuen, 11–29.

213

Davison, W. Phillips, and Frederick T.C. Yu (eds.). 1974. *Mass Communication Re-search: Major Issues and Future Directions.* New York: Praeger.

Dewey, John. 1925. *Experience and Nature.* Chicago: Open Court.

Dewey, John. 1931. *Philosophy and Civilization.* New York: Minton, Balch.

Dewey, John. 1954. *The Public and Its Problems.* Chicago: Swallow Press.

Dewey, John. 1960. *Quest for Certainty: A Study in the Relation of Knowledge and Action.* New York: Capricorn.

Dewey, John. 1966. *Democracy and Education.* New York: Macmillan.

Fenton, Frances. 1910–1911. "The Influence of Newspaper Presentations upon the Growth of Crime and Other Anti-Social Activity." *American Journal of Sociology* 16:3, 342–371 and 16:4, 538–564.

Festinger, Leon A. 1957. *A Theory of Cognitive Dissonance.* Evanston, Ill.: Row and Peterson.

Gerbner, George. 1956. "Toward a General Model of Communication." *Audio-Visual Communication Review* 4:2, 171–199.

Gerbner, George. 1964. "On Content Analysis and Critical Research in Mass Communication." In Lewis Anthony Dexter and David Manning White, eds. *People, Society and Mass Communication.* New York: Free Press, 476–500.

Gerbner, George. 1983. "The Importance of Being Critical—In One's Own Fashion." *Journal of Communication* 33:3 (Summer), 355–362.

Gitlin, Todd. 1981. "Media Sociology: The Dominant Paradigm." In G. Cleveland Wilhoit and Harold de Bock, eds. *Mass Communication Review Yearbook.* Vol. 2. Beverly Hills: Sage, 73–121.

Gombrich, Ernest H. 1969. *In Search of Cultural History.* Oxford: University of Oxford Press.

Gouldner, Alvin W. 1970. *The Coming Crisis of Western Sociology.* New York: Basic Books.

Gouldner, Alvin W. 1976. *The Dialectic of Ideology and Technology: The Origins, Grammar, and Future of Ideology.* New York: Seabury Press.

Gramsci, Antonio. 1988. *An Antonio Gramsci Reader.* David Forgacs, ed. New York: Schocken Books.

Grossberg, Lawrence. 1984. "Strategies of Marxist Cultural Interpretation." *Critical Studies in Mass Communication* 1:4, 392–421.

Habermas, Jürgen. 1971. *Knowledge and Human Interests.* Boston: Beacon Press.

Habermas, Jürgen. 1979. *Communication and the Evolution of Society.* Boston: Beacon Press.

Habermas, Jürgen. 1981. *Theorie des kommunikativen Handelns.* 2 vols. Frankfurt: Suhrkamp.

Habermas, Jürgen. 1984a. *The Theory of Communicative Action.* Vol. 1. *Reason and the Rationalization of Society.* Boston: Beacon Press.

Habermas, Jürgen. 1984b. *Vorstudien und Ergänzungen zur Theorie des kommunikativen Handelns.* Frankfurt: Suhrkamp.

Habermas, Jürgen. 1985. "Questions and Counterquestions." In Richard J. Bernstein, ed. *Habermas and Modernity.* Cambridge, Mass.: Polity Press, 192–216.

Haight, Timothy R. 1983. "The Critical Researcher's Dilemma." *Journal of Communication* 33:3 (Summer), 226–236.

Hall, Stuart. 1979. "Culture, the Media and the 'Ideological Effect.'" In James Curran, Michael Gurevitch, and Janet Woollacott, eds. *Mass Communication and Society.* Beverly Hills: Sage, 315–348.

Hall, Stuart. 1980a. "Cultural Studies and the Centre: Some Problematics and Problems." In Stuart Hall, Dorothy Hobson, Andrew Lowe, and Paul Willis, eds. *Culture, Media, Language.* London: Hutchinson, 15–47.

Hall, Stuart. 1980b. "Introduction to Media Studies at the Centre." In Stuart Hall, Dorothy Hobson, Andrew Lowe, and Paul Willis, eds. *Culture, Media, Language.* London: Hutchinson, 117–121.

Hallin, Daniel C. 1985. "The American News Media: A Critical Theory Perspective." In John Forester, ed. *Critical Theory and Public Life.* Cambridge, Mass.: MIT Press, 122–146.

Halloran, James D. 1983. "A Case for Critical Eclecticism." *Journal of Communication* 33:3 (Summer), 270–278.

Hardt, Hanno. 1979. *Social Theories of the Press: Early German and American Perspectives.* Beverly Hills: Sage.

Hardt, Hanno. 1988. "Communication and Economic Thought: Cultural Imagination in German and American Scholarship." *Communication* 10:2, 141–163.

Harris, Marvin. 1979. *Cultural Materialism: The Struggle for a Science of Culture.* New York: Random House.

Haskell, Thomas. 1977. *The Emergence of Professional Social Science.* Urbana: University of Illinois Press.

Heider, Fritz. 1946. "Attitudes and Cognitive Information." *Journal of Psychology* 21 (January), 107–112.

Horkheimer, Max. 1941a. "Preface." *Studies in Philosophy and Social Science* 9:1, 1.

Horkheimer, Max. 1941b. "Notes on Institute Activities." *Studies in Philosophy and Social Science* 9:1, 121–123.

Horkheimer, Max, and Theodor W. Adorno. 1972. *Dialectic of Enlightenment.* New York: Herder and Herder.

James, Henry (ed.). 1920. *The Letters of William James.* Vol. 2. Boston: Atlantic Monthly Press.

Jay, Martin. 1973. *The Dialectical Imagination: A History of the Frankfurt School and the Institute of Social Research, 1923–1950.* Boston: Little, Brown.

Jay, Martin. 1985. *Permanent Exiles. Essays on the Intellectual Migration from Germany to America.* New York: Columbia University Press.

Johnson, F. Craig, and George R. Klare. 1961. "General Models of Communication Research: A Survey of the Developments of a Decade." *Journal of Communication* 11:1 (March), 13–26.

Katz, Elihu, Jay G. Blumler, and Michael Gurevitch. 1974. "Utilization of Mass Communication by the Individual." In Jay G. Blumler and Elihu Katz, eds. *The Uses of Mass Communications.* Beverly Hills: Sage, 19–32.

Lasswell, Harold D. 1948. "The Structure and Function of Communication in Society." Lyman Bryson, ed. *The Communication of Ideas.* New York: Harper and Row, 37–51.

Lazarsfeld, Paul F. 1941. "Remarks on Administrative and Critical Communications Research." *Studies in Philosophy and Social Science* 9:1, 2–16.

Lazarsfeld, Paul F. 1969. "An Episode in the History of Social Research: A Memoir." In Donald Fleming and Bernard Bailyn, eds. *The Intellectual Migration: Europe and America, 1930–1960*. Cambridge: Harvard University Press, 270–337.

Lerner, Daniel, and Lyle M. Nelson (eds.). 1977. *Communication Research—a Half-Century Appraisal*. Honolulu: University of Hawaii Press.

Matthews, Fred H. 1977. *Quest for an American Sociology: Robert E. Park and the Chicago School*. Montreal: McGill-Queens University Press.

McCombs, Maxwell E., and Donald L. Shaw. 1972. "The Agenda-Setting Function of Mass Media." *Public Opinion Quarterly* 36:2 (Summer), 76–87.

McCombs, Maxwell E., and Donald L. Shaw. 1976. "Structuring the 'Unseen Environment.'" *Journal of Communication* 26:2 (Spring), 18–22.

McIntyre, Jerilyn S. 1987. "Repositioning a Landmark: The Hutchins Commission on Freedom of the Press." *Critical Studies in Mass Communication* 4:2 (June), 136–160.

McLuskie, Ed. 1975. *A Critical Epistemology of Paul Lazarsfeld's Administrative Communication Inquiry*. Unpublished dissertation, University of Iowa.

McLuskie, Ed. 1977. "Integration of Critical Theory with North American Communication Study: Barriers and Prospects." Unpublished paper, ICA convention, Berlin, Germany.

McQuail, Denis. 1984. "With the Benefit of Hindsight: Reflections on Uses and Gratification Research." *Critical Studies in Mass Communication* 1:2 (June), 177–193.

McQuail, Denis, and Sven Windahl. 1981. *Communication Models for the Study of Mass Communications*. New York: Longman.

Mead, George Herbert. 1967. *Mind, Self and Society*. Chicago: University of Chicago Press.

Merton, Robert. 1957. *Social Theory and Social Structure*. New York: Free Press.

Mills, C. Wright. 1970. *The Sociological Imagination*. Harmondsworth: Penguin.

Morrison, David E. 1978. "Kultur and Culture: The Case of Theodor W. Adorno and Paul F. Lazarsfeld." *Social Research* 45:2 (Summer), 331–355.

Mosco, Vincent. 1983. "Critical Research and the Role of Labor." *Journal of Communication* 33:3 (Summer), 237–248.

Newcomb, Theodore M. 1953. "An Approach to the Study of Communicative Acts." *Psychological Review* 60:6, 393–404.

Novack, George. 1975. *Pragmatism Versus Marxism: An Appraisal of John Dewey's Philosophy*. New York: Pathfinder Press.

Oberschall, Anthony (ed.). 1972. *The Establishment of Empirical Sociology*. New York: Harper and Row.

Ogburn, William F. 1964. "Trends in Social Science." In Otis Dudley Duncan, ed. *William F. Ogburn on Culture and Social Change*. Chicago: University of Chicago Press, 207–220.

Park, Robert E. 1938. "Reflections on Communication and Culture." *American Journal of Sociology* 44:2 (September), 187–205.

Park, Robert E. 1967. Foreign Language Press and Progress." In Ralph H. Turner, ed. *Robert E. Park on Social Control and Collective Behavior*. Chicago: University of Chicago Press, 133–144.

Parsons, Talcott, and Edward A. Shils (eds.). 1951. *Toward a General Theory of Action: Theoretical Foundations of the Social Sciences.* New York: Harper Torchbooks.

Patten, Simon Nelson. 1924. *Essays in Economic Theory,* edited by Rexford G. Tugwell. New York: Knopf.

Quandt, Jean B. 1970. *From the Small Town to the Great Community.* New Brunswick: Rutgers University Press.

Riesman, David. 1959. "The State of Communication Research: Comments." *Public Opinion Quarterly* 23:1 (Spring), 10–13.

Rogers, Everett M. 1986. *Communication Technology: The New Media in Society.* New York: Free Press.

Rogers, Everett M., and Francis Balle (eds.). 1985. *The Media Revolution in America and Western Europe.* Norwood, N.J.: Ablex.

Rorty, Richard. 1985. "Habermas and Lyotard on Postmodernity." In Richard J. Bernstein, ed. *Habermas and Modernity.* Cambridge, Mass.: Polity Press, 161–175.

Ross, Edward A. 1910. "The Suppression of Important News." *Atlantic Monthly* (March), 303–311.

Ross, Edward A. 1918. "Social Decadence. " *American Journal of Sociology* 23:5 (March), 620–632.

Schiller, Herbert I. 1983. "Critical Research in the Information Age." *Journal of Communication* 33:3 (Summer), 249–257.

Schramm, Wilbur. 1954. "How Communication Works." In Wilbur Schramm, ed. *The Process and Effects of Mass Communication.* Urbana: University of Illinois Press, 3–26.

Schroyer, Trent. 1975a. *The Critique of Domination: The Origins and Development of Critical Theory.* Boston: Beacon Press.

Schroyer, Trent. 1975b. "The Re-politicization of the Relations of Production: An Interpretation of Jürgen Habermas' Analytic Theory of Late Capitalist Development." *New German Critique* 5 (Spring), 107–128.

Shannon, Claude, and Warren Weaver. 1949. *The Mathematical Theory of Communication.* Urbana: University of Illinois Press.

Shaw, Eugene F. 1979. "Agenda-Setting and Mass Communication Theory." *Gazette* 25:2, 96–105.

Sklar, Robert. 1975. "The Problem of an American Studies Philosophy: A Bibliography of New Directions." *American Quarterly* 27:3 (August), 245–262.

Slack, Jennifer Daryl, and Martin Allor. 1983. "The Political and Epistemological Constituents of Critical Communication Research." *Journal of Communication* 33:3 (Summer), 208–218.

Small, Albion. 1910. *The Meaning of Social Science.* Chicago: University of Chicago Press.

Small, Albion. 1912. "General Sociology." *American Journal of Sociology* 18:2 (September), 200–214.

Small, Albion, and George Vincent. 1894. *An Introduction to the Study of Society.* New York: American Book.

Smythe, Dallas W. 1969. "Preface." In Herbert I. Schiller *Mass Communications and American Empire.* New York: Augustus M. Kelley, vii-viii.

Smythe, Dallas W., and Tran Van Dinh. 1983. "On Critical and Administrative Research: A New Critical Analysis." *Journal of Communication* 33:3 (Summer), 117–127.

Stevenson, Robert L. 1983. "A Critical Look at Critical Analysis." *Journal of Communication* 33:3 (Summer), 262–269.

Thayer, H. S. 1973. *Meaning and Action: A Study of American Pragmatism.* Indianapolis: Bobbs-Merrill.

Vincent, George. 1905. "A Laboratory Experiment in Journalism." *American Journal of Sociology* 11:3, 297–311.

Westley, Bruce, and Malcolm S. MacLean. 1957. "A Conceptual Model for Mass Communication Research." *Journalism Quarterly* 34:1 (Winter), 31–38.

Williams, Raymond. 1977. *Marxism and Literature.* New York: Oxford University Press.

Yarros, Victor S. 1916. A Neglected Opportunity and Duty in Journalism." *American Journal of Sociology* 22:2, 203–211.

Chapter 2
Looking for the Working Class

Abbott, Pamela, and Roger Sapsford. 1987. *Women and Social Class.* London: Tavistock.

Abercrombie, Nicholas, Scott Lash, and Brian Longhurst. 1992. "Popular Representation: Recasting Realism." In Scott Lash and Jonathan Friedman, eds. *Modernity and Identity.* Oxford: Blackwell, 115–140.

Abercrombie, Nicholas, and John Urry. 1983. *Capital, Labour, and the Middle Classes.* London: Allen and Unwin.

Acker, Joan. 1973. "Women and Social Stratification." *American Journal of Sociology* 78, 936–945.

Aronowitz, Stanley. 1973. *False Promises: The Shaping of American Working Class Consciousness.* New York: McGraw-Hill.

Aronowitz, Stanley. 1992. *The Politics of Identity: Class, Culture, Social Movements.* New York: Routledge.

Bonacich, Edna. 1980. "Class Approaches to Ethnicity and Race." *The Insurgent Sociologist* 10:2, 9–24.

Bottomore, Tom. 1965 [1991]. *Classes in Modern Society.* London: Routledge.

Bourdieu, Pierre. 1980. *Distinction.* Boston: Harvard University Press.

Bourdieu, Pierre. 1987. "What Makes a Social Class? On the Theoretical and Practical Existence of Groups." *Berkeley Journal of Sociology* 32, 1–17.

Bourdieu, Pierre, and Loïc J. D. Wacquant. 1992. *An Invitation to Reflexive Sociology.* Chicago: University of Chicago Press.

Breed, Warren. 1960. "Social Control in the Newsroom." In Wilbur Schramm, ed. *Mass Communications.* Urbana: University of Illinois Press, 178–194.

Brenner, Johanna, and Maria Ramas. 1984. "Rethinking Women's Oppression." *New Left Review* 144, 33–71.

Burke, Martin J. 1995. *The Conundrum of Class: Public Discourse on the Social Order in America.* Chicago: University of Chicago Press.

Butsch, Richard. 1992. "Class and Gender in Four Decades of Television Situation Comedy: Plus ça Change . . ." *Critical Studies in Mass Communication 9*, 387–399.

Chaffee, Steven, and Jack McLeod. 1972. "Adolescent TV Use in the Family Context." In George Comstock and Eli A. Rubinstein, eds. *Television and Social Behavior.* Vol. 3, *Television and Adolescent Aggressiveness.* Washington, D.C.: U.S. Government Printing Office. 149–172.

Clarke, John, C. Critcher, and Richard Johnson (eds.). 1979. *Working-Class Culture: Studies in History and Theory.* New York: St. Martin's Press.

Couvares, Francis. 1984. *The Remaking of Pittsburgh: Class and Culture in an Industrializing City, 1877–1919.* Albany: SUNY Press.

Creedon, Pamela J. (ed.). 1993. *Women in Mass Communication.* Thousand Oaks, Calif.: Sage.

Dahrendorf, Ralph. 1957. *Class and Class Conflict in Industrial Society.* Stanford: Stanford University Press.

D'Alba, Richard. 1990. *Ethnic Identity: The Transformation of White America.* New Haven: Yale University Press.

Daly, Mary. 1978. *Gyn/Ecology: The Metaethics of Radical Feminism.* London: Women's Press.

Denning, Michael. 1987. *Mechanic Accents: Dime Novels and Working-Class Culture in America.* London: Verso.

Dex, Shirley. 1985. *The Sexual Division of Work.* Brighton: Wheatsheaf.

Dines, Gail, and Jean M. Humez. 1995. *Gender, Race and Class in Media: A Text Reader.* London: Sage.

Edgell, Stephen. 1993. *Class.* London: Routledge.

Eisenstein, Zillah. 1979. "Developing a Theory of Capitalist Patriarchy and Socialist Feminism." Zillan Eisenstein, ed. *Capitalist Patriarchy and the Case for Socialist Feminism.* New York: Monthly Review Press, 5–40.

Ferguson, Ann. 1989. *Blood at the Root: Motherhood, Sexuality and Male Dominance.* London: Pandora.

Ferguson, Marjorie. 1990. "Images of Power and the Feminine Fallacy." *Critical Studies in Mass Communication 7*, 215–230.

Feuer, Jane. 1984. "Melodrama, Serial Form and Television Today." *Screen 25:1*, 4–16.

Fink, Leon. 1994. *In Search of the Working Class: Essays in American Labor History and Political Culture.* New Haven: Yale University Press.

Franklin, Sarah, Celia Lury, and Jackie Stacey. 1991. "Feminism and Cultural Studies: Pasts, Presents, Futures." *Media, Culture and Society 13*, 171–192.

Frow, John. 1995. *Cultural Studies and Cultural Value.* Oxford: Clarendon Press.

Gamarnikow, Eva. 1983. *Gender, Class and Work.* London: Heinemann.

Gans, Herbert J. 1974. *Popular Culture and High Culture: An Analysis and Evaluation of Taste.* New York: Basic Books.

Gans, Herbert J. 1980. *Deciding What's News: A Study of CBS Evening News, NBC Nightly News, Newsweek and Time.* New York: Vintage Books.

Garnham, Nicholas. 1986. "Contribution to a Political Economy of Mass-Communication." In Richard Collins, James Curran, Nicholas Garnham, Paddy Scan-

nell, Philip Schlesinger, and Colin Sparks, eds. *Media, Culture and Society: A Critical Reader.* London: Sage, 9–32.

Garnham, Nicholas. 1990. *Capitalism and Communication: Global Culture and the Economics of Information.* London: Sage.

Genovese, Eugene D. 1965. *The Political Economy of Slavery.* New York: Pantheon.

Giddens. Anthony. 1973. *The Class Structure of the Advanced Societies.* London: Hutchinson.

Gilbert, Dennis, and Joseph Kahl. 1982. *The American Class Structure.* Homewood, Ill.: Dorsey Press.

Glazer, Nona. 1980. "Overworking the Working Woman: The Double Day in a Mass Magazine." *Women's Studies International Quarterly* 3, 79–93.

Gordon, David, Richard Edwards, and Michael Reich. 1982. *Segmented Work, Divided Workers: The Historical Transformation of Labor in the United States.* Cambridge: Cambridge University Press.

Gordon, Linda. 1976. *Women's Body, Women's Right: A Social History of Birth Control in America.* New York: Grossman-Viking.

Gordon, Milton. 1963. *Social Class in American Sociology.* New York: McGraw-Hill.

Grimes, Michael D. 1991. *Class in Twentieth-Century American Sociology.* New York: Praeger.

Gutman, Herbert. 1973. "Work, Culture, and Society in Industrializing America, 1815–1919." *American Historical Review* 78, 531–588.

Hall, Stuart. 1982. "Cultural Studies: Two Paradigms." In Tony Bennett, Graham Martin, Colin Mercer, and Janet Woollacott, eds. *Culture, Ideology and the Social Process.* London: Open University Press, 19–37.

Hansen, Karen V., and Ilene J. Philipson (eds.). 1990. *Women, Class, and the Feminist Imagination: A Socialist-Feminist Reader.* Philadephia: Temple University Press.

Hardt, Hanno. 1995. "Without the Rank and File: Journalism History, Media Workers, and Problems of Representation." In Hanno Hardt and Bonnie Brennen, eds. *Newsworkers: Towards a History of the Rank and File.* Minneapolis: University of Minnesota Press, 1–29.

Hardt, Hanno, and Bonnie Brennen (eds.). 1995. *Newsworkers: Towards a History of the Rank and File.* Minneapolis: University of Minnesota Press.

Hartmann, Heidi. 1980. "The Family as the Locus of Gender, Class, and Political Struggle: The Example of Housework." *Signs* 6:3, 366–394.

Hartmann, Heidi. 1981. "The Unhappy Marriage of Marxism and Feminism: Towards a More Progressive Union." In L. Sargent, ed. *Women and Revolution.* Boston: South End, 1–42.

Heath, Anthony, and Nicky Britten. 1984. "Women's Jobs Do Make a Difference." *Sociology* 18, 475–490.

Hoggart, Richard. 1970. *The Uses of Literacy.* New York: Oxford University Press.

hooks, bell. 1994. *Outlaw Culture: Resisting Representations.* New York: Routledge.

Hout, Michael, Clem Brooks, and Jeff Manza. 1995. "The Democratic Class Struggle in the United States, 1948–1992." *American Sociological Review* 60:6 (December), 805–828.

Huyssen, Andreas. 1986. *After the Great Divide: Modernism, Mass Culture, Postmodernism.* Bloomington: Indiana University Press.

James, David E., and Rick Berg (eds.). 1996. *The Hidden Foundation: Cinema and the Question of Class.* Minneapolis: University of Minnesota Press.

Jhally, Sut, and Justin Lewis. 1992. *Enlightened Racism: The Cosby Show, Audiences, and the Myth of the American Dream.* Boulder: Westview.

Johnson, Richard. 1978. "Edward Thompson, Eugene Genovese, and Socialist-Humanist History." *History Workshop* 6 (Autumn), 79–100.

Jordan, Amy B. 1992. "Social Class, Temporal Orientation, and Mass Media Use Within the Family System." *Critical Studies in Mass Communication* 9, 374–386.

Joyce, Patrick (ed.). 1995. *Class.* New York: Oxford University Press.

Kelley, Robin D. G. 1994. *Race Rebels: Culture, Politics, and the Black Working Class.* New York: Free Press.

Lears, T. J. Jackson. 1994. *Fables of Abundance: A Cultural History of Advertising in America.* New York: Basic Books.

Lerner, Gerda. 1986. *The Creation of Patriarchy.* New York: Oxford University Press.

Lipsitz, George. 1981. *Class and Culture in Cold War America.* New York: Praeger.

Lull, Jack. 1982. "How Families Select TV Programs: A Mass Observational Study." *Journal of Broadcasting* 16:4, 801–811.

Lynd, Robert. 1939. *Knowledge for What? The Place of Social Science in American Culture.* Princeton: Princeton University Press.

MacKinnon, Catharine A. 1982. "Feminism, Marxism, Method and the State: An Agenda for Theory." *Signs* 7:3, 514–544.

MacKinnon, Catharine A. 1987. *Feminism Unmodified: Discourses on Life and Law.* Cambridge: Harvard University Press.

MacKinnon, Catharine A. 1989. *Toward a Feminist Theory of the State.* Cambridge: Harvard University Press.

Mantsios, Gregory. 1995. "Media Magic: Making Class Invisible." In Paula Rothenberg, ed. *Race, Class and Gender in the United States.* 3rd ed. New York: St. Martin's Press, 409–417.

Mattelart, Armand. 1978. "Introduction: For a Class Analysis of Communication." In Armand Mattelart and Seth Siegelaub, eds. *Communication and Class Struggle.* New York: International General, 23–70.

Mattelart, Armand, and Michele Mattelart. 1992. *Rethinking Media Theory.* Minneapolis: University of Minnesota Press.

McQuail, Denis. 1994. *Mass Communication Theory: An Introduction.* London: Sage.

Messaris, Paul, and Dennis Kerr. 1983. "Mothers' Comments About TV: Relationship to Family Communication Patterns." *Communication Research* 10:2, 175–194.

Middleton, Chris. 1974. "Sexual Inequality and Stratification Theory." In Frank Parkin, ed. *The Social Analysis of Class Structure.* London: Tavistock, 179–203.

Miliband, Ralph. 1977. *Marxism and Politics.* Oxford: Oxford University Press.

Miliband, Ralph. 1991. *Divided Societies: Class Struggle in Contemporary Capitalism.* New York: Oxford University Press.

Millett, Kate. 1971. *Sexual Politics.* New York: Avon.

Mills, C. Wright. 1951. *White Collar: The American Middle Classes.* New York: Oxford University Press.

Mosco, Vincent. 1983. "Critical Research and the Role of Labor." *Journal of Communication* 33:3, 237–248.

Mosco, Vincent, and Janet Wasko (eds.). 1983. *Labor, the Working Class and the Media.* Norwood, N.J.: Ablex.

Mukerji, Chandra, and Michael Schudson (eds.). 1991. *Rethinking Popular Culture. Contemporary Perspectives in Cultural Studies.* Berkeley: University of California Press.

Murdock, Graham, and Peter Golding. 1977. "Capitalism, Communication and Class Relations." In James Curran, Michael Gurevitch, and Janet Wolllacott, eds. *Mass Communication and Society.* Beverly Hills: Sage, 12–43.

Page, Charles. 1940. *Class and American Sociology.* New York: Dial Press.

Parkin, Frank. 1979. *Marxism and Class Theory: A Bourgeois Critique.* New York: Columbia University Press.

Peiss, Kathy. 1985. *Cheap Amusements: Working Women and Leisure in New York City, 1880 to 1920.* Philadelphia: Temple University Press.

Potter, David M. 1954. *People of Plenty: Economic Abundance and the American Character.* Chicago: University of Chicago Press.

Poulantzas, Nicholas. 1974. *Classes in Contemporary Capitalism.* London: Verso.

Press, Andrea L. 1989. "Class and Gender in the Hegemonic Process: Class Differences in Women's Perceptions of Television Realism and Identification with Television Characters." *Media, Culture and Society* 11:2, 229–251.

Press, Andrea L. 1991a. *Women Watching Television: Gender, Class, and Generation in the American Television Experience.* Philadelphia: University of Pennsylvania Press.

Press, Andrea L. 1991b. "Working-Class Women in a Middle-Class World: The Impact of Television on Modes of Reasoning about Abortion." *Critical Studies in Mass Communication* 8, 421–441.

Rich, Adrienne. 1977. *Of Woman Born: Motherhood as Experience and Institution.* London: Virago.

Roberts, Helen (ed.). 1981. *Doing Feminist Research.* London: Routledge.

Rodgers, Daniel T. 1974. *The Working Ethic in Industrial America, 1850–1920.* Chicago: University of Chicago Press.

Roediger, David D. 1991. *The Wages of Whiteness: Race and the Making of the American Working Class.* London: Verso.

Roemer, John. 1982. *A General Theory of Exploitation and Class.* Cambridge: Cambridge University Press.

Scase, Richard. 1992. *Class.* Minneapolis: University of Minnesota Press.

Slotkin, Richard. 1985. *The Fatal Environment: The Myth of the Frontier in the Age of Industrialization, 1800–1890.* New York: Atheneum.

Steeves, H. Leslie, and Marilyn Crafton Smith. 1987. "Class and Gender in Prime-Time Television Entertainment: Observations from a Socialist Feminist Perspective." *Journal of Communication Inquiry* 11:1 (Winter), 43–63.

Sweezy, Paul M. 1953. *The Present as History.* New York: Monthly Review Press.

Szymanski, Albert. 1983. *Class Structure: A Critical Perspective.* New York: Praeger.

Thomas, Sari. 1985. "The Route to Redemption: Religion and Social Class." *Journal of Communication* 35:1, 111–122.

Thompson, E. P. 1966. *The Making of the English Working Class.* New York: Vintage.

Vanneman, Reeve, and L. Weber Cannon. 1987. *The American Perception of Class.* Philadelphia: Temple University Press.

Walby, Sylvia. 1986. *Patriarchy at Work: Patriarchal and Capitalist Relations in Employment.* Oxford: Polity Press.

Walby, Sylvia. 1990. *Theorizing Patriarchy.* Oxford: Blackwell.

Walkerdine, Valerie. 1996. "Subject to Change without Notice: Psychology, Postmodernity and the Popular." In James Curran, David Morley, and Valerie Walkerdine, eds. *Cultural Studies and Communications.* London: Arnold, 96–118.

Watson, Walter B., and Ernest A. Barth. 1964. "Questionable Assumptions in the Theory of Stratification." *Pacific Sociological Review* 7, 10–16.

Weber, Max. 1946. "Class, Status, Party." In Hans Heinrich Gerth and C. Wright Mills, eds. *From Max Weber: Essays in Sociology.* New York: Oxford University Press, 180–195.

Weber, Max. 1968. *Economy and Society.* Vol. 2. New York: Bedminster Press.

Wesolowski, Wlodzimierz. 1979. *Classes, Strata, and Power.* London: Routledge and Kegan Paul.

Williams, Raymond. 1966. *Culture and Society, 1780–1950.* New York: Harper Torchbooks.

Wright, Erik Olin. 1979. *Class Structure and Income Determination.* New York: Academic Press.

Wright, Erik Olin. 1985. *Classes.* London: Verso.

Wright, Erik Olin. 1989a. "Women in the Class Structure." *Politics and Society* 17, 35–66.

Wright, Erik Olin (ed.). 1989b. *The Debate on Classes.* London: Verso.

Chapter 3
Communication in the Media Age

Bock, Irmgard. 1966. *Heideggers Sprachdenken.* Meisenheim: Hain.

Buber, Martin. 1937. *I and Thou.* New York: Scribner's.

Dewey, John. 1925. *Democracy and Education.* New York: Macmillan.

Fuss, Peter L. 1965. *The Moral Philosophy of Josiah Royce.* Cambridge: Harvard University Press.

Heidegger, Martin. 1947. *Über den Humanismus*. Frankfurt: Klostermann.
Heidegger, Martin. 1953. *Einführung in die Metaphysik*. Tübingen: Niemeyer.
Heidegger, Martin. 1956. *Existence and Being*. London: Vision Press.
Heidegger, Martin. 1962. *Being and Time*. New York: Harper and Row.
Jaspers, Karl. 1948. *Philosophie*. Berlin: Springer.
Jaspers, Karl. 1970. *Philosophy*. Vol. 2. Chicago: University of Chicago Press.
Mead, George Herbert. 1967. *Mind, Self and Society*. Chicago: University of Chicago Press.
Royce, Josiah. 1913. *The Problem of Christianity*. Vol. 2. New York: Macmillan.
Vietta, Egon. 1960. *Die Seinsfrage bei Martin Heidegger*. Stuttgart: Schwab.
Vycinas, Vincent. 1961. *Earth and Gods: An Introduction to the Philosophy of Martin Heidegger*. The Hague: Nijhoff.
Wallraff, Charles F. 1970. *Karl Jaspers: An Introduction to His Philosophy*. Princeton: Princeton University Press.

Chapter 4
The Decline of Authenticity

Adorno, Theodor. 1973. *The Jargon of Authenticity*. Evanston: Northwestern University Press.
Arendt, Hannah. 1957. "Karl Jaspers: Citizen of the World." In Paul Arthur Schilpp, ed. *The Philosophy of Karl Jaspers*. La Salle, Ill.: Open Court, 539–550.
Arendt, Hannah. 1958. *The Human Condition: A Study of the Central Dilemmas of Modern Man*. Chicago: University of Chicago Press.
Belsey, Catherine. 1980. *Critical Practice*. London: Methuen.
Benjamin, Walter. 1969a. "What Is Epic Theater?" In Hannah Arendt, ed. *Illuminations*. New York: Schocken Books, 147–154.
Benjamin, Walter. 1969b. "The Work of Art in the Age of Mechanical Reproduction." In Hannah Arendt, ed. *Illuminations*. New York: Schocken Books, 217–252.
Benjamin, Walter. 1986. "The Author as Producer." In Peter Demetz, ed. *Reflections: Essays, Aphorisms, Autobiographical Writings*. New York: Schocken Books, 220–238.
Berman, Marshall. 1988. *All That Is Solid Melts into Air: The Experience of Modernity*. Harmondsworth: Penguin.
Brecht, Bertolt. 1967. "Radiotheorie." In *Gesammelte Werke*. Volume 18. *Schriften zur Literatur und Kunst I*. Frankfurt: Suhrkamp, 119–134 [author's translation].
Brecht, Bertolt. 1974. "The Epic Theater." In Maynard Solomon, ed. *Marxism and Art: Essays Classic and Contemporary*. New York: Vintage Books, 360–369.
Callinicos, Alex. 1990. *Against Postmodernism: A Marxist Critique*. New York: St. Martin's Press.
Chambers, Ian. 1986. *Popular Culture—The Metropolitan Experience*. London: Methuen.
Deleuze, Gilles, and Felix Guattari. 1987. *A Thousand Plateaus: Capitalism and Schizophrenia*. London: Athlone Press.
Dewey, John. 1939. *The Quest for Certainty*. New York: Minton, Balch.

Dewey, John. 1971. *Experience and Nature*. La Salle, Ill.: Open Court.

Etzioni, Amitai. 1968. *The Active Society: A Theory of Societal and Political Processes*. New York: Free Press.

Forgacs, David. 1988 (ed.). *An Antonio Gramsci Reader*. New York: Schocken Books.

Frankfurt Institute for Social Research. 1972. *Aspects of Sociology*. Boston: Beacon Press.

Frith, Simon. 1983. *Sound Effects: Youth, Leisure, and the Politics of Rock 'n' Roll*. London: Constable.

Fromm, Erich. 1955. *The Sane Society*. New York: Holt, Rinehart, and Winston.

Habermas, Jürgen. 1970a. "On Systematically Distorted Communication." *Inquiry* 13 (Winter), 205–218.

Habermas, Jürgen. 1970b. "Towards a Theory of Communicative Competence." *Inquiry* 13 (Winter), 360–375.

Habermas, Jürgen. 1979. *Communication and the Evolution of Society*. Boston: Beacon Press.

Habermas, Jürgen. 1983. "Modernity: An Incomplete Project." In Hal Foster, ed. *The Anti-Aesthetic: Essays on Postmodern Culture*. Port Townsend, Wash.: Bay Press, 3–15.

Hall, Stuart. 1980. "Encoding/decoding." In Stuart Hall, Dorothy Hobson, Andrew Lowe, and Paul Willis, eds. *Culture, Media, Language*. London: Hutchinson, 128–138.

Hardt, Hanno. 1972. "The Dilemma of Mass Communication: An Existential Point of View." *Philosophy and Rhetoric* 5:3, 175–187.

Hardt, Hanno. 1992. *Critical Communication Studies. Communication, History and Theory in America*. London: Routledge.

Heidegger, Martin. 1947. *Über den Humanismus*. Frankfurt: Klostermann.

Heidegger, Martin. 1962. *Being and Time*. New York: Harper and Row.

Horkheimer, Max, and Theodor Adorno. 1972. *Dialectic of Enlightenment*. New York: Herder and Herder.

Jaspers, Karl. 1965. *Nietzsche: An Introduction to the Understanding of His Philosophical Activity*. Tuscon: University of Arizona Press.

Kellner, Douglas. 1992. "Popular Culture and the Construction of Postmodern Identities." In Scott Lash and Jonathan Friedman, eds. *Modernity and Identity*. Oxford: Blackwell, 141–177.

Lippmann, Walter. 1961. *Drift and Mastery*. Englewood Cliffs, N.J.: Prentice-Hall.

Lowenthal, Leo. 1987. "Scholarly Bibliography." In Martin Jay, ed. *An Unmastered Past: The Autobiographical Reflections of Leo Lowenthal*. Berkeley: University of California Press, 111–138.

Lowenthal, Leo. 1989. "Sociology of Literature in Retrospect." In Phillipe Desan, Priscilla Parkhurst Ferguson, and Wendy Griswold, eds. *Literature and Social Practice*. Chicago: University of Chicago Press, 11–25.

Mannheim, Karl. 1951. *Freedom, Power and Democratic Planning*. London: Routledge and Kegan Paul.

Marcuse, Herbert. 1964. *One-Dimensional Man*. Boston: Beacon Press.

Mead, George Herbert. 1967. *Mind, Self and Society*. Chicago: University of Chicago Press.

Mills, C. Wright. 1959. *The Sociological Imagination.* New York: Oxford University Press.

Mueller, Claus. 1973. *The Politics of Communication.* New York: Oxford University Press.

Schroyer, Trent. 1973. "Foreword." In Theodor Adorno. *The Jargon of Authenticity.* Evanston: Northwestern University Press, vii-xvii.

Thompson, John B. 1990. *Ideology and Modern Culture: Critical Social Theory in the Era of Mass Communication.* Stanford: Stanford University Press.

Wellmer, Albrecht. 1991. *The Persistence of Modernity: Essays on Aesthetics, Ethics and Postmodernism.* Cambridge: MIT Press.

Williams, Raymond. 1975. *Television, Technology and Cultural Form.* New York: Schocken Books.

Chapter 5
Communication and Economic Thought

Bruch, Rüdiger vom. 1980. "The Science of the Press: Between History and the National Economy." *Publizistik* 25, 579–607.

Bücher, Karl. 1926. *Gesammelte Aufsätze zur Zeitungskunde.* Tübingen: Laupp.

Cherington, Paul T. 1925. "The Economics of Advertising—Discussion." *American Economic Review* 15, 36–41 (supplement).

Childs, William W. 1924. "Problems in the Radio Industry." *American Economic Review* 14, 520–523.

Clark, Fred E. 1925. "An Appraisal of Certain Criticisms of Advertising." *American Economic Review* 15, 5–13 (supplement).

Craig, Robert Leo. 1985. *The Changing Communicative Structure of Advertisements, 1850–1930.* Unpublished dissertation, University of Iowa.

Dewey, John. 1929. *Experience and Nature.* LaSalle, Ill.: Open Court.

Dewey, John. 1939. *Freedom and Culture.* New York: Capricorn Books.

Dorfman, Joseph. 1949. *The Economic Mind in American Civilization.* Vol. 3, 1865–1918. New York: Viking.

Dorfman, Joseph. 1959. *The Economic Mind in American Civilization.* Vols. 4 and 5, 1918–1933. New York: Viking.

Ely, Richard T. 1884. "The Past and Present of Political Economy." *Johns Hopkins University Studies in Historical and Political Science* 2/3, 1–64.

Ely, Richard T. 1938. *Ground Under Our Feet: An Autobiography.* New York: Macmillan.

Fenton, Francis. 1910, 1911. "The Influence of Newspaper Presentations upon the Growth of Crime and Other Anti-Social Activity." *American Journal of Sociology* 16, 342–371, 538–564.

Fetter, Frank A. 1943. "The Early History of Political Economy in the United States." *Proceedings of the American Philosophical Society* 87, 60.

Fogg-Meade, Emily. 1901. "The Place of Advertising in Modern Business." *Journal of Political Economy* 9, 218–242.

George, Henry. 1981. *The Science of Political Economy: A Reconsideration of Its Principles in Clear and Systematic Form.* New York: Robert Schalkenbach Foundation.

Hall, Stuart. 1982. "The Rediscovery of 'Ideology': Return of the Repressed in Media Studies." In Michael Gurevitch, Tony Bennett, James Curran, and Jane Woollacott, eds. *Culture, Society and the Media*. London: Methuen, 56–90.

Haney, Lewis H. 1911. "Magazine Advertising and the Postal Deficit." *Journal of Political Economy* 19, 338–343.

Herbst, Jürgen. 1965. *The German Historical School in American Scholarship: A Study in the Transfer of Culture*. Ithaca: Cornell University Press.

Hess, Roscoe R. 1911. "The Paper Industry in Its Relation to Conservation and the Tariff." *Quarterly Journal of Economics* 25, 650–681.

Hobson, John A. 1902. *Imperialism: A Study*. London: James Nisbet & Co.

Hotchkiss, George B. 1925. "An Economic Defence of Advertising." *American Economic Review* 15, 14–22 (supplement).

Jenks, J. W. 1895. "The Guidance of Public Opinion." *American Journal of Sociology* 1, 158–169.

Knies, Karl. 1857. *Der Telegraph als Verkehrsmittel. Mit Erörterungen über den Nachrichtenverkehr überhaupt*. Tübingen: Laupp.

Machlup, Fritz. 1984. *Knowledge: Its Creation, Distribution, and Economic Significance*. Vol. 3. *The Economics of Information and Human Capital*. Princeton: Princeton University Press.

Moriarty, W. D. 1925. "An Appraisal of the Present Status of Advertising." *American Economic Review* 15, 23–35 (supplement).

Nabers, Lawrence. 1978. "Veblen's Critique of the Orthodox Economic Tradition." In Douglas F. Dowd, ed. *Thorstein Veblen: A Critical Appraisal*. Ithaca: Cornell University Press, 77–111.

"Organization of the American Sociological Society—Official Report." 1906. *American Journal of Sociology* 9, 555–569.

Patten, Simon Nelson. 1899. *The Development of English Thought: A Study in the Economic Interpretation of History*. New York: Macmillan.

Patten, Simon Nelson. 1908. *The New Basis of Civilization*. New York: Macmillan.

Patten, Simon Nelson. 1924. *Essays in Economic Theory*. Rexford G. Tugwell, ed. New York: Knopf.

Perry, Arthur L. 1866. *Elements of Political Economy*. New York: Scribner's.

Roscher, Wilhelm. 1849. "Der gegenwärtige Zustand der wissenschaftlichen Nationalökonomie und die nothwendige Reform desselben." *German Quarterly Journal* 45, 186.

Ross, Edward A. 1938. *Principles of Sociology*. New York: D. Appleton-Century.

Schäffle, Albert. 1873. "Uber die volkswirthschaftliche Natur der Güter der Darstellung und der Mittheilung." *Zeitschrift für die gesammte Staatswissenschaft* 1, 1–70.

Schäffle, Albert. 1881. *Bau und Leben des Sozialen Körpers*. Tübingen: Laupp.

Siegelman, Philip. 1967. "Introduction." In John A. Hobson. *Imperialism: A Study*. Ann Arbor: University of Michigan Press, v–xvi.

Small, Albion W. 1895. "The Relation of Sociology to Economics." *Journal of Political Economy* 3, 169–184.

Small, Albion W. 1910. *The Meaning of Social Science*. Chicago: University of Chicago Press.

Small, Albion W. 1912. "General Sociology." *American Journal of Sociology* 18, 200–214.

Small, Albion W. 1916. "Fifty Years of Sociology in the United States." *American Journal of Sociology* 21, 721–864.

Small, Albion W., and George Vincent. 1894. *An Introduction to the Study of Society.* New York: American Book.

Sombart, Werner. 1922. *Modern Capitalism.* 5th ed. Vol. 2. München: Duncker and Humbolt.

Veblen, Thorstein. 1900. "The Preconceptions of Economic Science II." *Quarterly Journal of Economics* 14, 240–269.

Wallas, Graham. 1914. *The Great Society: A Psychological Analysis.* New York: Macmillan.

Ward, Lester F. 1892. *The Psychic Factors of Civilization.* Boston: Ginn.

Ward, Lester F. 1902. "Contemporary Sociology." *American Journal of Sociology* 7, 475–500.

Weyl, Walter E. 1912. *The New Democracy: An Essay on Certain Political and Economic Tendencies in the United States.* New York: Macmillan.

White, Morton. 1973. *Pragmatism and the American Mind.* New York: Oxford University Press.

Wiener, Norbert. 1948. *Cybernetics: Or Control and Communication in the Animal and the Machine.* Cambridge: MIT Press.

Wiener, Philip P. (ed.). 1958. *Values in a Universe of Change: Selected Writings of Charles S. Peirce.* Garden City, N.Y.: Doubleday.

Yarros, Victor S. 1899. "The Press and Public Opinion." *American Journal of Sociology* 5, 372–382.

Yarros, Victor S. 1909. "Is an Honest and Sane Newspaper Press Possible?" *American Journal of Sociology* 15, 321–334.

Yarros, Victor S. 1916. "A Neglected Opportunity and Duty in Journalism." *American Journal of Sociology* 22, 203–211.

Chapter 6
The Making of the Public Sphere

Aaron, Daniel. 1961. *Writers on the Left.* New York: Harcourt, Brace and World.

Adorno, Theodor. 1975. "Culture Industry Reconsidered."*new german critique,* 6 (Fall), 12–19.

Aronowitz, Stanley. 1992. *The Politics of Identity: Class, Culture, Social Movements.* New York: Routledge.

Beard, George M. 1881. *American Nervousness: Its Causes and Consequences.* New York: Putnam's.

Bell, Daniel. 1960. *The End of Ideology.* New York: Free Press.

Bernstein, Basil. 1973. *Class, Codes and Control.* St. Albans, Herts: Granada (Paladin).

Birnbaum, Norman. 1969. *The Crisis of Industrial Society.* New York: Oxford University Press.

Blum, John Morton. 1967. *The Promise of America: An Historical Inquiry.* Baltimore: Penguin.

Bradbury, Malcolm, and James McFarlane (eds.). 1976. *Modernism 1890–1930.* Harmondsworth: Penguin.

Burke, Martin J. 1995. *The Conundrum of Class. Public Discourse on the Social Order in America.* Chicago: University of Chicago Press.

Calhoun, Craig (ed.). 1992. *Habermas and the Public Sphere.* Cambridge: MIT Press.

Charity, Arthur. 1995. *Doing Public Journalism.* New York: Guilford Press.

Chomsky, Noam. 1979. *Language and Responsibility.* New York: Pantheon.

Crunden, Robert M. 1993. *American Salons: Encounters with European Modernism, 1885–1917.* New York: Oxford University Press.

Curran, James. 1991a. "Mass Media and Democracy: A Reappraisal." In James Curran and Michael Gurevitch, eds. *Mass Media and Society.* London: Arnold, 82–117.

Curran, James. 1991b. "Rethinking the Media as a Public Sphere." In Peter Dahlgren and Colin Sparks, eds. *Communication and Citizenship.* London: Routledge, 27–57.

Dahlgren, Peter. 1987. "Information and Ideology in the Public Sphere." In Jennifer Slack and Fred Fejes, eds. *The Ideology of the Information Age.* Norwood, N.J.: Ablex, 24–46.

Dewey, John. 1927. *The Public and Its Problems.* New York: Henry Holt.

Engels, Friedrich. 1989. "The Labor Movement in the United States." Lewis S. Feuer, ed. *Marx & Engels: Basic Writings on Politics and Philosophy.* New York: Anchor Books, 489–497.

Feuer, Lewis S. (ed.). 1989. *Marx & Engels: Basic Writings on Politics and Philosophy.* New York: Anchor Books.

Fraser, Nancy. 1989. *Unruly Practice: Power, Discourse and Gender in Contemporary Social Theory.* Minneapolis: University of Minnesota Press.

Fraser, Nancy. 1990. "Rethinking the Public Sphere." *Social Text* 25–26, 56–80.

Fromm, Erich. 1955. *The Sane Society.* New York: Holt, Rinehart and Winston.

Garnham, Nicholas. 1990. *Capitalism and Communication: Global Culture and the Economics of Information.* London: Sage.

Golding, Peter, and Graham Murdock. 1991. "Culture, Communications, and Political Economy." In James Curran and Michael Gurevitch, eds. *Mass Media and Society.* London: Arnold, 15–32.

Gorz, André. 1976. "Technology, Technicians, and the Class Struggle." In André Gorz, ed. *The Division of Labour: The Labour Process and Class Struggle in Modern Capitalism.* London: Harvester Press, 159–189.

Gramsci, Antonio. 1971. *Selections from the Prison Notebooks of Antonio Gramsci.* Quintin Hoare and Geoffrey Novell Smith, eds. New York: International Publishers.

Gunn, Giles. 1992. *Thinking Across the American Grain: Ideology, Intellect, and the New Pragmatism.* Chicago: University of Chicago Press.

Habermas, Jürgen. 1962. *Strukturwandel der Öffentlichkeit.* Neuwied: Luchterhand.

Habermas, Jürgen, 1989. *The Structural Transformation of the Public Sphere: An Inquiry into a Category of Bourgeois Society.* Cambridge: MIT Press.

Hohendahl, Peter. 1979. "Critical Theory, Public Sphere, and Culture: Jürgen Habermas and His Critics." *new german critique* 16 (Winter), 89–118.

Keane, John. 1991. *The Media and Democracy.* London: Polity Press.

Kellner, Douglas. 1990. *Television and the Crisis of Democracy.* Boulder: Westview.

Leab, Daniel J. 1970. *A Union of Individuals: The Formation of the American Newspaper Guild, 1933–1936.* New York: Columbia University Press.

Lemert, James B. 1984. "News Context and the Elimination of Mobilizing Information: An Experiment." *Journalism Quarterly* 61, 2, 243–249, 259.

Lichtenberg, Judith (ed.). 1990. *Democracy and the Mass Media.* New York: Cambridge University Press.

Liebling, A. J. 1975. *The Press.* New York: Ballantine Books.

Marcuse, Herbert. 1964. *One-Dimensional Man: Studies in the Ideology of Advanced Industrial Society.* Boston: Beacon Press.

Marx, Karl. 1975. *Early Writings.* New York: Vintage Books.

McLuhan, Marshall. 1964. *Understanding Media: The Extensions of Man.* New York: McGraw-Hill.

Peters, John. 1993. "Distrust of Representation: Habermas on the Public Sphere." *Media, Culture and Society* 15, 541–571.

Peters, John, and Kenneth Cmiel. 1991. "Media Ethics and the Public Sphere." *Communication* 12, 197–215.

Potter, David M. 1954. *People of Plenty: Economic Abundance and the American Character.* Chicago: University of Chicago Press.

Riehl, Wilhelm H. 1990. *The Natural History of the German People.* David J. Diephouse, trans. and ed. Lewiston, N.Y.: Edwin Mellen Press. Parts of this book were originally published in *Die bürgerliche Gesellschaft.* Stuttgart: Cotta, 1861.

Rodgers, Daniel T. 1974. *The Working Ethic in Industrial America, 1850–1920.* Chicago: University of Chicago Press.

Rosen, Jay. 1996. *Getting the Connections Right. Public Journalism and the Troubles in the Press.* New York: Twentieth Century Fund.

Schudson, Michael. 1992. "Was There Ever a Public Sphere? If So, When? Reflections on the American Case." In Craig Calhoun, ed. *Habermas and the Public Sphere.* Cambridge: MIT Press, 143–163.

Schumpeter, Joseph A. 1942. *Capitalism, Socialism and Democracy.* New York: Harper.

Sexton, Patricia Cayo. 1991. *The War on Labor and the Left: Understanding America's Unique Conservatism.* Boulder: Westview.

Sinclair, Upton. 1907. *The Industrial Republic.* New York: Doubleday.

Sinclair, Upton. 1936. *The Brass Check.* New York: Boni.

Smythe, Dallas W. 1994. *Counterclockwise: Perspectives on Communication.* Thomas Guback, ed. Boulder: Westview.

Sombart, Werner. 1976 [1906]. *Why Is There No Socialism in the United States?* White Plains, N.Y.: Sharpe.

Weber, Max. 1946. "The Social Psychology of the World Religions." In H. H. Gerth and C. Wright Mills, eds. *From Max Weber: Essays in Sociology.* New York: Oxford University Press, 267–301.

Wilson, Woodrow. 1913. *The New Freedom.* New York: Doubleday.

Zinn, Howard. 1973. *Postwar America: 1945–1971.* Indianapolis: Bobbs-Merrill.

Chapter 7
The World According to America

Birkhead, Douglas. 1982. *Presenting the Press: Journalism and the Professional Project.* Unpublished dissertation, University of Iowa.

Blumer, Herbert. 1933. *Movies and Conduct.* New York: Macmillan.

Blumer, Herbert and Philip M. Hauser. 1933. *Movies, Delinquency and Crime.* New York: Macmillan.

Brownlie, Ian (ed.). 1971. *Basic Documents on Human Rights.* London: Oxford University Press.

Bryan, Carter R. 1964. "Government and the Press." In John C. Merrill, Carter R. Bryan, and Marvin Alisky, eds. *The Foreign Press.* Baton Rouge: Louisiana State University Press, 23–33.

Cannon, Carl L. (ed.). 1924. *Journalism: A Bibliography.* New York: New York Public Library.

Cantril, Hadley, Hazel Gaudet, and Herta Herzog. 1940. *Invasion from Mars.* Princeton: Princeton University Press.

Carey, James W. 1979. "Mass Communication Research and Cultural Studies: An American Review." In James Curran, Michael Gurevitch, and Janet Woollacott, eds. *Mass Communication and Society.* Beverly Hills: Sage, 409–425.

"Changes in the French Press." 1906 (November 22). *Nation,* 432–433.

Clark, Keith. 1931. *International Communications: The American Attitude.* New York: Columbia University Press.

Codon, Elaine C. 1973. *Introduction to Cross Cultural Communication.* New Brunswick, N.J.: Rutgers University Press.

Cohen, Bernard C. 1963. *The Press and Foreign Policy.* Princeton: Princeton University Press.

Cunliffe, J. W. 1925. "Comparative Journalism." *Journalism Bulletin* 2 :1, 15–17.

Desmond, Raymond W. 1937. *The Press and World Affairs.* New York: Appleton-Century.

"Development of the Press in China." 1909 (July 31). *Literary Digest* 39, 158–159.

Dinwiddie, William. 1904 (June 4). "Experiences as a War Correspondent." *Harper's Weekly* 48, 862–864.

Edelstein, Alex S. 1982. *Comparative Communication Research.* Beverly Hills: Sage.

"Freedom of Information." 1948 (May 1). *Economist* 154, 700–702.

Gallup, George H. 1976. "Human Needs and Satisfactions: A Global Survey." *Public Opinion Quarterly* 40, 459–467.

Gerald, J. Edward. 1931. "Aspects of Journalism in South America." *Journalism Quarterly* 8, 213–223.

Gerbner, George, and George Marvanyi. 1977. "The Many Worlds of the World's Press." *Journal of Communication* 27:1, 52–66.

Golding, Peter. 1974. "Media Role in National Development: Critique of a Theoretical Orthodoxy." *Journal of Communication* 24:3, 39–53.

Gunter, Jonathan F. 1979. *The United States and the Debate on the World "Information Order."* Washington, D.C.: Academy for Educational Development.

Hachten, William A. 1981. *The World News Prism.* Ames: Iowa State University Press.

Hall, Stuart. 1979. "Culture, the Media and the 'Ideological Effect'." In James Curran, Michael Gurevitch, and Janet Woollacott, eds. *Mass Communication and Society.* Beverly Hills: Sage, 315–348.

Hall, Stuart. 1982. "The Rediscovery of 'Ideology': Return of the Repressed in Media Studies." In Michael Gurevitch, Tony Bennett, James Curran, and Janet Woollacott, eds. *Culture, Society and the Media.* London: Methuen, 56–90.

Harvey, G.B.M. 1908. "Journalism, Politics, and the University." *North American Review* 187, 598–610.

Hester, Al. 1971. "An Analysis of News Flow from Developed and Developing Nations." *Gazette* 77, 29–43.

Hinkle, Roscoe C., and Gisela J. Hinkle. 1954. *The Development of Modern Sociology: Its Nature and Growth in the United States.* New York: Random House.

Horkheimer, Max, and Theodor Adorno. 1972. *Dialectic of Enlightenment.* New York: Herder and Herder.

Hovland, Carl. 1953. *Communication and Persuasion.* New Haven: Yale University Press.

Journalism Quarterly. 1933. "World-Wide Symposium on Journalism in the Year 1933." 70, 265–322.

Journal of Communication. 1974. "Cultural Exchange Or Invasion." 24:1, 89–117.

Journal of Communication. 1977. "When Cultures Clash." 2:2, 112–162.

Journal of Communication. 1978. "World Communication." 28:4, 140–193.

Journal of Communication. 1979. "Third World News and Views." 29:2, 134–198.

Journal of Communication. 1981. "The Press, the U.S., and UNESCO." 31:4, 102–188.

Journal of Communication. 1984. "The Global Flow of Information." 34:1, 120–188.

Kang, Myung Koo. 1986. *Communication, Culture and History: An Interpretive and Dialectical Perspective on Comparative Communication Research.* Unpublished dissertation, University of Iowa.

Kent, Kurt, and Ramona Rush. 1977. "International Communication as a Field: A Study of *Journalism Quarterly* Citations." *Journalism Quarterly* 54, 580–583.

Laski, Harold J. 1937. "Introduction." In Raymond W. Desmond, *The Press and World Affairs.* New York: Appleton-Century, xxiii–xxv.

Lasswell, Harold D. 1927. *Propaganda Technique in the World War.* New York: Knopf.

Lasswell, Harold D. 1960. "The Structure and Function of Communication in Society." In Wilbur Schramm, ed. *Mass Communications.* Urbana: University of Illinois Press, 117–130.

Lazarsfeld, Paul F. 1941. "Remarks on Administrative and Critical Communications Research." *Studies in Philosophy and Social Science* 9, 2–16.

Lazarsfeld, Paul F. (ed.). 1969. *Mathematical Thinking in the Social Sciences.* New York: Russell and Russell.

Lee, James M. 1918. *Instruction in Journalism in Institutions of Higher Education.* Bulletin no. 21. Washington, D.C.: Department of the Interior Bureau of Education.

Lerner, Daniel. 1958. *The Passing of Traditional Society: Modernizing the Middle East.* Glencoe: Free Press.

Loory, Stuart H. 1974. "The CIA's Use of the Press." *Columbia Journalism Review* 13:3, 9–18.

Lowenstein, Ralph L. 1966. "PICA: Measuring World Press Freedom." *Freedom of Information Center Publication* (no. 166). Columbia: University of Missouri Press.

Lowenstein, Ralph L. 1967. "World Press Freedom." *Freedom of Information Center Publication* (no. 181). Columbia: University of Missouri Press.

Lyons, Eugene. (ed.). 1937. *We Cover the World.* New York: Harcourt, Brace.

Markham, James W. 1967. *Voices of the Red Giants.* Ames: Iowa State University Press.

Martin, L. John, and Anju G. Chaudhary (eds.). 1983. *Comparative Mass Media Systems.* New York: Longman.

McPhail, Thomas L. 1981. *Electronic Colonialism.* Beverly Hills: Sage.

Media, Culture and Society. 1985. Special issue on telecommunications policy. 7, 3–125.

Mels, Edgar. 1904 (July 2). "War News—Its Cost and Collection." *Saturday Evening Post,* 14–17.

Merrill, John C. 1968. *The Elite Press: Great Newspapers of the World.* New York: Pitman.

Merrill, John C. (ed.). 1983. *Global Journalism: A Survey of the World's Mass Media.* New York: Longman.

Mills, C. Wright. 1970. *The Sociological Imagination.* Harmondsworth: Penguin.

Nash, Vernon. 1931. "Chinese Journalism in 1931." *Journalism Quarterly* 8, 446–452.

Nisbet, Robert A. 1969. *Social Change and History—Aspects of Western Theory and Development.* New York: Oxford University Press.

Nixon, Raymond. 1960. "Factors Related to Freedom in National Press Systems." *Journalism Quarterly* 37, 13–28.

Nordenstreng, Kaarle. 1984. *The Mass Media Declaration of UNESCO.* Norwood, N.J.: Ablex.

Park, Robert. 1972. "Reflections on Communication and Culture." In Henry Elsner Jr., ed. *Robert Park: The Crowd and the Public and Other Essays.* Chicago: University of Chicago Press, 98–116.

Peters, John D. 1986. "Institutional Sources of Intellectual Poverty in Communication Research." *Communication Research* 13, 527–559.

Peterson, Ruth C., and L. L. Thurstone. 1933. *Motion Pictures and Social Attitudes of Children.* New York: Macmillan.

Pool, Ithiel de Sola. 1963. "The Mass Media and Politics in the Modernization Process." In Lucian W. Pye, ed. *Communications and Political Development.* Princeton: Princeton University Press, 234–253.

Pye, Lucian W. (ed.). 1963. *Communications and Political Development.* Princeton: Princeton University Press.

Quandt, Jean B. 1970. *From the Small Town to the Great Community.* New Brunswick: Rutgers University Press.

Read, William H. 1976. "Global TV Flow: Another Look." *Journal of Communication* 26:3, 69–73.

Renaud, Jean-Luc. 1985. "U.S. Government Assistance to AP's World-Wide Expansion." *Journalism Quarterly* 62, 10–16, 36.

Rogers, Everett M. 1969. *Modernization Among Peasants: The Impact of Communication.* New York: Holt, Rinehart, and Winston.

Salinas, Raquel, and Leena Paldán. 1979. "Culture in the Process of Dependent Development: Theoretical Perspectives." In Kaarle Nordenstreng and Herbert I. Schiller, eds. *National Sovereignty and International Communication.* Norwood, N.J.: Ablex, 82–98.

Samovar, Larry A. (ed.). 1976. *Intercultural Communication: A Reader.* Belmont, Calif.: Wadsworth.

Sarbaugh, L. E. 1976. *Intercultural Communication.* New York: Hastings House.

Schiller, Herbert I. 1969. *Mass Communication and American Empire.* New York: Kelley.

Schiller, Herbert I. 1976. *Communication and Cultural Domination.* White Plains, NY: International Arts and Sciences Press.

Schneider, Michael J. 1979. *Cross-Cultural Communication and the Acquisition of Communicative Competence.* Unpublished dissertation, University of Iowa.

Schramm, Wilbur. (ed.). 1954. *The Process and Effects of Mass Communication.* Urbana: University of Illinois Press.

Schramm, Wilbur. 1956. "The Soviet Communist Theory." In Fred S. Siebert, Theodore Peterson, and Wilbur Schramm, eds. *Four Theories of the Press: The Authoritarian, Libertarian, Social Responsibility, and Soviet Communist Concepts of What the Press Should Be and Do.* Urbana: University of Illinois Press, 105–146.

Schramm, Wilbur (ed.). 1960. *Mass Communications.* Urbana: University of Illinois Press.

Schramm, Wilbur. 1964. *Mass Media and National Development.* Stanford: Stanford University Press.

Siebert, Fred S., Theodore Peterson, and Wilbur Schramm. 1956. *Four Theories of the Press: The Authoritarian, Libertarian, Social Responsibility, and Soviet Communist Concepts of What the Press Should Be and Do.* Urbana: University of Illinois Press.

Smith, Bruce L., Harold D. Lasswell, and Ralph D. Casey. 1946. *Propaganda, Communication and Public Opinion.* Princeton: Princeton University Press.

Smith, Bruce L., and Chitra M. Smith. 1956. *International Communication and Political Opinion.* Princeton: Princeton University Press.

Stevenson, Robert L. 1980 (July 5). "The Western News Agencies Do Not Ignore the Third World." *Editor and Publisher* 11, 15, 32.

Tunstall, Jeremy. 1982. "The Media are (still) American." In L. Erwin Atwood, Stuart J. Bullion, and Sharon M. Murphy, eds. *International Perspectives on News.* Carbondale: Southern Illinois University Press, 133–144.

UNESCO. 1980. *Many Voices, One World.* Paris: UNESCO.

United Nations. 1946. *Yearbook of the United Nations.* Lake Success, N.Y.: United Nations.

Weaver, David, and G. Cleveland Wilhoit, 1981. "Foreign News Coverage in Two U.S. Wire Services." *Journal of Communication* 31:2, 55–63.

Weaver, James H., and Marguerite Berger. 1984. "The Marxist Critique of Dependency Theory: An Introduction." In Charles K. Wilber, ed. *The Political Economy of Development and Underdevelopment.* New York: Random House, 45–64.

Worsley, Peter. 1972. *The Third World.* Chicago: University of Chicago Press.

Znaniecki, Florian. 1968. *The Social Role of the Man of Knowledge.* New York: Harper.

Chapter 8
Alien Culture, Immigrant Voices

Bleyer, Willard G. 1927. *Main Currents in the History of American Journalism.* Boston: Houghton Mifflin.

Brennen, Bonnie.1993. *'Peasantry of the Press:' A History of American Newsworkers from Novels, 1919–1938.* Unpublished dissertation, University of Iowa.

Carey, James W. 1974. "The Problem of Journalism History." *Journalism History* 1:1, 3–5, 27.

Dann, Martin E. (ed.). 1971. *The Black Press 1827–1890: The Quest for National Identity.* New York: Capricorn.

Dewey, John. 1935. *Liberalism and Social Action.* New York: Putnam's.

Dewey, John. 1938. *Logic: The Theory of Inquiry.* New York: Holt.

Emery, Edwin. 1962 [1954]. *The Press and America: An Interpretive History of Journalism.* Englewood Cliffs, N.J.: Prentice-Hall.

Emery, Edwin, and Michael Emery. 1988 [1984]. *The Press and America: An Interpretive History of the Mass Media.* Englewood Cliffs, N.J.: Prentice-Hall.

Folkerts, Jean, and Dwight L. Teeter Jr. 1989. *Voices of a Nation: A History of Media in the United States.* New York: Macmillan.

Gordon, George N. 1977. *The Communications Revolution: A History of Mass Media in the United States.* New York: Hastings House.

Grabo, Carl H. 1919 (May 31). "Americanizing the Immigrants." *Dial* 66: 791, 539–541.

Grant, Madison. 1916. *The Passing of the Great Race; or, the Racial Basis of European History.* New York: Scribner's.

Handlin, Oscar. 1951. *The Uprooted: The Epic Story of the Great Migration that Made the American People.* Boston: Little, Brown.

Handlin, Oscar. 1959. *Immigration as a Factor in American History.* Englewood Cliffs, N.J.: Prentice-Hall.

Hirsch, E. D., Jr. 1988. *Cultural Literacy: What Every American Needs to Know.* New York: Vintage.

Hoerder, Dirk, and Christiane Harzig (eds.). 1987. *The Immigrant Labor Press in North America, 1840s–1970s: An Annotated Bibliography.* 3 vols. Westport, Conn.: Greenwood.

Hudson, Frederic. 1973 [1872]. *Journalism in the United States from 1690 to 1872.* New York: Harper.

Jones, Robert W. 1947. *Journalism in the United States.* New York: Dutton.

Kallen, Horace M. 1915. "Democracy Versus the Melting-Pot. A Study of American Nationality."*Nation* 100:2, 217–220, 591.

Lee, Alfred McClung. 1937. *The Daily Newspaper in America. The Evolution of a Social Instrument.* New York: Macmillan.

Lee, James. 1923 [1917]. *History of American Journalism.* Boston: Houghton Mifflin.

Mayo-Smith, Richmond. 1895. *Emigration and Immigration: A Study in Social Science.* New York: Scribner's.

Miller, Sally M. (ed.). 1987. *The Ethnic Press in the United States: A Historical Analysis and Handbook.* Westport, Conn.: Greenwood.

Mott, Frank Luther. 1962 [1941]. *American Journalism: A History: 1690–1960.* New York: MacMillan.

Murphy, James E., and Sharon M. Murphy. 1981. *Let My People Know: American Indian Journalism.* Norman: University of Oklahoma Press.

Park, Robert E. 1922. *The Immigrant Press and Its Control.* New York: Harper.

Payne, George H. 1920. *History of Journalism in the United States.* New York: Appleton-Century.

Scardino, Albert. 1988 (August 22). "A Renaissance for Ethnic Papers." *New York Times,* 21, 26.

Smith, William C. 1939. *Americans in the Making: The Natural History of the Assimilation of Immigrants.* New York: Appleton-Century.

Strout, Cushing. 1958. *The Pragmatic Revolt in American History: Carl Becker and Charles Beard.* Ithaca: Cornell University Press.

Tebbel, John. 1969 [1963]. *The Compact History of the American Newspaper.* New York: Hawthorn.

Tebbel, John. 1974. *The Media in America.* New York: Crowell.

Thomas, Isaiah. 1970 [1810]. *The History of Printing in America.* New York: Weathervane.

Turner, Frederick Jackson. 1920. *The Frontier in American History.* New York: Holt, Rinehart, and Winston.

Chapter 9
Against the Rank and File

Bagdikian, Ben H. 1971. *The Information Machines.* New York: Harper and Row.

Berger, Asa A. (ed.). 1988. *Media USA: Process and Effect.* New York: Longman.

Biagi, Shirley. 1988. *Media/Impact: An Introduction to Mass Media.* Belmont, Calif.: Wadsworth.

Black, Jay, and Frederick C. Whitney. 1988. *Introduction to Mass Communication.* Dubuque, Iowa: Brown.

Bleyer, Willard G. 1927. *Main Currents in the History of American Journalism.* Boston: Houghton Mifflin.

Carey, James W. 1974. "The Problem of History," *Journalism History* 1:1, 3–5, 27.

Emery, Edwin. 1962 [1954]. *The Press and America: An Interpretive History of Journalism.* Englewood Cliffs, N.J.: Prentice-Hall.

Emery, Edwin. 1978. *The Press and America.* Englewood Cliffs, N.J.: Prentice-Hall.

Emery, Michael, and Edwin Emery. 1988. *The Press and America.* Englewood Cliffs, N.J.: Prentice-Hall.

Folkerts, Jean, and Dwight L. Teeter. 1989. *Voices of a Nation: A History of the Media in the United States.* New York: Macmillan.

Gordon, George N. 1977. *The Communications Revolution: A History of Mass Media in the United States.* New York: Hastings House.

Hallin, Daniel C. 1985. "The American News Media: A Critical Theory Perspective." In John Forester, ed. *Critical Theory and Public Life.* Cambridge: MIT Press, 121–146.

Hardt, Hanno. 1989. "The Foreign-Language Press in American Press History." *Journal of Communication,* 38:2, 114–131.

Hardt, Hanno. 1995. "Without the Rank and File. Journalism History, Media Workers, and Problems of Representation." In Hanno Hardt and Bonnie Brennen, eds. *Newsworkers: Towards a History of the Rank and File.* Minneapolis: University of Minnesota Press, 1–29.

Harless, James D. 1990. *Mass Communication: An Introductory Survey.* Dubuque, Iowa: Brown.

Hohenberg, John. 1973. *Free Press, Free People.* New York: Free Press.

Hudson, Frederic. 1973 [1872]. *Journalism in the United States from 1690 to 1872.* New York: Harper.

Jones, Robert W. 1947. *Journalism in the United States.* New York: Dutton.

Leab, Daniel J. 1970. *A Union of Individuals: The Formation of the American Newspaper Guild, 1933–1936.* New York: Columbia University Press.

Lee, Alfred McClung. 1937. *The Daily Newspaper in America.* New York: Macmillan.

Lee, Alfred McClung. 1957. *The Daily Newspaper in America: The Evolution of a Social Instrument.* New York: Macmillan.

Lee, James. 1923 [1917]. *History of American Journalism.* Boston: Houghton-Mifflin.

Lindstrom, Charles E. 1960. *The Fading of the American Newspaper.* New York: Doubleday.

Merrill, John Calhoun, John Lee, and E. J. Friedlander (eds.). 1990. *Modern Mass Media.* New York: Harper and Row.

Mott, Frank Luther. 1942. *American Journalism.* New York: Macmillan.

Mott, Frank Luther. 1962 [1942]. *American Journalism: A History, 1690–1960.* New York: Macmillan.

Payne, George H. 1920. *History of Journalism in the United States.* New York: Appleton-Century.

Pool, Ithiel de Sola. 1983. *Technologies of Freedom.* Cambridge: Harvard University Press.

Pursell, Carroll. 1980. "The American Ideal of a Democratic Technology." In Teresa de Lauretis, Andreas Huyssen, and Kathleen M. Woodward, eds. *The Technological Imagination: Theories and Fictions*. Madison, Wis.: Coda Press, 11–25.

Ryan, Michael. 1979. "Tough Question: To Judge or not to Judge the Media."*Journalism Educator* 34 (1), 3–5, 42.

Schudson, Michael. 1978. *Discovering the News: A Social History of American Newspapers*. New York: Basic Books.

Smith, Anthony. 1978. "The Long Road to Objectivity and Back Again: the Kinds of Truth We Get in Journalism." In George Boyce, James Curran and Pauline Wingate, eds. *Newspaper History: Fom the 17th Century to the Present Day*. London: Constable, 153–171.

Tebbel, John. 1969 [1963]. *The Compact History of the American Newspaper*. New York: Hawthorn Books.

Thomas, Isaiah. 1970 [1810]. *The History of Printing in America*. New York: Weathervane Books.

Wells, Alan. (ed.). 1987. *Mass Media and Society*. Lexington, Mass.: Heath.

Williams, Frederick. 1987. *Technology and Communication Behavior*. Belmont, Calif.: Wadsworth.

Chapter 10
The End of Journalism

Bell, Daniel. 1960. *The End of Ideology*. New York: Free Press.

Birkhead, Douglas. 1982. *Presenting the Press: Journalism and the Professional Project*. Unpublished dissertation, University of Iowa.

Boyce, George. 1978. "The Fourth Estate: the Reappraisal of a Concept." In George Boyce, James Curran, and Pauline Wingate, eds. *Newspaper History: Fom the 17th Century to the Present Day*. London: Constable, 19–40.

Boylan, James. 1986. "Declarations of Independence." *Columbia Journalism Review* (November-December), 29–45.

Braverman, Harry. 1974. *Labor and Monopoly Capital: The Degradation of Work in the Twentieth Century*. New York: Monthly Review Press.

Breed, Warren. 1955. "Social Control in the Newsroom: A Functional Analysis." *Social Forces* 33 (May), 326–335.

Brennen, Bonnie. 1995. "Cultural Discourse of Journalists: The Material Conditions of Newsroom Labor." In Hanno Hardt and Bonnie Brennen, eds. *Newsworkers: Towards a History of the Rank and File*. Minneapolis: University of Minnesota Press, 75–109.

Brucker, Herbert. 1949. *Freedom of Information*. New York: Macmillan.

Brucker, Herbert. 1973. *Communication Is Power: Unchanging Values in a Changing Journalism*. New York: Oxford University Press.

Burnham, David. 1996. "The Lens of Democracy." In *News in the Next Century. Digital Debate: Covering Government and Politics in a New Media Environment*. Chicago: Radio-Television News Directors Foundation, 11–15.

Byerly, Carolyn M., and Catherine A. Warren. 1996. "At the Margins of Center: Organized Protest in the Newsroom." *Critical Studies in Mass Communication* 13:1 (March), 1–23.

Carey, James W. 1969. "The Communication Revolution and the Professional Communicator." In Paul Halmos, ed. *The Sociological Review Monographs* (United Kingdom) 13, 23–38.

Connors, Tracy Daniel. 1982. *Longman Dictionary of Mass Media and Communication.* New York: Longman.

Consoli, John. 1995 (May 6), "Top Sears Exec Touts 'Partnership' with Newspapers." *Editor & Publisher* 128, 24–25.

Derber, Charles. 1983. "Managing Professionals: Ideological Proletarianization and Post-Industrial Labor." *Theory and Society* 12:3, 309–341.

Dicken-Garcia, Hazel. 1989. *Journalistic Standards in Nineteenth Century America.* Madison: University of Wisconsin Press.

Editor & Publisher. 1995 (May 6). "Preliminary Results Issued in Newspaper Departure Study," 128, 23.

Emery, Edwin. 1978. *The Press and America.* Englewood Cliffs, N.J.: Prentice-Hall.

Emery, Michael, and Edwin Emery. 1988. *The Press and America.* Englewood Cliffs, N.J.: Prentice-Hall.

Encyclopedia Americana. 1993. International edition. Danbury, Conn.: Grolier.

Fitzgerald, Mark. 1995 (May 6). "Newspaper Circulation Report." *Editor & Publisher* 128, 12–13.

Friedman, Milton. 1970 (13 September). "The Social Responsibility of Business Is to Increase Its Profits." *New York Times Magazine,* 32–33, 122–126.

Fukuyama, Francis. 1992. *The End of History and the Last Man.* New York: Free Press.

Gans, Herbert. 1980. *Deciding What's News: A Study of CBS Evening News, NBC Nightly News, Newsweek, and Time.* New York: Vintage.

Garry, Patrick M. 1990. *The American Vision of a Free Press.* New York: Garland.

Gitlin, Todd. 1980. *The Whole World Is Watching: Mass Media in the Making and Unmaking of the New Left.* Berkeley: University of California Press.

Glasser, Theodore. 1996 (September). "Remarks." Future of Journalism Colloquium, Euricom, Piran, Slovenia.

Habermas, Jürgen. 1996. *Between Facts and Norms: Contributions to a Discourse Theory of Law and Democracy.* Cambridge: MIT Press.

Hardt, Hanno. 1990. "Newsworkers, Technology, and Journalism History." *Critical Studies in Mass Communication,* 7:4 (December), 346–365.

Hardt, Hanno. 1996a. "Looking for the Working Class: Class Relations in American Communication Studies." Unpublished manuscript.

Hardt, Hanno. 1996b. "The Making of the Public Sphere: Industrialization, Media, and Participation in the United States." *Javnost/Public* 3:1, 7–23.

Herman, Edward S. 1996. "The Propaganda Model Revisited." *Monthly Review* 48:3 (July-August), 115–128.

Hohenberg, John. 1973. *Free Press, Free People.* New York: Free Press.

Horgan, John. 1996. *The End of Science. Facing the Limits of Knowledge in the Twilight of the Scientific Age.* Reading, Mass.: Addison-Wesley.

Hulteng, John, and Roy Paul Nelson. 1983. *The Fourth Estate: An Informal Appraisal of the News and Opinion Media.* New York: Harper and Row.

Im, Yung-Ho. 1990. *Class, Culture, and Newsworkers: Theories of the Labor Process and the Labor History of the Newspaper.* Unpublished dissertation, University of Iowa.

Jones, R. W. 1947. *Journalism in the United States.* New York: Dutton.

Leslie, John. 1996. *The End of the World: Science and Ethics of Human Extinction.* New York: Routledge.

Levy, Leonard W. 1985. *Emergence of a Free Press.* New York: Oxford University Press.

Marx, Karl. 1975. "Critique of Hegel's Doctrine of the State." In *Early Writings.* Introduced by Lucio Colletti. New York: Vintage, 57–198.

McAllister, Matthew P. 1995. *The Commercialization of American Culture.* Thousand Oaks, Calif.: Sage.

Meiksins, Peter. 1986. "Beyond the Boundary Question." *New Left Review* 157 (May-June), 101–120.

Merrill, John Calhoun. 1974. *The Imperative of Freedom: A Philosophy of Journalistic Autonomy.* New York: Hastings House.

Mott, Frank Luther. 1942. *American Journalism.* New York: Macmillan.

News in the Next Century. 1996. *Digital Debate: Dollars and Demographics: The Evolving Market for News.* Chicago: Radio-Television News Directors Foundation.

Oxford English Dictionary. 1989. 2nd ed. Oxford: Clarendon Press.

Payne, George Henry. 1924. *History of Journalism in the United States.* New York: Appleton.

Powe, Lucas A. Jr. 1991. *The Fourth Estate and the Constitution: Freedom of the Press in America.* Berkeley: University of California Press.

Riehl, Wilhelm Heinrich. 1990. *The Natural History of the German People.* David J. Diephouse, trans. and ed. Lewistown, N.Y.: Edwin Mellen Press. A discussion of the fourth estate was originally published in *Die bürgerliche Gesellschaft.* Stuttgart: Cotta, 1861.

Rosen, Jay. 1994. "Making Things More Public: On the Political Responsibility of the Media Intellectual." *Critical Studies in Mass Communication* 11, 362–388.

Salcetti, Marianne. 1995. "The Emergence of the Reporter: Mechanization and the Devaluation of Editorial Workers." In Hanno Hardt and Bonnie Brennen, eds. *Newsworkers: Towards a History of the Rank and File.* Minneapolis: University of Minnesota Press, 48–74.

Schudson, Michael. 1995. "How News Becomes News." *Forbes Media Critic* 2:4 (Summer), 76–85.

Schwartz, Bernard. 1992. *Freedom of the Press.* New York: Facts on File.

Sigal, Leon V. 1973. *Reporters and Officials: The Organization and Politics of Newsmaking.* Lexington, Mass.: Heath.

Solomon, William S. 1995. "The Site of Newsroom Labor: The Division of Editorial Practices." In Hanno Hardt and Bonnie Brennen, eds. *Newsworker: Towards a History of the Rank and File.* Minneapolis: University of Minnesota Press, 110–134.

Stein, M. L. 1995 (May 6). "Beware of Public Journalism." *Editor & Publisher* 128, 18–19.

Stewart, Potter. 1975. "And of the Press." *Hastings Law Journal* 26 (January), 634–637.

Stinnett, Lee (ed.). 1989. *The Changing Face of the Newsroom: A Human Resources Report.* Washington, D. C.: American Society of Newspaper Editors.

Touraine, Alain. 1995. "Post-Industrial Classes." In James D. Faubion, ed. *Rethinking the Subject: An Anthology of Contemporary European Social Thought.* Boulder: Westview, 181–192.

Underwood, Doug. 1993. *When MBAs Rule the Newsroom. How the Marketers and Managers Are Reshaping Today's Media.* New York: Columbia University Press.

Waller, Judith C. 1946. *Radio: The Fifth Estate.* New York: Houghton Mifflin.

Weaver, David H., and G. Cleveland Wilhoit. 1996. *The American Journalist in the 1990s.* Mahwah, N.J.: Erlbaum.

Webster's Third International Dictionary. 1971. Springfield, Mass.: Merriam.

Wilson, William Julius. 1996. *When Work Disappears.* New York: Knopf.

Index

About the Author

Hanno Hardt is John F. Murray Professor of Journalism and Mass Communication and Professor of Communication Studies at the University of Iowa, where he has taught since 1968, and Professor of Communication at the Faculty of Social Sciences, University of Ljubljana, Slovenia. He is the author of numerous articles in scholarly journals in the United States and abroad and several books, most recently *Critical Communication Studies: Communication, History, and Theory in America*, 1992, and *Newsworkers: Toward a History of the Rank and File*, 1995, which he edited with Bonnie Brennen. His work as a documentary photographer has appeared in exhibitions, magazines, and books.